SKYSCRAPERS

SKYSCRAPERS

A Social History of the Very Tall Building in America

by GEORGE H. DOUGLAS

McFarland & Company, Inc., Publishers
Jefferson, North Carolina, and London

The present work is a reprint of the library bound edition of
Skyscrapers: A Social History of the Very Tall Building in
America, first published in 1996 by McFarland.

LIBRARY OF CONGRESS CATALOGUING-IN-PUBLICATION DATA

Douglas, George H.
 Skyscrapers : a social history of the very tall building in
America / by George H. Douglas.
 p. cm.
 Includes bibliographical references and index.

 ISBN-13: 978-0-7864-2030-8
 (softcover : 50# alkaline paper) ∞

 1. Skyscrapers—Social aspects—United States. 2. Skyscrapers—
United States—History. I. Title.
NA6232.D68 2004
720'.483'0973—dc20 95-39761

British Library cataloguing data are available

Cover illustration ©2004 Digital Vision

Manufactured in the United States of America

*McFarland & Company, Inc., Publishers
Box 611, Jefferson, North Carolina 28640
www.mcfarlandpub.com*

TABLE OF CONTENTS

PREFACE

There have been numerous histories of the skyscraper from an architectural point of view. The present book does not entirely neglect architectural history — no book can in discussing this subject — but it mainly concerns itself with the social history of the skyscraper in the United States. That is to say, its main concern is the place of the skyscraper in American cities, the relationship between tall buildings and the people who work in them, interact with them or view them up close or from afar. It does not rely on the reader's having a great deal of specialized knowledge, and thus it is suitable for the general reader.

This book also deals with the ideas that have been expressed about skyscrapers by those who designed them and those who have attempted to explain their place in urban environments and in American life. Further, it considers skyscrapers as they have appeared in literature, the arts and popular culture.

Why limit the discussion to the skyscraper in America? Very tall buildings now exist all around the world, appearing most recently in Asia and Africa, but they appeared first in the United States. They began to rise in the 1880s, mostly in response to rapidly rising land values in cities, and perhaps also as an expression of American boosterism. American architects, some of them poorly trained by Old World standards and nearly all flying by the seat of their pants, were the first to develop the technology of the skyscraper and the first to concern themselves with the aesthetic of tall buildings. With the passage of time European architects became fascinated by the development of the American skyscraper and enunciated their own ideas on the subject. European architectural movements such as the German Bauhaus school eventually had a great influence on American architecture, particularly after World War II, but the skyscraper was first and foremost an American innovation. Its original home — and the place where it has flourished most prominently — remains the United States. A geographical limitation was needed for this book, and

the United States seemed therefore the most important area to cover. There is, however, a brief discussion of Canadian skyscrapers because Canada's cities closely resemble those of the United States and because skyscrapers in both countries rose almost indistinguishably in terms of architecture and function. In many cases the same architects responsible for America's most notable buildings designed important Canadian skyscrapers, so it seems appropriate to discuss the skyscrapers of Canada to some extent.

For purposes of identification it should be made clear that this book employs the word skyscraper to refer to commercial structures of considerable height at the time of their construction. The majority of such buildings are office buildings, although it is important to realize that there are skyscraper hotels, apartment buildings, university buildings, even hospitals. The present book excludes discussion of television towers, observation towers and other structures which may be of interest because of their height but are limited in their human uses. "Skyscraper" has always meant a very tall building, but of course the phrase "very tall" has implied different heights over the years. A very tall building in 1910 would seem diminutive even 20 years later, and today it might be lost in a forest of 40-, 60- and 80-story neighbors. For this reason the reader will note that there is no firm height cutoff for inclusion in this book; the practical meaning of "skyscraper" depends upon both time and place. This book limits itself to discussing only buildings that were clearly very tall in their original urban context.

Skyscrapers in the United States are largely the product of American dreams and aspirations. Naturally they are also the product of specific economic and social needs of the cities in which they were built. For example, the design of the classic skyscrapers in 1920s New York was as much the result of the setback laws that came in the wake of the Equitable Building of 1915 as it was of the International Style or the art deco aesthetic. Too, some of the unique uses of skyscrapers in America are doubtless due to peculiarly American thrusts of the imagination. One thinks, for example, of Samuel Insull's florid dream of a combined opera house and office building in Chicago, a project which, despite amazingly complicated engineering problems, took shape in the form of the Civic Opera Building.

The present author has had a fond interest in skyscrapers for a good number of years. Growing up in northern New Jersey on the first range of the Watchung Mountains, near Eagle Rock, I was always within sight of the towers of New York City. My indefatigable grandmother and great-grandmother took me on regular tours of Manhattan before I was ten

years old, not neglecting the observation decks of all the skyscrapers that had them — including many long since closed, such as those of the Woolworth, Chanin and Chrysler buildings, and others pleasurably still open such as the RCA Building and the Empire State Building. Some years ago, while working on a pictorial history of Chicago as a railway town (*Rail City: Chicago USA*), I was engaged in photographing the great Chicago railway terminals from some of the city's skyscrapers, and this effort led to a project of photographing Chicago's office buildings from Victorian times to the present. A few of the resulting pictures are found in this book.

No work of this kind can see the light of day without the assistance of a host of individuals, libraries and institutions. Among the individuals who have been helpful to me are Jane Block, librarian of the Ricker Architectural Library at the University of Illinois, and Walter Creese and Alan Laing, professors of architectural history at the University of Illinois. I should also like to thank the late Paul Gapp, the Pulitzer Prize–winning architectural critic of the *Chicago Tribune*; Ira J. Bach, author of *Chicago's Famous Buildings* and chairman of the Commission on Chicago Historical and Architectural Landmarks; and Carl W. Condit, professor of history, urban affairs and art history at Northwestern University.

Among the libraries and institutions that have been helpful to me, I should make mention of the Chicago Historical Society, the Museum of the City of New York, the Library of the Art Institute of Chicago, the Newberry Library, the Ricker Library of the University of Illinois, the Center for Urban Affairs of Northwestern University, Columbia University Library, the New York Historical Society, the Archives of the Chase Manhattan Bank, the New York City Landmarks Preservation Committee, and the Illinois Historical Survey.

Also, thanks go to Rockefeller Center, Inc.; The Empire State Building, Inc.; Cities Service Corporation; Sears, Roebuck & Co.; the United Nations Public Affairs Office; Helmsley, Inc.; Irwin S. Chanin; the *Chicago Tribune*; the Chicago Visitors Bureau; the George Eastman House; the Foshay Building; the San Francisco Visitors and Convention Bureau; the Museum of Modern Art; Chrysler Corporation; Hugh Stubbins Associates; Metropolitan Life Insurance Co.; and United Technologies.

A Brief Note on Building Names

The names of some of the buildings mentioned in this book have changed over the years, some of them more than once. By and large I

have tried to use the names that most people are familiar with, or with which the building was associated for a long time. Most people in New York still call the dominant skyscraper of Rockefeller Center the RCA Building although it is now named the General Electric Building, somewhat confusingly since General Electric also has a striking skyscraper, opened in 1931, several blocks to the east. (A great many people call it the Rockefeller Center Building, a name it never had.) In the book I refer to the Pan Am Building as such even though Pan American Airways has flown into the sunset. The charming art deco classic on Chicago's North Shore originally known as the Palmolive Building and later the Playboy Building is now known only by its street address; I have used all of its names according to the time period where they are appropriate. Sometimes skyscrapers have gotten their old names back: the Kemper Insurance Building that was originally the Civic Opera Building is, perhaps humorously, the Civic Opera Building again. On the other hand one can take comfort in the fact that the Metropolitan Life Insurance Building, the tallest in the world when it was built in 1909, has kept the same name ever since. The lovely Chrysler Building also keeps its original name, although the Chrysler Corporation has long since moved to new quarters. One hopes that a century hence the Empire State Building will still be the Empire State Building.

INTRODUCTION:
SKYSCRAPER PANORAMA

Tall buildings are among the most forceful and defining character-istics of the American urban landscape. Skyscrapers, as they have been called for the better part of a century, are a distinctly modern style of architecture, and an American style in their origin. Since they are office buildings rather than churches, palaces, residences, or monuments to the dead, skyscrapers are often taken to be purely utilitarian products of modern technology — occupied, some may think, by faceless drones, com-puters or calculating machines. Nevertheless, the skyscraper has made an indelible impression on the civilization that created it; it is every bit as much a part of American culture as the great cathedrals were a part of the Middle Ages.

The history of the skyscraper is the story of Isaac Singer and F.W. Woolworth, the story of Louis Sullivan and his dogged determination to make the tall building an American art form. It is the story of countless day laborers placing rivets up in the rarefied air without a single hold or grip; of others working in the dark caverns below. A story of lives lost, of lover's leaps. It is the story of people who have raced to the top (how many steps does the Empire State Building have, and how long does it take for a conditioned runner to reach the 102nd floor?). It is the story of daredevils who see skyscrapers like mountains to be climbed up the outside, much to the chagrin of building managers and civic authorities. People have parachuted onto the tops of skyscrapers, landed helicopters on flat tops, attempted to moor blimps to them, shot holes in them from bazookas. King Kong and other cinematic troublemakers have thrown things at and from these seemingly invincible giants of modern technology. Sharks and con men have sold the towers of lower Manhattan to gulls and dupes newly arrived on the American shore, minutes after their arrival on the ferry from Ellis Island.

1

When approaching New York or Chicago or Atlanta or San Francisco from a distance, what does one see? Close up there are things that are not very comforting: littered streets, corner drug deals, broken-down tenements. But from a distance the story is quite different. A city's skyline seems to carry an element of magic and to generate much of the city's allure. People still want to live in cities in spite of all their apparent defects, and partly this is because of the beauty and majesty of these buildings.

New York, with all its warts and imperfections, remains the preeminent American city. It cannot be denied that New York is the world capital of the skyscraper: here the form and the reality may be seen in all of its glory. Everyone has seen it in pictures, but the reality is much grander and more spectacular than anything revealed in a color brochure or travel agent's poster. No single skyscraper among the many would be so extraordinary in and of itself; one finds such structures everywhere around the world. But here is a veritable sea of these giant office buildings glistening in the sun — towers, minarets, obelisks, an array of lavish structures that would have daunted the most imaginative dreamer of some faraway Babylon.

There is perhaps no equivalent of the Taj Mahal or the Colosseum of Rome or the Mausoleum of Halicarnassus. The meaning of these structures is not clear, and their aesthetics remain somehow a mystery. What do these buildings signify; what manner of civilization is behind them? Like these ancient structures, this modern skyline is moving, powerful, breathtaking. It has an immediacy, a presence and a spirit that cannot be denied. It is a work of man, not of nature, yet it is a thing of beauty and dramatic force. The skyline of New York is a monument, an outward symbol of an aggressive and once confident people, a technological achievement that is matchless in the history of the human race.

In the private opinion of the typical European visitor and world traveler, the United States is a land of materialists, and indeed it may be that the vast and lofty buildings are a symbol of a shallow and money-grasping people, although there is much evidence to the contrary. It may be that these buildings really have nothing of importance to say, but for that brief moment when one first sees the New York skyline it is impossible to be gripped by such a mean spirited emotion. So overwhelming and commanding are these structures that even the most ungenerous mind is willing to admit that here is some notable historical achievement of the human spirit, some great work of man, quite the equal of the historical wonders of antiquity.

Not a phenomenon of New York alone — or of Chicago, the city

where the modern skyscraper had its birth — the phenomenon of the tall office building has spread widely around the nation to towns and cities of even modest size. Very often the nearness of a small metropolis is revealed to a traveler approaching across some vast and bleak prairie by the sudden and eruptive presence of a single office tower — perhaps a local bank or general office building. Such a building may not be very tall; it may not even be what would be called a skyscraper in New York or Chicago. But it is, somehow, a symbol that this once struggling and diminutive community has arrived. Americans are a city people, although the founding fathers wished otherwise, and the tall office buildings serve as a city's claim to urban respectability. If there is a tall office building there must also be a decent hotel or lodge, and a restaurant worthy of the name. The skyscraper is an ensign of style and substance and prosperity.

Obviously, the skyscraper is a recent achievement of American life. Its origins can be traced only back to the 1880s, and its full flowering had to wait for the early decades of the twentieth century. Of course this late development was partially a technological matter, since the vast number of building techniques needed to bring the skyscraper about had not only to be invented but orchestrated. Skyscrapers needed elevators, electric lights, running water, central heating, and other engineering achievements, none of which existed at the beginning of the nineteenth century. It would not have been sufficient to have one or two without the others.

On the other hand, there also had to be an impetus and a rational justification for skyscrapers, and this was supplied by the phenomenal growth and concentration of the American city after the Civil War. Today skyscrapers are devoted to many needs — there are skyscraper hotels, hospitals, apartment houses, universities, even state capitol buildings — but the original skyscrapers were office buildings designed to house large numbers of urban workers. Before the Civil War there were no large numbers of urban workers, and the office workers that did toil in the city's core were generally cogs in small operations. Even the large banks of the mid-nineteenth century consisted of not more than a handful of gentlemen workers (a female office force did not yet exist). The counting house of Ebenezer Scrooge as portrayed by Charles Dickens in the 1840s required but a single clerk, Bob Cratchit. A half century later such an establishment could not have gotten along without row after row of Bob Cratchits, now toiling over the latest tabulating machines and typewriters. In America in the 1850s, Henry du Pont, president of E.I. du Pont de Nemours & Co. (then, as now, one of America's largest corporations), managed the whole gunpowder manufacturing business himself with the aid of four

men and a boy. Du Pont wrote all his own letters with a quill pen—
sometimes as many as 6,000 letters a year.

All of this changed in the years after the Civil War. The nation that
Thomas Jefferson dreamed of as an agrarian paradise had begun moving
to the city, and the whole nature of the nation's workforce had to change.
Into the picture came endless scribes and paper handlers—many of
whom, in time, would be women—and also new kinds of businesses that
would tax such work forces to the limit. There was the insurance business,
for example, which would require large numbers of clerical workers in
centralized locations to serve the rapidly burgeoning army of policy-
holders. Small wonder that a great many of the early American sky-
scrapers housed insurance companies, as do they to this day.

For many years the great manufacturing firms of the nation kept
their offices and headquarters connected to the manufacturing plant,
where company executives could keep close watch on day-to-day opera-
tions. In time, though, as the organization became more complicated, the
office no longer needed to be out in front, so it could move to the more
genteel surroundings of the great city, with a president and treasurer no
longer watching the smoke from the stacks or giving a watchful eye to the
assembled workers passing through the gates. The captains of industry
could safely remove themselves to the sybaritic precincts of cities where
they could enjoy the comforts of clubs, theaters, and the best restaurants.
Of course all of this would eventually mean crowding, and other problems
of urban existence. Finally, it would also mean constructing office
buildings to the skies. The skyscraper would become a symbol of collec-
tive and corporate power, and many a great financier or industrialist
sought to have a high building bear his name, even if only as a flamboyant
gesture of public relations and advertising.

Skyscrapers have not been without their detractors over the years.
There are those who find them vulgar, pretentious and vainglorious.
There are those who find little beauty in the skyscraper as an art form—
and among this number have been not a few architects. The twentieth
century has also seen the rise of cultural critics who have predicted the
downfall of the large metropolis and who blame the skyscraper for con-
tributing to overcrowding and to a concentration of certain kinds of func-
tions at the expense of other functions of more pronounced human
concern. The voices of doom have long pointed out the poor wisdom of
allowing cities to become cruelly subdivided into lavish and overpampered
commercial districts and neglected, impoverished fringe and residential
areas.

Some or all of these charges may be well grounded. On the other

hand, in the 1980s and 1990s some urbanologists and social thinkers have timidly suggested that cities may, after all, be fun places. And there must be something to this view since people definitely are not deserting the great cities in droves. There is an excitement and a challenge about city life that people enjoy, even in the face of decaying mass transit, cruel taxation and crime-ridden streets.

If the cities are fun and filled with adventure, one cannot help but think that tall buildings have often made them such. Skyscrapers are among the more obvious and striking characteristics of American cities, so perhaps they respond to certain needs and moods of the American people. We take some joy in tall buildings; they give us a lift; they do something for the spirit.

At the same time, Americans have come to take skyscrapers for granted. They are there to be looked up at when visiting some new and unfamiliar city, but regular inhabitants of America's giant metropolises merely pass by these technological wonders without a second thought. An occasional trip to the observation deck of the Empire State Building or the RCA Building or the Sears Tower may bring a momentary exhilaration or thrill, but very often we go away with questions never asked or questions unanswered. Who built these buildings? When were they built? Who works in them? Who owns them? How many of them are there in the United States? (Are there 50 of them, or 200, or 2,000? Or 20,000?) How many humans do they house? How do water and heat flow from the basement to the 65th floor? These and other similar questions float aimlessly through the mind of the casual visitor to the Empire State, and then usually float right out again before being answered.

This book is an attempt to answer these and other questions like them for the general reader who has taken some interest in the skyscraper and has wondered where they came from, how they developed, who built them, and what their purpose has been in our society. I have tried to ask the basic questions: How were the great heights achieved? Are the American skyscrapers acts of personal aggrandizement and symbols of capitalistic fantasy, or are they something else?

Skyscrapers do move people. At least one must imagine that this was the case for newly arriving immigrants in the early years of the twentieth century, when by the millions they got their first glance of their new homeland at the port of New York where a forest of giant buildings grew in the narrow tip of lower Manhattan. Countless letters and memoirs have told us how that little plot of land with its soaring buildings brought tears to the eyes of the huddled masses to whom they represented tangible proof that here at last was a land of wealth, prosperity and obvious

achievement. These towers glistening in the sun were manifest proof that this was no land of famine, of worn-out soil, of grasping landlords and degenerate aristocrats. A walk up Broadway and down Wall Street showed this to be a land of brisk and forward-looking people, full of confidence and audacity. They were people looking into some glorious future, not into the grim mists of history.

If America has been a land of opportunity to many, if it has been a land of the frontier and of beautiful skies, it is also the land where things get built and get done. The American is a creature who loves to build things new and to freshen things up. The week's end seems to find the typical American with a hammer or paintbrush, trying to make something just a little bit bigger or a little bit better. We take joy and refreshment in these new makings. Skyscrapers, perhaps better than anything else, dramatize this side of the American nature. They are vivid and flamboyant expressions of the desire to build something fresh, new and forceful.

LOOKING FOR A WAY UPWARD

In the year 1850 the tallest building in the city of New York was Trinity Church on lower Broadway, at the head of Wall Street. Its steeple rose to a height of 284 feet, and visitors and sightseers seeking a "bird's eye view" of the city would pay one shilling to ascend a narrow wooden stairway in the steeple to get a clear view of America's largest city, although in 1850 it had a population of only slightly more than a half million.

Trinity Church was built in 1841, and it would remain the tallest structure in New York for 53 years—curiously a record in longevity that has been held by no other structure since. Trinity Church is still one of the most famous churches in New York, but it has long been dwarfed by the vast skyscrapers of New York's financial district which surround it. If anyone were to ascend its steeple today, it would only be to look up—not down.

A bird's eye view of New York in 1850 from Trinity Church would have made clear to the casual visitor the reasons for the city's dominance among the commercial centers of America: New York was the nation's greatest port, and even aside from the few church steeples pushing tentatively into the sky, the city already offered a feeling of vertical thrust, with hundreds of shipping masts completely surrounding the lower end of Manhattan Island. All sides of lower Manhattan were flanked by masts of these sailing vessels from every port-of-call in the world.

The lower tip of Manhattan had been a busy and crowded place for two hundred years, indeed since the time of the Dutch when Governor Peter Stuyvesant stomped along the busy cobblestone streets with his silver peg leg. To be sure, not all of the sixteen-mile-long island of Manhattan was filled in and devoted to urban pursuits in 1850; indeed much of the island north of 59th Street to the Spuyten Duyvil was strictly open country, with many small farms and much unused land. But the steady push northward in the late nineteenth century would have convinced any thinking person that this little island (which, by itself, was New York City

at that time, since the consolidation of the various outlying boroughs did not occur until 1898) would before long be crowded to its limits. The time would come when the city could no longer grow outward; it would have to grow upward.

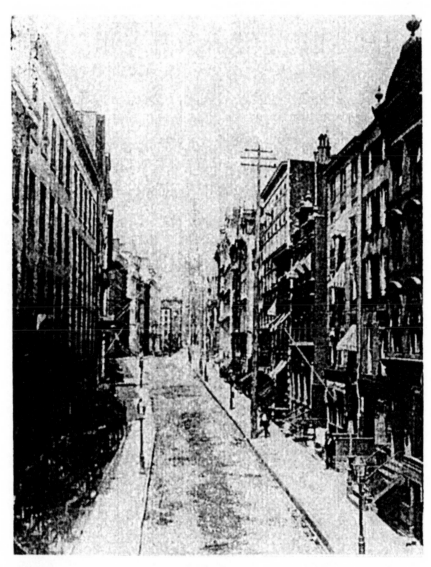

New York's Wall Street in the 1880s looking west toward Trinity Church. The street was already filled with office buildings, but none was more than six stories high (Museum of the City of New York photo.)

In the century that followed, New York became the greatest show-case for the skyscraper — a new kind of building that became the foremost American achievement in the history of architecture and public building. On the other hand, while New York was to become the great showcase for the skyscraper, it was not the birthplace of that art form. The birth-place of this great new technological art was not the city which in 1850 was clearly the commercial and financial capital of the nation, but rather a bustling boom town to the West, a city that in 1850 had a population of only 29,000 people. The railroad, the institution that made Chicago one of the great cities of the world, had not made its appearance in the growing Illinois city until 1848, and in that year Chicago was largely a place of log cabins and unpaved streets, with rude barbarians following squealing pigs up and down the rustic byways and prostitutes stalking the dreary neighborhoods with red lanterns to announce the nature of their trade.

But Chicago would grow with breathtaking swiftness during the 1850s and through the Civil War years. By 1870 the city would reach a population of almost 300,000 — ten times its size in 1850. It was largely a jerry-built city, though, a city of wood. It was characterized by a strange blending of frontier and city life, puffed up by wild speculations and land booms. But the hand of fate was to play a dramatic role in the destiny of this overnight metropolis. For on October 8 and 9, 1871, the city was swept by a fire so severe and so extensive that some believed the city had been completely wiped out. The fire started south and west of the main business districts of the city in a little barn behind the frame cottage of Patrick O'Leary on De Koven Street, and abetted by a strong wind from the southwest, it spread furiously through the De Koven Street neighbor-hood of its origin — a neighborhood of shabby wooden houses, small barns and sheds, unpainted fences and mud streets. On it raged toward the center of the city, devastating whole neighborhoods as it went. For a time there was some hope that the south flank of the Chicago River would pro-tect the prime business neighborhoods of the city, but the fire was roaring so well that it leaped over the river itself and caught the buildings on the other side.

The result was cruel and devastating, even for the better-built buildings of the city. Among the casualties was the new building of the *Chicago Tribune* that was believed to be fireproof, and the magnificent marble department store of Field and Leiter. The Chamber of Commerce fell at midnight, and by three in the morning of October 9 the courthouse, its great bell pealing until its tower toppled, gave way to the flames. The fire then raced on to the north side of the city, destroying almost every-

thing in its wake, until it was finally contained by Lake Michigan and the city's northern limits. Seemingly little remained in its wake; wooden houses, factories, industrial buildings, stone mansions, and even markers in the cemetery were consumed in the high heat. In the following year's report of the Board of Public Works it was reported that "the loss of property was greater than has ever occurred before in the history of the world, amounting to two hundreds of millions of dollars" and that the fire itself covered "a territory about four miles in length, by an average of two-thirds of a mile in breadth, and comprising about 1,688 acres." The loss of life was not exceptionally high, but one-third of the people of the city were left homeless, and most of the commercial section of the city was completely gutted.

Almost unbelievably, Chicago did not accept this blow as a death knell for its metropolitan ambitions. From almost the day of the fire itself there was a universal and indomitable will to rebuild, and to do it solidly and well. Very few of the city's leaders acted as if they had been wiped out. Potter Palmer had lost a fortune in State Street real estate as well as his magnificent hotel, but he began to rebuild both of them immediately. Marshall Field and Levi Leiter had lost their department store, but they made immediate plans to build an even bigger and better one near the old site. In a matter of days, they even opened in a temporary location in a South Side car barn. William D. Kerfoot, later a great real estate tycoon, inspired his neighbors and captured the spirit of the day better than anyone else, by erecting a makeshift shack exactly one day after the fire and nailing to it a sign that read, "All lost except wife, children and energy."

The people were there and the energy was there and Chicago did rebuild. Almost every railroad station, hotel, or factory that was destroyed was rebuilt more solidly, more permanently than it had been before. In the decades of the 1870s and 1880s Chicago was constructed as an almost completely new city — the most modern city in America. It was a city that would be witness to the birth of some of the most ingenious and resourceful architectural innovations in the history of the world.

The thing uppermost in the minds of Chicagoans after the 1871 fire was the need for new approaches to the construction of commercial buildings. They became almost fanatical on the subject of fireproofing buildings, since the fire destroyed a good number of buildings that had been certified and advertised as fireproof. To be sure, fireproof buildings have always been an ideal, but one that has never strictly been met, as evidenced by the tragic fires that still occur in buildings that have been constructed according to the highest and safest modern standards (the fire

in 1980 at the Las Vegas Hilton is a good case in point). But even in the 1870s there was much that could be done to make buildings many times safer than they had been in an earlier period.

At the time of the great fire there stood at the corner of La Salle and Monroe streets a brand new building, not yet opened to the public, known as the Nixon Building. It was one of the few large commercial buildings to survive the fire, and this was because it employed all of the fireproofing techniques available at the time — walls of heavy masonry and an interior frame composed of cast iron girders and wrought iron floor joists and roof rafters. Of course the effects of this superior construction were not lost on the architects and engineers of the post-fire period.

Arriving from New York shortly after the fire was one George H. Johnson of the staff of Badger's Architectural Iron Works, a firm that had recently discovered a way to provide fire protection by employing hollow-tile construction for partitions and subflooring. Almost immediately he won a contract for fireproofing the Kendall Building at 40 North Dearborn Street, a building which enjoyed a long existence free of serious fire; it surrendered to old age in 1940.

It should be obvious that the key material in all of this new fireproofing design was steel. And it was this very same material that would later make possible the construction of the kind of building we now call the skyscraper. Without steel the modern office building could not have been made safe, and the skyscraper of great height could not have been made at all. The great buildings that were to arise in Chicago in the 1880s and 1890s were, as much as anything, achievements that grew out of technological achievements in the use of iron and steel — materials that were rare in building construction, but not exactly new, in the middle of the nineteenth century.

Construction techniques using iron and steel saw their birth in England, the country first touched by the industrial revolution. As early as 1775, Abraham Darby and John Wilkinson constructed a small arch bridge of cast iron over the River Severn at Coalbrookdale, England. Early in the nineteenth century English engineers invented the suspension form of construction for bridges, a technique that would be greatly advanced in America a few decades later, and have a great influence on building construction. There was some use of cast iron in English building construction as early as 1770, for example, when St. Anne's Church in Liverpool used cast iron in all of its interior columns. By the middle of the nineteenth century, English engineers were startling the world with striking exhibitions of iron construction, most spectacularly the Crystal Palace at the London International Exhibition in 1851. Here for the first time a

very large building was constructed of transparent glass stretched over a delicate frame of iron members.

The great Crystal Palace of London resulted in a flurry of similar "experimental" projects in the next few years: New York had its own Crystal Palace in 1853; then there was the famous tower of Alexandre-Gustave Eiffel in Paris, which somehow remained a satisfying triumph for the French, who had not previously been impelled toward the use of steel in high buildings. At the same time engineers were having practical building problems which brought about further experimentation with the uses of iron and steel. The industrial demands of the period were everywhere calling for structures with wide spaces uninterrupted by intermediate supports. Factories, market halls and theaters were examples of these, but perhaps most important of all were the rapidly expanding railroads which needed giant sheds for metropolitan terminals. As early as 1852 in England, I.K. Brunel and M.D. Wyatt designed for the Paddington Station a huge balloon shed with wrought-iron ribs carrying a shell of glass and iron. Several other similarly grandiose train sheds followed in London, such as the St. Pancras Station, and exercises similar in scale began with the construction in New York of the first Grand Central Station in 1869–71.

In the middle of the nineteenth century the very technology and manufacture of iron and steel products was undergoing a revolution. For centuries the word steel referred to a very expensive process of taking the impurities out of iron by cementation and crucible techniques. Such techniques could make the steels used in the fine blades of Damascus and Toledo, but the product was impossibly costly for use in constructing a building, a railroad or a battleship.

Onto the scene came Henry Bessemer with his rather simple discovery that by blowing air through molten pig iron it was possible to make a low-carbon steel that was mostly free from the weakening slag found in wrought iron. Still later refinements superseded the Bessemer process with open hearth furnaces similar to those still in use by the steel industry today. At the same time, there were developments in shaping and forming the new steel in rolling mills, and rolling mills were built as early as 1811 in Pittsburgh.

In a way this new steel was not steel of the kind known to the great cutlery makers of the past, and modern steel makers appropriated the name for something altogether new. The public mind that was accustomed to finding the word steel applied to razors, fine swords and precision tools now saw the word being applied to a new kind of iron intermediate between cast and wrought. It lacked the extreme hardness

of true steel, was free from the slag of wrought iron, but still had the malleability that gave wrought iron its usefulness.

Where architecture was concerned, the newer technology of steel was not immediately apparent as it was to railroad builders. Indeed, even after tall buildings began to rise, and even after techniques for the use of steel had been thoroughly worked out by Chicago architects, the big iron founders were still competing for the construction business. As late as 1901, two large and very substantial hotels were built in New York using cast iron columns, even though by 1901 this approach was burning itself out in architecture as it was elsewhere. (For example, in 1870 all iron ships were of wrought iron; by 1901 they were universally made of steel.)

But the Chicago architects who began experimenting with steel in the 1880s did not take their clues from the great steelmakers of Pittsburgh and the Great Lakes region. Their inspiration and their technology came from another group of individuals working in steel, but of a much different sort—the bridge builders. In later years the great Chicago architect Louis Sullivan remarked on numerous occasions that one of his principal inspirations was the Eads Bridge over the Mississippi River in St. Louis—a 520-foot structure employing fixed steel arches.

The art and genius of bridge building were flourishing in the middle of the nineteenth century, and projects of almost incredible dimension were being proposed. These advances were not lost on those thinking of high buildings. German-born engineer John Roebling was proposing a bridge three times the length of the Eads Bridge to span the East River between Brooklyn and Manhattan. And most remarkably he was proposing a suspension bridge—a bridge with supports only at the ends, none in the middle.

Roebling's background for this incredible endeavor was somewhat curious, but he was one of the great authentic engineering geniuses of the nineteenth century, and his achievements seem as remarkable today as they were a century ago. Roebling was trained as a civil engineer at the Royal Polytechnic Institute of Berlin. For a while he engaged in road building in Germany, where he became fascinated with the subject of bridge construction. Finding few opportunities for practicing his profession in Germany, he emigrated to America in 1831. For a while he found not many more rewards in America, but shortly he got back into the bridge business by an indirect route.

After working as a surveyor Roebling found himself involved in the new American rage of building canals. He became irked by the great cost and clumsiness of the thick hemp hawsers required to haul loaded cars up the inclined planes of the canal systems, so he began experimenting with

a cable that was both thinner and stronger because it was composed of a number of strands of wire. In time, Roebling got into the wire manufacturing business, establishing his own manufacturing company at Trenton, New Jersey, where he was lured by Peter Cooper, the famous eastern iron master. Roebling made all kinds of wire and cable, and these in turn brought him back to his first love, bridge building. He pioneered new techniques for bridge building, including ways to spin metal cables at the actual site of construction. In 1851–55 he built an enormous single-span suspension bridge of 825 feet across the Niagara River. When that bridge opened to railroad traffic on March 16, 1855, the waiting crowds stood in stunned disbelief that a bridge of this kind, and of this length, could actually support a heavy railroad train.

Roebling built some other major buildings, including one across the Ohio River between Cincinnati and Covington, but his greatest achievement was the design and initial construction of the 1,595-foot Brooklyn Bridge across the East River in New York City. Roebling did not live to see the completion of the Brooklyn Bridge (although his son Washington Roebling saw the work through to its conclusion), but the structure remains one of the great wonders in the history of engineering, a wonder accentuated not only by the magnitude and immensity of the project, but by the promise it revealed for the technology of steel construction in many fields. From the early days of suspension bridges, the technique's applications to the problems of erecting tall buildings must have been apparent. And they certainly were not lost on the architects then gathering in Chicago.

The chief similarity between bridge and building construction was in the possibility of erecting extremely lengthy but still perfectly safe steel spans. Roebling's achievement in the Brooklyn Bridge was a discovery of a way to harmonize conflicting forces: a combination of strength and lightness; an extension into space with compactness and economy; the precision of steel with some accompanying beauty of form. The first builders of skyscrapers were moved by the same ideals and technical commands.

Interestingly, for many years the builders of skyscrapers ordered their steel from bridge shops rather than the large steel mills. This was because traditionally the steel mills rolled only standard and uniform shapes, whereas skyscraper construction called for columns and girders of many different lengths and strengths. The bridge shops did what the large rolling mills would not do: they fabricated beams and columns to order, even punching the rivet holes, riveting on the lugs, and combining the shapes into girders and columns. Too, the skilled workers of the bridge construc-

tion industry could transfer their skills to skyscraper construction. The main labor union in the field became the Bridge and Ornamental Iron Worker's Union, and there were not a few laborers of later years who spent time working on the Empire State Building and the George Washington Bridge, both under construction at the same time.

In the burgeoning city of Chicago, a technology was needed to erect tall buildings, and the solution was slowly emerging from a number of different directions. But before tall buildings were built there had to be a need for them and a belief in them. Why tall buildings at all? Why not just continue to expand horizontally as cities had done from time immemorial? Here again there were special conditions which made Chicago the ideal locale for experiments in verticality. Not only was Chicago an apt location for experimentation in office building of any kind, but the central business district, destroyed in the 1871 fire, was hemmed in, limited geographically in ways that were not evident in the much larger island of Manhattan in New York.

The accepted business district in Chicago, at least by habit and convention, was a very small parcel of land, only three-eighths of a square mile. (The island of Manhattan, by contrast, contained 22 square miles — quite sufficient for lateral expansion.) This area was strictly defined — on the east by Lake Michigan, on the north and west by the Chicago River, and on the south by railroad yards and other industry that would forbid office and commercial development in that direction. Of course the city was developing in all directions, but streetcar lines all led into this central location, making it a natural center city area. In the twentieth century great office buildings did arise to the north of what became known as the Loop, but in the nineteenth century this part of the city was inaccessible, the bridges leading from the Loop being meager and inadequate. (Many Chicagoans do not realize that the splendid North Michigan Avenue area was not developed until after 1920; it was formerly an undistinguished residential street called Pine Street.)

Chicago, unlike most other American cities of its time, seemed to be hemmed in by geography and by circumstance. If one wanted to carry on commerce and trade one had to be in the Loop, for that was where upscale Chicago was. (The word Loop, incidentally, did not strictly identify the area; that word was taken from the ring of elevated tracks that is slightly inside of this area.) Since the area was small, and possibilities of horizontal development slight, at least in the 1880s, it was inevitable that a pinch would be felt. And of course it came in the form of increasing land values. The population of Chicago, keenly dependent on this small business district, was wildly increasing in the 1880s (the population of the

city was 505,185 according to the census of 1880; in 1890 it was 1,099,850), but more importantly the value of the land was soaring astronomically: in 1880 an acre of land in the Loop was valued at $130,000; by 1890, this same acre of land would be worth $900,000. There was just no way for a newcomer to buy land at those prices. Chicago had nowhere to go but up.

Chicago financiers and builders of the older generation were not so quick to notice this need for tall construction as the newcomers and the outsiders. A thoroughgoing Yankee and successful Boston financier named Peter C. Brooks had made a fortune in shipping and then looked westward for new ways to invest his money. New Englanders had been among the first to see the potential of Chicago—quicker sometimes than Chicagoans themselves. (Curiously it was another New England financier, John Murray Forbes, who saw in 1850, when Chicagoans did not, the need for a rail link between the East and Chicago to replace the slow Great Lakes passage.) Brooks immediately located another young New Englander and Yale graduate named Owen F. Aldis who had arrived in Chicago after the fire to make some money in real estate and title transactions. On May 22, 1881, Brooks wrote to Aldis with a keen note of prophecy: "Tall buildings will pay well in Chicago hereafter, and sooner or later a way will be found to erect them." This was only common sense considering the high land values in downtown Chicago, but many natives were slow in coming to the same conclusion.

To match deed to word, Brooks asked Aldis to find him a parcel of land that could be obtained at a reasonable price and an architectural firm to plan a tall building for it. Brooks's investment interests in Chicago real estate went back to 1879 when he first asked Aldis to purchase property in Chicago for him—in that instance the "Portland Block" which Aldis cagily got in a foreclosure sale. This block already contained a six-story building that had been designed by William Le Baron Jenney just after the Chicago Fire. Now Brooks wanted to go higher, and to commission a wholly new tall building. And for this purpose he authorized Aldis to purchase a piece of property located at 64 West Monroe Street, near the northwest corner of Monroe and Dearborn known as the Montauk Block.

Brooks had obviously given a great deal of thought to the construction of this building and to the problems of skyscrapers in general, for he wrote Aldis a detailed letter embodying philosophies that were to influence all of the major Chicago architects. "The building," he said, "is to be for use and not for ornament. Its beauty will be in its all-adaptation to its use." He also sent a long list of detailed and helpful specifications that revealed a mind very well acquainted with the existing state of the building arts.

For this work Aldis very sensibly selected the young and innovative architectural firm of Burnham and Root, a pair likely to be experimental and also willing to please. And he could not have made a better choice, for here were two younger architects in a growing American tradition of experimentation and derring-do, willing to give up any and all of the school-book architectural principles and strike out in entirely new directions.

Like many of the upcoming generation of Chicago architectural geniuses, neither Burnham nor Root had any strong ties with academic and textbook architecture. John Wellborn Root was the better educated of the two, a southerner who had gone to school in England and studied engineering in New York. He was planning to attend the École des Beaux Arts in Paris, but his money ran out and he had to start working. He drifted to Chicago and became a draftsman for the architectural firm of Carter, Drake and Wight.

Burnham's formal training was even more skimpy than Root's. Born in Henderson, New York, Daniel H. Burnham had hoped to attend Harvard, but flunked the entrance exam. In 1870 he went to Nevada on a gold-digging expedition, but when this didn't pan out he returned to Chicago on a cattle train. For a while, in the wake of the great fire, he made his living as a plate glass salesman, but he later became a draftsman for Carter, Drake and Wight, where he met Root.

Architectural historians have remarked how perfectly suited these two were to each other. Root, aesthetically the more sensitive, was doubtless the chief designer during his relatively short life. Burnham was a great organizer, the executive and managerial type that is always needed in the field of architecture. In later years he became one of America's most successful commercial architects, and, what is more important historically, one of the great American city planners. Burnham was a kindly rumpled teddy bear of a man, affectionately referred to as "Uncle Dan" by his coworkers and colleagues, and he was undoubtedly ideally suited to the task of overseeing the projects of great magnitude that would soon come to the office.

Yes, the real architectural learning was in the École des Beaux-Arts in Paris, in London and in Boston, but Burnham and Root could not have made any use of this learning had they enjoyed the privilege. This was one of those rare times in history when a new art had to be created from the ground up. The art and technology of the skyscraper was now ready and waiting to be invented.

The Montauk Block of Burnham and Root was not the first skyscraper in the modern sense — that title is usually reserved for the Home

Life Insurance Building of William Le Baron Jenney of 1883 — but it advanced the art significantly and became a textbook for later builders. The plans called for greater use of steel than in any previous Chicago buildings, with many interior columns and beams. On the other hand, the exterior was heavy load-bearing masonry of the sort that would later have to be abandoned when skyscrapers reached for the sky.

But Burnham and Root were experimenting in other important areas as well, most importantly in the foundation. Chicago's soil presented some serious difficulties that made the matter of anchoring tall buildings problematical at best. The soil in Chicago is composed of sand, clay, and gravel, interspersed with some water pockets as might be expected in a city bordering a great inland lake. Bedrock is not encountered until some 125 feet below ground level. Builders knew and expected that their structures would sink, and the possible consequences were known. A $5,000,000 federal building built in Chicago in 1880 sank so badly that it had to be condemned and razed in 18 years. It was obvious that new techniques would have to be found for keeping this from happening to tall buildings; otherwise the city might well find its buildings dangerously tilting.

The technique of actually driving to bedrock in Chicago was not worked out for another 20 years, so Burnham and Root had to devise a series of techniques for anchoring a building without this advantage. They designed a floating raft, which consisted of a single concrete slab two or four feet thick and reinforced with steel beams. This had the effect of distributing the building's entire weight uniformly over the whole site. This technique had its defects, unfortunately: the masonry pyramids so completely filled the basement that the boilers and engine room had to be located behind the building, and for all practical purposes the building had no basement for the usual utility functions. Clearly, though, the Montauk represented a start toward overcoming Chicago's tricky footing.

The Montauk Building represented innovative ideas in almost every phase of building construction, including fireproofing (a very small reliance on wood, and the first use of flat tiled arches), corridor and office design, plumbing, heating, and window design. The Montauk Building became an immediate success and a big money maker for Peter C. Brooks and Owen F. Aldis.

Especially Aldis, as things turned out, for Aldis became Chicago's great real estate impresario in the years between 1880 and the turn of the century. Burnham and Root went on to advance the state of the art by light years with two other Aldis projects — the Rookery at La Salle and Adams streets in 1888 and the Monadnock Building at 53 West Jackson

Boulevard, erected in 1891. The Rookery was an aesthetic as well as a technical triumph, featuring new uses of glass and pleasing interior and exterior architectural details that make the building a wonder of modern building construction nearly 100 years after its construction. The 16-story Monadnock Building was the tallest wall-bearing masonry structure ever built in Chicago, and it remains a rich source of architectural inspiration.

Of course Aldis was discovering other architects as well, and promoting building projects of all kinds in the 1880s and 1890s. By the turn of the century nearly one-fifth of the Loop buildings were either built or managed by Aldis, who created a million square feet of new office space in this period, a great deal of which was still functional and satisfying to tenants and users a century later.

It hardly needs to be said that this commercial development and the inrush of funds for the construction of high buildings brought Chicago to the attention of the nation's architects. From the Boston drawing boards of Henry Hobson Richardson, probably America's foremost architect, came a new building for Marshall Field & Co. in 1885. But Chicago was also in the process of developing or attracting its own native architectural talent — some of the greatest talent in the history of the art. Associated with Chicago and its environs over the next several decades would be such giants as not only Burnham and Root, but also William Holabird and Martin Roche, William Le Baron Jenney, Dankmar Adler, Louis Sullivan and Frank Lloyd Wright. A close-knit fraternity they were, knowing one another well, sometimes despising one another, but always profiting by each other's genius and discovery. They seemed to complement one another to perfection, combining the aesthetic powers and philosophical breadth of Sullivan, the engineering resourcefulness of Jenney, the organizing abilities of Burnham, and the perfectly rounded architectural abilities of Root. They all lived off each other's talents in a symbiotic way, even when they most wildly disagreed.

The architects just mentioned were not all keenly (or equally) interested in skyscrapers; for example, Frank Lloyd Wright, a youngster who had worked variously under Sullivan and Burnham, eschewed skyscrapers and instead revolutionized domestic architecture in America starting nearby in the Chicago suburbs. But for twenty years Chicago, and Chicago alone, was the great laboratory where architects discovered how to make buildings tall. One discovery or achievement was piled on another until the great Chicago architects had learned almost everything of importance that would be known a century later about how to build skyscrapers. There have been many recent advances to be sure, but the men in Chicago laid out the basics on which all the world could build.

CHICAGO: A NEW GENIUS
FOR BUILDING TALL

Most experts agree that the first real skyscraper was the Home Life Insurance Building in Chicago, designed by William Le Baron Jenney in 1883 and built in 1884-85. What made the Home Life building the first skyscraper was not the cast iron masonry in its walls and piers, for this had already been done by other builders. Similarly, others had introduced wrought iron floor beams. But Jenney went one step further and introduced a theoretical concept that would make the construction of really tall buildings possible. He took the dead load off the building's walls and placed it on the skeletal framework of iron that was concealed inside the masonry.

In this great decisive step in architectural history, Jenney had perceived the advantages of a building whose exterior wall becomes a mere curtain or covering that encloses the building but does not support it. All the support is provided by interior framing. The outside of such a building can be covered with anything that offers protection to the occupants — yes, even glass, as we now see in our modern skyscrapers. In a way, one might say this was a new kind of building that had no wall, only a skin. Adopting a biological analogy, Jenney proposed to build skyscrapers as vertebrates rather than crustaceans. Instead of being covered by some heavy armor serving as a structural framework, as in the case of a crab, the new creature was held together by the interior superstructure and only lightly covered by skin on the outside, as is the human body for example.

The most important point of all, however, is not that the Home Life Insurance Building was a great architectural masterpiece, but that it gave birth to the possibility of really tall buildings that would rise only after the beginning of the twentieth century. Tall, all-masonry buildings — and very good ones, like Burnham and Root's Monadnock Building — were built

20

after the Home Life Building, but it soon became evident that such buildings had reached the end of the road where height was concerned. To rise much higher than the Monadnock Building would require the adoption of the Jenney philosophy with refinement and technical development of his techniques.

In later years there were other claimants to the title of being the first to conceive of modern skyscraper construction. The Minneapolis architect Leroy S. Buffington claimed that he had thought up and applied the idea of internal framing in 1882, but it is apparent that he first learned about this kind of construction from an article by Jenney in the *Sanitary Engineer* of 1885. Buffington later made some interesting contributions to skyscraper construction, but his claim of priority to Jenney was fraudulent. Jenney must get the credit for the birth of the skyscraper and for its newly acquired potentiality.

Jenney was not one of the world's great architects, to be sure, and his place, even among the Chicago school of architects, is not a lofty one. But in some ways he was the most typical of the lot. A man of imperfect and desultory architectural training, he was an eclectic and a pragmatist. He came to a city that needed miracles and he found a way to perform them to get the job done. He borrowed from here and he borrowed from there; he struck out to the right and then to the left, but he came up with what was needed at the time.

William Le Baron Jenney, like a number of great Chicagoans of his day (one thinks, for example, of Gustavus Swift), was a dyed-in-the-wool Yankee. He was born in Fairhaven, Massachusetts, in 1832, the son of a whaling captain. His training and background were in engineering rather than architecture—a training that would put him in good stead in his later chosen field. He studied engineering at the École Centrale des Arts et Manufactures in Paris, where he graduated in 1856. Later he was an engineer in the Union Army during the Civil War, where he obtained much of his early practical training. When the war was over he was the engineer-in-charge at Engineering Headquarters at Nashville, and had obtained the rank of major, a title he retained for the rest of his life, although it was sometimes employed only jocularly by his friends and colleagues.

After the Civil War Jenney came to Chicago, then a very lively spot for someone wishing to make architecture a career. He opened his own architectural office in the city in 1868 and remained there for the rest of his life except for one year during the 1870s when he accepted an appointment as professor of architecture at the University of Michigan. Perhaps Jenney did not take architecture wholly seriously; he was a generalist, an eclectic, a tinkerer. Louis Sullivan, who spent six months as a draftsman

in Jenney's office, offered an amusing description of the man in his *Autobiography*, indicating, in his usual well-chosen words, that the Major was not to be taken wholly seriously as an architect:

> The Major was a free-and-easy cultured gentleman, but not an architect except by a courtesy of terms. His true profession was that of engineer. . . .

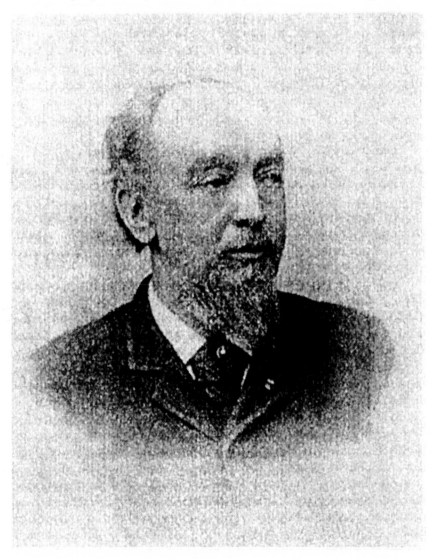

William Le Baron Jenney, who designed the first true skyscraper, the Home Insurance Building, in 1883. (Library of Congress photo.)

He spoke French with an accent so atrocious that it jarred Louis's teeth, while his English speech jerked about as though it had St. Vitus's dance. He was monstrously pop-eyed, with hanging mobile features, sensuous lips, and he disposed of matters easily in the manner of a war veteran who believed he knew what was what. Louis soon found out that the Major was not, really, in his heart, an engineer at all, but by nature, and *in toto*, a *bon vivant*, a gourmet.

Jenney may not have been a hard-nosed professional going by the book, but he was an amazingly versatile and inventive individual nonetheless. During his professional life he contributed a number of papers to the *Inland Architect*, and they displayed the breadth and generality of his interests. These papers included, for example, one on the history of Babylonian and early Hellenic architecture and another on the subject of the preservation of building stone which showed considerable erudition in the area of minerology and chemistry.

Jenney was apparently a resourceful and observant world traveler, for he got a number of his ideas for building construction from things that he had seen around the world. His partner in later years, William D. Mundie, suggested that Jenney's inspiration for steel framing came from an early voyage Jenney took to Manila in one of his father's whaling ships. The Filipinos had developed a curious form of housing construction using whole tree-trunks as columns with split trunks as beams, joists and braces.

Of course the technology Jenney needed was already available in America, waiting only to be brought on stage. Jenney was familiar with the technology of building as it was currently going on around him, and he brought the full force of his own knowledge and ingenuity into play when it came time to build the Home Life Insurance Building. He was familiar, of course, with the work of the great bridge builders like Eads and Roebling. He was familiar with the kind of steel frame structures that had appeared in the great London and New York exhibitions of the 1850s. He was undoubtedly familiar with the tower built by James Bogardus in 1855 for the McCullough Shot and Lead Company in New York which employed a kind of construction that foreshadowed the skyscraper ideal: brick "curtain" panels were carried entirely by cast-iron beams spanning eight iron posts that were the real bearing members. Similarly, Jenney was almost certainly influenced by the findings of George H. Johnson, the man with the fireproof tile who had arrived from New York after the fire of 1871. Johnson had, in fact, done some designing in the East that may have influenced Jenney, especially his United States Warehousing Building in Brooklyn in 1860, which used brick curtain walls and iron framing.

It was really all a matter of putting together a rich store of technical knowledge that was available but not yet assembled to good practical effect. And Jenney the intellectual wanderer was naturally just the one to do it. There is also, however, a quite possibly apocryphal tale told of Jenney that explains his conception of the internal frame theory in a different way. The story goes that when Jenney was working on the Home Life project he reached a snag early one afternoon and found himself looking out his office window in frustration. Rather than continue to torture himself he went home for the day. His wife was startled to see him so early and thought he might be ill. Getting up suddenly from her chair where she was reading, she looked around for the most handy place to set down her book, and accordingly laid it on top of a bird cage. As the story goes, Jenney jumped with surprise when he noticed that this lightweight bird cage could support a heavy load without the slightest difficulty. Back to the office Jenney went with the clue to the skyscraper—"cage design."

Probably there is no truth to this story, and Jenney himself was inclined to account for the development of his plan as a step-by-step procedure, whereby he used the various techniques that were presently at his command. Inspiration, to be sure, but it was mostly derived from simple pragmatism and resourcefulness. Jenney was no textbook engineer or architect; rather he was the type to plough along, adopting what worked and discarding what did not. His design took a bit of ingenuity and a bit of play—after all, the Home Life Building could have been built using the known techniques of 1883. But Chicago was Chicago, and Jenney was an architect ready to experiment with the new and the startling.

By a strange irony of history, the importance of the Home Life Insurance Building did not dawn on either the general public of the time or the Chicago architects working in close alliance with Jenney on other building projects of their own. Buildings of the older type would go up for a number of years, and some of them made advances that were considered more important at the time. It was only years later that critics and historians came to view the Home Life Insurance Building as the first real skyscraper.

Indeed for many years a great many people believed that the Tacoma Building (1886–89) at La Salle and Madison streets was the first skyscraper. Some controversy raged over the issue until the early thirties when both the Home Life and Tacoma buildings were demolished. At this time the whole historical matter was thoroughly investigated by several blue ribbon committees of architects and engineers who determined that the Tacoma Building was not as fully of steel construction as the Home Insurance Building, although in one definite way the Tacoma represented

a further advance in skyscraper design: it was the first building with a riveted steel frame, whereas the Home Life Insurance Building was bolted together.

The Tacoma Building, in fact, introduced so many technical and

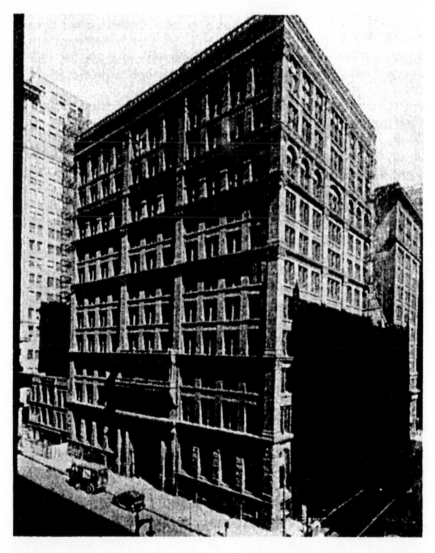

The Home Insurance Building at the corner of La Salle and Adams streets, demolished in the 1930s. It was the first building to utilize the new cage construction, which took the dead load off the walls and made extremely tall skyscrapers possible. (Courtesy University of Illinois Library.)

design advances that a reasonable argument can be made that it repre-
sented the birth of the skyscraper. The architects, William Holabird and
Martin Roche, were to play a much more important role in the history of
Chicago architecture than William Le Baron Jenney. The two of them
formed a partnership in 1881 and continued designing Chicago buildings
until 1927, some 46 years later. Both of them—Holabird, who had been
born in New York state, and Roche, from Cleveland—had started their
careers as draftsmen in Jenney's office, and both of them, like Jenney
himself, were geniuses in the rough, with much more in the way of native
talent and drive than formal learning.

Holabird, for example, attended the U.S. Military Academy at West
Point for two years but was kicked out for a minor infraction of the rules.
He then gave up the idea of engineering education and went to Chicago
hoping to become an architect. Martin Roche's formal education con-
sisted of no more than his public high school training in Cleveland. In the
first few years of their association in Chicago these two uneducated
greenhorns turned up few commissions, but their association with the
practical Jenney must have paid big dividends. In the Tacoma Building
they proved that they not only knew the state of the art but had, in one
great bound, leaped to the forefront of skyscraper designers.

It may be true that the technology of skyscrapers moved forward by
inches, and so it did in the Tacoma—but in this case a great many inches
were covered. The foundation was unique for the time. The builder made
50-foot test borings which revealed the presence of pockets of water and
soft clay. These were pumped out and filled with concrete, using a tech-
nique that later became commonplace. The architects then planned
floating rafts of concrete for the column footings. Every kind of structural
metal in use at that time was called for in the skeleton of the building, in-
cluding spandrel beams and floor girders of wrought iron, intermediate
floor beams of steel, and columns, mullions and lintels of cast iron.

The building was L-shaped to provide as much outer exposure for the
offices as possible. Projecting bays also provided for the admission of light
from three directions, and these bays gave the building a distinctive ar-
chitectural and aesthetic quality. Much thought was given to the place-
ment of service facilities, and for the first time all toilet and lavatory
facilities were concentrated in one area of two central floors, thus limiting
piping to one central shaft.

It is little short of startling that the Chicago architects of the 1880s
and 1890s, men mostly of spotty formal training, managed to produce
buildings that were both technically inventive and advanced, but pleasing
to the eye as well. The buildings of Burnham and Root and of Holabird

and Roche solved an extraordinary number of problems that had never presented themselves to builders, and for sheer attractiveness they can continue to be of instructional value to architects and designers of a younger generation.

As aesthetic matters go, no architect of the Chicago school comes to mind ahead of Louis Sullivan, whom some have called the greatest American architect. Sullivan practiced in Chicago throughout most of his adult life, and although his tall buildings were not numerous, he nonetheless had a great deal to say about skyscraper style, and won an influence over the field of architecture that was entirely out of proportion to his actual output as a professional architect.

Sullivan was the most philosophically minded of the Chicago architects, and he commanded a large audience in fields outside architecture — sometimes to a happy and sometimes to an unhappy effect. Sullivan was brilliant and had an imaginative command of language, which he used to scorch his opponents and bless a favored few. He was an ideologue, and when his ideas were wrongheaded, as they often were, he promoted them as stridently as when he brilliantly perceived some important architectural advance. In the last twenty years of his life, living in a shabby South Side hotel and foundering in alcoholism, he could continue to stab out at objects of his contempt in dramatic grandiloquence.

If Sullivan was the most imaginative of the Chicago architects, it was not because he arrived on the scene with a richer and more conventional formal training. The truth is that Sullivan's background was every bit as unconventional as that of Jenney or Burnham. He may have had the soul of an architect, but he got most of his training on his own.

Louis Henry Sullivan was born in Boston in 1856, his father being an Irish immigrant who ran a dancing academy, his mother being of French-German extraction. As a child he developed obvious artistic talents early and spent long hours making drawings of flowers and leaves, an interest that he was to carry with him in his later career as an architect where he was always fertile in the field of architectural ornamentation. He was also fascinated with buildings from his youth, and other kinds of structures as well. In his richly detailed *Autobiography* he describes the exhilaration he felt over the construction of the Eads Bridge over the Mississippi, and his visits to bridges at earlier times in his childhood.

Sullivan attended the English High School in Boston and in 1872 entered the architectural school of the Massachusetts Institute of Technology. But this he found to be an uninspired, rigid and mechanical sort of place, teaching what Sullivan called "architectural theology." He put up with it for only one year. Sullivan's parents had moved on to Chicago, and

after a year in Philadelphia as an apprentice to architect Frank Furness, Sullivan moved to Chicago also. The city had only recently recovered from the fire and Sullivan saw in the charred ruins and newly erected tar-paper shacks a heavenly future for architecture.

The way Sullivan found work was to wander around the city and take note of a building that took his fancy, then ask the name of the architect. He would go around to the offices and ask to be taken on as a draftsman. This practice brought him, either by coincidence or by strange intuition,

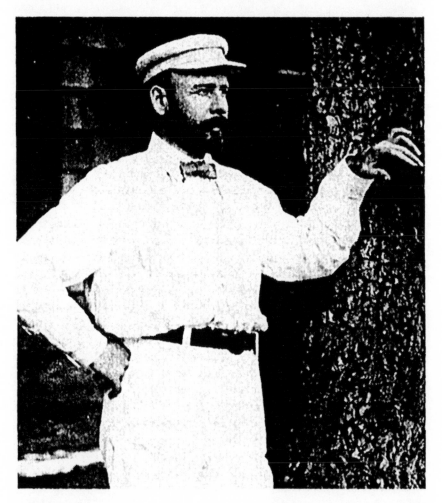

Louis H. Sullivan, whom some have called America's greatest architect. Based in Chicago, Sullivan elaborated his own aesthetic notions for the new art of the skyscraper. (Photo courtesy University of Illinois Library.)

to the offices of William Le Baron Jenney. And in this office he also en-
countered a number of other youngsters nearly ready to make names for
themselves: William Holabird, Martin Roche, and Daniel Burnham.
While working as an apprentice draftsman, however, and while grumbling
all the while, he determined to make good on his youthful dream to study
architecture in Paris. In less than a year he was off to the École des Beaux-
Arts, in the hope of becoming a real trained professional architect.

But Sullivan was a restless and eccentric individual, and he adapted
no better to the École des Beaux-Arts than he did to MIT. It was the same
old stale academicism founded on rote learning of styles and methods of
the past, none of which, he thought, would be of the slightest use to the
architect of the future. By this time Sullivan must have arrived at least at
the kernel of the philosophy that was to guide his work in the years to
come. Architecture must grow organically from the present needs of
society, from the social life of a people. If called upon to build a tall
building the architect must forge ahead using the technologies presently
available, and with the current uses of such buildings firmly in mind. It
would not be of the slightest value for a student of architecture to have
studied the beauties of a Gothic Cathedral or the Palace of Versailles if
his job were going to be to build buildings to house typists, actuaries and
certified public accountants. Later on this philosophy was expressed in
the famous dictum that form follows function. Sullivan's goal was to
create a building to fill a specific need. An architect charged with building
a skyscraper ought to find out the essence and soul of such a building and
design accordingly.

After his brief fling with the conventional architectural training of
Europe, Sullivan returned to Chicago, the city of reckless abandon that
had already become lodged in his romantic spirit. Here, in 1879, he was
lucky enough to be taken into the office of Dankmar Adler, a German-
born Jew and son of a rabbi, with whom Sullivan formed one of those ideal
symbiotic relationships based on mutual need and respect. Adler was
practical, tactful, diplomatic; Sullivan, the artistic genius, was difficult,
tactless, elusive and not always dependable. Adler was somewhat aware
of Sullivan's genius (he offered him a full partnership after only one year),
and for a number of years the relationship between them worked out to
the benefit and advantage of both of them.

The firm of Adler and Sullivan prospered, but slowly. They must
have seemed an eccentric pair to the outside world. Adler's knowledge of
acoustics had the effect of bringing in a commission for one of Chicago's
finest buildings, the Auditorium, on which Sullivan toiled for several
years, refining and simplifying his conceptions. In the course of designing

this building, of solid masonry construction with no steel framing, Sullivan came under the influence of Boston architect Henry Hobson Richardson, who had just completed a magnificent store (later converted to a warehouse) for Marshall Field & Company. Sullivan brought a lighter touch to Richardson's ideas, and the exterior of the Auditorium was notably lacking in ornament, although inside there was an endless profusion of the lacy and flowery ornament that Sullivan did so well.

At the time of its completion, the Auditorium was probably the most famous civic building in the country, and it naturally won a great deal of respect for the firm of Adler and Sullivan – surely a great ego satisfaction for Louis Sullivan, who was still in his early thirties.

During these years, of course, the skyscraper was growing up all around in Chicago, and it was not unusual that Sullivan, long an admirer of the great soaring masterpieces of Eads and Roebling, would want to get involved in this area of architecture as well. Indeed, the skyscraper provided the greatest challenge to Sullivan's imagination. "How shall we impart," he asked, "to this sterile pile, this crude, harsh, brutal agglomeration, this stark, staring exclamation of eternal strife, the graciousness of those higher forms of sensibility and culture that rest on the lower and fiercer passions?" Like John Wellborn Root, Sullivan attempted to develop an aesthetic of the skyscraper, and of course a program of skyscraper design and implementation. He described his ideas to the public in an article in *Lippincott's Magazine* in 1896:

> The practical considerations are, broadly speaking, these, Wanted – First, a story below-ground, containing boilers, engines of various sorts, etc. – in short, the plant for power, heating, lighting, etc. Second, a ground floor, so-called, devoted to stores, banks, or other establishments requiring large area, ample spacing, ample light, and great freedom of access. Third, a second story readily accessible by stairways – the space usually in large subdivisions, with corresponding liberality in structural spacing and in expanse of glass and breadth of material openings. Fourth, above these an indefinite number of stories of offices piled tier upon tier, one tier just like another tier, one office just like all the other offices – an office being similar to a cell in a honeycomb, merely a compartment, nothing more. . . . What is the chief character of the tall office building? And at once we answer, it is lofty. This loftiness is to the artist-nature its thrilling aspect. . . . It must be every inch a proud and soaring thing, rising in sheer exultation that from bottom to top it is a unit without single dissenting line – that is the new, the unexpected, the eloquent peroration of most bald, most sinister, most forbidding conditions.

Those last few sentences express the essence of Sullivan's ideas about the skyscraper. The skyscraper is a lofty structure and it must express

loftiness. It must inspire confidence and belief in the usefulness and worthiness of commercial and urban endeavors. It must be a thing of beauty by virtue of its adaptation to its newly discovered purpose and function. As Sullivan was fond of emphasizing time and time again, form

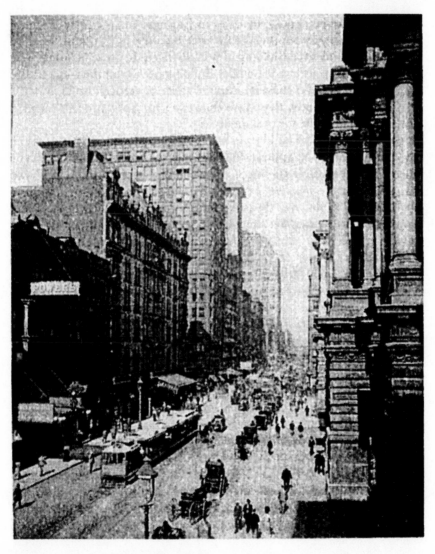

Chicago's Randolph Street as it looked in 1900. The three tall buildings on the left side of the street are Burnham and Root's Ashland Block, Sullivan's Schiller Building (mostly hidden), and the pointed roof of Burnham and Root's Masonic Temple. (Library of Congress photo.)

follows function: it is the job of the architect to find a whole new style for the skyscraper, a grammar of skyscraper design, much like that achieved for the Gothic cathedrals by those long-departed architects now swallowed into the mists of history.

As things turned out, and by a tragic irony, Sullivan never got to design many skyscrapers — only a few in Chicago. Undoubtedly his most famous skyscrapers were the Wainwright Building in St. Louis, built in 1891, and his Prudential Building in Buffalo (1895). In these buildings and in two Chicago projects, the Schiller Building (1892) and the Gage Building (1898), Sullivan did show an inspired sense of vertical thrust, of loftiness. More importantly, they were showcases for Sullivan's free-ranging artistic talent and gift for ornament.

In the Wainwright Building in St. Louis, commissioned by one of that city's wealthy brewers, Sullivan believed that for the first time, "the steel frame . . . was given authentic recognition and expression." The lower stories were made massive with the corners emphasized for dramatic effect, as a gift to the eye. He attempted to deal with the problem of the monotony of the upper floors by placing beautifully decorated terra cotta panels beneath the windows; he treated the simple cornice with delightfully airy friezes. In his Buffalo Prudential Building, not a very tall building by today's standards but surely one of the most beautiful office buildings anywhere in the world, Sullivan reached out further to find aesthetic formulas for buildings of height. The ornament became even richer, the vertical accent little short of startling. The walls were of rich red terra cotta, decorated with some of Sullivan's most glorious conceits. The top story provided a magnificent climax with round windows set off with rich flower-like patterns.

Sullivan's greatest building in Chicago — perhaps his masterpiece — was not a skyscraper at all, but the Schlesinger and Mayer Department Store on State Street (later Carson, Pirie Scott & Co.). Some have reached the conclusion, perhaps correctly, that Sullivan had an even finer gift for horizontal structures than for lofty spires, and this building displayed Sullivan's purely architectural imagination at its most mature.

Unfortunately Sullivan's career as an architect went into a slump after the middle of the 1890s and his commissions petered out. He broke with Adler (who died in 1900) before the turn of the century, and few builders and financiers were willing to trust the erratic and difficult Sullivan with big projects of his own. Sullivan's work was magnificent in its own right, but it left little to follow for those who came after.

What Sullivan left for the later architects of the skyscraper was not a great body of work to be copied, but an inspiration, a newfound belief

that the skyscraper could be an art form, an inspiration to mankind. Of the other Chicago architects, none, save perhaps John Wellborn Root, saw the skyscraper in this way. They knew that buildings had to go up; they knew that they were being deluged with commissions to build them, and they solved the problems that had to be solved. But the belief that the skyscraper was some great and marvelous invention of the American spirit was clearly introduced by Louis Sullivan.

The Chicago architects solved the initial technical problems of rooting skyscrapers to the ground and of steel cage construction—advances that in time would permit construction of very tall buildings. They conceived an aesthetic of the skyscraper that was apt and congenial to the buildings they built themselves, although when height limitations were put on Chicago buildings in the 1890s, they lost the opportunity to see what they could do to make form follow function in buildings of 60 or 80 stories. This problem had to be passed on to architects in other cities— mostly New York—in the next several decades. Louis Sullivan, at least, was not pleased with much of what followed, and with his personal life in disarray after 1900 he was not given a chance to continue his work in this area.

But the Chicago school of architects proved that large office buildings could be pleasing to look at, pleasing to work in, and a useful contribution to urban geography. They proved that the buildings would stay up, that they would not fall over or slip wildly out of plumb like the Leaning Tower of Pisa. They made buildings that expressed a kind of magic and grace and of which their municipality could be proud.

C h a p t e r 3

TIMID NEW YORK
GROWS BOLD

In the 1880s and 1890s Chicago was world famous as the showplace of the new architectural wonder that its skyscrapers represented, just as it would be known as the disreputable home of gangsterism in the 1920s. But Chicago's eminence in this area did not last, for after the beginning of the twentieth century New York became the primary focus of skyscraper construction and mystique. It was New York and not Chicago that built a great skyline which became the admiration of the world, and it was many years before Chicago was to get back in the running.

Chicago's drop from the race to the skies was due not to economic factors or a lack of interest in tall buildings. All of these forces remained strong after 1900, but the city of Chicago interfered by setting what appeared to be arbitrary limits on the height of office buildings. After the opening in 1892 of the Masonic Temple, on the northeast corner of State and Randolph streets, the city of Chicago placed an absurd height limitation of 130 feet on all future buildings. The Masonic Temple itself was 305 feet (21 stories), and a good number of other early Chicago skyscrapers were also over the 130-foot limitation. The limit was raised in 1900, but only to 260 feet, a regulation that remained in effect until the 1920s. The law completely eliminated Chicago from the skyscraper competition during this period. Things improved somewhat in the twenties, but it was not until well after World War II that Chicago made up for its long years of indifference to this art form that sprang from its own soil.

Until the 1890s there had been few office buildings of height in New York and seemingly little impetus to build them. Trinity Church, built in 1841, remained the tallest structure in New York until the Manhattan Life Insurance Building at 66 Broadway bested it in 1894. New York society had long thought of itself as old money, as the center of conservative business dealings (whether true or not), and there seemed to be little desire

to mimic the brash and reckless outlanders in Chicago in the way of thrusting tall buildings into the heavens. Too, New York was never as severely restricted in land area as the Chicago Loop, and businesses that needed more room could always find cheaper land uptown.

But there was one congested area which was soon to offer fertile ground for the development of the skyscraper, and that was lower Manhattan, the narrow tip of land that had been the city's financial heart since the days of Peter Stuyvesant. Here it was that the squeeze was eventually to come, and here it was that the first truly great towers of commerce were to arise. There was considerable resistance, however, and some of the early building efforts were met with mirth, derision or outright suspicion.

New York's first steel-framed building built in the Chicago mode was a startling sight to behold, and New Yorkers thought of it as something of a practical joke. The building was located at 50 Broadway and went up in 1888 on a plot of land only 25 feet wide. Wafer-thin, the building rose to a height of 11 stories, all of which had to be negotiated by steps since there was no elevator. The building, later referred to as the Tower Building, was owned and financed by a young man named John Noble Stearns who had taken possession of this odd little parcel of land with the hope of getting his money's worth out of it. Stearns consulted architect Bradford Lee Gilbert, who suggested that the dream of a multi-storied building on this plot was not at all absurd and recommended giving a try to the type of steel-cage construction then in vogue in Chicago. As the building went up, all of Stearns' friends and the gaping sidewalk superintendents laughed convulsively, vowing never to go up this peculiar needle that was sure to be toppled over at the first wind. But the Tower Building did not topple, and before long timid New Yorkers cautiously took the climb to the 11th floor where they enjoyed the sights and took in the fresh breezes of Upper New York Bay.

The Tower Building would shortly be dwarfed by much taller buildings, and its awkward lot caused it to be razed in 1914 to make room for a three-story arcade. But a point was made and New Yorkers were prepared, if only a little, for what was to follow. At least the advantage of steel framing was evident to those who would open their eyes to see.

After the Manhattan Life Insurance Building thrust its head above Trinity Church in 1894 there was a flurry of activity on lower Broadway, and a good number of other tall buildings were erected. Photographs taken in 1894 show New York to have nothing very much like a real skyline, but pictures from 1897 to 1898 show an entirely different silhouette, with the city taking on the obvious vertical thrust that marked it for all newcomers in the years to come. With the construction of the Park Row

RECORD SKYSCRAPERS OF THE TWENTIETH CENTURY[a]

Building	City	Height	Stories	Years as Tallest
Park Row Building	New York	382 ft.	32	1900–1908[b]
Singer Building	New York	612 ft.	47	1908–1909
Metropolitan Life Building	New York	700 ft.	50	1909–1913
Woolworth Building	New York	792 ft.	60	1913–1929
Chrysler Building	New York	1,046 ft.	77	1929–1931
Empire State Building[c]	New York	1,250 ft.	102	1931–1971
World Trade Towers (2)	New York	1,350 ft.	110	1971–1974
Sears Tower	Chicago	1,454 ft.	110	1974–

[a]Includes only figures for skyscraper office buildings. The tallest structure in the world for many years was the 984-foot Eiffel Tower, which held the record from 1889 to 1929, when it was topped by the Chrysler Building. The world's tallest free-standing structure at the beginning of the 1980s was the Canadian National Tower in Toronto, at 1,821 feet.

[b]The Park Row Building was built in 1897-98.

[c]If one considers its 222-foot television tower, the Empire State would still be the world's tallest building at 1,472 feet.

The Park Row Building, photographed in 1899, with St. Paul's Chapel in the foreground. The Park Row Building (left of center) was the tallest in the world at the beginning of the twentieth century. (Museum of the City of New York photo.)

Building in 1897-98 (Park Row was New York's newspaper row, the equivalent of London's Fleet Street, and the Park Row Building came to house the office of the Associated Press), New York grabbed the distinction of being the city with the highest building in the world, a distinction that would not be challenged for over 70 years. New York's pride in these skyscrapers did not blossom overnight, and surely there were many who saw this development as unseemly and unnecessary. Too, there were not a few who still feared and distrusted these structures as they had at the time of the construction of the Tower Building.

One of the most notable buildings put up in New York shortly after the turn of the century was the Flatiron Building at Broadway and 23rd Street. This building, designed by no less an architect than Daniel Burnham of Chicago, was far away from the other high buildings downtown, and was something of a curiosity. It occupied a curious triangular patch of ground created by the meandering path of Broadway as it intersected other north-south thoroughfares. The sensible thing might have been to leave this little plot of ground for a park or for some insignificant structure, but Burnham took the problem boldly in hand and gave the odd site an imaginative architectural solution. The Flatiron Building (its true name was the Fuller Building, but nobody called it that since the popular nickname "Flatiron" stuck almost immediately) was an eccentric building, but also a beautiful one. From certain angles it seemed to be nothing but a flat wall, and in many people this inspired the fear that the building would surely topple in some strong wind — the idea of steel cage construction, after all, was not yet implanted in most people's minds — and there were many New Yorkers who refused to go anywhere near the building for many years.

Nevertheless, the building soon became a tourist attraction. An observation lounge was established on the top floor, so all those who did not fear themselves being thrown out on Broadway broken into a thousand pieces could view New York from a lofty and isolated eminence — up- and downtown, Brooklyn, the Hudson and East rivers, the great New York harbor, the New Jersey shore, and in the mists to the north the lordly cliffs of the Palisades. Because of its unusual location, uptown and off the beaten path, the Flatiron Building quickly became the city's most famous building, and it remained so for many years in the minds of many.

For all of its eccentric qualities it was a fine building, too. After his work with Chicago's Columbian Exposition in 1893, Burnham had moved over to classical renaissance styles — much to the chagrin of some of his fellow architects, especially Louis Sullivan — and he soon rivaled McKim, Mead and White as the foremost commercial architect in America.

Burnham built a large number of buildings in this classical mode, a number of which, such as Washington's Union Station, continue to be great monuments to a daring and aggressive era in American life. In the Flatiron Building he was at his best, erecting a very attractive structure in the style of an Italian palace. The façade was rusticated limestone with rich Renaissance ornamental detail. The midsection was broken up with gently undulating bays that counteracted the severity of the sheer wall. Contrary to what many might have thought, the odd triangular shape made interior office design a snap, and the building was an immediate commercial success.

Many New Yorkers believed that the Flatiron was the tallest building in the world when it was built. It did not, however, overtop the 392-foot Park Row Building on lower Manhattan. But in its own neighborhood it stood alone. Because of its shape and its mystique, the Flatiron Building won the hearts of the multitudes over the years and drew a great many visitors. It is one building that somehow could never be overshadowed by height or upstaged by character. The intersection in front of the building was always a congested spot and a windy one, too, and in the old days the corner was a favorite spot for young lads to watch women's skirts being whipped around. So famous was the spot, in fact, that policemen would occasionally have to shoo off these perpetual watchers, and the expression "Twenty-Three Skidoo" was said to have been born on this windswept corner. The building itself doubtless contributed to these odd wind patterns.

As far as high buildings were concerned, however, New York hadn't seen anything yet. The real growth was about to arrive, and in the years between 1900 and the First World War, New York was crowned for all time as the world capital of the skyscraper, an honor that has hardly diminished since. By 1910 if there were any native New Yorkers left who believed that skyscrapers were unsafe and likely to topple in a strong gale, they were a tiny minority. Skyscrapers rose in those years like tall grasses on the summer prairie. New building activity in 1907 alone cost a staggering $178,000,000—three times the amount spent in Chicago that same year. In the 25 months ending on April 1, 1908, a half billion dollars was spent on building construction in the city of New York. And all of the figures for capital growth were phenomenal during those years. Between 1890 and 1908, New York had seen the rise of 539 structures that could fairly be described as tall buildings, and the biggest ones were just starting to rise. Between 1902 and 1903, New York built over 19,000 apartment houses, and by the end of that period had a population of 4,442,000 (nearly 5 percent of the population of the United States), with taxable real

estate of nearly $6 billion. In only a few years, New York would become the largest city in the world.

In these years, too, New York business leaders came to see in the skyscraper not only convenient and economical office space, but a possible means of corporate glory and aggrandizement. A great tower, obviously, could not only house management but glorify it. Doubtless the first firm to seize this opportunity was the Singer Company, already for several decades the world's largest manufacturer of sewing machines. The Singer Company had erected an office building on property at Broadway and Liberty streets in the 1890s, and this building housed the firm's executive offices and some other tenants as well. Shortly after the turn of the century the company decided to construct a tower of considerable height at the same spot, thus avoiding the necessity of acquiring another building for expansion at some other location. The tower, when it was completed and opened in May 1908, reached a height of 612 feet, making it by far the tallest building in New York at that time—a distinction it would keep for a mere 18 months.

Perhaps the Singer Company could have done without the tower for

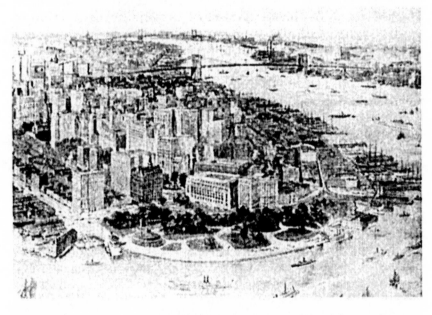

The New York skyline as it appeared shortly after the turn of the twentieth century. Though New York was already famous for its cluster of skyscrapers in downtown Manhattan, no truly tall buildings had yet been built. (From King's Views of New York, *1903.)*

its own office requirements, but executives felt they needed to do something for what a later age would call the corporate image — and in the tall building they hit upon a gimmick that really worked. The building was to become a lasting monument to Isaac Merrit Singer, a man who knew how to sell himself and his company if ever such a person was born. The history of the Singer Company had been one of slow but irrepressible growth into the heavens from the moment that Isaac Singer first laid eyes on the primitive ancestor of the sewing machine.

Isaac Singer was born in upper New York state in 1811 and died in 1875, long before the building bearing his name rose on lower Manhattan. He started life as a kind of itinerant inventor who also spent a few years as an actor and theater manager. Certainly he had a feel for the dramatic. The greatest turning point in his destiny came about in the early 1850s when he saw a sewing machine that had been invented and patented by Elias Howe several years before. Singer perceived that the Howe machine was little more than a trinket, and he was convinced that he could build a machine that would sell. (Howe had never succeeded in selling any machines, and remained content with exhibiting it in fairs and industrial expositions.) Singer succeeded in his own endeavor almost immediately, inventing a machine that could do continuous stitching. He then proceeded to make regular and marked improvements in every phase of the machine's design. Unfortunately Howe did not lie down and take all this without a fight. He sued Singer for patent infringement and after a protracted legal battle won a judgment. This victory was more or less meaningless, however, since the Singer Company had moved so far ahead, and introduced so many new advances (between 1851 and 1865 Singer had patented no fewer than 20 improvements on the machine) that Howe was left choking in the dust of it all. Howe was able to squeeze out a few meager royalty payments, but the Singer Sewing Machine Company had taken over the lead through the combination of manufactures and the pooling of patents.

Singer was a crackerjack salesman. In the first few years he made a number of machines, but sales were far from brisk. Success required that the machines sell to housewives all over the country, and Singer could not persuade them to plunk down the $125 it cost to buy a sewing machine. Cagily he hit upon the idea of letting customers pay $5 down and $3 a month on an installment plan for the machines, feeling confident that once they had the machines in their homes they would refuse to be without them. Waves of itinerant salesmen flooded the country charged with the slogan "A machine in every home," and orders started coming in by the thousands. By 1871 the company was making and selling over

700,000 machines a year. There were a few competitors in the industry, but by the time Singer died in 1875 his company was making three quarters of the sewing machines in the United States. In 1873 the company consolidated its manufacturing operations in one gigantic manufacturing plant at Elizabethport, New Jersey, not ten miles from its executive offices on lower Manhattan. Historians who credit Henry Ford with inventing mass production might do well to consider this gigantic plant at Elizabethport, where 3,000 workers turned out 700,000 of these whirring machines a year with efficiency and dispatch — when Henry Ford was still a boy in knickers.

The Singer Company remained an aggressive competitor in the years after the death of Isaac Singer, and it was always good at selling its products and company image. It is no wonder, then, that the company decided to build an elaborate and showy office building in the 1890s at the corner of Broadway and Liberty streets. That building was hardly a skyscraper, but an elaborate French-style office building of 14 stores. The famous Singer tower was a later addition, clearly and obviously erected as an advertising venture, an exercise in self-glorification. And if the building was not an architectural wonder, it was nonetheless a structure of considerable charm and personality that quite fully succeeded in its mission.

The Singer tower opened in 1908, and remained for 18 months the tallest building in the world. Only 70 feet square, it rose to a height of 612 feet (47 stories) and, as designed by Ernest Flagg, attempted to duplicate the modern French styling of the original structure below. The tower was unusually rich in ornament, and the various decorative features managed to counteract the impression that it was, after all, a very slender tower. On each of the four sides were long bays, extending from the fourteenth to the thirty-fourth floor, and framed by corners of heavy masonry, each containing only one small window on the border. The structure was crowned by a three-story mansard roof gracefully curved. There was also a semicircular observation platform for sightseers, a necessity for any building claiming to be the tallest in the world.

The offices in the Singer tower were quite desirable in most ways; certainly they were well suffused with light. The offices were arranged on all four sides, with elevators, stairways and service facilities in a center core. Furthermore, every modern convenience for 1908 was provided. There was hot and cold running water in all the offices, steam heat regulated by individual thermostats, and even a central vacuum cleaning system with outlets on every floor.

The Singer Building had problems with elevators that the planning and resourcefulness of later years could have overcome. The equipment

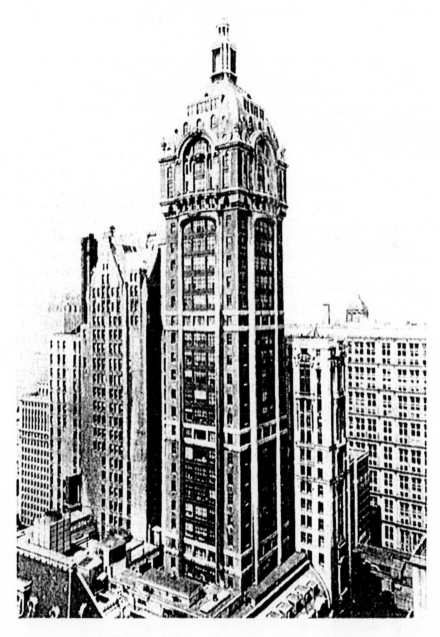

The Singer Building at Broadway and Liberty Street opened in 1908. Alas, it is one of the few major skyscrapers in New York to have suffered demolition. (Museum of the City of New York photo.)

itself was good enough: there were 16 modern elevators, monitored by an
elaborate panel board which kept the starter informed of the location of
all the cars. The tower itself accommodated only four of the elevators,
each of which ran as an express to the 14th floor and then local for the
next 27 floors. The regular stopping at 27 floors was very time-consuming
and made the upper stories less than desirable for tenants. (What a misery
it must have been for the poor elevator operators in those days long before
the period of the automatic elevators.)

In spite of the elevator problem, the Singer Building was a clear suc-
cess financially, and all of the space not used by the Singer Company was
quickly occupied. And of course the building was a continuing ensign of
power and prestige for the Singer Sewing Machine Company to the far
corners of the earth. Unfortunately, the Singer Building no longer graces
the lower Manhattan skyline. Its eccentric charm and authoritarian
presence were lost in the 1960s when the building was razed to make room
for a banal and colorless 743-foot structure called One Liberty Plaza.

Before the opening of the Woolworth Building in 1913 there was
another claimant for the title of the tallest building in the world, namely
the Metropolitan Life Insurance tower at Madison Square. This tower
was on the drawing boards before the tenants had claimed their offices
down in the Singer Building. Like the Singer Building, the Metropolitan
tower was an addition to an existing structure. In fact, it was a third addi-
tion to an already large and successful complex. The Metropolitan Life
Insurance Company became convinced as early as 1890 that the city was
moving northward, and it purchased a plot of land at Madison Avenue
and Twenty-Third Street, which was then largely a posh residential
district with a few quality department stores and retail establishments.
But there was no business development in the vicinity, and those in the
know believed that construction of a large office building at that site was
idiotic and suicidal. But the Metropolitan built an 11-story building that
was an immediate smash success. On the strength of that success, the
company erected an adjacent building of 12 stories in 1895, and the space
here was also immediately gobbled up. In five short years the Metro-
politan had opened up 850,000 square feet of office space, all of it eagerly
sought.

In 1900 the Metropolitan Life Insurance Company owned nearly the
whole block bounded by Twenty-Third and Twenty-Fourth streets and
Fourth and Madison avenues. A remaining quarter of this block was oc-
cupied by the Madison Avenue Presbyterian Church, but that property
was bought up by Metropolitan in 1906. Forthwith the insurance com-
pany hired architects Pierre and Michel Le Brun to build the tallest and

grandest tower in New York. What these gentlemen delivered, late in 1909, was a tower of 700 feet, 88 feet higher than the Singer Building. The building and land cost over $6 million, but the president of the Metropolitan Life Insurance Company claimed that the project cost the company not one cent — it was all tenanted space, and the tenants were paying for free advertising and goodwill for the life insurance landlord.

The Metropolitan tower was for many years one of New York's most pleasing and celebrated tall buildings. It is a campanile in the manner of St. Mark's in Venice; the ornamental detail was striking and the tower was charming and well proportioned. Even more than the Singer Building, the Metropolitan tower became a symbol and an image. Displayed on company letterheads and promotional material, it became as much a symbol of Metropolitan as the Rock of Gibraltar was for Prudential over in Newark. The tower also inspired the company slogan "The Light That Never Fails," suggested by the beacon that was installed in the tower before the building was completed, and used spectacularly during the presidential election of 1908 to beam out election results in the years before radio. This beam was the first of its kind on a high building, and probably the most memorable.

The Metropolitan tower still stands, but it was subjected to much abuse in the 1950s when original lower buildings were demolished to make room for new structures and the tower was given a kind of unwanted facelift in which much of its ornament was stripped off. The proportion and scale of the tower remain, but the removal of the ornamentation was an unsightly and grievous development.

The race for the sky was not the only compelling interest in New York office building construction in the early years of the twentieth century. Height was not the only answer to problems of urban congestion, especially on lower Manhattan. Towers like the Metropolitan and Singer had their advantages as corporate symbols and as monuments of goodwill, but they were not always as efficient in filling a lot as might be hoped for. There came a certain impetus, especially on lower Manhattan, to find newer and yet more efficient ways to crowd office square footage into an ever-dwindling area.

The most notorious result of this quest was the Equitable Life Insurance Building, erected in 1914-15 in the very heart of New York's financial district, on the block bounded by Broadway, Cedar, Pine and Nassau streets. This building, when it was opened, was the largest office building in the world, though not the tallest, and was designed to fill up every bit of space available for construction. The Equitable Building was a monster, a 40-story block of solid mass built right to the sidewalk on all

sides so that nothing would be wasted. Plans for the building were attacked before a spade of dirt was removed from the ground. Many New York business and civic leaders saw this cruel monster as gobbling up all of the available light and air, casting a pall of gloom over an entire

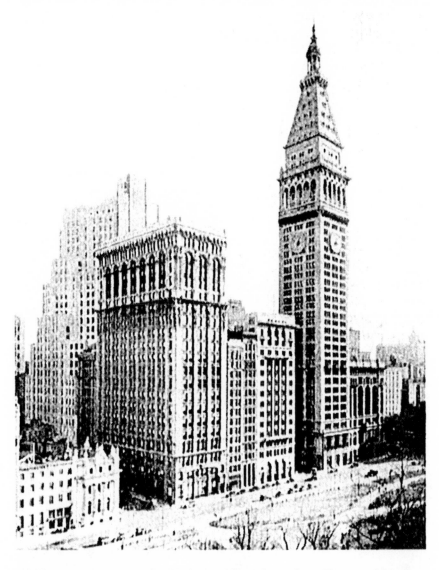

The first skyscraper to reach 700 feet was the Metropolitan Tower at 1 Madison Avenue (1909). Its flashing beacon at the top became a logo for the insurance giant. (H.M. Douglas photo, from author's collection.)

neighborhood. Still the building was built. Architecturally it was not a thing of beauty, but it played an important role in the history of skyscraper architecture because it was responsible for the New York City setback ordinance of 1916 that influenced the design and construction of skyscrapers for the years to come.

Even before the coming of the setback ordinance there were those who were worried that the Equitable's offices could not be filled. (This in addition to the aesthetic and civic worries of the building's neighbors.) Even the venerable Louis J. Horowitz of the firm of Thompson-Starrett & Co., the best-known builder of office buildings in the city, was skeptical and advised against the project, although there would be millions in it for him and his firm.

The origins of this great monster were interesting. The Equitable Life Assurance Society had owned this block for some time and had on the site a low rambling building until January 1912, when it was greatly damaged by fire and the firm of Thompson-Starrett was engaged to wreck the building and clear the lot. An eager New York architect, perhaps hopeful of a juicy commission, approached Louis Horowitz with the idea of suggesting to General Coleman Du Pont, then the leading light of the Equitable, the desirability of putting up some kind of tall, massive office building on this lot. Horowitz spoke against the project to the surprise of Du Pont, who assumed that Horowitz would gobble up any plan that would lead to a fat contract for his construction firm. But the more objections Horowitz found to the scheme the more Du Pont liked it, and eventually the dubious Horowitz was won over to the scheme.

Horowitz was skeptical of the financing, of the possibility of fully renting the space, and of the aesthetic and practical encroachments on the environment. On this last score he was joined by many business leaders who begged General Du Pont to reconsider, even offering him a bribe to scale down the project. Meetings were held decrying the fact that this giant would tax beyond endurance the sewers, transportation, sidewalk space, and other public facilities of the surrounding area. At one point Du Pont agreed to sell the plot of land to neighboring businessmen if they would agree to dedicate the block to a park. But this immediately silenced all objections from the financiers of the day, who would willingly speak out for environmental protection but not pay any money for it.

The Equitable Building is not a disgrace as it stands, although one can still wish that it had not been built. The architect who had originally proposed the project was euchred out of the commission with full payment for his plan, and the job was given to E.R. Graham of Chicago, a former protégé and partner of the recently deceased Daniel H. Burnham.

Needless to say the project was a massive one, requiring the services of a large and comprehensive architectural firm. The building exceeded 20,000,000 cubic feet, with rentable floor space of 1,200,000 square feet. The Pentagon in Arlington, Virginia, the world's largest office building today, is less than 4 million square feet, so even though the Equitable is considerably smaller it remains immense when one considers that it had to fit into one tiny block of less than one acre, while the Pentagon sprawls over a vast 34 acres.

Unlike some of the "tower" buildings under construction in Manhattan in those years, the Equitable did not dwindle into some thin shaft as it went skyward; it was a massive block that rose a full 40 stories right at the sidewalk line. The building was not quite a monolith since it was H-shaped with exterior courts on the narrow ends of the block. Nonetheless, it did succeed in blocking out the sunlight from many of its neighbors in the financial district, and some poorly located folk received virtually no sunlight at all.

The Equitable was a modern building by all the standards of the day. It had 48 elevators capable of accommodating 12,000 people an hour. When fully occupied it could house 20,000 office workers. The building is still worth a visit today to see the massive first-floor lobby. These vast vaulted chambers remain impressive as a remarkable and flamboyant use of commercial interior space.

The real historical significance of the Equitable is not as a work of the building art, but as a turning point in skyscraper construction in New York. The owners and builders had hoped to get away from the slight inefficiencies of tapering towers, but the reckless space-hogging of the Equitable brought about New York's zoning restrictions of 1916. Mercifully these restrictions were carefully and intricately thought out, unlike those of Chicago. They prevented the construction of blockbusters like the Equitable without preventing the construction of ever-taller buildings on suitable parcels of land.

The city was zoned into nine height districts, with the use and type of buildings permitted in each also regulated. In each of these zones the height of the building at the street line could not exceed the width of the street multiplied by a stipulated factor. In the lowest height district the figure was one-fourth the width of the street. What was most important, however, was that if the building were set back from the street, it could exceed the height restriction for that particular location. In the lowest height district the building could be increased one foot for each two feet of setback; in the district permitting the highest buildings, the height could be increased four feet for every foot of setback.

What all this permitted, and prompted, was a continued skyward thrust, but of buildings whose bulk was continually reduced like a pyramid as they climbed to the heights. Ruled out at one sweep was the possibility of further light-restricting buildings like the Equitable (the Equitable Building, for example, had a floor area about 30 times the square footage of the plot; the new zoning restrictions would have permitted an area less than 12 times that of the plot). And so came about the characteristic New York skyscraper building, which steps back after so many floors to create pleasing, tall, but unobtrusive towers.

The first building to illustrate the aesthetic advantages of the new setback requirements was the building at 27 W. 43rd Street, constructed in 1917-18, and with design features that were praised all around. New York would continue to grow and it would build its finest skyscrapers in the next fifteen years. It would build tall buildings and it would do so in high style.

THE FIRST GREAT TOWER – MR. WOOLWORTH BUILDS HIS SHRINE

When the twentieth century dawned, skyscrapers were only beginning to raise their heads in New York. When Dan Burnham brought his Chicago experience to New York and designed the Flatiron Building, which opened in 1901, New York was still behind Chicago in the race to the sky. The Flatiron Building itself was only 23 stories high. But in the next few years all this would change, and New York was on its way to developing its world-famous skyline. In a few years the 612-foot Singer Building in downtown Manhattan would be the tallest building in the world, and by 1909 it was eclipsed by the Metropolitan Life Insurance Building up on 23rd Street.

Up and up and up they seemed to go in the early years of the century. Still, the tall building remained in the public mind a natural development of the city's congestion and the high cost of land. The newly built skyscrapers were inspiring and impressive, but they hadn't quite caught the imagination of the public as objects of supreme awe and wonder. But now, all of a sudden, like Jack's Beanstalk, these towers started to reach up to the very sky. Now there were buildings that would take the very breath away, leaving the spectator on the pavement below gaping with astonishment and disbelief. Suddenly the office building became an obvious child of American industry and frenzied self-confidence, an expression of pure megalomania some would say, but at the very least an expression of the desire to overtop and surpass. The skyscraper had hitherto been a practical solution; now, all of a sudden, the desire to build became a race, a competition.

The first great skyscraper to catch the public's imagination, and the first building to keep for any considerable length of time the title of tallest

building in the world, was the dream and wish fulfillment of a man who revolutionized retail merchandising in the United States — Frank W. Woolworth, the inventor of the "five and dime" store, and father of all its modern-day counterparts. Woolworth had made a fortune on nickels and dimes, and he wanted to show anyone who still doubted that nickels and dimes in large enough quantity were nothing to be sneezed at; indeed that they were sufficient to build a palace worthy of Croesus. At the beginning, Woolworth had intended only a building of modest height, but the more he thought about it the more he was certain that he had to have the biggest and best — something that would silence all the doubters and stand as an everlasting monument to individual initiative and enterprise.

F.W. Woolworth, the great five and dime merchant, as he appeared in his prime. At first he hoped only to top the Metropolitan Tower by a few feet — he hated the insurance company. Finally he decided to erect a tower that would shame all others. (Photo courtesy University of Illinois Library.)

Frank W. Woolworth was a self-made man in the best Horatio Alger tradition. He came into the world with nothing, and went out one of the great American millionaires. And he did it all with good old-fashioned American ingenuity. Woolworth was a man who had a lot to be proud of, who went against the grain and won. He was born on a farm in upstate New York in 1852, but like so many farm lads before and since he detested the back-breaking labor of his father's farm, so he began clerking in stores. He seemed to have few gifts as a salesman, however, and in one job his performance was so poor that his employer reduced his wages from $10 to $8.50 per week. But his inability to bargain and haggle and his poor performance as a salesman were the clues to his later successes. His mind wandered to other ways of selling, and he soon hit upon the importance of presenting and displaying merchandise. His first success came in a dry-goods store in Watertown, New York, where he found a way to place a great many items in the window to draw customers inside. Hearing of another merchant who successfully sold a large number of handkerchiefs because they were all sold at 5 cents apiece, Woolworth got the idea of having a five-cent counter, for which he bought several hundred dollars' worth of items of all sorts — buttons, safety pins, soap, baby toys, harmonicas, measuring cups, note tablets, etc. — all useful items, no gewgaws or baubles. The table was topped by a big sign indicating the price for every item on the table. In the first day everything sold out.

Within a few years Woolworth was off on his own, opening stores first in Utica, New York, and then in Lancaster, Pennsylvania. The philosophy that led to his later success was evident from the beginning. It consisted of the belief that people would be drawn to stores with fixed prices, and that the average person disliked haggling and bargaining over price. Similarly, he felt, a store ought to be able to advertise itself by the proper use of window displays and the availability of the kinds of items the public wanted. Woolworth never had much faith in newspaper advertising, and to the very end believed that the things in his store ought to be able to sell themselves.

Some might wonder how it was that Woolworth was able to fill a whole store with merchandise that sold for a nickel or a dime. It was not easy even in the 1880s, but Woolworth managed it by buying on a large scale and inventing many new items himself, thereby creating a demand for all sorts of items that people never thought about before. And always there was the belief that the proper display and selection of these inexpensive items would guarantee their sale. Woolworth believed that his stores did not need hotshot salesmen; indeed his employees were mere "clerks" who stood around until a customer made a selection and

then merely rang the item up on a cash register and put the item in a bag.

Thus was born the stereotype of the "dumb salesgirl" who only had to be physically present to perform repeated simple tasks and was not supposed to "know or question" anything. In the early days the young women Woolworth employed earned a salary of $1.50 a week, and Woolworth was always reluctant to give them a raise. One young lady wrote to him that she had been around for several years, knew more than the other help and was deserving of a raise. Woolworth responded that she had better go elsewhere. He did not want or need experienced help since his merchandise ought to sell itself.

And the Woolworth Company thrived on this philosophy. By 1886 Woolworth controlled five stores that were using his merchandising methods. By 1895 he had 28 stores; by 1900 he had 59. But still this was nothing in comparison with what was to come, and like the skyscrapers that were rising in New York in the early years of the twentieth century, the Woolworth Company began skyrocketing out of sight. At the time of Frank Woolworth's death in 1919 his company controlled more than 1,000 stores in the United States and Canada, and had even begun operations in England. When Woolworth died his personal fortune was said to be worth $65 million. And his business practices had been successfully taken up by other five-and-dime merchants, including Kresge, Kress, Newberry and others.

Like a lot of self-made millionaires in the age of the robber barons, Woolworth took to living on a grand scale. He sported himself elegantly, indulging a garish taste in dress. Too, he became something of a trencherman in the manner of Diamond Jim Brady, stuffing himself at the best New York restaurants with steak, lobster, and all the other delights available. He became portly, if not downright fat, a very caricature of the bloated man of business. In 1901 he moved into a 30-room mansion at Fifth Avenue and Eightieth Street in New York. The place was fitted out with, among other things, a magnificent organ, and the great man himself entertained friends at the keyboard. Alas, the poor farmboy from upstate New York had no touch of music in him, so the organ had to be an automatic one, like the old-time player pianos, operated by rolls of perforated paper.

But Woolworth never exactly gave up the parsimonious habits of his youth. He wanted luxury, the best that money could buy, but he didn't want to shell out big money to get the things that pleased him. He would haggle over the cost of anything if the fancy suited him, and his philosophy seemed to be that one ought to be able to get steak at hot dog

prices — that is, if one were F.W. Woolworth. While indulging himself in all the best that money could buy he might fly into a rage over a request for a 50 cent per week increase on the part of his office boy. At a time when his company was making millions of dollars a year he once kept his private secretary hours overtime trying to locate a quarter which Woolworth believed had fallen out of his change purse.

Woolworth's greatest dream and personal triumph, the building which continues to bear his name and remained for over 15 years the tallest building in the world, was similarly the child of his megalomania, but it suffered a tortured birth, as Woolworth tried to get the most extravagant building possible without paying for it. As was his usual habit he wanted a tower of gold, and he wanted to get it by paying in nickels and dimes.

Early in the twentieth century the Woolworth Company had already moved into new quarters in New York in a rather elaborate building overlooking City Hall Park, and from there Woolworth governed his rapidly expanding empire from a mahogany and gold desk. But he was soon discontented with this office. It didn't stand out; it didn't advertise the Woolworth Company as one of the great business enterprises of the world; it was a mere building in a big city of buildings.

Around the time that the Metropolitan Life Insurance Building was going up, Woolworth conceived the notion of building some kind of skyscraper of his own. Perhaps he did not think right away of having the tallest building in the world; probably he did not know precisely what he wanted except something grandiose and eye-catching. Here, after all, was the man who built an empire by finding ways to display merchandise. Now was the time to display the success of his business, which doubtless a great many people sniffed at as cheap and undistinguished.

Late in 1909, Woolworth purchased a new tract of land in lower Manhattan on Broadway, west of City Hall Park, and the following spring he engaged the popular architect Cass Gilbert to design a building for it. Gilbert, who started out his career as an apprentice of Stanford White and later developed a successful practice in St. Paul, Minnesota, where he designed the state capitol building, was one of a long line of American architects — like Daniel H. Burnham, perhaps — who had the ability to handle clients and keep them happy. He knew how to put architecture on the layman's level. He was solid and convincing.

But Woolworth was hard to handle, even for a master like Gilbert. Over the next several years Gilbert must have wished more than once that he could dump Woolworth and his building in the Hudson River. In the

end Gilbert did manage to build for Woolworth an awe-inspiring edifice, but for several years it was all storm and stress.

First of all there was the problem that Woolworth could not or would not make up his mind how tall he wanted his building to be. His first idea was a building of about 42 stories, just tall enough to top the Singer Building, then the second highest building in the world. Later on, however, Woolworth complained to Gilbert that such a building would be too expensive; perhaps he could settle for a building about 25 stories that might later be expanded when more funds became available. (Such a practice was not uncommon in those days—the Singer tower of a few years before had been an addition to an older and lower structure at the same address.)

No sooner had poor Gilbert put such a building on his drawing boards than Woolworth came around talking in terms of something higher. So Gilbert started working on a building of 620 feet. But the minute this one was on the drafting boards at Gilbert's office Woolworth started thinking again. As long as he was going to surpass the Singer Building and have for himself the second tallest building in the world, why not go still taller? How tall after all was the Metropolitan Building up on 23rd Street?—not that much taller, was it? Gilbert knew the answer: at 700 feet and 2 inches, a figure clearly etched in Gilbert's brain, it was 88 feet taller than the Singer Building. Doubtless Gilbert had hoped from the beginning that Woolworth might be persuaded to go to the top, but Woolworth had to arrive at his ideas himself.

But now the idea was in his head—the tallest building in the world! Woolworth had his reason, too, for wanting to overtop the Metropolitan: He resented that the company had at one time turned him down for a loan. How sweet it would be to dwarf its proud edifice and get some real glory to boot. So once again Gilbert had to put aside his plans, and now he set about creating a building 750 feet high—quite sufficient to top the Metropolitan Life tower. (The actual final height of the building would be 792 feet, or 60 stories.)

This issue of height was only part of the problem that Gilbert had with Woolworth. The latter was a constant nuisance, forever suggesting changes in matters of aesthetic and practical concern. And he never let up, from the time of the preliminary sketches to the last phase of construction—always changing his mind, always arguing over costs, constantly demanding modifications in plans long ago decided upon, as if his building were some child's clay model that could be entirely rebuilt at a moment's notice. In the middle of the work Woolworth even tried to get Gilbert to reduce his fees by 5 percent, hinting that he could have found

other architects just as good who would have worked for less. Gilbert
stood firm, however, and got his 5 percent.

Woolworth played the same kinds of tricks on other people con-
nected with his building during the course of its construction. He chose
the well-known New York construction firm of Thompson-Starrett as
general contractor, but no sooner had he done so than he began complain-
ing to its president Louis J. Horowitz that there were other firms in the
city that would be glad to accept the commission and do the work for
nothing to get the glory and prestige of building the highest building in
the world. But Horowitz, too, held firm, and Woolworth had to pay up.
Horowitz obviously had Woolworth figured out from the beginning: "I
had the feeling that Mr. Woolworth was turning on me, as if it were a
fire hose, his customary way of buying goods for his five and ten cent
stores."

Even so, Woolworth managed to keep architects and builders alike
on their toes from the beginning to the end of construction. He let no
detail evade his scrutiny, especially where money was concerned. During
the course of construction Woolworth wrote to Gilbert to complain that
Thompson-Starrett had employed a telephone-messenger boy at the site
at the wage of $2.50 per day, a figure which Woolworth regarded as exorbi-
tant. And Gilbert was always having to put a damper on these outrages
of Woolworth's, even though they added enormously to his personal ex-
penses and work effort.

On a number of occasions Gilbert strenuously remonstrated with
Woolworth for the changing of plans in midstream. Nearly always build-
ing owners depend on the expertise of their architects for the thousands
of practical details and finishing touches, but not Woolworth. He had his
hands in everything. He argued with Gilbert about the width of corridors,
the layout of offices, the style of radiators, the light fixtures, the elevators,
and everything else that came to his attention. When it was time to pick
out the plumbing fixtures, Woolworth himself visited the offices of the
Sanitas Manufacturing Company to look at the line of toilets and other
bathroom fixtures available. He personally picked out the design of the
levers that he wanted for the urinals in the men's rooms.

With all this meddling the Woolworth Building should have come to
grief. But it did not. Gilbert gave the building his best effort, and it became
one of the most graceful and awe-inspiring of American skyscrapers. Later
on there would be those who would scoff at the Gothic detail and or-
namentation, and from the start there were critics aplenty to pick apart
any skyscraper as a sinful display of wealth and ostentation ("A cathedral
of nickels and dimes," they called it), but the man on the street was duly

The main (Broadway) entrance of the Woolworth Building. Such rich Gothic details would be scorned in later years. Architects favoring them waned, and craftsmen capable of executing them vanished in America. (H.M. Douglas photo, from author's collection.)

impressed and looked up at a structure that was both solid and warmly appealing to the eye.

To be sure, the Woolworth Building was built at a time when American businesses had little taste for refined or subtle architectural features. They wanted buildings that impressed with a certain kind of gaudy opulence, and this meant employing features from traditional architecture. The kinds of skyscraper design dreamed of by Louis Sullivan were not yet making themselves felt in the land, and architects like Gilbert, and Burnham in Chicago, were seeking their inspiration from the baths of Roman emperors or from Gothic cathedrals. These influences were what their clients wanted, and being commercial architects they sought to satisfy the client.

Though admittedly a conspicuous monument to wealth and commerce, the building was a thing of beauty, artfully conceived, and far more comely than the Singer and Metropolitan towers which preceded it as the tallest buildings in New York. The Gothic inspiration was much more apt for the skyscraper than its later detractors would allege, and Gilbert's design wedded an exceptionally good choice of material with appropriate ornamental detail. The building was finished with matte glazed ivory white terra cotta with seven colors for ornamental detail. Gilbert was not without imagination in using a free form of Gothic style to accentuate the upward sweep of the great tower. Gothic pilaster and moulding actually accented the soaring height, and terra-cotta crockets and finials gave the top of the tower a delicate lacy quality as if the building were somehow tapering off into the clouds.

To those who did not stand and gape up at the building from the outside but wandered the halls of the interior (and in the early days, while the Woolworth Building was the tallest in the world, it was visited by some 3 million tourists a year) the building was equally inspiring. The king of buttons and bows spared no expense to present a building that would startle and inspire his visitors. The main entrance on Broadway was a magnificent arch treated to rich Gothic detail and filigree. The lobby might well have served as the entrance to a Turkish sultan's palace or harem. The walls were of golden marble from the Isle of Skyros. The ceiling was a glittering green, gold and blue mosaic with stylized flower patterns and exotic birds. Even the elevator doors were treated to intricate and elaborate design—a kind of craftsmanship that would probably be unavailable at any price in the second half of the twentieth century. (The elevators themselves were the most modern in the world and for the first time were controlled by a central dispatcher.) For his own private offices Woolworth had ransacked the galleries and auction houses of Europe, and, impressed

by Napoléon's tastes and zest for power, he emulated the decor of Napoléon's palace at Compiègne.

Whatever its faults or excesses, the Woolworth Building was, and is, one of the most beautiful of skyscrapers. When it was given its first thorough cleaning in 1932 the terra cotta exterior was found to be in

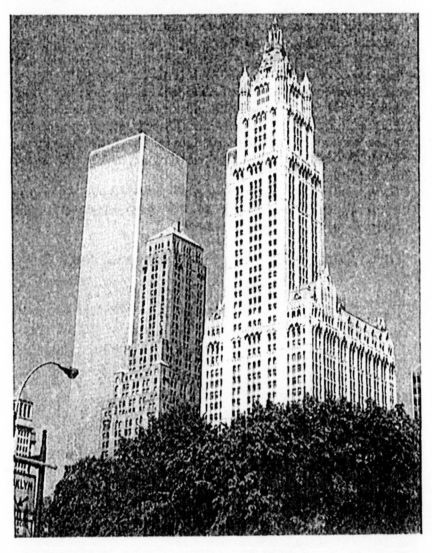

The Woolworth Building still adds an element of grace and dignity to lower Manhattan, although it is now surrounded by many plain and utilitarian giants. (Photo by author.)

perfect condition. And to this day, in spite of trouble with some of the turrets and gargoyles at the top coming loose, the building continues to lighten up and sanctify its drab environment. Even those who do not share the grandiosity of the age of the robber barons cannot help seeing that Gilbert and Woolworth put their hearts into the thing. They planned well and came up with a building that continues to command respect and admiration. It remains one of the world's great skyscrapers.

What is perhaps more important from a historical standpoint is that the Woolworth Building ushered in the era of the great skyscraper. The building opened on April 24, 1913. At 7:30 P.M. on that day, during the course of a dinner to honor Cass Gilbert held in a banquet hall on the twenty-seventh floor of the building and attended by numerous dignitaries, a telegraph signal was sent from the White House where President Woodrow Wilson was waiting to push a button that would light up the building with some 80,000 bulbs and put the building on public display for the first time.

Before that day in 1913 the skyscraper had been a thing of architectural and engineering curiosity. Now at last it was clearly revealed as one of the great wonders of the modern world.

Chapter 5

OF LIGHTS, ELEVATORS, AND WATER THAT RUNS TO THE SKY

To a casual observer in the late twentieth century, the development of the skyscraper may seem to have been mostly a matter of solving the technical problems involved in getting tall structures to stand up without toppling over. However intricate these problems might have been, their solution would not have made the skyscraper a practical and attractive achievement. The invention of the skyscraper required a multitude of technologies most of which existed only in a very primitive form, if at all, in the middle of the nineteenth century. Without the elevator and the electric light, the skyscraper could have been nothing but a dark and unpleasant cave rising out of the ground — a thing unfit for human habitation. Similarly, without the refinements of modern plumbing and heating, life in tall buildings would have been intolerable. Without the telephone, life in the skyscraper would have been possible but not very convenient; communication would have been at a snail's pace, and some of the obvious advantages of building tall would have been lost.

Most of the technologies needed to make the skyscraper work were already available in 1880, but making them work often required herculean efforts by architects, builders and suppliers. For example there were elevators in 1880, but the sort then available would not have been usable in the Singer Building a few decades later. The concept of central heating was not exactly new in 1880, but developments in that area would have to come fast and furious if it was to be usable in massive city buildings. And of course with the demand for such buildings, and with a wildly growing urban population, the developments did come.

A controllable and self-sufficient light source was an especially complicated problem before 1880. Up to this time gas was used for lighting in hotels and public buildings. But it was a perpetual nuisance and a

61

constant source of danger. For many years there had been a hope that artificial lighting could be achieved by means of electricity, but most of the early kinds of electric lights left much to be desired. As early as 1808, Sir Humphrey Davey had demonstrated an arc light powered by batteries. Arc lights afterwards came into a very limited usage for street lighting in urban areas, but they were full of disadvantages. The arc light produced a dazzling light that could not be reduced, so that it was not really suitable for indoor lighting. Too, arc lights operated in a series which meant that they all had to be turned on or off together — an obvious defect for separate and independent offices. Above all, arc lights involved an open flame. This meant, as with gas, a potential source of danger.

Many scientists and inventors had attempted over the years to perfect the idea of an electric light that avoided the dangers inherent in gas or arc illumination. But the results had been frustrating and unproductive by and large. Onto the scene in the late 1870s came Thomas Alva Edison, the prolific and energetic inventor who a few years earlier had decided to stay out of this race for a useful electric light. Edison, however, was a very pragmatic man, and early in life he had formulated the philosophy that an inventor is not just a person who tinkers around and invents things that strike his fancy, but one who first locates a certain need and then moves in to fill that need.

As a youthful telegraph operator Edison had seen the possibilities surrounding the use of telegraphy, and his first patent was for a telegraphic vote recording machine. Even more important was his invention in 1869 of the stock ticker, also arising from his telegraphic background. In the years that followed he produced the quadruplex telegraph (1874), the carbon telephone transmitter (1876), and the phonograph (1877). Armed with his success as an inventor and the moderate profit he realized as a promoter of his inventions, Edison opened at Menlo Park, New Jersey, a laboratory for the development of socially needed inventions. The laboratory was to turn out scores of inventions in the decades that followed; it was here that Edison got involved in the race to develop a practical electric light for indoor illumination.

At first Edison had wanted to keep strictly away from the electric light sweepstakes since so many others were working on it and the whole business had proven elusive and frustrating. But when he finally did commit himself to it in 1878, he moved forward with relentless and frenetic energy, thinking about the problem day and night. Interestingly enough, the part of the contest which Edison believed to be most important was not the part with which he is popularly identified today. Today Edison is remembered as the man who invented the incandescent lamp, a lamp that

would glow without consuming itself and that could be safely contained in an airtight bulb. And Edison did indeed invent the incandescent lamp, after a frustrating series of experiments with hundreds of filaments. In October 1879 he managed to produce a glowing lamp with a carbonized cotton filament that glowed for 40 hours. But what had drawn Edison to the search for an electric light was another idea which he considered much more important. After working on the light project for only a few weeks at Menlo Park, he feverishly cabled his European agent that he had found a reason that made the battle for the electric light worthwhile: "Have struck a bonanza on electric light — infinite subdivision of light."

Of course Edison wanted to invent a soft and gentle light (which the arc light was not), but what was really important was the subdivision of light, a new kind of circuit that would allow each light to be turned on and off separately. Also important, the electric light must be tied in with a central power station so that thousands of electric lights in homes, offices and stores could be supplied from a single source.

Edison did all of these things, of course, but it was his concept of the divisibility of light that he believed to be his most important (and socially valuable) contribution. And so it certainly turned out to be as far as a rapidly urbanizing America was concerned. Surely nothing could have been more important to the development of the skyscraper, for without this advance, electric power in offices would have lumbered along under many of the bothersome and labor-demanding qualities of gas. Edison not only invented the electric light, he socialized it, democratized it. Within only a few years of his invention thousands of city office workers would be able to raise or extinguish individual lights, in individual offices, with no more effort than flipping a switch.

Edison's system of electric lighting became operative in only a few years, at least in the large metropolitan areas where central power stations were feasible. But another essential ingredient of the modern skyscraper, the elevator, came about in slow and drawn-out stages. Some form of elevator or lifting device had been known for centuries. As early as the third century B.C., Archimedes had used a rope and pulleys and a winding drum to hoist heavy objects, and there were elevators of sorts in the Colosseum of Rome, powered by human or animal effort. In some of the grand palaces of Europe in the eighteenth century elevators were installed to save royal personages from having to climb stairs, but again the power was supplied by slaves or servants concealed below stairs. Too, the lift involved was usually only one or two floors, and the mechanism was very slow.

With the coming of the Industrial Revolution, heavy objects had

to be moved in factories. The need for power-driven elevators became obvious. As early as the 1830s a steam-powered hoist was in use in England. Different forms of steam-powered elevators soon appeared in America, not only to lift freight but to carry humans as well. Hotels and department stores were already multistoried before the Civil War, and

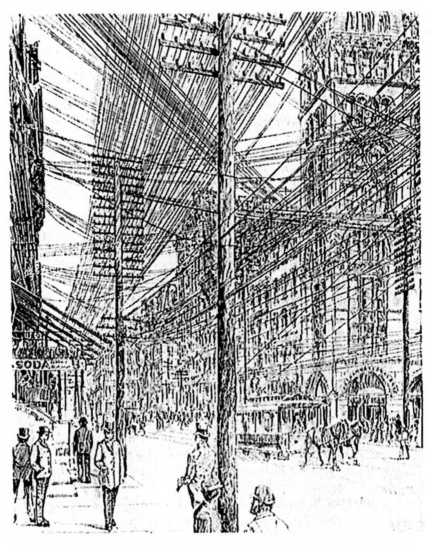

Tall skyscrapers would have been impossible without elevators and telephones. This drawing from Harper's Weekly *shows the corner of Broadway and John Street in 1888, by which time the telephone had clearly become a blight on the cityscape.*

such institutions called for an easy way to get guests and customers transported comfortably to the upper floors in a manner that required no severe human exertion.

But in the 1850s people were more concerned about safety than they were about the source of power. The older kind of freight elevator, in which the cage was counterweighted with a plunger that descended into the ground, was safe enough, but painfully slow. To get rid of the slowness it was necessary to develop a system of pulleys which resulted in constant wear on the ropes holding up the cage. The speed increased, but so did the danger. Elevator riders lived in constant fear that their ride would end with a plummeting cage.

Then a resourceful Yankee tinkerer and inventor, Elisha Graves Otis, figured out a way to prevent an elevator from plummeting to the ground every time the ropes wore out. He placed ratchets along the side of the shaft, and attached teeth to the cage of the elevator. These teeth did not come in contact with the ratchets as long as the rope was in tension, but if the rope was released or broken, the teeth were released and gripped the side of the shaft, keeping the cage at that level. Otis himself demonstrated the effectiveness of this device at the Crystal Palace Exposition in New York in 1854. An open elevator shaft was set up in one of the exposition halls, and Otis put on a demonstration of the "safety elevator." Riding in the cage personally, he would have himself hauled up some 30 feet, at which time he would have an assistant climb up on the apparatus and cut the hoisting rope. Instead of plummeting to the ground, which is what all of the spectators expected, the elevator merely settled an inch or two until the iron teeth, or safety dogs, were forced into the ratchets. Leaning over to the spectators with a deep bow, Otis announced ceremoniously, "All safe, gentlemen, all safe."

In the years that followed the Crystal Palace Exposition in 1854, Otis made many improvements and advancements in elevator technology, and he established a company for their manufacture which is today the world's largest elevator manufacturing firm. Otis had numerous competitors right from the beginning. For example a man named Otis Tufts took out a patent in 1859 for a "vertical screw railway" that eliminated the need for the safety measures of Elisha Otis by supporting the car from underneath with a giant screw. When this thick, heavy screw rotated in the right direction it lifted the elevator to the top of the building. Other competitors introduced similarly curious systems of weights and balances; many of them received patents, but most came to naught.

Elisha Otis and his family got most of the important patents and commissions in the early years. Otis patented a steam-powered elevator in

1861, and by the time the Eiffel Tower was built in 1889 elevators were capable of rather long hauls. An Otis-built elevator in the Eiffel Tower carried visitors to the top in seven minutes. (Actually a series of three elevators was needed for the trip under steam power.)

The matter of safety was solved fairly early in the development of the elevator. Speed was a different matter, and the kind of elevator installed at first in the Eiffel Tower would have been unsatisfactory in the really tall office buildings that were to go up in America after 1900. From the steam-driven elevators Otis (and his competitors) moved to hydraulic lift. The elevator cage moved up and down on top of a long piston inside a cylinder sunk far into the ground. Some hydraulic elevators are still in operation today, most of them mechanically sound. Still, although they were much quicker than steam driven elevators of an earlier generation, they were too slow for tall skyscrapers.

It came to be generally accepted that the only way to serve tall buildings with quickly moving elevators was through electricity, but the technology for this was slow to arrive. Electric motors were available in the 1880s and 1890s, but no way could be found to step up and down the load on the motor for gentle starts and stops. When this problem was solved, the electric elevator won the day over all of its competitors.

In the domain of the electric elevator the Otis Company was again in the forefront in improvements and inventiveness. In 1903 it introduced an extremely effective elevator of the gearless traction variety, powered by a variable-speed electric motor that was located at the top of the elevator shaft. The motor sidestepped the need for unwieldy underground equipment to operate the hydraulic elevators. In 1913 the Otis Company introduced an automatic leveling device that allowed operators to make smooth stops without having to go through the time-consuming nuisance of making intricate and tricky landing maneuvers at each floor. Still later, of course, ways were found to eliminate elevator operators entirely, with automatic leveling and door opening.

It hardly needs to be added that the original Otis safety device was not sufficient for the modern high-speed electric elevator. Over the years numerous advances had to be made in elevator safety. In 1878 Otis' son Charles invented a safety brake of sorts, and refinements on this could be used to stop a quickly moving elevator. After all, no elevator plummeting groundward could be brought to a swift halt by teeth and ratchets without injuring, or at least bumping around, its occupants. The 1878 invention was a flying-ball type of speed governor of the kind used on steam engines, and it would bring a runaway car to a gradual stop.

Elevator improvements came rapidly in the twentieth century.

Almost everyone today has ridden in completely automated elevators, elevators operated by automatic brains or computers that judge the flow of passenger traffic, and other such advanced units. Some have been hauled to the top of skyscrapers in glass elevators positioned on the outside of the building. The present-day elevator rider is treated to sophisticated lighting systems, modern decor, Musak, even perfumed ventilation. Too, when the enormous skyscrapers of the first three decades of the century were built there were ponderous logistical problems to be solved—placement of banks of elevators, distinctions between local and express elevators, synchronization of elevators in rush hours, and so on. Any one of these problems could have taxed the resourcefulness of a field marshal.

But it was not only people that needed to be hauled up hundreds of feet in the modern skyscraper. Human beings aloft were cut off from their usual sources of air, heat and water, and ways had to be found to get these things to them high up in the sky. Again, the technology for most of these things was only in its infancy at the time the first tall buildings began to push skyward in the 1880s.

Water was a good example. Today Americans take running water for granted, but the convenience does not predate the nineteenth century. Indeed, running water was a strictly American invention. When English travelers early in the nineteenth century found running water in American hotels, they thought the whole thing rather amusing, just another American labor-saving device. The United States, after all, was a sparsely populated country by European standards, and menial labor was in short supply. In Europe the rich could afford someone to draw water for them; the poor got their water while drawing water for the rich or they shifted for themselves. In America some easy way had to be found to eliminate the menial labor, so systems of plumbing and running water came into existence.

Tied in with running water were plumbing fixtures. America was the birthplace of the bathtub and the flush toilet, logical extensions of piped water. If an English lord wanted to take a bath he could have his tub placed in any room of the house. But with fixed pipes, "bathrooms" or centralized locations of some sort became imperative. The first U.S. patents for water closets were issued in the 1830s, but it was not until the 1850s that a permanent bath and water closet were installed in the White House.

One of the reasons for the slowness of development in this area was that running water and permanently fixed plumbing appliances required systems of disposal, which presented enormous difficulties. Cities with buildings containing running water would also need municipal systems of sewage disposal. But few municipalities saw any reason for putting money

into this kind of nicety. In 1860, by which time there were 136 city water systems in the United States, there were only 10 municipal sewage disposal systems.

A complete history of plumbing and sanitary facilities in the skyscraper could fill a whole volume, but it was all dependent historically on the very rapid growth of water supply and sanitary systems in the period just before the skyscrapers took their greatest leaps. Large office buildings of the twentieth century are indeed cities in themselves, housing thousands of workers, and the requirements in serving them are staggering. For example, when the Empire State Building was built in 1930-31, the builders called for four six-inch water mains to supply an average of 80,000 cubic feet of water per day. Similarly, the Empire State Building had to accommodate an enormous drainage load; for example, the storm water system alone was designed to remove 15 cubic feet of rainfall per second. The building was provided with ten separate sewers, ranging in size from 6 to 12 inches. These ran into street sewers to carry off sanitary and storm water as well as ejector and air conditioner discharges.

Heating and ventilating systems were also slow in coming. Centralized heating did not arrive until the nineteenth century, and modern ventilating could not have been provided before the invention of electric motors in the late 1880s. Once again, though, the United States was in the forefront and was the site of every important advance in the areas of heating and ventilation.

Obviously, the traditional ways of heating buildings would not work for a skyscraper. Central heating was an absolute must. The nuisance of installing flues or chimneys for each of hundreds (or even thousands) of rooms and hauling up fuel for individual fires would have been prohibitive even had the labor been available. At first central heating was limited to luxurious hotels and other such establishments, but by 1870 it was beginning to appear in schools, offices and factories. Most of the earliest systems were forced hot air, fired by wood or coal.

Then came the radiator, another American technological contribution. The word radiator is used for any fixture through which steam or hot water circulates from a central heating plant to warm a given space. In 1874 one William Baldwin patented a serviceable radiator that consisted of short lengths of one-inch pipe screwed into a cast iron base. A number of radiators of this kind were installed in commercial buildings in the 1880s, although large-scale commercial manufacture of radiators did not begin until the 1890s. In 1895 the American Society of Heating and Ventilating Engineers established an experimental laboratory at the University of Illinois, and out of work there the technology was developed

to make central heating available to ordinary homeowners at reasonable prices.

Again, though, huge buildings, whether vertical or horizontal, required vast heating and ventilating systems of very elaborate design. The Empire State Building contained 7,000 radiators (most of them ingeniously concealed in wall recesses), having a total of 227,000 square feet of heating surface. Obviously, in a building of 86 stories plus a tower of an additional 200 feet, it was not possible to have only one set of risers supplying radiators on all the floors. The pipes required to do this would have been too thick. So the heating system was divided into four separate zones, each heated from different mains. The first five floors were supplied from mains in the sub-basement; the second zone, floors 6–29, was supplied downward from a set of mains in the twenty-ninth floor ceiling; the third zone, floors 30–54, was supplied from mains in the ceiling of the twenty-ninth floor; and the rest of the building, including the tower, was supplied from a set of mains in the ceiling of the fifty-fourth floor.

At the heart of this complicated system there were four turbine-driven vacuum pumps. Because of the limited space available in the basement, the Empire State Building did not have its own boilers, but instead contracted with an outside supplier for steam. The requirements were considerable. To heat the first through the fifth floors alone required a maximum supply of 292,000 cubic feet per minute, with an exhaust of the same amount.

The Empire State Building was built before centralized air conditioning became readily available in commercial buildings (although Willis H. Carrier had invented the air conditioner back in 1906), but even without the presence of this kind of complicated system, ventilating and exhaust systems were of great importance in buildings the size of the Empire State Building. In a mechanical age there are a great many systems that simply can't do without exhaust of some kind, even in a strict "office" setting.

For example, in the Empire State Building there were dining rooms and kitchens on the twenty-first floor. All toilets were interior rooms and required toilet exhausters. There also had to be seven blowers and seven exhausters in various parts of the building for ventilating the elevator machinery rooms. These alone required a total capacity of about 75,000 cubic feet per minute for supply and exhaust.

All of these requirements not only had to be met, but had to be planned for long in advance. The space requirements for ventilating systems alone were considerable, as evidenced by the fact that in the Empire State Building about 400 square feet had to be set aside on the upper floors (the first five floors had much heavier and more complicated requirements) just for

exhaust flues from kitchen, basement and toilet areas. Very little of the equipment to accomplish these chores was available in anything but the most rudimentary form before 1900.

The modern skyscraper, then, is more than an inert structure, a thing without motion. It is a far cry from the pyramids, the Parthenon or the Taj Mahal. Skyscrapers may photograph as static or inert structures standing against the horizon, and they may seem to be nothing more than that on architects' plans, but except in their earliest and most primitive forms, they are organisms, with heart, blood, lungs, and systems of metabolic adjustment. Without these specialized organs, without various forms of energies and their control, the skyscraper would have been a dead and forbidding place, repellant to all human habitation.

Chapter 6

CHICAGO REACHES FOR SPLENDOR: THE GREAT TRIBUNE COMPETITION

The skyscraper was born in Chicago, and in the 1880s and early 1890s the windy city was the national showcase for construction of tall office buildings. Around the turn of the century the spotlight shifted to New York, with impressive height being the order of the day in the erection of the Singer, Metropolitan and finally the Woolworth buildings. Chicago would never really catch up to New York until the 1960s and 1970s, when Chicago at last gave birth to its own latter-day giants.

Still, Chicago did return to erecting tall buildings once height restrictions were eased, and its buildings grew taller right up to the Depression, when conditions brought the building boom to a dramatic end with the 44-story Board of Trade Building, erected in 1929-30. Chicago would build no taller than that for many years, but the city was neither down nor out in the 1920s as a showcase for tall office buildings, and it continued to have influence far out of proportion to the number of buildings constructed.

Chicago also had something that New York lacked: a kind of civic pride, an enduring belief in the distinctiveness of this most American of cities. New Yorkers took their city for granted, the city's financial giants going about their separate businesses, believing that what was good for them was good for New York. Chicagoans wanted to do something to call attention to the prosperous city they had built. This desire was evident as far back as the great Columbian Exposition of 1893, which was a celebration of recovery from the great Chicago Fire of 1871. (The exposition was later excoriated by architectural critics, but nonetheless it gave Chicagoans a vision and sense of impressive public architecture and developed in them a craving for city planning and the effective uses of urban space.) It became still more evident with civic enthusiasm for Daniel H. Burnham's Chicago Plan, adopted by the city in 1910. Burnham, who

had played no small role as a leader in the development in the Chicago school of architecture, and who subsequently went on to become one of the nation's foremost commercial architects, won his most enduring fame as a city planner. His enthusiasm was born of passionate feelings of pride in his own home city and belief in its aesthetic potential.

Burnham and other civic-minded Chicagoans had a number of important concerns in the early years of the twentieth century: the betterment of commercial facilities, the upgrading and simplification of transportation, the provision of recreational settings for ordinary citizens, the planning and construction of impressive groupings of public buildings. One of the most important fruits of the Chicago Plan was the restoration of the city's lakefront which in places had fallen victim to commercialism, often of the shabbiest sort, as waterfronts often do. Quite luckily, a number of prominent Chicago citizens, including catalog magnate A. Montgomery Ward, saw to it that Burnham's ideas prevailed, and eventually eight miles of scruffy and tattered shoreline were replaced by the magnificent Grant Park and, as far south as 67th Street, parks, beaches and recreational areas. The capstone to this whole program of improvement was a conglomeration of cultural buildings along Michigan Avenue and in Grant Park which became surely one of the greatest cultural centers of its kind anywhere in the world, including the Auditorium, built in 1889, the Art Institute (1893), the Public Library (1897), and Orchestra Hall (1904). With further landfill in Grant Park, the Field Museum of Natural History was built in 1919, and the Shedd Aquarium in 1929.

One of the things the Chicago Plan called for was the construction of new boulevards to relieve unspeakable traffic congestion (predating the automobile era) in the downtown area. The area south of Randolph Street was well provided for because the laying out of Grant Park involved the construction of wide and generous thoroughfares. But north of Randolph to the Chicago River was a blighted area reminiscent of the old Chicago, with waterfront dives, dreary warehouses and the like. Above all, Michigan Avenue came to an end, and the old bridges across the river were inadequate and jammed even in off hours. A new bridge for the continuation of Michigan Avenue was needed, and although a bond issue for it was opposed by some citizens who saw this as a mere convenience for "rich automobile owners" and "fancy Dans," the bridge was finally opened in 1920.

The opening up of this new artery, together with a complete rehabilitation of Michigan Avenue north of the river (previously known as Pine Street), resulted in one of Chicago's most glittering jewels, a mile-long boulevard of glamorous shops, hotels and luxury offices that quickly

took on the character of a Chicago Fifth Avenue. In the true spirit of Chicago boosterism, the strip came to be known locally as "the magnificent mile"—not an altogether inappropriate name, since it was magnificent and it was a mile, 14 blocks north from the river to the lake.

The elimination of the old bottleneck bridge at Rush Street, the opening of the Michigan Avenue bridge, and the widening of north Michigan Avenue all gave strong impetus to a new spate of building on a grand scale—a drive for the sublime and the imposing. And it all began right at the bridge, immediately across the river, where a splendid site loomed up, a magnificent showcase for tall buildings that could hardly have gone unnoticed. Grabbing off the choice location was William K. Wrigley, the chewing gum king, who as early as 1918 saw the beautiful advantages of a site just across the river. Not only did he see the aesthetic advantage of the generous foreground provided by the river—assuring that his building would never be obscured—he also saw that the bridge required a jog to the right coming up Michigan Avenue, so that the owner of the prize tract of land on the west side of the street would be able to erect a building that seemed to be right in the middle of the street as one approached it on Michigan Avenue.

Wrigley built himself a very nice skyscraper on that location, a building designed by the local architectural firm of Graham, Anderson and Probst and constructed in 1919–21. Every bit of space in the building not set aside for the Wrigley Company was rented by the time the first office was opened in 1920. The Wrigley Building was a striking edifice that immediately challenged the imaginations of other Chicago entrepreneurs, and doubtless sparked much of the building on Michigan Avenue in the decade of the twenties. The building remains a very appealing office building by any standard. It consisted of a main block of 17 stories, and a slender tower rising above that for another 11 stories. The designing architect was Pierce Anderson, who took as his inspiration the Giralda tower of Seville Cathedral, a work of the Spanish Renaissance that in turn was inspired by vague influences of Moorish minarets. The beautiful vaulted entranceway, the highly ornamental cornice of the main block, and the setbacks at the eighteenth and twentieth stories that give smooth transition to the slender tower resulted in a building of commanding intelligence and beauty that remains one of Chicago's loveliest buildings.

Needless to say, the plot of land directly across the street, east of Michigan Avenue, called for similarly imaginative treatment, and that parcel of land gave rise to one of the most controversial developments in the history of American architecture—for here a few years later rose the

now famous *Chicago Tribune* tower, a building of continuing interest to students of skyscrapers around the world.

The background of the Tribune Building was interesting in itself, and characteristic of commercial and industrial development in the United States in the early part of the twentieth century. The *Chicago Tribune* had erected in 1902 an entirely new building of 18 floors at Madison and

The Tribune (right) and Wrigley buildings stand across the street from one another and serve as the gateway to Chicago's "magnificent mile." (Photo by author.)

Dearborn streets at a cost of $1,800,000, and the building was considered adequate for all of the *Tribune*'s editorial and mechanical needs for many years to come—surely for a half century, the owners believed. This was not to be, however, and within 20 years it was clear to management that the building at Madison and Dearborn was not going to be adequate for a newspaper that was growing by leaps and bounds and a city that was do-ing likewise.

Very wisely, and with Wrigley's venture clearly in mind, the *Tribune* management in 1919 purchased property which, with the Michigan Ave-nue improvements, would number 431 to 439 North Michigan Avenue, directly across from the Wrigley Building. On the easternmost portion of this plot, the *Tribune* immediately built a printing plant for production of its daily editions, but the printing plant was to be a mere beginning. Be-tween the plant and the grand new boulevard was to stand not just any old newspaper building, but the greatest newspaper building of them all, the greatest skyscraper in the world.

A very brazen goal this may seem, but it must be remembered that the *Tribune* was for many years a spunky and aggressive newspaper that styled itself on its masthead—in large boldface type—as "the greatest newspaper in the world." What there was about the *Tribune* that made it the greatest newspaper in the world was a mystery to many, but there were few who would deny that the raucous midwestern giant was unique in its way. And Chicago—the world capital of boosterism—could never get enough of glorifying its major institutions.

The *Tribune* had grown from an infant to a roaring giant in a mere 75 years, and it was as a celebration of its Diamond Jubilee that the paper held a design competition in 1922 for a new building. The paper first ap-peared on June 10, 1847, with 400 copies having been printed that day on a hand press in a single-room plant in a building at Lake and La Salle streets. In 1847 the city of Chicago was nothing but a little boom town in the mud, a place of log cabins and muddy streets. The city had a popula-tion of 16,000, yet two decades earlier it had had but 40 people. Even in 1847 Chicago showed no sign that it would become one of the great cities of the world; after all, the railroad, the institution that would make it so, was still a year off.

The *Tribune* was established as a Whig paper in a town that had already had a weekly Democratic paper for a number of years. It was only a very mild success until it was taken over in 1855 by Joseph Medill, a Canadian by birth, who had already founded several Whig papers in Ohio. Medill became a driving force behind the Republican Party when it was established in the 1850s, and later became a chief supporter of Abraham

Lincoln for the presidency. As such, his Chicago paper became something of a national newspaper during the Civil War. Medill lived on until 1899, and in the years after the great Chicago Fire of 1871 he made the paper into one of America's liveliest daily papers, an institution known for good reporting and strong opinions.

By the time of the *Tribune*'s Golden Jubilee in 1922 the paper had come under the control of two of Medill's grandsons — Robert R. McCormick and Joseph Medill Patterson. These two cousins, both graduates of Yale, and both about the same age, had taken over the *Tribune* empire in 1914, and would rule it together for about another decade. However, in 1919, Patterson had the idea of establishing a tabloid newspaper in New York, *The Daily News*. This paper would in time become the largest selling newspaper in America, and after 1925 Patterson gave up his interest in the *Tribune* and moved to New York. For the next several decades, until his death in the 1950s, the *Tribune* was under the authoritarian rule of Robert R. McCormick, surely one of America's most extravagantly colorful newspapermen.

Col. Robert R. McCormick was born in 1880 and was educated at private schools in England, at Groton (where he was a classmate of Franklin Delano Roosevelt), and at Yale. He earned his military title, of which he was uncommonly proud, during World War I. As publisher of the *Tribune*, McCormick continued and deepened the old Republican traditions of the paper, making it an unabashed and shameless Tory sheet. The Colonel acted the part of a newspaper lord with a flourish, and ran his dominions with all the air and authority of a grand seigneur. Unquestionably the *Tribune* during this period was a one-man fiefdom, and it supported the Colonel's prejudices to the letter. The Colonel was a flag-waving true-blue American in his prejudices, and hated most foreigners and foreign governments. He even hated the British, although curiously he spoke with an outlandish *opera buffa* British accent that some people complained was very hard for American ears to understand.

Under McCormick's rule the *Tribune* was by temperament distinctly conservative Republican, eccentric, distrustful, paranoid, nationalistic, dyspeptic, xenophobic and combative. It was not afraid of a fight, and its editorials were outspoken and immodest. Invariably the paper would run a blood-boiling color cartoon on the first page, and even the regular comics page was not immune from editorializing. For years Col. McCormick saw to it that Harold Gray's *Little Orphan Annie*, with its work-ethic ideology, was prominently placed on the first page of the comic section.

For years *Tribune* editorials were served up with a sauce that could have been concocted by the likes of Westbrook Pegler and H.L. Mencken

in their more undisciplined moods. Shortly after World War II, in an editorial entitled "In Which We Skin a Skunk," the *Tribune* attacked a British war correspondent and radio commentator who had offended the paper, calling him "a deliberate and contemptible liar," a "pipsqueak who persuaded a physic vendor to buy time for him on the National Broadcasting chain." Always suspicious of the rival metropolis of New York, a *Tribune* editorial accused Mayor LaGuardia of that city of using air raid wardens "to push citizens around and to insult and molest women." New York, the paper insisted, "is completely under the tyrant's heel." The *Tribune's* dislike of McCormick's old Groton classmate Franklin Roosevelt was never even mildly disguised, and the paper's writers brought against him all the dirt they could find, however wildly implausible.

As often as not the gullibility of Americans bothered the Colonel as much as the venality of foreigners. Hardly a day went by during the McCormick years when the *Tribune* failed to find something to go into a high dudgeon about on the American shore. One time the Colonel got so incensed over something that had happened in Rhode Island that he ordered Rhode Island's star gouged out of the big front-page American flag. After having been warned by lawyers that this was an illegal mutilation of the flag, the Colonel, probably having cooled off anyway, ordered the star put back.

The *Tribune* had become under McCormick a loud and pugnacious sheet. Chicagoans often hated it, and sometimes even burned it in the streets. Still, in some queer sense they believed in it and were devoted to it as an institution. It was their newspaper as was no other. They bought it and read it unfailingly, and it became America's biggest selling non-tabloid newspaper, a million or more copies rolling off the presses on weekdays for many years. Whether it was the world's greatest newspaper was doubtful, but surely it had the ambition and drive to be so, and in certain peculiar ways it probably was.

The desire of "the world's greatest newspaper" to build the world's greatest office building resulted in plenty of sparks, general confusion and annoyance—and a lot of simple youthful fun. The *Tribune* got itself a worthy monument, a striking building, but one that quite suitably kept architects and critics of architecture in heated disagreement for years.

Strangely enough the great *Tribune* competition was carried out in a more or less conventional manner, and certainly with every sign of professional decorum and propriety. There was a jury of award which, though dominated by *Tribune* bigwigs and presided over by Col. McCormick himself, was chaired by Alfred Granger of the American Institute of Architects. There were also an advisory committee and a paid supervising

architect who drew up the specifications for the contest, and there can be no doubt that the judging was fair, painstaking and meticulous. The judging of the drawings was anonymous.

The contest was announced to the public on the *Tribune's* seventy-fifth anniversary, June 10, 1922. Entries were to be submitted by November 1, though a month's grace was given to entries from distant places. There was to be a first prize of $50,000, a second prize of $20,000 and a third prize of $10,000. A certain amount of money was also set aside for ten architectural firms that were specifically invited to submit drawings. In addition to these awards, of course, the winning architect was to receive the usual architect's fee, commissions and expenses.

The jury did not take very long to sift through the large number of entries and pick for first place the drawings submitted by the New York architectural firm of Howells and Hood. It also tentatively selected for second place the work of the well-known Chicago firm of Holabird and Roche, which had been (as had Howells and Hood) an invited entrant. Just before the expiration of the grace period, however, there arrived from faraway Finland, having been miraculously released from customs in time, one further set of drawings from Eliel Saarinen, the excellence of which immediately impressed the judges. A flurry of last minute deliberations caused the judges to bump Holabird and Roche to third place, and when the final verdict was announced, Saarinen was awarded the $20,000 second prize.

Altogether, by December 1, 1922, 204 designs were received from all points of the compass, including many from abroad. The vast majority were uninspiring and derivative and some were even downright ugly, some no doubt from architects with little or no experience with tall buildings. Some were comical, perhaps mere cartoons or lampoons; there was, for example, a drawing showing nothing but an elongated Doric column, and another showed a giant standing Indian wearing the feathered headdress of a war bonnet. There were a number of obviously good entries that could certainly have done the *Tribune* proud. To this date, however, there is little doubt that the first and second place entries stood head and shoulders above the others. The first prize plans had something else to recommend them: the architects had given very careful thought to the available lot and the problems of local construction.

Still, it was the selection of first place which subsequently gave birth to one of the great controversies of modern architecture, a controversy still alive at this writing. That inimitable genius and strident spokesman for modern architecture, Louis Sullivan, still alive in 1923, began it with an uncontrolled and torrential attack on the design of Howells and Hood,

intimating that it should be consigned forthwith to the dustbin of history, and that the Saarinen design should have been elevated to first place on the basis of its clean modern lines, its unabashed functionalism. The Howells and Hood design, on the other hand, called for what Sullivan thought to be unnecessary Gothic illusions. The main entrance was a phony door to a cathedral; high up the whole thing degenerated into a fraudulent stage set, with flying buttresses and meaningless Gothic tracery, all of which could only be intended to astonish and confound the groundlings.

Or so thought Sullivan. The truth is that Sullivan's judgments could not be entirely relied upon. In spite of his great achievements in architecture, in spite of his way with words—for he was as superlative a literary man and intellectual gadfly as he was an architect—Sullivan was living out his last days in a third-rate South Side hotel, a bitter alcoholic, and his rages and tirades were really far from just. Sullivan rightly saw in the Saarinen building the kind of skyscraper that would dominate the American skyline in the years to come, but he offered slim evidence for his belief that the first place design was mediocre. On aesthetic grounds the first place design was an enduringly pleasing and inspiring structure, and over the years it has proved to be a well thought out building.

The battle royal waged among architectural critics and historians over the years was mostly a tempest in a teapot. Saarinen's building was certainly a distinguished work that foreshadowed things to come, but it really was not especially novel or original, even in 1922. The work of Howells and Hood was probably the deserving winner on technical grounds since the architects had made such a careful study of the site and the uses of the building. In addition to that the building was unquestionably useful. Carl Condit, the celebrated historian of the Chicago school of architecture, has made it clear that Sullivan's wild accusations were more rhetorical than substantial. Sullivan, the great exponent of beauty, failed to see it when it suited his purpose not to, and he malignantly failed to see that the Gothic detail, "the tower, the pierlike bands, and the buttresses are elements in a purely aesthetic program that demanded their presence." What was most important, Condit wrote, was that

> Hood and Howells' final design was based on an exhaustive study of all the formal features that are visible in the tower—the overall silhouette, the proportions of structural, quasi-structural, and external utilitarian elements, the relations of all these elements among themselves, and the strictly ornamental details. Thus the preparation of the working drawings came only after a long evolution of planning that began with siting on the irregularly shaped lot and extended to the coordination of all details large and small. . . .

The Tribune Tower is a distinguished work of American building for technical reasons alone; its intricate structural system was dictated by formal considerations, specifically the numerous deviations in the envelope from the pure prismatic shape, the ring of the pseudobuttresses that constitutes a transitional device between shaft and tower, and the need to brace the whole complex against wind loads. The building as a whole is undoubtedly overbusy, with its historic stones imbedded in the lower part of the masonry sheathing, its niches and screens and hoods, and its symbolic sculpture drawn from classical and medieval sources; yet this rich detail was not only well executed as ornament, it was ingeniously designed to shed water and hence to prevent damage from cracking of the stonework caused by freezing.

Certainly the Tribune Tower, as built in the next year, was a beautiful building. Even if it was, as some alleged, "overbusy," the ornamentation was never so excessive as to do violence to the organic concept. True enough, the building made an unabashed attempt to appeal to a wider public than an avant garde architect of 1922 would have liked, and chief designer Raymond Hood, in his subsequent career as a builder of skyscrapers in New York, would continue to appeal to wider public tastes — as have commercial architects throughout history. It is possible to argue that had the Saarinen building been built in the early twenties instead of Hood's Gothic design, the cause of architecture would have been significantly advanced, but the truth of this assertion is very doubtful, and the great boom in art deco skyscrapers soon to hit New York would probably have progressed much as it did.

The main arguments against the Tribune Tower over the years were waged over issues of intangible philosophical principles. Neither Sullivan nor any of his followers offered solid evidence that the winning entry in the competition was other than an aesthetically pleasing and utilitarian building. It is not, perhaps, one of the very greatest American skyscrapers, and for aesthetic appeal it cannot stand comparison with some of Hood's later efforts, such as the RCA Building in New York, but it is an uncommonly pleasing and distinctive building, and one that seems to fit its rather odd parcel of land almost to perfection. It is a Chicago landmark and likely to remain so.

Nobody can deny that the Tribune Tower has a commanding presence somewhat out of proportion to its modest height. Coming up Michigan Avenue and crossing the river, where there is a bend in the road, one gets a spectacular glance at the Wrigley Building and at the picturesque silhouette of the Tribune Tower, as well as the beginning of the "Magnificent Mile." The view is stunning. The collection of buildings on both sides

of the bridge constitutes one of the most awesome groupings of sky-scrapers anywhere in the world.

The Tribune Building was opened and dedicated in 1925. As one might expect, the brouhaha over the design competition scarcely came to the attention of the general public. Still, the issue became something of a cause célèbre among the critics and philosophers of modern architecture and has continued to fire up people's passions over the decades. On the other hand, a great many later historians of architecture probably made too much out of the issue. The competition was frequently taken to represent some turning point in the history of skyscraper design, which it almost certainly was not.

It is said, for example, that Louis Sullivan's call for a skyscraper aesthetic which scorned a phony, "literary" romanticism pointed the way to the modern style of skyscraper that would come to dominate the American skyline after World War II. Sullivan praised the second-place design of Eliel Saarinen over that of Howells and Hood, and the Saarinen design seemed, at least superficially, to be leading the way toward the clean, stark buildings that were shortly to be on the drawing boards of the Bauhaus School in Germany. To be sure, the European architects who came to hold sway over American architecture a quarter century later endorsed Sullivan's invective about the competition and what they understood of his ideas about form and structure. The truth was, however, they had not read his works on architecture and they apparently did not understand that Sullivan was not recommending some simplified engineering func-tionalism as the goal of architecture. In Sullivan's skyscrapers of the 1890s the imagery was organic, not mechanistic. Sullivan had been seeking to find spiritual and religious functions in architecture, much like those claimed for poetry by Walt Whitman.

The engineering-inspired architects of a later generation did not, for example, realize how important ornament was for Sullivan; they probably did not realize that it was not ornament as such that he objected to in the Tribune Building, but only ornament that was not an organic expression of an artist's talent or of the aims and higher purposes of the building. Too, if they had taken the trouble to read Sullivan's article about the *Tribune* competition they would have noticed that Sullivan made not a single mention of the entry sent in by Walter Gropius, which he most cer-tainly would have seen. They would also have been surprised to learn that at the end of his life the only two architects of the younger generation whose work Sullivan could endorse were Frank Lloyd Wright and Eliel Saarinen. A fuller knowledge of Sullivan's writings, which apparently were not known at the Bauhaus, would have been quite sufficient to make

clear to these newer "functionalists" that Sullivan was not in their camp. That later critics and historians of architecture awkwardly attempted to demonstrate a linear progression between Sullivan's ideas and the later glass box skyscrapers only shows how easy it is to become disoriented in the field of architectural history.

There are, on the other hand, a few more mundane criticisms that might have been made of the winning *Tribune* design, although architectural critics seldom if ever bother with them. It could be argued that the Gothic conceits of the tower were somewhat out of character for this raucous miscreant of American journalism. The design seems out of harmony with a newspaper of swagger and bluster, forever trying to kick Uncle Sam in the seat of the pantaloons. Hood's idea of skyscraper beauty and dignity (as of 1922) may not have harmonized with the brash Gargantua of midwestern journalism, although perhaps it ministered to Col. McCormick's frequent moods of grandiosity. These, after all, were the days when architects gave their clients what they wanted, or what they believed they wanted. Perhaps the Tribune Building design would have been more suitable for a great bank or surety company, or some stodgy financial institution. Still, over the years, generations of pencil-behind-the-ear newspapermen have taken pride in having the Tribune Tower as their office and, for the most part, have expressed fondness for the place.

What the Tribune Tower has done for the *Chicago Tribune* must remain something of a mystery, but it is still an impressive building in a peerless location. It continues to command and adorn the place where it stands. It continues to be a great Chicago landmark. And it is even possible that the building may have worked some charms on its occupants over the years in ways that we know nothing about and that defy explanation. A great many buildings do.

Chapter 7

SKYSCRAPERS IN HIGH STYLE: THE 1920s

The decade of the 1920s was a pivotal one in American history and social life. It was a decade that virtually transformed the face of the nation. Those familiar with the great American cities of the 1990s will likely realize that this was the time when the major cities took the forms they presently have. It was in these years that the majority of the great and sumptuous hotels were built, and that many colleges and universities grew from clusters of one or two simple structures into giant research institutions. So it was, also, with hospitals and department stores, many of which had long histories, but which suddenly took on the outward form of grandeur and dignity. It was the time of the boulevard, of cafe society. Great wealth and prosperity now moved out of the private drawing rooms of the rich into the streets outside. It was a time for outward expressions of things. It was a time, said President Harding, to be "high, wide and handsome."

It was a foregone conclusion that the 1920s would become *the* decade of the skyscraper. The skylines of New York and Chicago had been in the making for several decades, but now, all of a sudden, they burst forth in dramatic splendor, with breathtaking panache. The buildings not only thrust dramatically into the sky, but they did so in splendor and high style. It was not only a matter of an expression of loftiness, which Louis Sullivan believed was the aim or goal of the skyscraper, but also a matter of designing skyscrapers that themselves expressed richness and affluence. The skyscraper now had to be not only a thing of tallness, but a thing of expensive beauty dramatically proclaimed.

Of course the impetus to build more beautiful and grandiose buildings was also a direct result of a general boom in building. It was related to the growth of new business districts, new commercial neighborhoods. In Chicago in the early twenties, for example, the construction of the

Michigan Avenue Bridge and the development of the entire North Michigan Avenue into the so-called "Magnificent Mile" were responsible for the city's first impressive skyscrapers outside the Loop—the Wrigley Building and the Tribune Tower—and subsequently a number of other luxurious tall buildings to the north.

There was a similar spread of the skyscraper in New York. Early in the twentieth century, most of the city's tall buildings were confined to the area of lower Manhattan—the financial district or Park Row. The Metropolitan Life Tower up at 23rd Street was considered far off the beaten path in 1909. Many business and economic experts were certain that office space could not be rented at that location. Not only was the Metropolitan rented immediately, but the building paid for itself within a few years. During the 1920s, especially at the end of the decade, there was a burst of activity up on 42nd Street and along upper Fifth Avenue, with the construction of some of New York's most luxurious skyscrapers and the concomitant development of a whole new business district of high desirability. There continued to be growth and skyscraper development down in the financial district during these years, but suddenly it was possible to have a fashionable high rise address uptown in such buildings as the Chanin and Chrysler buildings, or 500 Fifth Avenue. Between 1925 and 1931, Manhattan office space increased by an unbelievable 92 percent.

The growth of expensive new skyscraper neighborhoods was going on elsewhere around the country as well. In Cleveland the prime business district had been near the intersection of Superior and Ontario streets, at the center of the four-block public square. As the tall buildings started rising in the 1920s the center of activity moved eastward along Euclid Avenue, from the southeast corner of the square. This trend was started by the construction of the gigantic Union Trust Building at Euclid and Ninth streets in 1924. Cleveland's tallest skyscraper, the Terminal Tower, finished in 1929, was also a result of this shift. And south of the Terminal Tower rose some other tall buildings like the Republic and Midland buildings, which gave this neighborhood the distinct feeling of a skyscraper row.

Detroit got its new prestigious address along West Grand Boulevard about two miles from the traditional business district, beginning with the construction of the General Motors Building in 1920 and the Fisher Building in 1928. This trend could be felt in smaller cities all over the

Opposite: *The classic skyline of lower Manhattan, as it looked for many years before the addition of a crowd of boxy towers. The three tallest buildings, from left to right, are the Bank of Manhattan, Farmer's Trust, and Cities Service buildings. (Photo by author.)*

country, and implanted in people's minds the firm (and certainly correct) belief that the decade of the 1920s was a time of unprecedented growth and prosperity.

Most importantly from a later perspective, since nearly all of the skyscrapers of the 1920s still stand and continue to flatter and define the American cityscape, the 1920s was a time for the refinement and perfection of skyscraper style. Except for some critics who are hostile to skyscrapers in general—and probably to capitalism as well—the decade of the twenties was the time of the erection of some of the most beautiful and distinguished American skyscrapers, those of the most enduring popularity. Nearly all of these buildings went up in the four-year period between 1927 and 1931, but this feverish building activity was clearly the result of the great twenties prosperity, even though some of the new office space was only becoming available as the clouds of the Depression closed in.

The skyscraper boom got off to a slow start in the twenties, and at first there was neither the money nor the impetus for ambitious building. Those of a conservative turn of mind believed that the cities had been overbuilt before World War I. Commercial architects, too, were a bit timid about tall buildings; there seemed to be a kind of vacuum in style, especially since Raymond Hood had taken a drumming from many of the aesthetes for his design of the Tribune Tower in Chicago. The skyscraper should not look like a Gothic cathedral with flying buttresses and it was impossible to go on copying the Woolworth Building forever, so which way were the architects to turn? How were they to satisfy clients and their own desire for adventure at the same time?

What appeared on the skylines of America's great cities in the 1920s was not one single style of building, but a tendency toward designing skyscrapers in what many were beginning to call a "modern" style. Truth to tell, recent architectural critics and historians, including architectural critic Ada Louise Huxtable in her excellent study *The Tall Building Artistically Considered,* have made a sharp distinction between modern and modernistic. It is a distinction that would have meant little to the average citizen in the twenties, but it has inspired a great deal of argument among architectural historians in the years since.

Modernism, the more extreme and more seductive of the two trends, resulted in buildings that were radical, austere, abstract, stark, purely utilitarian. Skyscrapers of this kind were already on the drawing boards of the Bauhaus School in Germany, and would later be associated with architects such as Mies van der Rohe, Walter Gropius and Le Corbusier. Such buildings aspired to appeal to intellectuals, to sophisticated minds, and perhaps there was a hint that they would shatter the sensibilities of the

low-minded bourgeois. The modernists wanted to annihilate the idea that the skyscraper could be enjoyed as some afflatus of a materialistic or hedonistic society.

"Modernistic" came to mean something related but different. The American architects who designed most of the important skyscrapers in the 1920s had indeed been strongly influenced by the Saarinen entry in the *Tribune* competition, and they wanted to go down a similar road themselves. At the same time, they rejected the starkness and abstractness of the extreme moderns. They were interested in decoration, ornament, perhaps, too, in hedonistic values; they certainly wanted to offer buildings that would appeal to the giants of commerce and industry who were paying the bill and who wanted buildings that were in some sense glamorous. So they developed a competing style that they called modernistic—a term that became something of a pejorative among the European moderns, who believed that the modernistic style involved fakery and pandering to popular tastes. After World War II the European moderns won out, at least for a time, and many buildings in that style, some of which possessed real beauty, were built in New York, Chicago, and other American cities. In the 1920s, however, a different mood won the day. These buildings, too, were modern, but this was an expansive and ebullient time in which cities wanted to inject themselves with massive doses of glamor and hubris. Accordingly, few builders or corporate moguls would have been pleased by utilitarian boxes, so a more decorative skyscraper design became the order of the day.

Around the mid-twenties, with a building boom under way, a mood of supreme self-confidence spread throughout the land as American architects began to indulge their clients in a kind of modernism derived not so much from the machine-culture Bauhaus as from a more playful and uninhibited trend in the arts. This was an "internationalism" which took its impetus largely from the Exposition Internationale des Arts Décoratifs and Industriels Modernes which was held in Paris in 1925. This style, at the time and also occasionally thereafter, was referred to as "International Style" or more commonly as art deco, although other words were occasionally heard as well: 1925 style, Jazz Modern, Zigzag Modern, Twenties Style, and a few others.

The term art deco probably refers to this newly emerging style as descriptively as any other. But what is art deco in the skyscraper? In very loose and general terms it refers to the use of sumptuous ornament, rich textures, a novel and imaginative use of colors, a lush mixture of materials (stone, brick, terra cotta, metal)—anything in fact that would evade the stark simplicity and austere style associated with Gropius and Mies. Art

deco lavished special attention on details of all sorts: dramatic entrances and lobbies, elaborate and posh public spaces, richly ornamented elevator doors and chandeliers, spiral staircases of marble and nickel, modernistic sculpture and bas-relief, and many other such touches. To be sure, efforts had been made to provide dramatic and opulent effects in earlier skyscrapers such as the Singer and Woolworth buildings, but somehow, except for a few startling effects here and there, office buildings were still just office buildings. But now architects tried to outdo themselves in building skyscrapers with a theatrical and festive quality while remaining in a modernistic vein. The office building was not merely to suggest the presence of thousands of accountants or office drones scribbling away in a marble dungeon; it was to become a place where one might bring a stylish lady for lunch, a place that was in harmony with the fancy modern shops, restaurants and department stores which were going up everywhere at the time.

Probably the most representative architect of the skyscraper in the 1920s was none other than Raymond M. Hood, the oft-castigated villain of the *Chicago Tribune* competition. In spite of Louis Sullivan's belief that the Tribune Tower with its flying buttresses did not represent American architecture for Americans, Hood proved that he was ready to move in any direction and build buildings that the great American capitalists would see as suitable for the affluent years of the 1920s. And time showed that Hood had in him even better stuff than the Tribune Building. He put Gothic and classical styles behind him and went modern. In doing so he became the Cecil B. DeMille of the skyscraper and built some of the finest American skyscrapers — the McGraw-Hill Building, the Daily News Building, and finally the RCA Building in the Rockefeller Center complex — before his premature death in 1934.

Hood was surely a representative American man if ever there was one. If not cast strictly in the Horatio Alger mold of rags to riches, he was living evidence of the old adage that a rolling stone gathers no moss, and probably of some other adages as well. Hood was born in Pawtucket, Rhode Island, in 1881, the son of a prosperous box manufacturer. He was a young man who never needed to hustle, but who decided early in life that he could make all his own goals and obstacles. He attended Brown University, then the MIT School of Architecture. Later he set himself up in architectural practice in Boston, but like Louis Sullivan he decided that he really ought to get the high-quality treatment of École des Beaux-Arts in Paris. Like Sullivan, too, he found little inspiration there, and amused himself instead with making a Grand Tour of Europe, a leisurely jaunt that in those days could be afforded by the sons of the rich.

When Hood took his diploma from the École des Beaux-Arts in 1911, his final project gave evidence that he was already thinking about skyscrapers. It was a rather fanciful tower proposed for the city hall of his own hometown of Pawtucket, a tower that almost certainly would not have won any prizes. But it was the work of a budding professional from whom much could be expected.

Clearly Hood was a dynamo, although like a lot of dynamos, he did not generate much power until he really got humming. He opened a professional office in New York in a brownstone at 7 W. 42nd Street. He wanted to paper his walls in gold, but he lacked the money to get the whole job done. Few clients appeared, and he comforted himself with the most modest commissions. His big chance came in 1922 when he met and became friends with John Mead Howells, one of the invited architects in the Tribune competition. Howells, who was too busy to enter, offered Hood a chance to enter for him. The Hood design won and the rest is history. Louis Sullivan and others were lying in wait with their calumny, their denunciations of surrender to bourgeois tastes, but Hood's reputation was secure. He had in fact designed a striking building for Chicago's magnificent mile.

The attacks on the Tribune Building design hardly caught Hood off balance. He was and remained a harp for whatever winds were blowing, and he was willing and eager to design whatever kinds of buildings were in demand. He had his own ideas, and he injected those wherever he could, but he was more than glad to assimilate whatever architectural ideas were popular or likely to become so. He was willing to learn by Saarinen's second place *Tribune* design, and he was anxious to learn what he could from the modern European architects. He read Le Corbusier's first book, *Towards a New Architecture.*

The beginning of Hood's eclecticism, and a good example of early art deco architecture, was his American Radiator Building at 40 West 40th Street in New York, designed in 1923. In this building Hood was obviously attempting a cross between his own Tribune Tower style and the cleaner, more modern look of Saarinen's second place entry. But the building was beautiful for some new reasons, mainly its use of color. In 1926, a noted architectural historian observed that the American Radiator Building was "the most daring experiment in color in modern buildings yet made in America." The building was of black brick, with a top of gold terra cotta which, when illuminated at night, gave a very impressive glowing appearance. Hood also used the New York setback requirement to good effect, with gold cubistic masses prefiguring the kinds of art deco ornamentation soon to become popular.

Hood was sometimes viewed as a derivative architect who merely hauled out the clichés of bygone centuries for modern consumption, but this idea can surely be dispelled by a skyscraper masterpiece of great individuality — the McGraw-Hill Building at 330 West 42nd Street, which went up a few years later during the great building boom of the late twenties. McGraw-Hill, the prosperous publishing conglomerate, decided to build a startling new building far over on the west end of 42nd Street — away from the upscale neighborhoods — partially in the expectation that this part of town, always rather seedy and unattractive, would catch on and join the building boom. As things turned out, the neighborhood never did improve very much and few other large office buildings were constructed there. In fact, 42nd Street west of Times Square became even more seedy after World War II, finally becoming a haven for porno book stores, cheap john shops, winos, deviates and loafers of every description. In 1973 McGraw-Hill got out of the neighborhood and moved to a very sterile looking modern skyscraper at 1221 Sixth Avenue. That the West 42nd Street neighborhood never prospered had only one real visual advantage, namely that it allowed the great idiosyncratic wonder of the McGraw-Hill Building to keep its lonely eminence on the west side of town.

The McGraw-Hill Building (later the Group Health Insurance Building), remains one of New York's most remarkable skyscrapers. Called the "green skyscraper" by many New Yorkers and visitors, the building is remarkable for a number of features besides the novel bright bluish-green terra-cotta sheathing. Hood was responding not only to the New York set-back requirement, he was quite clearly inspired by it, and the unique shape of the building gave it the feel of a gigantic jukebox (Vincent Scully called the style "proto jukebox modern"). There was a large number of decidedly art deco touches: in the detailing of the entrance and lobby, in the metallic bands of green, silver and gold that encircled the ground floor and then continued in the lobby, and in the very forceful horizontal stripes of the windows. If the McGraw-Hill Building never succeeded in raising the land values of the west side of midtown Manhattan, it remains an appealing and uplifting vision in an otherwise drab environment and one of New York's most charming skyscrapers.

The east side of 42nd Street was an altogether different story, for in the 1920s a long row of inspiring skyscrapers rose into the sky, some of them perfect examples of the art deco style. Hood had his hand in the action here, as could be expected, with his Daily News Building, the furthest east of the lot in those days. But strolling down 42nd Street from Fifth to Third avenues, one could encounter some of the finest examples of commercial architecture in the United States.

Undoubtedly it was the presence of the elegant Grand Central Station (as well as the nearness to that major railroad terminal) that gave an impetus to a number of lofty and luxurious office buildings in the late twenties. As one moved eastward from Fifth Avenue there was the stylish 699-foot building at 500 Fifth Avenue designed by Shreve, Lamb and Harmon, later the architects of the Empire State Building. There was next the Lincoln Building of 53 stories—hardly art deco style, but at 60 East 42nd Street always a desirable address. Then was the Chanin Building, designed by Sloan and Robertson to house the offices of (among others) the great Chanin real estate empire. Here, to be sure, was a genuine art deco masterpiece, especially obvious in the lobby with its bronze convector grills, its waves on the floors, its jeweled clocks and its low-relief mailboxes and elevator doors. There was an elaborate auditorium on one of the upper floors that disappeared early to make room for more commercial space, and there was once a very nice observation platform which provided good views of the nearby skyscrapers.

The Chanin Building was thoroughly modern in design, distinguished for the cleanness of its lines. It provides a stinging reminder to the builders of the box type skyscrapers built since World War II that it is possible for a skyscraper to be clean, thoroughly modern, but elegant at the same time. This was the twenties style at its best, and the architects and builders were proud of the international quality of the materials used—American steel, Belgian marble, English hardwood, South American golden ebony, and tiger wood from British Guiana. To the Lexington Avenue pedestrian, the most memorable characteristic of the building was the base of terra cotta ornament in floral patterns. But for all the ornament and international flavor, Sloan and Robertson adhered strictly to Louis Sullivan's dictum that a skyscraper should look lofty, should dramatize its tallness. Like the Empire State Building a few years later, the feel of the Chanin is one of thrust, of eruptive power. An interesting and imaginative tower with mock muted buttresses was kept illuminated in the early days by floodlights of 30,000 candlepower. Quite sadly the Chanin Building, which should have had a setting all its own, was shortly overshadowed by the Chrysler Building across the street.

Before the Chrysler Building was erected diagonally opposite the Chanin Building, another jewel arose at the 42nd Street latitude in the form of Raymond Hood's Daily News Building. Construction on this building began in 1929, the year that the Chanin Building was opened. It was located on the south side of 42nd Street, between Lexington and Third avenues. At the time of its construction it must have seemed to many that Hood had at last taken the plunge into some starkly modern

style, for the building at first glance has the appearance of so many of the slabs that went up in Manhattan after World War II. But there are slabs and then there are slabs, and Hood's Daily News Building shows that with a little imagination it is possible to make a slab into a thing of beauty.

Midtown Manhattan was a veritable museum of skyscrapers in the 1920s. Looking along 42nd Street in 1930 are, from left to right, The Lincoln Building, 295 Madison Avenue, the Chrysler Building, the Chanin Building, the Daily News Building. (H.M. Douglas photo, from author's collection.)

The choice of Hood as architect of the Daily News Building could not have been entirely fortuitous since the *Daily News* was the child of Joseph Medill Patterson, cousin of Col. Robert R. McCormick of the *Chicago Tribune*. Patterson had himself been on the board of judges for the *Tribune* competition. The *News* was founded in 1919 as the first of New York's tabloid papers. It was an almost immediate success and soon became the nation's circulation leader, a distinction that it maintained for many years. Already by 1925 its circulation was pressing a million copies daily, all built on snappy style, sex-and-crime sensationalism, contests, coupons and vivid photo journalism. By 1929 it had no difficulty at all funding a new $10 million home. The thought was that Hood could come up with something smashing for New York just as he had done earlier for Chicago. And he did.

The News Building involved more than a skyscraper, for the modern newspaper also has to have a gigantic printing plant adjacent to the editorial offices. What was purchased was an L-shaped plot, with the printing plant taking up almost the whole of the dowdy 41st Street side of the lot. The office building on 42nd Street was to pay for this very large-scale project, the *Daily News* itself only occupying a small part of the office space in the skyscraper.

The design of the building was quite ingenious. There were setbacks, but they were well disguised, so that from certain angles the building looked like a smooth, solid surface. Louis Sullivan could not have complained that the ornament of this one failed to give an impression of height, for the white brick verticals accomplished this purpose dramatically. Closer up one notices red and black brick spandrels that have the effect of counteracting the tendency toward verticality — altogether a most resourceful design.

Of course as a successful commercial architect and skyscraper impresario, Hood had his detractors in 1930 just as he did eight years earlier in Chicago. Some of his fellow architects were not chiding him because he was putting all of his buildings in stripes. One of Hood's contemporaries had a field day in an architectural journal:

> Stripes is Mr. Hood's middle name. He can't get away from them. He did the Beaux Arts Apartments, two blocks away from the News Building, in horizontal stripes. He is doing the McGraw-Hill Publishing Company's building, at the west end of 42nd Street, also in horizontal stripes.
>
> But he got the idea of building the News Building from seeing a pair of red and white striped B.V.D.'s in a haberdasher's shop on Third Avenue. They appealed to his taste. Peculiar? Yes, but that's Raymond M. Hood. He will probably stripe his buildings up or down, or sideways, for the rest

of his life, or until styles change; but what would he do if he had two on the same block? He'd quit, that's all, unless he could stripe them on the 45 degree line, or do a Scotch plaid, or do a polka dot!

The Daily News Building remains one of the finest tall buildings in New York, and it is only a pity that more of its kind could not appear before financial catastrophe put an end to the building boom.

Visitors to the Daily News Building have always been struck by the lobby, one of the most splendid art deco exercises ever constructed. Patterson gave Hood $150,000 to spend here, with the very intelligent idea that it would be better to put all the efforts into a beautiful lobby and neglect the ground floor exterior, only a few steps away from the tracks of the lumbering old Third Avenue elevated railway. Hood took on this chore with gusto and had the Rand McNally Company build him the world's largest illuminated globe. This became the center of an elaborate scientific and educational exhibit which included clocks showing times around the world and various meteorological instruments. These exhibits blended quite nicely with the art deco philosophy, and turned out to point the way toward Hood's final great project uptown—the RCA Building.

But 42nd Street's most fantastic art deco creation of the late 1920s was not Hood's. In the Chrysler Building, at the corner of Lexington Avenue and 42nd Street, the whole art deco movement rose to a crescendo and went out in a blaze of glory.

The Chrysler Building is the skyscraper of skyscrapers. It is perhaps the sort of building one might dream in a primitive dream—the sort of skyscraper a child might draw on paper if asked to draw a skyscraper. Its silvery tower points to the very heavens; its silhouette kindles the imagination of those who believe there is some life and glory in urban existence. It was, of course, commissioned as such, and was dreamed of by its owner as yet another of those great monuments to American industry and achievement—another dream of personal aggrandizement in the manner of F. W. Woolworth. Like the Woolworth Building, the Chrysler Building was a monument to its company's founder, the rags-to-riches automobile magnate Walter P. Chrysler.

Chrysler was a shooting star on the business horizon in the 1920s, so it was altogether appropriate that this building, with a spire jutting so forcefully into the sky, should celebrate a career's meteoric rise. Walter Chrysler was a boy from Kansas who seemingly appeared from nowhere in the twenties as a force in the automobile industry, long after the great corporations of the industry had been mobilized and institutionalized. Chrysler got his start as a lowly machinist's apprentice, and worked his

way up in the General Motors organization, becoming vice president of operations in 1919 at the age of 44. The following year he undertook the reorganization of the Willys Overland and Maxwell corporations, but the first car with the Chrysler name did not appear until 1924. The phenomenal Chrysler boom came after that.

What gave the Chrysler Corporation its great boost, however, was its hotshot competition to the ailing Model T Ford—the Plymouth. With Henry Ford's stubborn refusal in the mid-twenties to make any changes to the Model T (the Model A did not appear until 1928), there was a gaping hole in the automobile market ready and eager to accept a new "everyman's" car. And with that car the third of the big three automobile manufacturers was launched. By the end of the Coolidge prosperity, Walter Chrysler was one of the richest men in America, and quite ready to take possession of his dream office in the sky.

Like Woolworth, Chrysler wanted to build the tallest building in the world. He did so, although the record was to slip away from him after only a year when the Empire State Building was built. By the late twenties the challenge of overtopping the Woolworth Building became something of a fetish, and there was a certain intrigue in the vigorous competition. There were a number of tall buildings going up in lower Manhattan in the late twenties, but all of the builders and architects were keeping information about them close to their vests. William Van Alen, the architect of the Chrysler Building, had to do some quick finagling to get the better of his former partner H. Craig Severance, who with Yasuo Matsui, had designed a building downtown that would come to be known as 40 Wall Tower.

Van Alen was quite well aware that Severance had designs on the record, so he pretended to top off the Chrysler Building at 925 feet. The 40 Wall Tower, under construction at that same time, added another two feet so as to make it the tallest building in the world. Van Alen was ready for them, however, and had been ready all along. Inside his building he had secretly assembled a stainless steel spire which merely had to be raised through the dome and bolted into place to give the Chrysler Building a total height of 1,046 feet—making it the world's tallest, and the first building in the world to rise above 1,000 feet. In a way Severance had the last laugh, though, for the Empire State Building snatched the prize away in less than nine months.

The Chrysler Building remains one of the most appealing and awe-inspiring of skyscrapers. It has few equals anywhere in the world. And for those who have praised the art deco style, here perhaps was the skyscraper par excellence, the one above all others. It is rich, lavish and sumptuous, without being gaudy.

Words alone are not sufficient to describe the Chrysler Building. The chore is best left to the artist or photographer. The tower rises in impressive, unbroken vertical lines from a four-story portico on Lexington Avenue (which is the main entrance, the address being 405 Lexington Avenue) to a great semicircular dormer head 69 stories above street level. The dome grows smoothly out of the tower and beautifully repeats the semicircles of the dormer heads which are elongated so that they grow more slender with each repetition until they reach the base of a tall needle-like finial of polished nickel chrome steel. This continues to the ultimate height of 1,046 feet. So much wasted space, some may say, in these upper floors, and how unnecessary this elaborate spire, but from the decorative point of view how wonderful. The tower is a shining shimmering thing, like the work of some silversmith. The spire's appearance changes at different times of day, but can melt quite perfectly into the sky as part of a scheme of soft gray tones.

The Chrysler Building features quite exceptional exterior ornament, being one of the first buildings to use exposed metal as an essential part of the design. These features are especially evident at the various setbacks, where they are integrated quite smoothly. At the second setback there are large nickel-chrome steel ornaments formed of sheet metal, but with additional reinforcement inside; they are urn-like, but of modernistic design. At the fourth setback (at the thirty-first floor) there is a large and elaborate ornament of nickel-chrome steel in the form of a winged helmet of Mercury—the design of the Chrysler radiator cap at the time the building went up. In the sixtieth and sixty-first stories the tower takes the form of a Maltese cross, and this brings about the transition from the square shaft of the tower to the finial. Here there are eight large gargoyles of nickel-chrome steel in the form of eagles' heads.

As with most of the sumptuous skyscrapers of this era—like the Chanin and Empire State buildings—no expense was spared to make the entrances lavish and inviting. Approaching the Chrysler Building along Lexington Avenue, one saw a four-story entrance of black Shastone granite, enlivened by the gleam of polished nickel-chrome of the steel window frames and store fronts. For many years there was a Chrysler automobile showroom on the first floor of the building. There was an interesting triangular design pattern in a Siena travertine floor, spreading out to the elevator lobbies. There was a foyer faced with Rouge Flammé marble— rich red, marked with tones of buff. The entire ceiling was covered by a mural painted by Edward Trumbull in rich warm colors.

All of the public spaces were lavishly and painstakingly appointed. There were eight banks of elevators, but no two elevator cabs in any

bank were alike in design or color. They were all treated to beautiful inlays of wood, and the elevator cabs themselves had individual designs to avoid monotony and standardization. No expense was spared to make the Chrysler Building look and feel magnificent and expensive. The building featured subdued indirect lighting in the lobbies, aluminum window sills, and marble stairwells with railings of polished nickel-chrome steel. Even the sidewalk was drawn into the design, being laid in bands of gray and sparkling black that formed paths for pedestrian traffic.

In the early days the Chrysler Building had an observation gallery on the seventy-first floor. Here, in high-ceilinged rooms, visitors looked out of triangular windows that were part of the tower design. On display in the gallery, encased in glass, was Walter P. Chrysler's box of workman's tools with which he started his career as a mechanic. (It was as important to memorialize Chrysler's tools as it was for F.W. Woolworth to enshrine for all time the nickels and dimes that stood at the base of the Woolworth empire.) Alas, this observation gallery has not survived and now houses electronic equipment. The upper floors also contained the fabulous "Cloud Club" which occupied several floors, and the offices of Mr. Chrysler himself.

Walter Chrysler died in 1940, and the Chrysler Corporation has long since given up its hold on the Chrysler Building. The building is somewhat the worse for wear, and some of its erstwhile owners have not done much for either tenants or the building. Perhaps such elegance as that expressed in the Chrysler Building will never be seen again in America.

If one walks north and west from the Chrysler Building, one can take a tour of what was once the most fabulous part of commercial New York. Park Avenue north of Grand Central, although it has been obscured by some overly large and tasteless skyscrapers of the postwar years, retained an atmosphere of skyscraper grandeur that cannot be recalled to the more austere decades of the twentieth century.

Park Avenue in a sense became what North Michigan Avenue was to Chicago. It was a street recalled from oblivion to luxury and grandeur. Originally Park Avenue was a blighted neighborhood, a shoddy entrance to the old Grand Central Station, whose steam trains needed an open-air entrance to the 42nd Street Station. But when the new Grand Central Station was opened in 1912—and a magnificent and lordly station it was as designed by Warren and Wetmore—the tracks were laid underground for electric traction, providing the opportunity for a magnificent mile north of the station. Two buildings expressed the spirit of the old Park Avenue to perfection—the New York Central Building, just north of the station itself, and the Waldorf-Astoria Hotel at Park Avenue and 49th Street—

both pure delights of art deco skyscraper design. The New York Central Building (later the Helmsley Building) at the foot of the "new" Park Avenue (actually vehicular traffic threaded around the building, but the building clearly stood astride the avenue and punctuated it), with its elaborate pyramidal roof and cupola, expressed the meaning and essence of Park Avenue to perfection.

So, too, did the Waldorf-Astoria Hotel, which moved from 36th Street to make room for the Empire State Building. Here was hotel elegance to defy all hotel elegance. While many of the building's interiors have been updated and redesigned and in the process have lost some of their art deco smartness and frivolity, the twin-towered building continues to provide a reminder of the kind of opulence that once New York had in profusion.

The beauty and dignity of Park Avenue has been destroyed in the past several decades by the construction of such buildings as the Pan Am Building, which stands like some oafish giant threatening the whole of the avenue and totally obscuring the New York Central Building (the New York Central of course sold its air rights for this project which developers thanklessly used to obscure the railroad's own office masterpiece). Then, in succession, there were other out-of-scale projects, such as the Union Carbide Building and 245 Park Avenue, many of which contributed to the overshadowing and obliteration of the once elegant neighborhood.

The great building boom of the late twenties in New York has other representatives nearby, of course. Not far away are the General Electric Building, the Fuller Building, and a number of luxury midtown hotels and high-rise apartments that were built in these years. And this was also a time of continued development downtown in the Wall Street district as well. For the very compactness of the region gave rise to a need for skyscraper development — and, as things turned out, some of the city's tallest structures. There was big money downtown in those days, too, and the bankers and financiers were not opposed to spending it. Their tastes mostly ran to buildings of refined but sometimes playful dignity.

The movement to the art deco style began early downtown in fact, probably with the New York Telephone Building on West Street in 1926. This building, known in the 1990s as the Barclay-Vesey Building, is now totally obscured by the mammoth World Trade Towers, but its beautiful design and its elaborate lobby make it one of the lasting masterpieces of art deco architecture. And there are others. One must also look at One Wall Street (Irving Trust), designed by Voorhees, Gmelin and Walker in 1932, looming up above Trinity Church at the head of Wall Street. The banking interiors here are in the inspired art deco manner, and one can

only wish that something of the same spirit might be spread to bankers everywhere. The marvel is that such construction could have been undertaken at the very darkest period of the Depression.

Two other buildings in the financial district have the free-wheeling and dashing spirit of the twenties — the 40 Wall Tower already mentioned, and 70 Pine Street, constructed in 1932. The 71-story 40 Wall Tower is still the fifth tallest building in the city. It is not particularly ambitious in terms of decorative design, except for the elaborate lantern-topped tower. No. 70 Pine Street was built for the Cities Service Corporation, but that organization eventually abandoned crowded lower Manhattan for the wilds of Oklahoma. The building has an elaborate crown that somebody has aptly described as Jazz Gothic, but the lobby, with company logo and limestone models of the tower itself, is a cheerful and whimsical reminder of an age of prosperity that could take itself seriously but with a whimsical sense of humor at the same time.

The opulent skyscraper made its appearance across the land in the late twenties and early thirties — one may think of the Russ Building in San Francisco, the Union Trust Building in Detroit, the Bell Telephone and the Dallas Power and Light buildings in Dallas — but the Depression brought the style, and building construction generally, to a screeching halt. There were a few exceptions, of course, such as the large Radio City complex in New York, which, with Rockefeller money behind it, continued to add new structures throughout the thirties. But when building picked up after World War II, skyscraper design would move in other less playful directions.

Besides New York, Chicago is the finest showcase for the deluxe skyscraper of the twenties, although Chicago continued to be hobbled by restrictive height limitations. But the city that gave birth to the skyscraper was not lacking in architectural talent, and the trend that was so well represented in New York by Raymond Hood was equalled in every way by the firm of Holabird and Root, the successor to the great and durable firm of Holabird and Roche, which had been involved in skyscraper building from the start. William Holabird had died in 1923, and Martin Roche in 1927. In 1928 John A. Holabird and John Wellborn Root, Jr. established a firm that would be immediately successful and win commissions for some of Chicago's most celebrated buildings including the Board of Trade, Daily News, Palmolive, and 333 North Michigan buildings, all of which were erected, like the deluxe skyscrapers of New York, within a period of four or five years.

The demand for luxurious commercial buildings in Chicago grew quite naturally out of the development of North Michigan Avenue and

from the impetus provided by those two masterpieces at the base of the Magnificent Mile, the Wrigley and *Chicago Tribune* buildings. Holabird and Root became immediately active in this area, and designed some buildings that were every bit as handsome as those going up in New York, if not as tall. Just across the bridge from the Wrigley and *Tribune* buildings, Holabird and Root did a building known only by its address, 333 North Michigan Avenue. The building seems to have taken its inspiration from Saarinen's second place entry in the *Tribune* contest (it was only fitting, perhaps, that such an attempt should be made in Chicago), although it is less austere and more decorative in the art deco vogue. The building has long, narrow, slablike walls rising to 24 stories, but there is a 35-story tower at the northern end, which makes the building look imposing as one comes down Michigan Avenue and crosses the bridge over the Chicago River. The building is clad in limestone; there is a decorative base of four floors that are treated to polished marble, and above that, surrounding the windows of the fifth floor, ornamental scenes depict episodes from early Chicago history, though unfortunately they are not often noticed by passersby. In a nice art deco touch, vertical bands of windows accentuate three sides of the northern tower.

A little farther south is the Carbide and Carbon Building (originally the Union Carbide Building). Here one can see some unusual use of polychromatic effects that were coming into fashion in New York. The base of the building was sheathed in black polished granite with an entrance trimmed in black marble and bronze. The tower itself was of green terra cotta (now mostly obscured, alas, by decades of grime), and there is a pinnacle trimmed in gold leaf, very reminiscent of New York pinnacles of the period. The design was the work of the Burnham Brothers, and the building was constructed in 1928-29.

As one proceeds north on Michigan Avenue, there is much to see in this neighborhood of posh shops, hotels and restaurants. Especially notable is the Palmolive Building (later the Playboy Building), which was long a landmark as the "northernmost" of the Chicago skyscrapers. It retains the distinction today, although it has been completely overshadowed by its neighbors, especially the John Hancock Building. The Palmolive Building was well-known to an earlier generation of Chicagoans because of its 2 million candlepower airplane beacon, originally named for Charles A. Lindbergh and said to be the most powerful in the world. The building is 468 feet (37 stories), and for many years it stood alone in its neighborhood, totally dominating the north end of Michigan Avenue.

The Palmolive Building was one of the great triumphs of Holabird and Root, and the building was always commercially successful: it was

nearly 90 percent rented when it opened in the dark Depression year of 1933, and it has continued to be in great demand since. Two famous men's magazines had their editorial offices in the building—*Esquire* in the 1930s and 1940s, *Playboy* in the 1960s and 1970s. *Playboy* managed to get its name affixed to the building for a time, although it occupied only a small fraction of the space. When *Playboy*'s empire shrank it moved out, and the building became simply 919 North Michigan Avenue—still a fashionable address.

Besides being popular, though, the building remains a beautifully designed skyscraper, even though it has been dwarfed by others and the beacon no longer lights up the north side of town. There are symmetrical setbacks which create a handsome pattern of receding masses, and the feeling of verticality is emphasized by vertical bands of windows set in recessed channels. The building was always especially striking at night, with floodlights placed at the setback levels playing up along the limestone walls and darkened recesses.

The interior design of the public spaces also captured the trend of the day toward an ornate modernism: marble floors and dadoes, etched glass lighting fixtures, Circassian walnut paneling, elegant metal trim on elevator doors, and so on. Much of this effect was of course lost in a later commercial environment.

During the late 1920s the Loop was not neglected in Chicago, although some of the buildings were of a more strictly commercial and utilitarian design. The most famous of the tall buildings to go up in this period was, of course, the Chicago Board of Trade. The Board of Trade building became the Empire State Building of Chicago, for it was the tallest building in the city until the skyscraper renaissance of the 1950s. In paintings, postcards, and mementoes it became the symbol of Chicago, much as the Eiffel Tower was the symbol of Paris. Nothing over-topped it before World War II, and it enjoyed an especially dramatic position at the foot of La Salle Street.

It was doubtless suitable that the Board of Trade should occupy this preeminent spot, as it was clearly one of the city's central institutions since the grain trade became a major source of the city's wealth shortly after 1848. At first the Board of Trade occupied a long, narrow, dingy room on the second floor of a building on South Water Street, not very far from the great grain elevators of the day. As the city filled in and the grain elevators were placed at more distant remove, the Board of Trade built substantial buildings for the convenience of city traders and financiers. One of these structures was destroyed in the Great Fire, but was almost immediately replaced with yet another and more substantial

structure. In 1885 the Board of Trade acquired a plot of land on La Salle Street, and built there a building that was to function until the 1920s, when a new and glorious skyscraper was planned.

The Board of Trade Building was designed to serve several different sorts of functions, of which perhaps the most important were those associated with the trading function itself. Appropriately, the base of the building provides an area for the enormous six-story trading room. In the tower of the building are offices not only for the Board of Trade but for traders, brokers and dealers of all sorts, as well as other tenants.

The building addresses these purposes admirably. There is a wider nine-story base containing the trading floors which is expressed on the outside with a façade containing tall windows above the third story, all being surmounted by an elegant clock. The main tower rises to a height of 605 feet (44 floors), and the pyramidal roof is topped by a 32-foot aluminum statue of Ceres, the Roman goddess of grain. On the main tower itself, two projections on the north face rise thirteen stories above the base, and this has the effect of creating a deep setback. A vertical effect is reinforced by tall continuous piers—a composition that is both stately and dignified, but hardly stuffy or foreboding.

Most of those who step inside the Board of Trade Building are interested in visiting the trading floors, although a nice observation platform was provided in the days when the building was the city's tallest. The trading rooms are not quite as gigantic as they once were, since there was a horizontal division made in 1975 to provide space for the Chicago Board Options Exchange, but the wild and frantic trading remains the most colorful feature of the building to the tourist. The lobby is worth noticing for the late twenties design featuring rich use of several kinds of contrasting marble, with details of translucent glass and nickel reflectors, and characteristically art deco rectilinear ornament.

During the late twenties in Chicago, skyscrapers were also giving a new luster to the west side of the downtown—an area that had once been neglected and was mostly shabby. On Wacker Drive, on the south fork of the Chicago River, the Civic Opera Building commanded much attention and praise in the last years of prosperity. The building was a project of the British-born utilities tycoon Samuel Insull, who wanted to build for Chicago a lavish new home for opera and other gala productions. At the same time, the building would presumably pay for itself through the renting of office space. It was a completely novel combination of functions.

Insull had been one of Chicago's foremost financial figures during the 1920s, and was long a major benefactor and philanthropist in the city. As a young lad he had served as a secretary to Thomas Edison shortly after

his arrival in the United States, but before very long Edison, who had little business sense, was trusting Insull to manage some of his important electric industry properties. In 1892 Insull was sent out to Chicago to operate the Chicago Edison properties, and thus independently operating he managed to come into personal control of them. Under his leadership the Chicago Edison Company became the sole supplier of electrical power to the city of Chicago.

In 1912 Insull was to form a utilities holding company called Middle West Utilities that would eventually bring him one of the great American fortunes, but would also lead to his eventual downfall in the Depression. In the meantime, Insull became one of Chicago's most respected citizens and benefactors. He also took over many of the city's electric railways, and the vast system of outlying interurbans over which he imposed innovative management practices. Above all, though, Insull was a man of culture and refinement who sought to bring some polish and civilization to the crude and freewheeling metropolis of the Midwest.

His construction of the Civic Opera Building is one of the projects for which he continues to be well remembered, although not always in a favorable light. Many Chicagoans, including architectural aficionados, never forgave Insull for taking the opera away from Louis Sullivan's Auditorium on Michigan Avenue. (After the opening of the Civic Opera Building the Auditorium quickly deteriorated, and the building was sold to Roosevelt University in 1946; quite luckily, however, Roosevelt never destroyed the theater part of the building and it was restored by the Auditorium Theatre Council in the late 1960s.) In the late 1920s, however, Insull was still in the good graces of the public and his great opera building project was wildly proclaimed.

The building was designed by the eminent Chicago firm of Graham, Anderson, Probst and White (successor to Daniel Burnham's firm), and inside and out it is a fine example of skyscraper design of the late twenties period. The firm designed a building that is impressive both from an engineering point of view and as an aesthetic object. There is a massive tower above a huge base that had to accommodate two enormous theaters that were large open spaces. This called for a complex system of enormous trusses transferring loads at various levels. On the Wacker Drive side of the building there are no setbacks so the building seems to be a broad, unbroken plane. On the opposite side, facing the Chicago River, there is a deep setback at the thirteenth floor, with two wings setting off the tower from this point.

Seen from this angle, the Civic Opera Building looks like a gigantic throne. Many Chicagoans believe that Samuel Insull had the building

designed as a throne for his empire, and no argument serves to convince them otherwise. Unfortunately, Insull's empire crumbled in the early thirties, and he was indicted on criminal charges (although never convicted) when his empire of utilities companies crumbled like a house of cards. Insull never regained the favor of the Chicagoans he had served so well, and

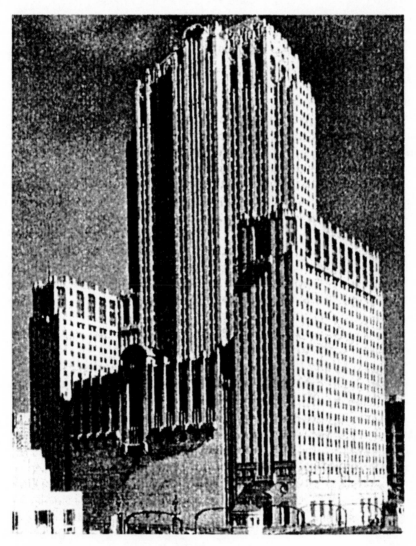

Art deco marvel of Chicago, the Civic Opera Building—part opera house, part office building. Some people thought utilities magnate Samuel Insull had built a throne to reflect his own glory. (Photo by author.)

history has certainly treated him harshly. But it would have been completely antithetical to his character to have designed an office building in the form of a throne for himself. Above all, the building's western exposure repeats a design used several times before in the twenties—in the New York Telephone Building for example.

In many ways the Civic Opera Building (which for a number of years was the Kemper Insurance Company Building, although the opera goes on below) is a typical building of the day. The vertical bands of windows are characteristic of the period, but above all, the careful attention to interior detail recalls that now bygone era. One would probably not want to use the term art deco to describe the building; it is a kind of conservative modern style combined with decorative principles from the French Renaissance. The theaters are set with their backs against the West side of the building, so that the lower walls above the river are windowless. But there is an enchanting decorative scheme here drawn from the musical arts—some of the motifs are the lyre, the trumpet, the palm leaf and the laurel wreath, which motifs are also found repeated in the lobbies.

The entire ground floor of the south wing of the building is devoted to an entrance lobby and a grand foyer to the opera auditorium. Those who ever visited the old Metropolitan Opera House in New York will immediately see that these spaces compete with that earlier structure in elegance but defeat it easily in spaciousness. The Grand Foyer measures 52 by 84 feet, with a 44-foot ceiling. In the entrance lobby one sees a fine example of the kind of lavishness that could only be provided in that day: walls of polished Roman travertine, floors of pink and gray Tennessee marble, entrance and elevator doors of bronze; ceilings finished in salmon and gold. All of the public rooms make exceptionally good use of rich color schemes.

The Civic Opera Building was both a thing of beauty and a testimony of the technical advances in skyscrapers since the early days of skyscraper construction. That two huge auditoria could rest below a tall skyscraper with no supporting columns through these open spaces must have confounded the uninitiated, but it was only one of several important technical problems to be solved. An oddly shaped lot and the nearness to the river also presented thorny difficulties. But in its final result the Civic Opera Building is both a masterpiece and charming eccentric in the roster of American skyscrapers.

Another building that illustrates the design trends of the late twenties stands directly across the river from the Civic Opera Building. A contribution of Holabird and Root, the Daily News Building (now the Riverside Plaza Building) was the first skyscraper to be constructed on railroad air

rights, specifically the northerly tracks of the giant Union Station which had been completed only four years earlier. The main technical problem to be solved was that of smoke removal, for in 1929 the diesel locomotive was still a few years away. The building is a singularly attractive slab of Indiana limestone, with dark polished granite below for the shop fronts on Madison Street. The building is symmetrical, a modest 26 stories in height. Although given to vertical bands, it seems to treat the eye to both a vertical and a horizontal feeling that is most pleasing.

A great deal has happened along the west bank of the Chicago River since the Daily News Building went up in 1929. To the south of the Daily News Building is a whole row of modernistic skyscrapers built in the 1960s and 1970s. The southernmost of these, the Marsh and McLennon Plaza, was built on the site of the Union Station Concourse Building. Thus the unseemly railroad avenue along the river was rehabilitated by tall buildings — one of the oft-forgotten byproducts of skyscraper construction. Nonetheless, the Daily News or Riverside Plaza Building was the first to go up, and somehow it stands as a reminder of a now bygone era of skyscraper luxury. Its neighbors to the south are expensive, attractive, lovely and tall, but there is something missing in them that can only be found in the opulent buildings of an earlier day.

For a few years, if only a few, architects wanted to build tall buildings that would be a feast for the eye, that not only housed important functions and ceremonies of the world but also convinced the rest of the world that whatever they housed *must* be important. The era of the deluxe skyscrapers would soon come to an abrupt halt as the economic skies darkened in the early 1930s. But before this happened there came another reminder, ever so dramatic, that great forces had been at work in American life and that the nation's architecture could be, on a few occasions, an exuberant and playful expression of the human spirit.

Chapter 8

THE ONE AND ONLY EMPIRE STATE BUILDING

For 40 years the Empire State Building was the tallest building in the world. Its very name became synonymous with tall building, and to a great many who knew it as the king of skyscrapers, it will never be surpassed, whatever upstart competitors may come along. Moreover the Empire State is beautiful to look at. Its gleaming nickel aluminum and limestone surfaces blend miraculously against any New York sky; it glistens in the rain and sparkles in the sunlight. Above all it possesses a hard, dramatic sense of loftiness; it is phallic, eruptive, dynamic — seemingly unyielding to the elements and the passage of time. And tall, yes, tall.

The Empire State Building was opened with pomp and circumstance on May 18, 1931, with President Herbert Hoover pressing a button to turn on the lights in the lobby. At the time of its opening, the country was entering the darkest time of the Depression, and things would get worse before they got better. There were 1,790,433 square feet of rentable office space, much of which would obviously have to wait a long time to be rented in the ever darkening real estate market. Somehow, though, the Empire State Building was a symbol of hope in those dark times, and the fact that every single beam of the building went into place after the stock market crash of October 1929 was taken by contemporaries as a sign that America could survive and endure, that the nation's vast economic and technological prowess was only shackled, not suffocated.

Part of the confident spirit expressed by the Empire State in the early years of the Depression may have been due to the fact that this was a general office building, reflecting faith in the diversity of American commerce and industry. The building was not the dream of some industrial tycoon, nor an extravagant monument to some financial empire; rather it was an all-purpose office building that derived its appeal from its location, its convenience and its distinctive style. The building has changed

107

hands several times since its construction, and its various owners have had reason to be pleased with it. Commercially it has been one of the most lucrative American skyscrapers.

The decision to build a gigantic skyscraper at the midtown location — the Empire State Building is located at Fifth Avenue and 34th Street — had a curious and somewhat complex history behind it. The building stands on a parcel of land that had been owned since 1827 by the famous New York family of Astors, the heirs of German-born merchant and trader John Jacob Astor, who sought riches all over the map but finally established one of the great American fortunes on a base of Manhattan real estate. When the Astors bought the property it was strictly farmland, and they had no intention of building there; they just wanted to hold on to the land for future profit, a business philosophy that never seemed to fail the family. However, in 1849 there were some ugly riots (known to history as the Astor Place riots) near Greenwich Village where the Astor clan had its mansions, so the Astors decided to build farther uptown. In the years that followed, the area where the Empire State Building now stands became a kind of millionaire's row, with several Astor mansions on the site. Later, one member of the family, William Waldorf Astor, used part of his land at the northwest corner of Fifth Avenue and 33rd Street to erect a lavish hotel that came to be known as the Hotel Waldorf. He continued for some time to live in his mansion at the corner of Fifth Avenue and 34th Street, although eventually he was prevailed upon to move up to better things. Meanwhile, William Waldorf Astor's aunt Caroline, either to spite or to outdo her nephew, erected a hotel at the other end of the block that became the Hotel Astor. The two were separate for a while but were eventually merged into one grandiose establishment known as the Waldorf-Astoria. The Waldorf-Astoria remained one of New York's most fashionable hotels until the 1920s, when the commercialization of the neighborhood made the location inappropriate for such a posh establishment.

With Park Avenue quickly developing as a luxurious residential neighborhood on New York Central air rights during the 1920s, the management of the Waldorf-Astoria decided to leave 34th Street and move uptown once again. They bought the land at Park Avenue and 49th Street where the present hotel stands. The old site was now available for commercial development, and it was a site that would have stirred the imagination of many a developer. One who immediately stepped forward was Floyd De L. Brown, president of the Bethlehem Engineering Company, who proposed to build a 25-story office building on the block to be called the Waldorf-Astoria Office Building. He laid down $100,000 as part of a

down payment of $1 million on the old hotel building, and subsequently convinced a bank to loan him $900,000 to make up the remainder. But his scheme failed to materialize and he was forced to sell out.

But the investors with the really big money were waiting in the wings. And they were thinking big, too—no paltry 25-story birdcage, but the tallest office building in the world. They included Louis G. Kaufman; Ellis P. Earle; John J. Raskob, chairman of the Finance Committee of General Motors; and Pierre S. du Pont, chairman of the board of E.I. du Pont de Nemours and Company. Raskob and du Pont, with their considerable financial clout, were of course able to lay their hands on the kind of capital needed for a project of this kind, and they shortly announced the successful acquisition of a $27 million loan from the Metropolitan Life Insurance Company to move the project forward.

In addition to Raskob and du Pont, one other figure of great importance was to appear on the scene—the most important of all, as things turned out. It was Al Smith, the great New York politician who lost the presidency to Herbert Hoover in 1928 and had been somewhat loose in the world since. Smith was picked by Raskob to be president of the Empire State Corporation at a salary of $50,000 a year, with his role obviously designed to be that of super salesman and public relations man.

Interestingly, Smith and Raskob had a great deal in common and were good friends; in fact, Raskob had managed Smith's campaign for the presidency in 1928. Raskob had met Smith only a few years before the election, and the two had liked each other from the start. Both were Catholic and both were strictly opposed to Prohibition. Both were self-made men, Smith rising from the sidewalks of New York to the governor's mansion in Albany, Raskob a high school dropout rising through the ranks of the Du Pont and General Motors organizations. (One of Raskob's great contributions to the automobile industry was to inaugurate the installment plan for buying cars, bringing the industry one of its greatest booms.)

Raskob was a Republican and Smith a Democrat, but Raskob had sufficient faith in Smith in the unlikely Democratic year of 1928 to make a handsome campaign contribution, an act which so flattered Smith that he offered Raskob the job of running his presidential campaign. But in spite of Smith's tremendous popularity and the fact that the majority of Americans were tired of Prohibition, there was virtually no way that a Democrat could be elected in the prosperous year of 1928. The "Happy Warrior" went into retirement, no longer governor of his beloved New York, rejected as president of the United States.

If Smith had been elected, he might well have offered the job of

secretary of the treasury to Raskob; instead things were turned around and Raskob had the opportunity to offer something to Smith—a job running the world's tallest office building, a building with the very appropriate name "the Empire State Office Building."

It is not clear how soon Raskob thought of making his building the tallest. The original idea was to acquire the site of the old Waldorf-Astoria, but it may be that Raskob first had in mind a building not a great deal taller than that conceived of by Floyd Brown. But Raskob hired the architectural firm of Shreve, Lamb and Harmon, and in a preliminary conference Raskob grew bold and asked William Lamb, "Bill, how high can you make it so that it won't fall down?" This naïve question really needed no answer, since there were other questions to be answered that were more important than that. How tall a building was feasible on that site, and could it be rented?

Raskob soon became determined to have the tallest building in the country, and at first it seemed that a building of about 80 stories would do. But this was the period of the building boom, and it was discovered that the Chrysler Building was also vying for that title, and Raskob was worried that Chrysler might be hiding some rod or spire inside the building that would play havoc with his plans—as indeed turned out to be the case. So it was decided to add another five stories to make sure that the Chrysler Building would be topped. Even this did not quite suit Raskob. He worried that Chrysler might outwit him in the end. Thus he proposed that above the eighty-fifth (it turned out to be the eighty-sixth floor), a large tower of an additional 200 feet be built to take a commanding lead. Raskob had a practical use for this tower, or so it seemed at the time. It would be a zeppelin mooring mast that would allow transatlantic zeppelin passengers to land right in midtown Manhattan and avoid the long trek to the U.S. Naval Air Station in the Pine Barrens at Lakehurst, New Jersey. The *Graf Zeppelin* had circumnavigated the globe in 1929, and Raskob thought that he had hit upon a coming thing.

Final plans then called for a building that would be 1,250 feet above the sidewalk. This would offer quite a safe margin over the Chrysler Building which logged in at 1,046 feet, even with the tall and extravagant spire. Clearly this also managed to deliver an American insult to the Eiffel Tower, which was only 984 feet. (A quarter century later a 222-foot television antenna was installed on the Empire State Building, and if this is calculated in the record-keeping, the Empire State Building is still the tallest office building in the world.)

The Empire State Building was an enormous undertaking by any standard. The whole project from demolition to dedication took but 18

months, and during this period some 3,500 workers were involved in the project. Millions of dollars had been borrowed and not a cent of profit could be earned until the building was occupied, so Raskob insisted that the work proceed at breakneck speed. Everything possible was done to avoid hand labor, to order parts that could be mass produced, and to include design features that would make for simple and rapid installation of parts and fixtures. The architects and builders went out and ordered marble for quick delivery. A new kind of window design provided for metal brackets on the outer walls of the building to which glass could be directly applied, and these were connected in series over the whole building. (Interestingly enough, this would help to give the building its glistening streamlined effect.)

The work began in October 1929, only a few weeks before the great stock market crash. The first step was the demolition of the Waldorf-Astoria Hotel, and this in itself was a large undertaking. Al Smith was on hand on October 1 when a truck lumbered through the main door of the hotel for the start of the demolition process. Smith proclaimed that the old New York landmark had to give way to "the march of progress," and reminded everybody what a spectacular building would occupy the site. During the next five months 16,000 truckloads of debris were carried away and dumped into the Atlantic Ocean off Sandy Hook. One unusual discovery (most of the hotel's treasures were sold) was a padlocked basement wine cellar that probably went back to the time of the Astors. Turning up here were some liquid treasures that must have warmed the hearts of anti-Prohibitionists Raskob and Smith: hundreds of cases of choice French wines and champagnes. There were also five hogsheads of whiskey from the time of the Spanish-American War. The partners divided the booty amongst themselves.

After the demolition came the excavation of a basement that was to be only five feet deeper than that of the Waldorf. But there would be footings for 210 steel and concrete columns; the first of these were sunk on Saint Patrick's Day 1930. From here on, every stage of the construction was well publicized, photographed, thoroughly documented.

The girders for the building's framework were set in Pittsburgh, shipped by rail to a supply yard in Jersey City, ferried and trucked to the building site and then lifted in bundles to the work site with the help of nine powerful electric derricks. Eventually the girders got to the riveters who fastened each girder with an earsplitting riveting gun. The total time from the Pittsburgh plant to riveting in place was 80 hours. Story by story the building rose to the amazement of spectators below. In one ten-day period during the fall of 1930 the building rose an amazing 14 stories.

In the wake of the steelmen, a great number of new carpenters, masons, plumbers, and electricians arrived on the scene, many of them to work on provisions for interior parts of the building when the framework was under construction high up. On busy days, Starrett Bros., the main contractors, had 1,900 workers on their payroll; 67 subcontractors often had as many as 1,500 on theirs. The mere business of providing for them all and keeping them out of each other's way was staggering to the imagination. Workers up high ate lunch with only a short break. For 40 cents, lunch came right up to them and they could eat it sitting out on the edge of a girder—two sandwiches, coffee or milk and a slice of pie. Temporary water pipes were installed to bring water to the construction site. There were nurses and medical facilities on the ground, and their services were needed often. Injuries were fairly numerous, and there were even 14 deaths at the site, not an enviable record when one considers that only one life was lost in the construction of the Chrysler Building.

The Empire State Building went up faster than any of its neighboring skyscrapers, although there were not a few who questioned the hurry and the needless loss of life. Why should the workers be put to the whip when they faced almost certain unemployment when the building was finished? Why hurry to open a building that could not possibly be filled up in the dreary year of 1931? One critic, Edmund Wilson, a reporter for the left-leaning New Republic, saw the Empire State as a symbol of the failure of the American economy. He admitted that the building was a thing of beauty. "In a warm afternoon glow the building is rose-bisque with delicate nickel lines; the gray air of rainy weather makes a harmony with bright pale facings on dull pale gray; a chilly late afternoon shows the mast like a bright piece of silverware, an old salt-cellar elegantly chased."

Yes, the building was beautiful, and expensive, but very much out of place within its urban environment, thought Wilson.

> Straight streets, square walls, crowded bulks, regular rectangular windows—more than ten million people sucked into that vast and ever-expanding barracks, with scarcely a garden, scarcely a park, scarcely an open square, whose distances in all directions are blotted out in pale slate-gray. And here is the pile of stone, brick, nickel and steel, the steel of offices, shafts, windows and steps, that outmultiplies and outstacks them all—that, most purposeless and superfluous of all, is being advertized as a triumph in the hour when the planless competitive society, the dehumanized urban community of which it represents the culmination, is bankrupt.

This was the mood of many in 1931, a time when millions were on the dole, when bread lines and soup kitchens were keeping the destitute

and the needy alive — only blocks away from posh hotels and costly art deco skyscrapers. To others, however, these great new buildings seemed to spark some hope; there seemed to be in them some hint that the American economy was not bankrupt after all, but only clogged, disoriented, baffled. The wealth that created the Empire State Building had not been destroyed, it merely needed to be rechanneled, redirected. And the Empire State held out the hope that this could happen.

The grand opening on May 1, 1931, was a gala affair, with Al Smith acting as master of ceremonies. Governor Roosevelt was in attendance, as was jaunty Mayor Jimmy Walker of New York City. President Hoover pushed the all-important button and Smith introduced the attending dignitaries over worldwide radio. It was a beautiful day, a cloudless sky of blue haze greeting those who took the trip to the observation deck and to the 102nd floor. Visitors were told that they could see for 80 miles — although what they could see at 80 miles was not made clear.

Smith moved into his new office on the thirty-second floor together with his black leather governor's chair from Albany, his memorabilia and his framed political cartoons. He knew that the road ahead was a difficult one. The Empire State Building was tall and it would not fall down, the standards of construction were beyond reproach, and the offices were fresh and desirable. But how could they be filled? In the year 1931 offices were being vacated all over Manhattan, not filled up. The chances for a new building were grim at best. It would be Smith's lot to put on all the political charm he could muster and rope in the tenants.

Alas, it would be many a long year before he was completely successful. During the 1930s the building was never filled. When the building opened in 1931 it was less than half filled, and at no time during the Depression years did it exceed two-thirds capacity. Early on there were those who called the building "Smith's Folly," or "The Empty State Building," or "the 102-story blunder," or even less complimentary names. Attempts were made at first to rent offices on the basis of the "prestige of the address" (this after all was the former site of the great Astor estates) and the convenience of the location. Later, throwing that approach to the winds, the Empire State Company reached out for those looking for a mid–Depression bargain. The suites, they said, were available at low prices because the building was "mass produced." There was some truth to this — the building was a model of efficient but sound construction, and it had in fact come in at $3 million less than estimated cost.

The building was finally filled in 1941 when, hat in hand, Al Smith went down to Washington to beg help from his erstwhile ally and later political foe, President Franklin Roosevelt. Roosevelt agreed to rent the

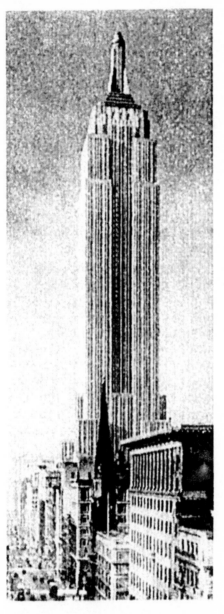

Perhaps the most famous skyscraper of all time, the Empire State Building stood in lonely eminence on New York's 34th Street, views of it not obscured by nearby giants. (Author's collection.)

sixtieth floor suites for the New York offices of the Department of Commerce. It was a long time coming, and the 1930s must have been a difficult time for Smith. But since 1941 the Empire State Building has been a smashing commercial success and it has paid back its investors many times over.

In one way the Depression years were not so unhappy for the Happy Warrior. If he failed to rent almost 2 million square feet of office space, he was at least successful in selling the building as an image and as a tourist attraction. The two observation floors were an immediate success with the general public, attracting over a million visitors the first year. Garnering ample revenues up here eased the pain caused by the vacant suites below.

And nobody could have surpassed Smith as a public relations man. He sent out a steady stream of invitations to the great and the near great, and dignitaries who showed up were given the grand tour by Smith himself. Before Smith's death in 1944 he had personally entertained thousands of visitors including Winston Churchill; Anthony Eden; French Premier Pierre Laval; Vittorio Mussolini, the son of Il Duce; Archduke Otto von Hapsburg, pretender to the throne of Austria-Hungary;

and innumerable mayors, governors and heads of state (some in tribal dress). Anything that would bring out the news cameras would bring out Smith—troops of monks, Olympic teams, and above all pretty girls. Smith was always delighted to stand next to a bevy of Rockettes, show girls, or burlesque queens, and few months went by without the wire services picking up a picture of Smith exchanging his New York brown derby for the Stetson of some pretty cowgirl from Texas. The only person who formally refused Smith's invitation to visit the Empire State Building was Walter P. Chrysler.

The height of the Empire State Building was its compelling attraction over the years, and the steady stream of visitors did not abate even with the opening of the taller World Trade Towers. The building's statistics were mind boggling in 1931, and they remain so more than half a century later. The building stands on a site of 83,860 square feet. The building itself contains 37 million cubic feet and 1,790,433 square feet of rentable space. It weighs 308,000 tons (although incredibly this is less than the weight of the stone and clay removed to make way for its foundations and basement). It cost $35 million or $1.03 per cubic foot.

An average of 2,500 workers were employed daily in the construction of the building, with the record number for a single day being around 4,000. The building has enough steel in it to build a double-track railroad from New York to Baltimore. It contains 63 passenger elevators and four freight elevators in seven miles of elevator shafts. The building has 6,500 windows, and its construction used nearly 10 million bricks, 200,000 cubic feet of stone, and 730 tons of exterior metal including nickel-chrome steel and aluminum. There are more than 17 million feet of telephone and telegraph wire and cable in the building. There are 7,000 radiators and a water supply system capable of delivering 80,000 cubic feet of water per day.

One thing that has contributed to the continuing fame and notoriety of the Empire State Building is its location. It occupies a special place in the New York skyline. It has no competitors in the immediate locale, most of the other New York skyscrapers being above 42nd Street or downtown in the financial district. The Empire State has always completely dominated the 35th Street neighborhood.

More importantly, the building is an architectural delight. William Lamb was an architect whose mind ran to the pragmatic and the utilitarian; he had no interest in the excesses of art deco (in exterior design) and refused to play around with fanciful spires, pinnacles and other such folderol. Yet he designed a building that offered the best that art deco styling had to offer. Few buildings in New York, or anywhere, made better

use of setbacks than the Empire State. The building is built to the street line for only five of its stories; the main tower is set back 60 feet offering the visitor and passerby aesthetic and psychological distance, thereby framing and setting off the building in a most pleasing way. The main tower is well carved, with indentations running its full height. The indentations and the additional setbacks cut into the mass of the building that might otherwise be either frightening or monotonous. They make it dynamic and lively.

After the Second World War an architect like Lamb might have gone for some kind of straight box; fortunately he produced instead a design of simple, clean lines, yet with a feeling of style and ornament. And the design was helped out by the sheathing of Indiana limestone and granite and the touches of nickel and aluminum in the spandrels and the mooring mast, all of which gave the building an ornamental quality that might not have been acceptable a generation later.

If the exterior of the building could be called straightforward and "clean," the public interior was clearly in the lavish art deco tradition. There was a four-story lobby made of imported marble giving the effect of crushed strawberries smeared into a gray surface. On the long ceiling were gold and silver suns and circles, as well as various other geometric patterns and shapes. There were streamlined bridges crossing the lobby, later encased in glass; the elevator doors were black with somber silver lines suggesting the entrances to Egyptian tombs. The interior was altogether far less expensive than the details of the Chrysler Building, but every bit as impressive.

The Empire State Building, in spite of its inauspicious beginnings in the dark days of the Depression, has been a commercial and artistic success. It has been surpassed in height, but it has not been displaced in the hearts of New Yorkers and of millions of visitors for whom it is *the* great skyscraper, the building that comes first to mind as the tallest of the tall. For style, and grace and dramatic thrust it is hard to find its equal anywhere in the world.

Chapter 9

THOSE WHO WORK ON HIGH

The skyscraper is an obvious triumph of modern technology, a structure that could never have been built by human toil alone. However many thousands of slaves or drones an Egyptian pharaoh or Roman emperor could have put to the lash, no amount of such energy would have been sufficient to erect even the most modest skyscraper of the twentieth century. This does not mean, however, that skyscrapers could have been built without human labor; in fact, they are the collective achievements of many highly skilled and specialized talents. Some of these talents and skills are common and widespread; others are not only specialized but rare. For example, in the days of the great skyscraper boom in New York one found relatively small numbers of workers doing the high steel work *usually moving in teams from one project to another. They were trained* in the work and, moreover, accustomed to it. It was no simple task to break new workers into the frightening experience of walking along a steel girder into empty space. There were those who had the stomach for it, and others who would have been terrified merely by the thought of setting foot on the high beams.

Obviously, though, skyscraper construction involved specialized talent from the very beginning. There were firms and workers specializing in demolition, in excavation, in steel-making, in steel fabrication, in high-steel erection, in stone cutting and finishing, in building ornament and decoration, in electrical wiring, in plumbing, in elevator installation, in air conditioning, and so forth. It was something of a happy coincidence that the American cities that built the really great skyscrapers in the first three decades of the twentieth century—New York and Chicago especially—were able to rely on a pool of workers developed locally and frequently used for closely related projects calling for identical skills.

Consider the matter of excavation. The tunnel workers, or sand hogs, needed to perform the very tricky and complicated foundation work for the skyscrapers of Manhattan were the same workers whose talents were

117

used in laying the city's hundreds of miles of subways, most of which were under construction during the same years as the major skyscrapers of the city. Too, the sand hogs were kept busy during this period with the even more complicated tunnel projects under the Hudson and East rivers, beginning with the Hudson tubes and the railroad tunnels of the Pennsylvania and Long Island railroads, and later with the vehicular tunnels: the Holland, Lincoln, Queens Midtown, Brooklyn, etc.

The same thing was true of the workers who rambled high in the sky when beams were being hoisted and bolted into place. These workers constituted a fraternity which also served the active bridge builders of the area — quite an important industry in New York for many decades. Just as giant buildings were being constructed in New York, so the many miles of waters surrounding Manhattan Island were being spanned with steel suspension bridges — first the Brooklyn Bridge, of course, the granddaddy of all such bridges, and then later the Manhattan and Williamsburg bridges, the Queensboro Bridge, the Hellgate Bridge, and finally the Triborough and George Washington bridges. It was not at all unlikely for a worker to be employed on the construction of the Chrysler Building in the late twenties, and then a few months later on the George Washington Bridge, for the skills involved were related and nearly interchangeable.

The close affinity of bridge-building and skyscraper construction was one of long standing. From the start the skyscraper builders purchased their steel from bridge shops since the steel mills rolled only standard and uniform steel. The typical skyscraper, like a bridge, could hardly get by with the kinds of standard length that, for example, a railroad would require; it needed hundreds of different lengths and strengths. The bridge shops were prepared to supply the many different dimensions from specifications and to punch the rivet holes, rivet on the lugs and combine the various shapes into girders and columns even before the steel reached the building site.

The workers, in a sense, had their origins in the bridge shops and knew the practices and the products of those shops. There was no way of sending steel workers up on high if they were not familiar with the many different kinds of beams and girders that they would have to deal with. Thus the working skills ultimately are traced back to the bridge shops, even if a particular worker did not get his start there; indeed the union which has always encompassed the workers who toil in high steel is the International Association of Bridge, Structural and Ornamental Iron Workers. In the early years of skyscraper construction, nearly all of the members of the locals near New York City had ample practice both on bridges and on steel-frame office buildings.

Watching the building of skyscrapers is one of the visual delights of urban life. The block cordoned off for the high work is nearly always a magnetic attraction to little streams of visitors, many of whom have sneaked out of the office to observe the progress of some benchmark accomplishment. First there is the makeshift wooden fence surrounding the gaping hole in the ground — and while the steam-shovels and sand hogs are at work, as the foundation is being laid, every peephole, every crack and crevice seems to have its own eager bystander or sidewalk superintendent. No contractor alive would be so heartless (and so bad at public relations) as to keep the below-ground activities completely shut off from view. There is always a crack or two, or a knothole, or sometimes an official window of plastic.

The first exciting development is the great day when the first steel columns above ground are laid, for the subterranean diggings are always mysterious and unexciting. But there is nothing hard to understand about the process from ground up, although before long the activities will only be observed by those who don't mind craning their necks, and shortly afterward by those who remember to bring their binoculars from home.

When the first vertical columns are placed, the dedicated bystander notices the derricks going about their work. The derricks are placed so that the reach of their booms overlaps, and they can service the most remote corners of the building. Suddenly there are a whole collection of freestanding steel columns looking like a little forest of trees set down in an unlikely city setting. In a matter of only a few days, however, the spectators will return and find the derricks at the level of the second floor, having gotten there by a kind of magic that only those who stay and watch all day will fully understand. Indeed to the untutored eye the whole process is something of a mystery. How do the derricks climb up floor by floor? Where do all the materials come from? The planks, the rivets and forges, the hoists — all seem to come on schedule, as from nowhere. Obviously, every step of the way is coordinated in masterly detail.

As soon as the first few floors are up in skeletal form, a new kind of activity takes place down below, and new crews of workers are immediately added to the scene. A scant few weeks after the basement area is bathed in sunlight, it becomes a dark and murky cavern, its sunlight shut off by the growing superstructure overhead. But things begin to happen immediately here also as the steel goes into place high above. Already electricians have strung temporary electric lights and the basement area becomes a busy place of sand-bins, mixing pots, tool houses and storage sheds of every description. Many new faces appear, for it is none too soon

Construction of modern skyscrapers requires thousands of workers representing many different crafts. Posing for their formal portrait are those who worked on the Chase Manhattan Building, probably in 1959. (Robert M. Mottar photo, courtesy of Chase Manhattan Archives.)

for plumbers, steamfitters and sheetmetal workers to pursue their respective tasks. In no time at all the first ventilation ducts will be in place.

Most of this new activity is obscured from view, but it would probably not be a spectacular sight to the typical passerby, who can observe the same sorts of activity in the construction of a local school, store or warehouse. All the attention seems to be focused on the topmost beams, the place where the real daredevils are doing their work. Life at the top is frightening, and to some terrifying. But there always have to be those who must experience the ultimate challenge of high steel—the feeling that one is walking out into sheer space. Here is a narrow beam shooting off into nothingness—no handhold, no grip, nothing but the air. It is no place for anyone with a weak stomach, but to the trained and habituated iron-setters, this territory is a natural environment; they move around in it freely with a nonchalant attitude, as if they were still puttering around on the first floor.

To the amusement or horror of those timid souls below, the workers of high steel frequently do not even come down for lunch, but have their lunch pails hauled up and then sit along a beam like birds on a branch, legs dangling into space, munching a sandwich and engaging in idle chit-chat just as would workers in a factory cafeteria. Close up they are average people, but as the building rises, 20, 30, 50 floors, they seem more and more to be creatures of the animal world—birds perched high in a tree, or better yet squirrels making their way up and down some tapering branch or limb.

How does one learn to walk, and even work, at these dizzying heights without being afraid? Some of these workers apparently acclimatize very rapidly, as if by instinct. Others become accustomed to their high-wire act only by a process of long and gradual habituation. Others never get used to it and must turn to some other line of work. Sometimes fear grips one after a favorable start and may never be overcome. Some experienced journeymen have seen beginners be so overcome by fear on a place of dangerous and obviously precarious footings that they get down and hug themselves around the beam, eyes shut—perhaps oblivious to the fact that their hands or work clothes are covered with fresh paint. The dread of space may come upon one suddenly, and occasionally those so stricken are coaxed down only with the greatest difficulty. Some will never return.

And of course the dangers are very real. A false step is a step into death and oblivion, and even the most experienced workers have been known to fall. Derricks are always moving giant steel beams around silently, and the occasional worker is brushed off like a fly from a shirtsleeve. The ability

to walk freely and unafraid at these great heights usually must be acquired and built up slowly, and it has to be practiced regularly. Workers who are laid off or leave building work for a year or so are back at square one, and have to learn the sense of balance and security all over again.

Builders recruited these workers from all kinds of backgrounds and ethnic groups, the only qualifications being that they could learn the trade and overcome the fear of heights. Especially gifted with the latter quality was one particular group of workers toiling on the country's bridges and skyscrapers: American Indians. Apparently they were quite comfortable in high places, for reasons that nobody was ever able to adequately explain.

The Native American involvement apparently began in the early years of the twentieth century when the Canadian Pacific Railroad wanted to span the St. Lawrence River in the province of Quebec, Canada, with a cantilever bridge. The work was to be done by the Dominion Bridge Company, which had obtained the right to use some land owned by the nearby Caughnawaga reservation for the bridge abutment, and in doing so promised to employ Indian laborers whenever possible.

Much to the delight of company officials, the Indians were excellent bridge builders who seemed not to mind great heights and could negotiate the spans with tremendous agility. An official of the bridge company later wrote: "They would walk a narrow beam high up in the air with nothing below them but the river . . . and it wouldn't mean any more to them than walking on solid ground. They seemed immune to the noise of the riveting, which goes right through you and is often enough in itself to make newcomers to construction feel sick and dizzy."

In time, the company wisely decided to train Indians as riveters. The company gained seemingly natural born workers on the high beam and there were important positive consequences for the Native Americans themselves. They got into bridge and building construction in a big way. A number of Mohawks from the Caughnawaga reservation followed major steel construction projects around the United States and Canada. Some of them were involved in the building of the Soo Bridge at Sault Ste. Marie, Michigan, and in 1907 they worked on the great Quebec bridge over the St. Lawrence River. In 1915 or 1916, a Caughnawaga bridgeman named John Diabo came to New York and got a job on the Hell Gate Bridge. He was followed by others of his tribe, and there eventually came to be something of a small Caughnawaga settlement in the North Gowanus neighborhood of Brooklyn.

By the 1950s as many as 80 Caughnawagas were members of the Brooklyn local of the International Association of Bridge, Structural and

Ornamental Iron Workers union, and there were a number of others in the Manhattan local, although nearly all of them lived in Brooklyn. In the years since the establishment of the Indian enclave in Brooklyn, Caughnawagas worked on a number of major bridge and skyscraper projects in the New York area and elsewhere: the George Washington Bridge, the Bayonne Bridge, the Pulaski Skyway, the Triborough Bridge, and various others. In the great building boom of the 1920s and 1930s they were among the crews who worked on such celebrated buildings as the Bank of Manhattan Building, the Waldorf-Astoria Hotel, the Chrysler and Empire State buildings and the RCA Building.

The Indians remained skilled and fearless workers and were highly sought after by contractors. They lived in Brooklyn most of the year but continued officially to be Canadian citizens and regularly traveled back and forth to their reservation in Canada using an authorization card supplied to them by the Indian Affairs Office. Unlike the many other ethnic groups nearby in Brooklyn, the Caughnawagans resisted complete assimilation and maintained as many native traditions as possible. Their children attended American schools, read comic books, listened to the radio, and played American style stickball in vacant lots, but all of the adults continued to speak the Mohawk language at home. (Most of them, however, were multilingual, speaking English and French as well as Mohawk.) The North Gowanus housewives were like typical white urban housewives in some respects, but they also spent some of their spare time making Indian souvenirs for sale: dolls, handbags, belts with traditional Iroquois signs, etc. In the fall of the year, when they were not employed in structural steel, many of the men took vacations to state fairs in New York, Connecticut or Pennsylvania where they augmented their incomes selling handicrafts. For these occasions they would sleep in canvas tepees pitched near the fairgrounds, and bring out of storage their buckskins and feathers. On occasion they might even be induced to make a halfhearted try at a wahoo or a Mohawk dance.

Skyscraper construction was more than a matter of the genius of the architect and the resourcefulness of the engineer. It always required, during the 1920s, when the classic art deco skyscrapers were being built, the most skilled and dedicated on-the-spot workers. After World War II, with the drift toward glass and steel construction, the importance of skilled on-site craftsmen subsided somewhat, but the contractors of such projects as the Woolworth Building or the Empire State Building always called for the best steel handlers and the best bricklayers in the city.

Before the time of glass-and-steel construction, prefabrication, and

inflated labor costs, the success or failure of a skyscraper was often strictly in the hands of the craftsmen on the spot. Consider bricklaying, an old and noble art which, in the construction of a simple structure, required only the most basic skills. But when it came to finishing off a building of 50 stories or more, the results of incompetence—or indeed anything less than perfection—would be fatal. So the builders of the Empire State Building called for and got the best bricklayers in New York.

Watching bricklayers at work was always less visually dramatic to the bystander far below than the insectlike antics of the steel men, but of course their success was every bit as important. The huge exposed surfaces of skyscrapers received regular but expected punishment from the elements, so it was absolutely essential that the bricklayers' finished product be perfect. The brick wall had to surround and completely encase the exterior of the structure and it must be so well and truly laid that not even the most severe storm and wind could penetrate. The brick work had to be solidly tied into the steel and perfectly pointed on the exterior. The joints between the windows and brick work had to be thoroughly caulked and sealed.

The work of the bricklayers was perhaps not as dangerous as that of the steel handlers, but it was still an airy business. The bricklayers had to work on the outside if they were to get the kind of perfection that was required in this sort of enterprise. Here was another area where completely new techniques had to evolve if bricklayers were to get proper access to the vast walls of the high towers. In the early days of bricklaying, scaffoldings could be constructed from the ground up—even to a height of several stories. Above that there seemed to be little alternative but to work from inside, and this is the technique that was used in building tall structures such as smokestacks. In a tall smokestack, for example, an interior scaffold and hoist permitted "overhand" bricklaying as the structure grew upward. The technique was tricky and difficult, and produced results that were adequate—but not perfect. To get the kind of absolute consistency and foolproof slickness that skyscraper construction entailed, a method had to be devised to allow bricklayers to work on the outside. At first the problem was solved by a system of outriggers, built especially for each floor, which resembled little cantilever bridges on which platforms could be built, with scaffolding being used for every five or six feet of altitude gained.

Later the hanging scaffold was invented and proved to be most useful. With this device a series of small winches located along the scaffold allowed the worker to work at the ideal height at all times. The worker could gradually retract the small winches as the work progressed, making

intricate adjustments all the time so that the work would not have to be interrupted for major height adjustments. Needless to say, the bricklayers were at work while the steel crews were not many floors above; there was no need to wait for the completion of the skeletal frame. This system of teamwork and synchronization of tasks was one of the reasons why skyscrapers could rise so quickly, yet enjoy such meticulous craftsmanship.

Brick as facing material in skyscrapers has all but disappeared, but it is interesting and important to remember that it was once a popular material that could be used not only for its economy but for decorative effect as well. Traditionally in domestic and commercial architecture in America, bricks were uniform in texture and appearance, and anyone who wanted a really handsome home expected a red brick front — indeed a red brick front was long a symbol of solid elegance and affluence.

In skyscraper construction it was seen rather early that a uniform and monolithic facing of brick would not be very desirable, so brick works were called upon to produce bricks of greatly varied texture and color. With these various shades and colors of brick (and variations of size) some very warm and pleasing effects were obtained in building façades that might otherwise appear cold, lifeless and mechanical.

There were, of course, other facing materials in the days of the classic skyscraper. Among the most expensive and lordly were granite and marble, but because of the great expense involved in the materials, they were seldom used for an entire wall, being reserved mostly for touches and for highly visible areas. The 20-story Hanover Bank Building in New York was an exception, boasting a solid granite wall. Needless to say, the setting of these stones required the services of the most skillful and practiced masons.

Two materials that were more suitable for giant walls in building construction were limestone and terra cotta. Limestone was the most commonly used of the available materials in skyscraper construction. It was not only easily available, but beautiful in appearance. It can be recognized by its grayish or buff color and its sand-like texture, and it was almost always considered the ideal building material for skyscrapers because it was so easily worked, and could be used to achieve startling effects not only in flat surfaces but for molded or carved ornament.

Limestone, however, was not cheap — certainly not in the way brick was cheap — and a very common pattern found in American cities was a building on which limestone facing rose only to the second or third floor, at which point it was terminated by a handsome cornice or frieze. Above this point the building might return to a sheer brick wall, with only sills or possibly lintels of limestone. In the affluent years of the 1920s, however, some beautiful all-limestone faces made their appearance.

Another material that was popular among builders and architects was terra cotta, a material that has a long and fascinating history. Like brick, terra cotta is an earthenware material of great antiquity, although its potential for architectural uses has only recently been exploited. It was in an urn of terra cotta that the bones of St. Peter were supposedly found in 1950 in the hypogeum under the basilica of St. Peter's, and both bones and urn were in excellent condition.

Italians had done a great deal with terra cotta since the Renaissance, and since the time of the Della Robbia family in the fifteenth century this magnificent material was found to be of use not only in roof tiles (for which it had been used since Classical times) but for sculptural relief, bas-relief, cornices, medallions, even tombs and altars. At the hands of the Della Robbias, the beautiful enameled polychrome effects that could be attained by the use of terra cotta raised the artifacts fashioned of the material to the status of fine art.

For a long time, in the Western world the advantages and glories of terra cotta were unavailable outside of Italy. In the early United States terra cotta in a miserable reddish form was used as a byproduct of pressed brick works. With the appearance of the skyscraper, however, terra cotta came into its own once again. Louis Sullivan, for example, used terra cotta with consummate skill for the stringcourses of some of his buildings. Its attractiveness was largely due to the fact that it was capable of infinite variety in shading and coloring. It could, like brick, be made badly, but with its increasing use as a finishing material in American commercial buildings, a number of firms became expert in its manufacture and got the important contracts.

As to terra cotta ornament, here again the hand of the Italians could be felt, and in the early years of the twentieth century cities like New York—quite rich in Italian-born craftsmen of all sorts—could call on a reliable pool of terra cotta modelers and sculptors for skyscraper construction. Some of these modelers worked right on the building itself; more often, however, they worked in the studio from designs supplied by the architect. Terra cotta appliqué was for years an extremely common but lavish architectural art, responsible for ornamental details of the highest quality on American buildings. The skilled artisans who contributed to this ornamentation were long an important (although relatively small) part of the architectural scene.

The casual bystander observing the progress of a particular building would sometimes notice on lower floors craftsmen applying some fine touches to terra cotta; sometimes they would notice a gaping hole which was the place where some large ornament, even an arch, would fit in. (One

of the advantages of terra cotta ornament was that it lent itself so nicely to this kind of addition.) Some deft modeler or sculptor could be working on a piece in the studio or at the terra cotta works, and it could be fitted in when ready. Terra cotta appliqué could then be fixed in place by brick-layers; it did not require the services of a stonemason.

Skyscrapers always called for the best that was available in any given pool of labor, and over the years the workers who toiled on the great American skyscrapers gave the best of themselves, often with stunning results. The sculptor executing a terra cotta ornament knew that the piece would be seen and admired by the multitudes. The sheetmetal workers or copper roofers knew that their roof had to stand the test of time, and that it simply had to be impervious to storm and wind and rain. The elec-trician knew that here was a building in which fire simply could not be allowed to occur. Every phase and ingredient of the structure had to hold up, and almost without an exception they did. The fact that American skyscrapers have succeeded, that they have not toppled or fallen over, or even given way to the wrecking ball except when superannuated, is a trib-ute to the great workers of the building trades. Even with the advantages of every modern tool and technological device, skyscrapers are still the work of human hands.

C h a p t e r 10

ROCKEFELLER CENTER:
A FESTIVAL OF SKYSCRAPERS

For many years, Rockefeller Center was one of the most spectacular collections of buildings in the world. It may still be. But times change, cities decay, and the urban landscape does not, even under the best of circumstances, maintain the shining brilliance of a moment. But from the moment of its opening in the dark years of the Depression, the center's buildings and general atmosphere have charmed millions of visitors to New York, and all but the most peevish and ungenerous of architectural critics. Skyscrapers, it has often been said, are like jewels: The setting is as important as the jewel itself. The setting at Rockefeller Center has been somewhat altered of late by large and unappetizing commercial buildings to the west, but their presence has not entirely tarnished the luster of the center's original complex. And in its original setting, in the relationship of space to masses of buildings, there are few equals to Rockefeller Center anywhere in the world. Of course the center has been tremendously popular and successful for reasons other than the aesthetic, as memories and associations of buildings are always deeply rooted in the surrounding atmosphere of local history.

Rockefeller Center came about as the result of a curious and complex set of circumstances, most of which are now forgotten by the typical New Yorker, to say nothing of the casual visitor. The nature and character of the development as it eventually came to exist were not at all what was originally planned or intended; indeed the plans for it went through several transformations before evolving into the final form.

It is impossible to speak about the origins of Rockefeller Center without reference to John D. Rockefeller, Jr., son of the founder of Standard Oil and America's first billionaire. Rockefeller Center would never have seen the light of day had it not been for the careful planning and generous endowment of that liberal son of the parsimonious father. But Rockefeller

was not in on the very beginning; indeed the initial plan predated his interest and involvement by several years. It grew out of a desire of patrons of the Metropolitan Opera to provide a new and more convenient home for their company, and perhaps for some of the other performing arts as well. The Metropolitan Opera House at Broadway and 39th Street was hardly old by European standards in the late 1920s, but, as is typical of New York, the neighborhood was no longer fashionable and therefore no longer suitable for limousines and ladies in ermine stoles. So a plan was conceived to move uptown to more commodious quarters, into something that might resemble the Place de l'Opéra of Paris—a home for the arts that could perhaps be encircled by fashionable shops and gardens. In addition to the Opera House, other large halls for musical concerts and other entertainment might be included.

But where in crowded Manhattan could the place for such a thing be found? The well-heeled opera buff could not be expected to go far off the beaten track or to unfashionable or otherwise blighted environs. So where? The Metropolitan's patrons and directors shortly hit upon the idea of developing the land bounded by Fifth and Sixth avenues, and between 48th and 49th streets. This privately held land was the site of Columbia University before the 1890s, at which time Columbia moved its entire campus up to Morningside Heights with the hopes of getting a more spacious and bucolic campus, a hope soon thwarted when the new neighborhood became just as crowded as the one left behind. Columbia had not sold the land it vacated in midtown Manhattan, but had instead rented it out to small tenants—primarily some old brownstones and a few small stores. The area was very much a part of the speakeasy belt during the Prohibition era. Elegance was not far away to the east of Columbia's midtown parcel, although Sixth Avenue was a bit seedy, with the old El still grinding its way up the avenue and depressing real estate values in the vicinity. In general, it was an undeveloped area, crying out for replacement with modern buildings and a fresh face.

Among the patrons of the Metropolitan Opera was the banker Otto Kahn, a man of considerable wealth. But Kahn's grandiose plans for a Place de l'Opéra in New York were going to call for bigger resources of money than even he had at his disposal, and for this reason he sought to spark the interest of John D. Rockefeller, Jr., then in his fifties and quite in his prime. Rockefeller was at first not very supportive, and it was not his nature to jump headlong into anything. But he was eventually won over, and negotiations with Columbia were begun.

Alas, the original plan was never realized. After Rockefeller was committed to the project, the opera company started quibbling about the

terms of the lease. Furthermore, negotiations had begun just before the stock market crash, and the crash itself made a number of the plan's supporters on the opera board wary of such a giant project. Accordingly, in December 1929 the opera group formally withdrew from the project. Its departure left Rockefeller with a commitment to Columbia and a new organization called the Metropolitan Square Corporation, but no single predominant and coherent tenant or governing idea. Elaborate plans had been undertaken for an opera center, and now there was no opera.

Rockefeller had selected John R. Todd, a noted engineer, to be executive director of the Metropolitan Square Corporation, and Todd managed to come up with a few tentative plans for a kind of commercial center – some department stores, probably a large office building, some open spaces. Unfortunately, with the opera out of it, there seemed to be no real focus, nothing to spark the imagination. For a while the project floundered in futile indirection.

But the picture changed drastically when a new prospective tenant came on the scene in the form of the Radio Corporation of America, a company that was just then attempting to gain its independence from its parent corporations, General Electric and Westinghouse. Owen D. Young, chairman of General Electric, was a friend of Rockefeller's and talked up the idea of having his stepchild take up some space at the new center. At first Rockefeller was cool to the idea because radio was still in its infancy and, with the coming of the Depression, there was some reason to doubt that radio had anywhere to go. Why make elaborate plans around an industry that might not be able to stand on its own legs?

Still, Rockefeller did not have much choice. By 1930 there were very few large businesses looking for new office space (and the gargantuan Empire State Building, already under construction, could be expected to snare many of them), so Rockefeller had to take what he could get or just abandon the project. And the development was a lucky one, for in a few years Rockefeller had the center of focus he needed for his new development. Instead of a temple of the higher arts he came up with something infinitely more profitable: an association with the mass media – radio, later television, the movies, the press, and the various advertising industries that served these media. Soon Rockefeller would be in the business of entertaining people on a grand scale, having discovered a formula that from a business standpoint seemed invincible.

Some of the early stopgap ideas of Todd and Rockefeller never came to fruition. They tried, for example, to lure some of the city's large department stores, most notably the downtown Wanamakers, to the center, but business forecasts were getting grim and none of the department store

magnates wanted to risk a move. On the side of entertainment, however, the picture was a little more promising. The center was successful in creating several large entertainment venues, most notably the one dreamed up by Samuel L. Rothafel (known familiarly as Roxy), who was already a successful New York theater owner and developer. Roxy's great dream was to build the largest movie house in the world, and probably the plushest as well. It was to be called the Radio City Music Hall, and indeed the whole cluster of buildings at the western end of Rockefeller Center soon came to be known as Radio City. Strangely the Radio City Music Hall was a big money loser for a few years, but when it did get into its stride — especially in the World War II era — it was one of the most phenomenally successful theaters in history.

The crowning monument of Rockefeller Center was the 70-story RCA Building, constructed in part to provide studios and offices for the National Broadcasting Company, the broadcasting wing of RCA. To design this building several teams of architects were employed, but it is no surprise that the architect who rose to the top of the heap was none other than the aggressive boy wonder of skyscrapers, Raymond Hood. Hood's firm, Hood, Godley and Fouilinoux, was joined by that of Reinhard and Hofmeister, long closely allied to John R. Todd and experts in the planning of urban rental properties, and Corbett, Harrison and Mac-Murray, whose middle partner, Wallace K. Harrison, was to become a powerful force in New York architecture in the years ahead. The RCA Building itself was mostly the work of Hood, who was able to push the Rockefellers and Todds around to his way of thinking. But the end result was what counted, and the RCA Building became a great triumph, probably Hood's masterpiece.

If the RCA Building was a masterpiece, though, it was the result not of Hood's inspiration alone, but of other factors of overall planning — the use of space, the plaza, the gardens, the diminutive size of the surrounding buildings which set off the giant to excellent effect, and perhaps a number of other factors as well. I.M. Pei, a celebrated architect of a later generation, called the plaza "perhaps the most successful open space in the United States." Here it was that the collective efforts of a number of planners and designers of taste — not excluding John D. Rockefeller, Jr. — brought into existence one of New York's most striking collections and arrangements of buildings.

The RCA Building utilized a slab approach similar to that which Hood had selected for his McGraw-Hill and Daily News buildings shortly before. This approach was prompted by the New York setback requirements, but even more importantly by the economic conditions of the early

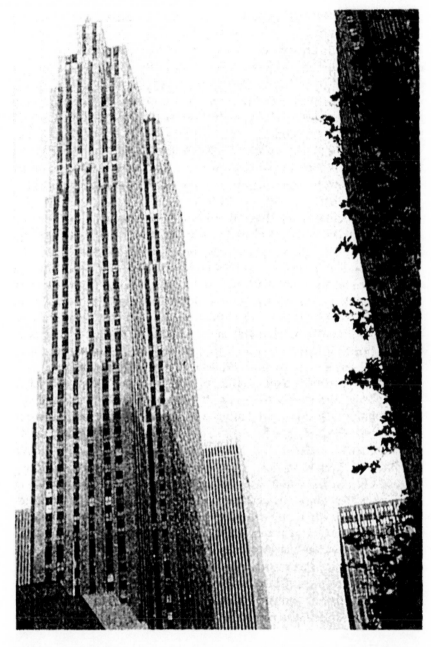

The RCA Building (today the GE building), shown here with afternoon shadows cast by lesser giants, remains one of the most striking and beautifully engineered art deco skyscrapers. (Photo by author.)

part of the Depression when the building was on the drawing boards. John Todd's familiarity with the New York real estate market caused him to pressure the architects to keep the offices on all the upper floors light and airy. He insisted that he had never collected an extra dollar of rent for any office space more than 30 feet from a window. Hood met this challenge with delight, and the building was treated to a series of ingenious and subtle setbacks and a new and clever arrangement of elevators.

The elevator banks were in the center of the building, leaving room for the main corridors and shops all around the perimeter. This arrangement differed from most earlier office buildings where the main corridor occupied the center with elevators grouped in recesses along the sides, a scheme which made for a great deal of lost loft space on the upper floors. Furthermore, Hood planned the elevator space in such a way that elevators served only the floors needed — 1-15, 15-30, etc. — and at the end of the run of one bank of elevators the saved space could be used for an additional setback, thus eliminating the unprofitable or hard-to-rent interior space that might be left over in the typical skyscraper.

Hood warmed to this whole design process, for in his eyes it was all a matter of form following function. He was making something infinitely agreeable in appearance by avoiding the effect of a harsh, sheer wall of building. The setbacks represented a feeling of energy, of form, of dynamism, yet they served a purpose that was manifestly economical and useful. In a 1932 article in *The Architectural Forum*, he justified the rationale of using the setback slab for the building: "As each elevator shaft ended, we cut the building back to maintain the same 27 feet from the core of the building to the exterior walls. By doing so we have eliminated every dark corner; there is not a single point in the rentable area of the building that is more than 22 feet away from a window."

The resulting building with its slim silhouette did not entirely thrill John D. Rockefeller in the beginning, and he did force the architects to make some compromises at the top so that he might have certain small satisfactions like those enjoyed by the owners of such skyscrapers as the Chrysler and Empire State buildings, which clearly "pointed to the sky." But whatever the compromises, the building was and remains a work of art, and a triumphant achievement. Its beauty became especially clear after World War II when architects surrendered to geometric blocks. The RCA Building joyfully challenges the monotonous uniformity of the commercial architecture that surrounds it.

Of course there were other buildings at the Center, most of which were interesting. There were 14 buildings built in the years between 1931 and 1939, at which time John D. Rockefeller, Jr., drove in what was called

"the last rivet" on the 20-story American Rubber Company Building. A number of original projects keenly hoped for in the early thirties fell through. The great department store, of course, was one. Also dreamed of, but never put on the drawing board, was a new railroad terminal which might by some means (subway or bus) have connected the various trunk line railroads that were forced to terminate their lines in New Jersey, including the Erie, the Lackawanna, the Jersey Central, and others. One

Raymond Hood, the designer of the RCA Building. One of the most famous skyscraper architects of the twentieth century, Hood won the Chicago Tribune competition in the early twenties and then began work in the "International Style." (Courtesy University of Illinois Library.)

part of the center dear to Rockefeller's heart was the international area, a series of buildings containing trade and governmental offices of other nations. Some of these projects went through at lightning speed; in fact, the British Empire Building was the first building in the center to be completed. Analogous buildings representing Germany and the Soviet Union fell through because of weak relationships with those countries. For a while Benito Mussolini was very enthusiastic in supporting an Italian Building and was even sent an impressive model of the project to look at, but in the end he did not back the project. Nonetheless a Plazzo d'Italia was built, although the funds were obtained wholly from Italian-American business interests.

As the Depression deepened in the early thirties it became a big question, widely debated in the press, how all of the vast amounts of available space would be filled by tenants in a quickly diminishing real estate market. By the mid-thirties there were some large and rapidly growing corporations wanting buildings of their own in this desirable location—the Associated Press, Eastern Airlines, Time-Life and American Rubber. But certainly the 70-story RCA Building presented some problems. There was no way in the early thirties that NBC and its parent company could be expected to fill up all that space; indeed most of the studios and offices were clustered in the lower floors.

Handed the job of drumming up business for the center was 24-year-old Nelson Rockefeller, the son of John D., Jr., who was later to move out of business and philanthropy to the turmoil of state and national politics. Nelson attacked his job with vigor. He set up an office to draw tenants away from other locations, even buying up their old leases when necessary. He did a certain amount of arm-twisting, especially of industries that were in some way related to the Rockefeller oil interests. Standard Oil of New Jersey, for example, was persuaded to take quite a large chunk of office space. Westinghouse, which provided the elevators for the buildings, was nudged into locating the offices of its elevator division there. After the phenomenal and total success of the center toward the end of the Depression, such arm-twisting was hardly necessary, but until then Nelson Rockefeller's salesmanship was of inestimable benefit to the family and the center.

In his direction of the center young Nelson had as much to be proud of as his father. But not all of his deals turned out well. A very public flap developed, for example, over the major murals in the entrance to the RCA Building. Young Nelson, later to become one of the country's foremost art collectors, was badly stung by the mischievous Mexican muralist Diego Rivera, who in the middle of his mural inserted a prominent portrait

of Lenin in an already radical motif. The Rockefellers, quite familiar with Rivera's leftward leanings since they personally owned quite a number of his works, should have known they were going to have their noses tweaked, and it fell upon Nelson to plead with Rivera that while such a thing might be fine in the home of a private individual, it was not suitable for a public place. Rivera, however, refused to remove Lenin and was sent packing with $7,000 of a promised $21,000 in his pockets. A year later the Rockefellers received the scorn of the art world when they had the mural destroyed.

Rockefeller Center has always been a great tourist attraction and one of the most exciting spots in New York. The RCA Building was especially a joy to the young, who now had a great skyscraper they could visit without prompting the cold and repressive glance of some elevator or security guard, the invariable fate of the unattached youth in the corridors of the Empire State Building or the Chrysler Building. The winding underground corridors strung out with shops of every imaginable kind were especially magnetic; tourists could spend hours wandering around there without going outdoors even once.

The radio industry was a strong magnet to tourists in the 1930s and 1940s. The masses were always drawn to the radio studio tours offered by NBC, although it was apparent that they were given only the most guarded and stereotyped view of the facilities. There was once a gallery near the 6th Avenue entrance in which were hung pictures of some of the great radio stars, many of whose faces were unknown to the general public. Visitors always hoped that some of these figures might be seen walking the corridors of the studios, but such encounters almost never happened. The stars entered the studio area by separate elevators undisturbed by the threatening crowds of tourists, who were as carefully herded around the facilities as the Intourist visitor in cold-war Moscow.

Even so, the tours of the studios were exciting enough. They almost invariably included a view of Studio 8-H, billed as the largest radio studio in the world. More often than not nothing was going on, but with luck some groups might get to see a rehearsal of the NBC Symphony with Arturo Toscanini conducting. The smaller studios, which were supplied with glass booths for tour audiences, were also usually inactive, but sometimes youngsters might be treated to a rehearsal of *Captain Midnight* and even a good look at the Captain himself as well as Pierre André, the famous seller of Ovaltine.

Before 1948 the tours of the studios were called Radio Tours, but with the coming of the television medium, radio quickly slipped into the background, and in only a year or so the tours came to be called Television

Tours. Too, the artificiality of the tours could more easily be disguised in television times by allowing tourists to see their friends and fellow tour members on television—several fully equipped rooms were set aside for this purpose.

The studio tours were not very revealing, but still they were enchanting, and few could pass them up on a visit to Radio City. It was similarly difficult to omit a visit to the Rockettes across the street at the Music Hall.

The observation deck in the RCA Building was also a big crowd pleaser. It was probably the best observation deck in New York because it afforded clear views of the parts of Manhattan that the average person wanted to see. The Empire State Building was slightly off the beaten track and lacked a good assortment of other tall buildings in the immediate vicinity. Also, in the 1940s, the Empire State Building had to put up some elaborate fencing to discourage the jumpers who for a while were frequent visitors at the highest building in the world. The observation deck at the RCA Building was open to the elements, and not fenced in. (The deck nonetheless discouraged jumpers since it was protected by a recessed ledge which would bring would-be suicides to their senses and give them ample opportunity to reconsider their decision.)

It cost only a nickel to get up to the roof when the building was first opened; soon it became 25 cents. But the elevator ride and the observation deck were well worth it. The RCA Building also had one of the first and best of the great rooftop restaurants in its Rainbow Room, which for many years was one of the most fashionable restaurants in New York. Anyone could enjoy its posh surroundings for the price of a cocktail, and the Rainbow Room offered fine views as well.

What made Rockefeller Center such an interesting place was that it fulfilled an American dream of providing elegance and drama for everybody. The artwork was civilized and understandable, the shops were posh and inviting, the galleries and lobbies were festive at all times of the year, (not just at Christmas, which seemed to be the season extraordinaire at the center), the attendants were courteous to even the most shabby and unpretentious of visitors, children felt at home everywhere, the gardens were an oasis in the summer, and the skaters in the sunken plaza were a delight in the months of frost.

No doubt it was the presence of wealth and success that made Rockefeller Center appealing to Americans. So it was said by Frederick Lewis Allen in an article written at the end of the thirties:

> Walk down the promenade from Fifth Avenue westward toward Rockefeller Plaza on a summer evening with the mighty flood-lighted prow of the

RCA Building looming up above you; look at the crowds gathered round the edges of the sunken plaza, watching the diners under the bright colored umbrellas below in the cafe, and listening to the music while the wind tosses the trees and the fountains play; go down the long corridor of the RCA Building, past the elevator bank, where clusters of well-turned-out people are waiting to be taken to the Rainbow Room and on to the lobby where sightseers crane their necks to see the NBC Broadcasting talent arrive — and you will see the tingle of Metropolitan success in the very air.

Allen believed there was more to it than mere material achievement:

For these buildings are not simply huge, efficient and comfortable. They are also gay. They convey the idea that people may work in agreeable surroundings and have a good time at it. They convey a sense of festivity. And that is something not often conveyed by the setting in which American business is conducted.

Rockefeller Center demonstrated that a mere collection of buildings, with admirably placed gardens, plazas and promenades, could inspire a feeling of festivity, of gaiety, not merely of the humdrum and the mundane. All this became obvious when in the 1970s the land west of Sixth Avenue began to be developed and filled in with imposing skyscrapers of the most modern design, including the Exxon, Celanese, and McGraw-Hill buildings. Although these buildings do not overtop the RCA Building, and are set back from Sixth Avenue by plazas so as not to crowd Rockefeller Center or destroy its breathing space, they nevertheless cannot seem to escape their destiny as purely utilitarian and functional representations of corporate America. They do not call out to the child or the fun-lover, but only to gray-suited adults. They are clean, severe, antiseptic, uninspiring, humorless, joyless, and their presence saps some of the spirit from the RCA Building.

John D. Rockefeller was a millionaire who could afford to play and to share his enjoyments with the general public. His like may not be seen again. In any case, no assemblage of buildings elsewhere in America has provided such a feeling of entertainment and good fun.

Chapter 11

OF ZEPPELINS, AIRPLANES, AND THINGS THAT COME FROM THE SKY

Moses King, the English-born writer of travel guides, was fascinated by the city of New York. Back in the days when the Singer and Woolworth buildings were making a rich visual feast of the city's skyline, King had a recurrent dream of New York — a dream of great and powerful buildings mingled and blended with every advanced form of motion and technology. In King's dream, illustrated in several editions of his book, *King's Views of New York*, giant skyscrapers are seen growing organically, plantlike, from the fertile urban soil. Snuggled down in this jungle of city life one sees moving staircases, subway and elevated trains of the most modern design, buses, automobiles, arches and bridges. Overhead, like butterflies trapped in some giant terrarium, are airplanes, dirigibles, and other imaginative vessels of the air.

In King's dream of future city life, these flying contraptions must have been a necessary part of the urban existence — conveyances, perhaps, for the messenger boy flying from Wall Street to catch a fast mail train at Grand Central Station. These airplanes and flying machines of King's, these navigable balloons, today seem to have a comic, surrealistic quality, as do some of his imagined buildings of Manhattan, recalling the odd towers and weird public places found in the paintings of de Chirico. The airborne creatures are remotely like the flying machines known to the world of 1910, but dreamlike, seen in a mist. No matter. It was obvious to King that the city of the future would require modes of air transportation, giant man-made bees and butterflies to cross-pollinate an otherwise static and ground-rooted culture.

Could King's dream have been realized? Could the tall buildings and canyons of lower Manhattan have played host to swarms of hovering aircraft — airplanes, balloons, dirigibles, and all the rest? They might have,

139

Moses King believed that the skies over New York would soon be congested by various flying contraptions. King's dream was never quite realized; the congestion is all in the streets. (From King's Views of New York, 1908 ed.)

had events unfolded differently. But to those of us living in the last half of the twentieth century, machines that fly are supposed to stay safely away from things that poke into the sky, and the old drawings of King seem to be a comic affront to logic. Flight in and amongst skyscrapers seems daft to modern sensibilities, with the exception of helicopter landings on the roofs of tall buildings. Though this practice caught on especially after World War II with the development of flat-top glass and steel buildings, it never developed on a large scale and the results were mostly disappointing.

The dream did not die easily, however, and on a few occasions the old King fantasy of standing skyscrapers being visited by curious creatures from the sky came close to being a reality. Of course as the airplane, that powerful instrument of American invention, became larger and mightier, the chances of its being compatible with skyscrapers diminished into nonexistence. The helicopter did not make its appearance for practical purposes until the 1930s and for commercial purposes still later, so for a long time it appeared that the only visitor to the urban jungle would be lighter-than-air craft of one sort or another, freed as they were from the necessity of rapid forward motion.

But even in this field of aviation nothing happened back in King's day, and, as things turned out, little progress was ever made. In the late twenties, however, it seemed for a brief time that real developments might be at hand. Large German-made dirigibles were in the news and were starting to be used on a fairly regular basis as a means of transatlantic transportation. In the summer of 1929, the immense German dirigible *Graf Zeppelin* amazed the world by sailing 20,000 miles around the world, and plans were made by the Zeppelin Company of Friedrichschafen, Germany, to put this craft into regular service between Germany and the United States in direct competition with the steamship lines which had once enjoyed a complete monopoly on the North Atlantic. (Even with the achievement of Lindbergh, use of the airplane for transatlantic passenger voyages seemed years off in 1929 — and was.)

So spectacular were the feats of the *Graf Zeppelin* in 1929 that the architects of the soon-to-be-built Empire State Building turned their minds to the possibility of mooring giant airships at the very highest point in Manhattan. And what an achievement this would be: the airship seemed perfectly suited to such an exploit, because even in its home port it was accustomed to "high landings" at giant mooring masts. In fact, high landings presented fewer problems than ground landings in these gas-filled monsters, supported by lighter-than-air hydrogen. Stubbornly they resisted being taken into captivity, requiring large ground crews to pull them in. They could more easily be brought to rest at a thousand feet.

The main advantage, though, seemed to be the commercial one. Here could be launched a direct and obvious threat to the steamship companies which in New York had to land people over at the unseemly docks on the wrong side of town. If a zeppelin could actually tie up at the Empire State Building, passengers could land only a few blocks from fashionable shops and hotels. The people in the lighter-than-air business both in Germany and America pushed for the idea, believed in it, laid plans and generated wild expectations. But in the end it all proved an elusive dream, not very different from King's dreams of 1910. It was not completely impossible, but it never quite worked.

In the planning of the Empire State Building, and for some time after the opening of the building itself, a great deal of publicity was given to the possibility of an airship landing. Gov. Al Smith, president of the Empire State Company, repeated the ideal to the newspapers:

> The Directors of the Empire State, Inc., believe that in a comparatively short time the Zeppelin airships will establish trans–Atlantic, transcontinental and trans–Pacific lines, and possibly a route to South America from the port of New York. Building with an eye to the future, it has been determined to erect this tower to land people directly on Thirty-Fourth Street and Fifth Avenue after their ocean trip, seven minutes after the airship connects with the mast.

But the number of these large airships outfitted for carrying passengers across the Atlantic was tiny; in fact, in 1931 there was only one, the *Graf Zeppelin*, and it was not supplanted on the North Atlantic route until 1936 when the *Hindenburg* was put into service. The United States had never been very successful in building the large dirigibles. It had a few in service, but in every case either the vessel was built in Germany or the crew was trained there. The U.S. Navy did have a number of small airships or blimps which it continued to use in costal reconnaissance until the 1960s, but none was suitable for the kind of transatlantic travel envisioned by Smith. Only the giant zeppelins were up to the chore, and the Zeppelin Company (which both manufactured and operated them) was not expected to turn them out like children's toys. The ships were extremely long, were complex to operate and land, and required large crews both in the air and on the ground—all factors which tied them severely to a few ports of call, at least in passenger service. The first large rigid ship of American manufacture, the *Shenandoah*, built in 1923, was wrecked in a violent storm in 1927. Another nominally American airship, the *Los Angeles*, was really the product of the Zeppelin Company, and although it navigated the Atlantic Ocean in 1924 (under the command of Capt.

Hugo Eckener, who later commanded the *Graf Zeppelin*), it brought no credit to American aviation. Two non-rigid dirigibles manufactured by the Goodyear Company, the *Macon* and the *Akron*, both came to grief after short lives. Only the Germans seemed capable of much success with these giant ships, and only the Germans had any experience with the passenger carrying business.

No zeppelin ever tied up at the Empire State Building, although Jerome Hansaker of the Goodyear Zeppelin Corporation declared that the project would be perfectly feasible. Two smaller non-rigid type ships did tie up at the Empire State a few months after the building's opening, but the results were disappointing to say the least. In September 1931, a small blimp managed to tie up at the mooring mast for three minutes but experienced considerable turbulence and a strong updraft caused by the building itself. A few weeks later, the Navy blimp *Columbia* made a similar attempt but experienced even greater difficulty and was almost upended in the attempt. In an effort to level the ship at the mooring mast the captain dropped some of his water ballast, producing a rather unwanted result in a city like New York. The water doused pedestrians within a radius of a few blocks from the building, surprising them greatly on a clear and cloudless day.

The only tangible result of the whole attempt was that the *Columbia* managed to drop a bundle of *New York Evening Journals*, although in the ship's haste to escape the terrible wind conditions, even this news drop was none too smoothly accomplished. The papers were dropped off at the edge of the observation deck, and a building workman had to retrieve them with the help of none other than building investor John Jacob Raskob, who held the workman's ankles as he drew in the bundle. The exploit was a dismal failure.

The fate of a giant airship of the zeppelin variety might have been somewhat different. These much larger ships contained elevators and stabilizers, and their crews were fully trained in the advanced art of holding a ship trim under difficult conditions. They might well have consummated a successful landing at the Empire State Building, but the operation could hardly have been successful for other reasons. The giant ships (it must be remembered that the *Graf Zeppelin* was nearly 800 feet long, the length of several city blocks) were designed with the passenger quarters inside the belly of the ship near the center. For this reason, getting passengers in and out at such a landing would have presented awkward and trying difficulties. Getting the vessel tied up was thus only one of the problems; even if docking were accomplished, the Zeppelin Company would be challenged to find a way to get babies, elderly people and

other timid passengers up from the underbelly of the ship and along precarious gangways to the nose of the ship. (Sending some unsupported 400-foot gangway out from the building along the flank of the ship to its midpoint would have been out of the question.) Even with the passengers in the nose, there remained the matter of transferring them to the building. So landing a giant airship at the top of a skyscraper, while not impossible, seemed to present a thorny set of problems not worth solving.

Fully aware of all these difficulties, and perhaps realizing that regular landings at the Empire State Building would be fraught with numerous complications (including the need for regular trained crews on the spot), the Zeppelin Company never even tried for an experimental touchdown with the Graf Zeppelin, but continued to take its transatlantic flights to the large U.S. Naval Air Station at Lakehurst, New Jersey, more than 50 miles from Manhattan. There it had full facilities for the complicated landing maneuver until the end of zeppelin service in North America in the spring of 1937.

While connection between lighter-than-air craft and skyscrapers in New York never became a reality, the zeppelins were a fine way to go sightseeing in New York. On their transatlantic voyages the captains of the Graf Zeppelin and later the Hindenburg were in the habit of flying low around the cities and giving passengers a full opportunity to enjoy the sights. Capable of very slow speeds, or even of pausing to rest above the city's spires, the giant ships gave passengers a delightful look at the city's geography, sometimes pulling right in among the skyscrapers and making a dead stop. One of the passengers on the ill-fated final voyage of the Hindenburg testified that it was possible to look right out of the ship and see people waving in the windows of the buildings. Of course the presence of these behemoths (longer than two football fields) was awe-inspiring to those below, and those who saw them over the city of New York will never forget the experience.

Alas, the expensive and inefficient zeppelins did not pass the test of time. They would probably have been done in by the airplane anyway, when the Atlantic span came within the reach of the big propeller planes. But the zeppelin era effectively came to an end on May 6, 1937, when the last product of the Zeppelin Company, the Hindenburg (LZ 129), burned in its landing maneuver at the Lakehurst Naval Air Station in New Jersey, killing 36 persons. The United States would not sell helium to Germany under Hitler's rule, and further flights with flammable hydrogen seemed out of the question after the Hindenburg disaster, so the Zeppelin Company soon folded.

But the 1930s saw the development of another flying machine that

seemed to have a brighter possibility of penetrating the dense urban jungle of skyscrapers and tall towers. It was the helicopter, a flying craft that, as every schoolchild knows, derived its lift from blades rotating about an approximately vertical axis. Being capable of perfectly vertical lift, and not requiring taxiing space, the helicopter seemed well suited to service in and around large cities, and perhaps even from the tops of tall buildings.

The helicopter was a long time in coming, and during the thirties it was still mostly an experimental craft and popular curiosity. After the Second World War, however, a number of serious and practical uses of helicopters presented themselves. They were effectively used in police work,

The Empire State Building was built with a mooring mast to land zeppelins, which proved to be a practical impossibility. Still, the huge crafts loved to park over Manhattan. Here is the Hindenburg at 3 P.M. on May 6, 1937, a few hours before it burned at Lakehurst, N.J. (G.D. Hackett Studio photo.)

in highway reconnaissance and patrol, and around the world in rescue missions of all sorts. Helicopters were able to play important roles in the military, and were employed in large numbers in the Korean and Vietnam wars.

As a passenger carrier the helicopter seemingly never achieved its expected potential, although from the beginning it was thought that there were numerous possibilities for transportation in and around cities. Early visionaries believed the craft might be used to relay people from one part of a city to another, to transport parcels, and so forth. None of these functions has been realized to any important extent, although in the United States helicopters have been used to connect major cities with outlying airports. Airport-to-airport or airport-to-downtown helicopter trips with regular schedules were eventually established in a number of cities including New York, Chicago, Los Angeles and San Francisco, though many such shuttle services eventually ceased operation.

The idea of landing helicopters on the roofs of tall buildings was not slow to dawn, but the implementation of it was. It was easier for the helicopters to use some airport closer to town or a landing pad at a lower altitude, and so they did for a long time. For example, New York Airways, which for a number of years served the New York metropolitan area, did most of its business connecting the city's three major airports, but for the convenience of some passengers during daytime hours it also had a downtown Manhattan landing. But this was at sea level at the foot of Wall Street. Operations here were successful for many years.

Midtown Manhattan seemed to have no such natural or easily accessible site for helicopter landings, so it was only natural that landings on top of one of the high buildings would be contemplated sooner or later. The older styles of skyscrapers — such as the Empire State Building or the Chrysler Building — could not have permitted such landings, but after the 1950s, with more and more box-type buildings with large flat roofs coming into being, the landing possibilities were expanded. It was altogether suitable that the Pan Am Building, right in the heart of the midtown area, only a stone's throw from Grand Central Station and the old airline bus terminal, should play host to this very convenient and attractive form of transportation. And so, with the approval of the Federal Aviation Administration, New York Airways constructed a heliport atop the Pan Am Building to provide easy access to the heart of Manhattan from the various airports.

Regular flights were planned and carried out with success, although passengers were generally not as pleased or as comfortable with these high landings as they were with the less dramatic ground-level landings. In the

end, though, these high landings seemed as doomed as the services of the ill-fated Zeppelin Company. On May 16, 1977, a nasty accident involving a New York Airways helicopter on the roof of the Pan Am Building brought a suspension and eventual discontinuation of that service, which previously had been judged satisfactory.

New York Airways did not give up on its desire to glean the publicity and prestige provided by landing atop city skyscrapers, and in early 1978 it received approval to make landings downtown on the roof of one of the twin World Trade Towers. This service might well have enjoyed long popularity, but the days of New York Airways were numbered for other reasons. After another bad accident at Newark Airport it went out of business and the idea of flights to the World Trade Towers was abandoned. Another helicopter line came in to pick up the pieces of New York Airways, and this line used much smaller helicopters, making its city landing not atop the World Trade Towers, but a few blocks south at the Battery Heliport.

Helicopters have probably not been resoundingly successful for a number of reasons having little to do with technical achievement. They are very expensive to ride, and therefore have never appealed to the masses or developed a regular clientele. Many people might be tempted to give it a try, but the hurried and busy executive mostly found the service — subject to the vagaries of weather and other problems — more a bother than a convenience. For less money a cab could leave the airport immediately and deliver its passenger at a specific address at a reasonably precise time. So the helicopter was a great invention, but it has been a marginal passenger carrier and is likely to remain so.

The airplane was an altogether different matter. Whatever Moses King may have dreamed in 1905, the airplane was never a welcome visitor in large cities, and it came to be an object of fear and trepidation. The airplane is a creature alien to downtown areas, and if those in skyscrapers think about them at all, it is of the dreadful possibility that some misguided flight might crash in at the seventieth or eightieth floor. Great pains are taken to see that this does not happen, and admittedly the threat has been minimal. The possibility nonetheless continues to exist, and one suspects that it is not often completely absent from the minds of passengers who fly into or near the great American cities.

Mercifully, only one airplane has ever crashed into a major American skyscraper. It was on July 28, 1945, when an army B-25 bomber crashed into the north side of the Empire State Building, killing 14 people. It was an earth-shattering day in the lives of New Yorkers who always knew it could happen, but who had lived with the facile belief that it was not supposed to happen, and probably would not.

The Empire State crash has never been adequately explained, but the main facts are clear enough. On a dark and foggy Saturday morning, only weeks before the end of World War II, Lt. Col. William Smith of the U.S. Army Air Corps had filed a flight plan allowing him to bring his B-25 from Boston's Bedford Airport to Newark Airport. He landed instead at New York's Municipal Airport, now La Guardia Airport, before continuing the trip to Newark, less than 10 miles away. In those times commercial aviation was at a virtual standstill, and military craft predominated at all of these airports. The control tower at the New York airport was suspicious of the weather over Manhattan—and Manhattan lay smack in the middle of Smith's course to Newark. Controllers advised against the trip. However military meteorologists reported better conditions near Newark, and eventually their views prevailed and Smith was allowed to take off.

Smith knew that he would be over Manhattan and that he would have to be at an altitude of at least 2,000 feet. Why he never gained that altitude is not altogether clear, but there is some evidence that he was having engine trouble or trouble with his rudder. Smith soon found himself flying low over midtown Manhattan, right over 42nd Street in fact, and in this vicinity some witnesses claimed that he was at an altitude of no more than three or four hundred feet. Seeing a jungle of buildings, Smith swerved to miss some of them, then banked to the left, unwittingly setting himself on a direct course for the Empire State Building. In the final seconds of his flight the plane was apparently ascending quickly—but not quickly enough to clear the tallest building in the world. At 9:49 A.M. the 12-ton bomber crashed into the seventy-ninth floor of the building. So powerful was the impact that one of the plane's engines sailed right through the building and out the other side, landing on the roof of a building on 33rd Street.

Quite luckily, the seventy-ninth floor of the Empire State was only partly occupied that Saturday morning, but a handful of workers of the Catholic War Relief Services were at their desks, and many of them were killed; 26 were injured. Needless to say the three crew members on the plane were killed—but in most cases the deaths were quick and merciful, the victims incinerated in a terrible conflagration as the airplane's fuel broke into immediate flames.

The crash did not do any major structural damage to the skyscraper, but it left a gaping hole that needed repair, and it did considerable damage to the seventy-ninth floor and to elevator equipment, interior service equipment and the like. It was a frightening experience, and an expensive one, since no such laceration in a building like the Empire State

could be a minor matter. Repairs took a whole year and cost a million dollars.

Happily, incidents of this kind have not been repeated in the years since, even as commercial aviation sent hundreds of thousands of planes into the air in the period of postwar affluence and prosperity. Fears have mostly abated, although the potential for collisions between airplanes and skyscrapers has always lurked as a dark and shadowy possibility. It is well known that landing patterns of many major airports take commercial flights right over busy metropolitan areas, and some of the older airports are dangerously close to the city. One thinks of those near New York (at least two and perhaps all three major airports), Boston (Logan), Washington, San Diego, Minneapolis, Philadelphia, and others. Nearness does not necessarily present a problem—Newark Airport, serving New York, is only seven miles from the spires of lower Manhattan, but none of the approaches is over those buildings. But even when cities are 15 or more miles away from a runway touchdown point, the distance can seem very short and threatening in the age of the fast-moving jet airplane.

An approach pattern for one of the runways at La Guardia Airport sends planes directly over Manhattan, which affords splendid views for passengers but brings back memories of Col. Smith and his ill-fated flight. Early in 1981 a near miss was reported in New York when an Argentine Airlines plane preparing to land at John F. Kennedy Airport was headed in over the World Trade Towers in lower Manhattan. An air traffic controller monitoring the radar screen for that airport noticed the altitude of the plane was alarmingly low (1,400 feet) and gave instructions for the flight to bank sharply and climb to avert what would certainly have been a catastrophe.

Moses King's dreams of New York were never realized: Things that fly and things that are rooted to the ground and point to the heavens can only enjoy an uneasy truce. The airplane and the skyscraper are both dramatic manifestations of the American material culture, and one would like somehow to see them united and harmonious. But at present it appears that the two must remain separate and distinct.

Chapter 12

THE HUMAN SPIDER
AND OTHER FANCIES
OF THE SILVER SCREEN

They are inert and lifeless things, but skyscrapers nevertheless stir the entire gamut of human emotions from envy and rage to hope and desire. Above all, they are dramatic, and they inspire acts of drama. Alas, there is no play written for the stage which is built around the appearance of a skyscraper, although some stage scene designers have done lovely backdrops of city skylines. But there is one medium of the imaginative arts for which the skyscraper is ideally suited, and this is film. The motion picture can not only capture and encompass the skyscraper, but it can transform it almost miraculously into a thing of motion, fury, danger or ecstasy. Skyscrapers house thousands of workers, they are representative products and symbols of urban life, they hint at excitement and sometimes danger, their appearance is awe-inspiring and they can invoke a multitude of emotions from fear to sexual excitement. So it should surprise no one that skyscrapers have appeared in hundreds of films, sometimes even taking starring roles.

It all began very early in movie history, since the major American motion picture studios were located in cities and were naturally drawn to city life and city action. The first city involved was New York, but around 1915, with the shift of the industry to the year-round salubrious climate of southern California, the city was Los Angeles. In the early days in New York some of the famous studios, such as the Edison Studio and D.W. Griffith's Biograph Studio, did most of their shooting right in their cramped city quarters, sometimes venturing out to Englewood Cliffs or to some Jersey meadow or suburban town for authentic outdoor settings. But nearby buildings and city streets beckoned—and were used frequently.

One movie name more than any other has been associated with skyscrapers over the years, and that is Harold Lloyd, a lad from Nebraska who

once aspired to be a serious dramatic actor but who, by chance, discovered himself instead as a movie comedian. If the skyscraper has more recently been the tool of the melodramatists of the movie, it was Harold Lloyd who proved that tall buildings could be fun — or, more precisely, fun and thrilling at the same time. Some of Lloyd's antics were copied by stuntmen in later years, but Lloyd brought the skyscraper to the general public's attention and his great sequences on the high walls have never been equalled.

Harold Lloyd's whole life seemed to be a series of fortuitous circumstances, and his discovery of the comic and breathtaking possibilities of tall buildings happened by a stroke of luck. Born in Burchard, Nebraska, in 1893, Lloyd referred to himself in his autobiography as "just a plain, freckled, ornery kid." Everything about him was ordinary, but especially his appearance, for all his life he continued to enjoy a classical nondescriptness. This nondescript quality was deceptive, however, for Lloyd packed an inner wallop that was to animate his later comic personality. And as time would show, he was a very athletic individual, with the grace of a dancer and the agility of a high-wire acrobat.

Lloyd's father moved to San Diego in 1911 after winning a large judgment in an accident case, and the choice of southern California was at least partially dictated by Harold's desire to get into movies. It just so happened that around that time the Edison Studios had established itself in Long Beach and came occasionally to San Diego for location shots. Lloyd's first appearance on film was as an Edison extra — a one-day role in which he played a naked Yaqui Indian for $3. Later the Lloyds moved to Los Angeles where Harold managed to get a very occasional extra job at the mushrooming Universal Studios. While at Universal, Lloyd met another underemployed extra, Hal Roach, recently in from Elmira, New York, and the two became close friends. In the years ahead they joined up to make one of the most successful teams in the world of comedy.

Roach came into a small inheritance and decided to make movies on his own — a wise decision since he and Harold were making only $5 a day as extras. Roach was impressed with Lloyd's comic talents and started to look for an identifiable comic personality for him. One idea was a character called "Lonesome Luke," which was inspired in part by Charlie Chaplin's "little tramp" character. Lonesome Luke went to the opposite of the Chaplin character. Chaplin wore loose-fitting, baggy pants; Lonesome Luke wore suits that were too tight. The Chaplin character wore big floppy shoes; Lloyd went out and bought some size 12 AAA shoes that must have been torture to wear. For a while Roach and Lloyd stuck with this character, although it seemed to have real limitations. But in a number

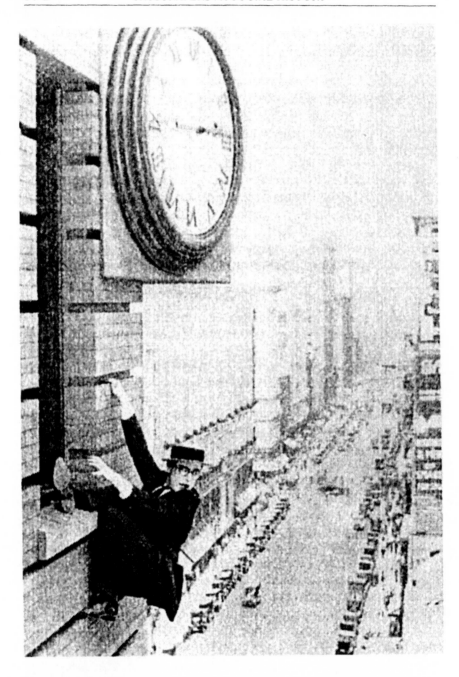

No actor of the silver screen succeeded in making the skyscraper more dramatic than Harold Lloyd. Lloyd did all his own stunts, as in this film of 1923, Safety Last.

of one- and two-reelers they learned the kinds of things Lloyd could do best, and by 1917 Lloyd launched a new character that was to stay with him throughout his career—a plain-looking bespectacled American boy that people could identify with as the boy next door.

The character was derived partially from a role Lloyd himself found when he attended a local movie theater and saw a film about a meek clergyman that anybody could push around, but who would turn into a tough and very effective he-man when the need arose. This was the fellow that Lloyd was to play in his many later movies. And it was a perfect comic device, because out of this stiff and seemingly inert little chap could burst all kinds of wonderful things that nobody would dream of, but that were quite within the capacities of the wonderfully agile and robust Lloyd. Here was a little bookworm or college professor chap who could climb up the side of a cliff or take charge of a runaway train when he had to.

By 1919 Harold Lloyd was a top-flight movie star, and with Roach and others he was churning out an unbelievable number of successful one- and two-reelers. The most memorable of all his films was probably *Safety Last*, released in 1923, in which for the first time Lloyd made one of his thrilling climbs up the side of a city office building. He was to do the stunt in later pictures, and he was in constant demand to repeat it. With the passage of time the stunt became closely identified with Lloyd, a signature role so to speak. Indeed, in later life Lloyd was a little rueful that the skyscraper pictures were so vivid in people's memory. "Doesn't anyone remember my other pictures? I made close to three hundred, and only five were thrill pictures." And it certainly does not follow that these "thrill" pictures were Lloyd's best, but they certainly showed off his physical talents effectively.

In those early days Lloyd developed most of his own ideas for pictures, and the skyscraper stunt was no exception. The idea for it came to him one day when he was walking down Seventh Street in Los Angeles and saw a large crowd outside the Brockman Building. It seemed as though some crazy fellow was about to climb up the outside of the building. The fellow was a steeplejack named Bill Strothers, and he was going to put on a little show for the gaping bystanders. This was not completely novel, incidentally, since steeplejacks were fairly common in those days, although dwindling in numbers as were the objects of their trade. Many of them became show-offs, and crowds often gathered to watch them at work on steeples, many of them hoping to see some grim accident.

Afraid to watch the spectacle, Lloyd walked around the corner of another building. He peeked around at the stunt, ready to draw back at a moment's notice. He was sure that the fellow would kill himself. But up

and up he went, following the window line, until finally he reached the roof. "I still don't know how he could possibly have done it, but he did," Lloyd remarked. After he got to the top Strothers rode a bicycle around the top. Then he went out to the end of a flagpole and stood on his head.

Lloyd was convinced that this kind of thing would work quite well in one of his films, and he immediately hired Strothers to come over to the studio and be the stuntman. Lloyd at first had no idea of doing any such crazy thing himself. Unfortunately Strothers, who was uneasy around movie folk, quickly broke a leg and other stuntmen had to be called in. Alas, none of them worked out since this kind of comedy depended almost entirely on the use of close-ups. So if Lloyd wanted a building climb sequence, he would need to do it himself. And he did.

The thrill was there, and it was real. Harold actually had to dangle from a clock's hands, make his way up a sheer wall like a human spider, and teeter along the roof's edge and from narrow ledges of upper floors. He was his own stuntman and he really did the stunts; there was no trick photography involved. That is not to say there was no protection. When he was working on a particular ledge or window the company placed a platform covered with mattresses some 15 feet below, though it is doubtful that they would have provided much protection. Once a dummy was dropped onto one of the platforms and it bounced off and fell to the street many floors below.

The technology for faking such shots did not exist in those days. There was no back projection, and recent techniques of doctoring the film were in the distant future. Lloyd had to do everything himself, and in *Safety Last*, his first feature "thrill" movie with the human spider routine, the filming of the sequence took months of preparation and rehearsal. "I was crazy to do it," Lloyd repeatedly said in later years. But the results were spectacular, ranking among the great moments in the history of the movies. The danger looked real because it was real. And of course it was choice material for the silent screen, because all of the scenes were purely visual—long stretches of perfect melodrama could be achieved without the need for a single subtitle.

Harold Lloyd made several hundred films before retiring in 1938, and he was one of the most successful movie personalities of all time. He was an exceptional manager of his own properties, and unlike some silent film stars who died in unhappy oblivion or in alcoholic collapse in some retired actors' home, Lloyd amassed one of the great American fortunes (for years *Fortune* magazine had him on their list of wealthiest Americans), became a considerable public benefactor and remained an all-around likable

person. He married his leading lady from *Safety Last*, Mildred Davis, and, as the saying goes, they lived happily ever after. Carefully nurturing and managing all his old films, Lloyd lived to see himself become popular all over again in the 1960s and 1970s, both in movie houses and on television screens.

And it was those great human spider scenes that pulled the audiences just as they did in the 1920s. Television is said to be the medium that people can watch while washing the dishes. But two or three seconds of Lloyd on the upper wall is usually enough to whip any usual human distraction. Their appeal is timeless and irresistible.

Lloyd never made extravagant claims that his cavorting above the city streets was a piece of cake. He was scared to death, as perhaps any ordinary mortal would be, and he would have gotten out of it if he could have. During the silent film days, however, there were calls for more of the dare-devil stuff, and with his fame pinned to it, Lloyd frequently found the role difficult to avoid.

Some people expected him to perform his human spider act on a moment's notice. In 1923, shortly after the release of *Safety Last*, Lloyd was in Chicago to promote the picture in a town where three dominant distributing organizations had the town's theaters sewn up and were not offering enough money for *Safety Last*. Lloyd and his producers decided to sponsor the film themselves. To gain publicity somebody in Chicago got the idea of having Lloyd dedicate the twenty-fourth-floor clock on the central tower of the newly opened Wrigley Building.

Lloyd made it clear that he had not the slightest intention of climbing around on the Wrigley Building, an intention his local supporters had obviously anticipated. To pull the stunt off they had hired a stuntman to dress in Lloyd's clothes and go up on the tower. He was to be lowered over the edge of the building in a boatswain seat and then make a daring pass at the giant clock with a bottle of champagne. The idea was that Lloyd would greet crowds out in front of the building, have photos taken, and then disappear inside the building, after which the paid human spider would take over, dressed in identical clothes and wearing the expected Lloyd-like spectacles. There were thousands of people waiting for the great moment, prompting Lloyd to exclaim, "My God, is everybody in Chicago here?"

But the prank never came off. The winds were blowing in typical Chicago fashion, and the substitute human spider would have nothing to do with being whipped around on top of the Wrigley Building. He decided against attempting the stunt.

"What are you going to do now, Harold?" asked the promoters.

"Would it be possible for you to substitute for the human spider like you do in your movies?" A typical Harold Lloyd plot seemed to be in the making, but Lloyd insisted that he most certainly would do no such thing. "Instead," he recalled, "I asked for a megaphone and permission to speak to the crowd from the top of an automobile. I told the crowd exactly what had happened, play by play. The story was so funny that the audience took it as a substitute for the deed." The clock on the Wrigley Building was never dedicated.

In the years since the hilarious antics of the human spider, the skyscraper has only occasionally been the central prop in films, although hundreds of movies have offered glimpses of skyscrapers as an easy symbolic presentation of urban life; good action shots of tall buildings have been used over and over again as a way to open films, to provide transitions, or simply to set a scene. Occasionally they have been used to introduce some quick-thrill action, with threatened suicides from high places, or perhaps a good chase across the roofs of high buildings, invariably resulting in a long drop for the bad guy.

Hollywood filmmakers have used New York as a backdrop over and over again, and in doing so have sometimes used film clips of famous buildings for long shots. But since the days of Lloyd, there has been a shift away from photographing real buildings, with cameramen preferring to use sets and trick photography for close-ups and models for cityscapes. The latter has been necessary, of course, in many science fiction and horror films in which buildings must be devoured by snakes, giant monsters or other unpleasant creatures.

Model cities also give free rein to the imagination and allow effects that would be impossible with the real thing. A good example of such effects from the silent days was the strange and moving city created by Fritz Lang for *Metropolis*, a German film of 1926. Lang's aim was to create a futuristic fantasy about the grim fate of urban life, and he wanted to use a cityscape that was both like and unlike New York. This movie was made long before Lang's immigration to the United States, and his ideas of New York were apparently not firsthand, but the film is exceedingly interesting nevertheless. The set created for the city seems to have been inspired in part by Moses King's old views of New York from 1910, with the buildings given a kind of futuristic facelifting.

Metropolis remains a moving and thought-provoking film, although the acting is crude and the story heavy and ponderous. The film introduced to many people in the United States and abroad the idea of the stifling quality of city life and the hideous possibilities of totalitarianism in dehumanized buildings and tunnels — ideas that were exploited in many a

later film, including George Orwell's *1984*, and in numerous other imaginative visions of the triumph of technology over humanity.

Science fiction and horror filmmaking blossomed in the 1930s, and Hollywood movie makers working in this vein had to follow Lang's precedent in using models of New York or other cities with a futuristic appearance. After all, New York officialdom might look kindly on almost any other aspect of movie making, even when it meant holding up city traffic for hours, but it was an altogether different matter to have giant monsters stepping on thousands, knocking over buildings and making a snack of their inhabitants.

The granddaddy of all of the New York City disaster films, and perhaps still the best to this day, was *King Kong*, released in 1933, which delighted hordes of Depression-stricken movie goers looking for something really bad to happen to a New York whose riches seemed paralyzed and useless. The great theater magnate Roxy simultaneously filled his two mammoth movie palaces, the newly opened Radio City Music Hall and his older RKO Roxy a block away, with this wonderful practical joke played on the citizens of the city.

The whole Kong idea seems to have been the brainchild of Merien C.

The German film director Fritz Lang made his film Metropolis *in 1926. Most likely he was strongly influenced by the earlier futuristic images of Moses King.*

Cooper, one of the country's best-known and most respected documentary filmmakers. Cooper became interested in the life style and natural habitat of African gorillas while working on Paramount's *The Four Feathers* in 1929. While tossing fitfully in his faraway African tent, Cooper conceived the idea for a film about a giant ape of superior intelligence running wild among the streets of some civilized metropolis. (Of course there was no doubt which metropolis this would be.) Cooper, with his background in documentaries, originally hoped to accomplish everything with live gorillas and lizards, enlarged by means of trick photography.

Later on, when Cooper moved to RKO from Paramount, he took a look at some models of jungle scenes and other special effects made by the brilliant and resourceful Willis O'Brien, and the decision was made to film *King Kong* completely in the studio using models and other special effects. A film about a giant ape that had to interact throughout the film with miniature humans called for the invention of a multitude of new movie technologies. To photograph Kong holding human miniatures that would then be replaced by a live human actor for close-ups, O'Brien used expensive and painstaking stop-motion photography. He also had to make extensive use of miniature rear projection, multiple printing, and traveling matte.

King Kong starts in Manhattan, and the story returns there in the end. In the meantime the viewer is treated to a five-reel build-up, which surely must account for much of the film's success and popularity (a gorilla, one suspects, has only a limited bag of tricks which are better held in abeyance). Still, the most memorable scenes of the movie are not those in the jungle, but those in Manhattan, where Kong has become reconciled with the lovely Ann Darrow (played by Fay Wray), with whom he had become enamored in earlier jungle scenes. Kong obviously is not a welcome addition to Manhattan society; his ways and manners (to say nothing of his size) clearly make him *persona non grata*. He in turn has even less affection for city ways and immediately begins to make a nuisance of himself. In fact, he wastes no time at all kicking up the place, stamping people at will, and knocking over towers, buildings and elevated railways. There are some splendid scenes, including a particularly violent one in which the bad-tempered Kong throws a woman right out of a building to the sidewalk several stories below. In another scene, viewers are brought up with a start when a giant eye peeps through the window of a midtown hotel.

The great finale of the film is Kong's last stand, which takes place atop the newly opened Empire State Building, the tallest building in the world—here constructed from models. After doing plenty of damage to

New York and killing thousands, Kong perches on the Empire State Building (none too comfortable with its spire top) to have his final fling. Here he is ultimately polished off by fighter airplanes, after making a shambles of the nearby neighborhoods. New Yorkers, many of them standing in bread lines, must have loved it.

King Kong enjoyed many revivals over the years, but by the 1970s it was apparently felt that a new version, taking advantage of modern special effects, was in order. The new film, quite similar in basic outline, was released in 1976 and enjoyed considerable commercial success, although it lacked the impact of the original. Still, the New York scenes were very well done. The Empire State Building, dethroned as the tallest building in the world, was replaced by the twin towers of the World Trade Center, and to very good effect. Indeed the towers seemed almost to be designed for Kong, since he could comfortably rest his legs on each tower, and deal destruction to the groundlings below in relative comfort as compared to his perch on the spired Empire State Building.

King Kong was the first of the oversized troublemakers to visit New York, but he was by no means the last. The succeeding decades saw a long stream of similarly destructive visitors. It is interesting to note that nearly all these giant apes, gorgons, godzillas, mammoth lizards and other similar nuisances were drawn specifically to New York as the place for their mischief, apparently unable to resist skyscrapers and great masses of people.

Among the more successful later pictures which required models of New York and the destruction of skyscrapers was a Warner Bros. picture from 1953, *The Beast from 20,000 Fathoms,* based on a very respectable story by Ray Bradbury. In this epic, more scientifically plausible than *King Kong,* underwater atomic tests wake up from their lethargy some giant prehistoric reptilian creatures, who eventually make their way to New York where they misbehave splendidly. The sets and models here are more slick and realistic than those for *King Kong,* and are the work of Ray Harryhausen, one of the most talented special effects artists of film history.

The considerable success and visual triumph of *The Beast from 20,000 Fathoms* resulted in a spate of similar movies about unpleasant creatures of the scientific imagination: *Them!,* which saw the birth of a swarm of 15-foot ants; *It Came from Beneath the Sea,* in which the villain was a giant octopus; and *The Monster That Challenged the World,* in which a gargantuan mollusk ran amok. By film's end, of course, modern technology is able to deal firmly with all such creatures. These films were all the product of the 1950s.

It is comforting to report that not all of these agitated creatures took the United States for their stomping ground. The Japanese seized on this theme and made a great many films about city-destroying monsters, the most infamous of which was Godzilla (*Godzilla, King of the Monsters; The Return of Godzilla; Godzilla versus the Thing*). Needless to say this Japanese troublemaker had little interest in New York, and instead took out his destructive urges on Tokyo.

Monsters were not the only threat to New York from the sci-fi and horror movie makers. Another 1950s film, *When Worlds Collide*, produced by George Pal, had some very realistic and believable models of New York, and in this case the city was done in by a great tidal wave, which is seen sweeping through Times Square. The models, photography and sets won a well deserved Academy Award for special effects.

Epic disaster films in the 1970s attempted to introduce more believable and realistic detail, and they tended to focus on weaknesses and lapses in technology that people know about and might even expect. One thinks of such films as *Earthquake* and *The China Syndrome*. During this period there arrived the only film in which a skyscraper was really the star — *Towering Inferno*, released in 1976. Here, a giant modern skyscraper is ravaged by fire, after a long and rather convincing build-up in which the audience is made to see (and believe) that fire, even in these most modern of buildings, is not at all an impossibility. A slick and very well done film of producer Irwin Allen, *The Towering Inferno* made use of the talents of Paul Newman, Steve McQueen, William Holden, Faye Dunaway, and Fred Astaire.

The Towering Inferno, even if over-dramatic, was sufficient to prove what a lot of people have forgotten in recent years, that there is no such thing as a fireproof building. Wherever there are things that can burn, fires are possible. Modern stainless steel buildings are relatively fire-proof, and most of them have elaborate fire detection and firefighting equipment, but the fire in the Las Vegas MGM Grand Hotel in the fall of 1980 reminded the wider public that even the most up-to-date and scientific high-rise buildings are not completely immune to the ravages of fire. And if this were not proof enough, the lesson of *The Towering Inferno* was taught again in Las Vegas with three other hotel fires in the months that followed, the most important of those being a devastating conflagration at the Las Vegas Hilton — the world's largest hotel, with 2,783 rooms — in which eight people were killed and 200 injured in February 1981.

As yet no major American skyscraper has ever been the victim of a disastrous fire. But fires do happen. The World Trade Towers, with very elaborate detecting equipment and numerous fire personnel, had over

twenty significant fires in the first five years of their operation, including a three-alarm blaze in the eleventh floor of the north tower in February 1975 which burned for three hours and spread to other floors via the insulation of telephone cables, causing a million dollars in damage. Considerable fire and smoke damage also followed in the wake of the World Trade Center bombing in 1993. So *The Towering Inferno*'s warning was far from being totally fanciful.

Threats to a skyscraper's well-being come from many sources. An excellent 1988 film, *Die Hard,* told the story of a cop who has to deal with terrorists holding a skyscraper to free his wife and children. This action-suspense thriller perhaps foretold some anxieties that would be all too real within a few years.

Danger, of course, has always been one of the compelling attractions of skyscrapers for movie makers. The shell of the building in and of itself presents little threat, but potential hazards (fire, power failure or human malice) are all about. Among the working parts of high buildings elevators have always had a dramatic attraction, and movie makers have not failed to capitalize on the possibilities inherent in elevators that fall, or trap people, or otherwise go wrong.

Fatal accidents involving elevators are very rare, although movie-goers must be aware that an elevator that just goes up and down in routine ways is not very exciting. So, the heroes and heroines of a great many movies get trapped in elevators, dropped to the basement, or otherwise traumatized. Elevators provide a convenient means of murder, as in such movies as *House of Wax* and *The List of Adrian Messenger,* and for suicide, as in *Ivy.* It is even more common for people to become trapped in elevators in films, as in *Cry Terror, A Night in Casablanca, Love Crazy, Sweet Charity,* and *Lady in a Cage.*

Not all of these elevators were in modern skyscrapers, to be sure, but elevators are sufficiently dramatic to have whole movies built around them. In *Lady in a Cage,* for example, an old-fashioned open-cage lift in a fashionable apartment house, in which Olivia De Havilland is trapped and threatened for an entire movie, turns this highly civilized and refined lady into a wild maniac in the course of an hour.

Scenes where elevators fall in modern commercial buildings are nearly always technologically far-fetched, although from time to time an effort is made to justify a runaway elevator. In *Hotel* (1967), a refined but dipsomaniacal English lord, played by Michael Rennie, plunged to his death in a hotel elevator, after the producers made a feeble (and inaccurate) effort to show how such a thing could happen. Still, the scene probably was convincing to the uninitiated. (Michael Rennie seemed to be jinxed where

elevators were concerned, for he also had trouble with them in *The Power* and *The Day the Earth Stood Still*.)

The dramatic potential of elevators for horror and violence was exploited in *Diamonds Are Forever* when Sean Connery, as James Bond, had a brutal fistfight in one. In 1980 Brian DePalma, the great master of erotic macabre, staged a gruesome stabbing in an elevator in *Dressed to Kill*.

So whatever one can say about the inertness, the fixedness, the immobility of skyscrapers, they remain exciting and dramatic places. For the most part, however, the movies have used skyscrapers not as protagonists for dramatic action in their own right, but as symbols and as fixed stage settings either for city ambience or for office intrigue. For every King Kong and for every falling elevator, there have been hundreds of movie sequences in which the skyscraper supplies requisite footage of people clawing their way up the corporate ladder (in Hollywood iconography the executive suite is always at the top of the building), or with romance in the steno pool, or for purely mechanical aspects of urban life. Few movie-goers will forget the clattering machines and dehumanized qualities of Jack Lemmon's office in *The Apartment*.

For Hollywood — itself the product of unbridled capitalist lust in the eyes of many — denizens of skyscrapers are invariably backstabbers, larcenists or wheeler-dealers. One thinks of the many films of the *Wall Street* variety, which haven't changed much over the years, except that women have now joined the ranks of the backstabbers and are often more successful at it than the male plutocrats of old. And it should be noted that even in *The Towering Inferno*, in which melodrama actually did swirl around a tall building as a physical presence, much of the storyline was built around cheating designers, architects and builders, grasping money men, crooked politicians and the like.

So the movie skyscraper has always been shrouded in the mists of fantasy and make-believe instead of more prosaic reality. Still, the make-believe has almost always been so good that few of us have minded.

Chapter 13

A VIEW FROM THE DECK

Skyscrapers may be places of daily toil and routine tasks to the countless thousands of workers who enter them on a weekday morning, but to those who come to visit, and those who crane their necks from the sidewalk below to the glistening tower above, a skyscraper may be a thing of excitement and awe. For the first-time visitor to a large American city, or to the person who has never seen a skyscraper, the immediate and often overpowering desire is to get to the top and look down. Being able to go up to their highest point and then look out from such a lofty vantage point to survey the great city underneath seems to validate the building of these great towers.

Building owners and managers were not slow to appreciate these impulsive desires, and from the earliest days did what they could to accommodate visitors and reap whatever public relations benefits might result from entertaining tourists and sightseers. Sometimes rooms were set aside on the top floor for observation purposes; sometimes the public was permitted access to the roof. Later on, with the coming of real giants like the Woolworth Building, architects ministered to these natural human desires by including in their plans an official observation platform or deck designed to give tourists a good view of things.

Observation decks, or at least vantage points or lookouts, are doubtless of considerable antiquity. They were probably known in some of the imposing buildings of ancient Rome; certainly provisions were made in some of the magnificent cathedrals in the Middle Ages. In New York, old Trinity Church, for many decades the tallest structure in the city, offered a modest few slats from the steeple through which visitors could view the ships' masts, wharves and counting houses of lower Manhattan.

Of course any kind of verticality suggests the possibility of a view or vantage on the world; the structure need not be a skyscraper. The kind of obelisk or monument represented so well in the United States by the Bunker Hill and Washington monuments would not seem to be completely

163

serving its monumental function without the inevitable little slanted holes whereby visitors might look out after an arduous climb (or in more recent times an elevator ride) to the topmost point. Gustave Eiffel would have been foolhardy indeed if he had dreamed of a giant tower, command-ing all of Paris at its feet, and had not planned some kind of platform or lookout to dramatize and explain this advantage. On the Eiffel Tower the elevators were slow and crowded, visitors often suffering long waits, but there was never any lack of a human throng waiting to undergo all of the indignities to attain that sumptuous view.

So it has been in the United States with the Statue of Liberty, that great lady of New York Harbor who, since her unveiling in 1886, has "lifted her lamp beside the golden door." For all of the millions who viewed the statue as they entered the new world through New York Harbor and saw in it a symbol of liberty, many other millions, native born and otherwise, had a strong desire to visit the statue and climb up in it. The French sculptor Bartholdi had made provisions for them to do so — both in the head of the statue, where a little observation deck was concealed under the cap, and in the torch, which offered a tiny open platform that could hold a small number of visitors. (The arm was later found to be structurally unsound, so the torch was eventually closed to visitors.) Alas, the Statue of Liberty has never been able to accommodate all of the millions of peo-ple who would like to visit it and climb to the head. The head (only 10 feet across from ear to ear) can obviously hold only a small number of people at one time, so the boatloads of visitors who go out to the statue contain many who will not be able to get to the top. The limitations are practical rather than official, but they are real nonetheless.

The major buildings in New York (the world record holders at least, and some others as well) offered greater opportunities, and they were quickly exploited. The strange china-closet windows of the Singer Tower offered a delightful view of lower Manhattan in the few years that that building ruled the roost. The Woolworth Building sported an open-air platform amidst its Gothic spires and battlements, and during the nearly two decades when that building was the highest in the world, millions of visitors to New York took in the view, lifted to the deck by high-speed elevators so that even the aged and the infirm faced no difficulties.

But there was nothing like the Empire State Building for con-venience, openness and ease of access, so the observation deck there became more than just an accepted convention to the building's owners. During the grim 1930s, when the building was jocularly called the Empty State Building, the observation deck was a real sweetener in the owners' cup of tea. The deck was a big money maker from the very beginning, and

because of the superb public relations talents of Al Smith, president of the Empire State Co., who was ever hauling beauty queens, heads of state and foreign dignitaries to the eighty-sixth-floor observatory, the observation deck proved to be a perfect selling tool for the building itself, as, during the late thirties, the building slowly filled up, office by office and floor by floor.

There were competitors to the Empire State Building's observatory, some very effective, others much less so. From its opening the Chrysler Building (for a year the tallest in the world) had an observatory, but the odd angles provided by the spire never made it a really good place from which to view the city. The RCA Building from the time of its opening was the biggest competitor. Like the Empire State, it offered an open-air platform with unexcelled views of the city. Too, the other tourist attractions of Radio City always pulled in the multitudes from the popular and fashionable environs, so this deck was long the number one competitor to the Empire State.

By the days of World War II, a fair number of New York skyscrapers sported observation decks where for a very reasonable admission charge one could ascend into the skies. For example, one could take the air at the Cities Service (60 Wall Tower) and the Bank of Manhattan downtown, or the Empire State, Chrysler, RCA and Chanin buildings midtown. By the forties the Woolworth Building had closed its deck, and the Chrysler would shortly.

In the 1970s the World Trade Towers became the biggest attraction in the downtown area, drawing thousands of daily visitors. The World Trade Towers observation deck is in the south tower, and consists of an all-weather observation deck on the 107th floor (with spacious glass windows) and an open deck on the roof for nice days. The deck affords unexcelled views of New York Harbor and the financial district of lower Manhattan. Interestingly enough, however, the World Trade Towers have not seemed to hurt the business of the Empire State, which retains its charm for the hordes of visitors to the Big Apple.

Chicago is also well supplied with observation decks for visitors, the most popular at this writing being those on the Sears Tower on the south edge of the Loop and the John Hancock Building on North Michigan Avenue. For many years the Board of Trade was the tallest building in Chicago, and it attracted people both to its observation deck and to its wild and vociferous trading floor. As is so often the case, the observation platform of the now dwarfed Board of Trade Building has regrettably faded into the recesses of history.

As late as the 1940s most of the observation decks of any real character

were in New York or Chicago. The great skyscrapers of the West or South had not yet sprung into existence. There was an observation deck in the full public sense in Cleveland's Terminal Tower, for many years the tallest building outside New York City. The City Hall towers of Philadelphia (500 feet) and Los Angeles (464 feet), once the high points in those cities, had modest observation windows, although these buildings were later topped by modern steel and glass skyscrapers. In Minneapolis visitors could take a look around from the strange pyramidal Foshay Tower and from the Northwestern Bell Telephone Building. Classic skyscrapers of the twenties in a number of cities offered observation decks that maintained an appeal for many years: the Russ Building in San Francisco and the Carew Tower in Cincinnati, for example. Observation decks in such cities as Houston, Dallas, Atlanta and Seattle were years away although all eventually gained respectable skylines and earned their own popular observation points or in some cases sky-high restaurants.

Observation decks have usually been a relatively inexpensive form of entertainment. During the 1930s, admission was often a mere 25 cents, or occasionally less. In the years since, prices have inflated, of course, but not in step with the rest of the economy. In the early 1980s admission to the Empire State Building and the World Trade Towers had not risen above $2.00. The Sears Building in Chicago was charging a mere $1.50 in 1980. But there have been considerable increases since. Sometimes there are cheaper rates for children, or groups or senior citizens. Obviously the

The south tower of the World Trade Center has both an open and an enclosed observation deck. This is the highest open deck in the world.

amount of goodwill and free publicity generated by observation decks makes the low admission prices a smart move by building owners. Still, the revenues brought by some of the popular observation decks are nothing to sneeze at and can run into the millions annually.

The styles of the observation decks have changed somewhat over the years. Not only did a trend toward enclosed as opposed to open-air decks develop, but the general mood and flavor changed also. Buildings like the Empire State Building and the RCA Building originally tried for a somewhat florid and opulent appeal to match the art deco grandeur of their architecture and ornament. When there was a restaurant, it was invariably a posh place, as exemplified by the Rainbow Room atop the RCA Building. Later places of this sort broadened their appeal and tried to offer something for the multitudes. (It is curious that in the Depression, when people were generally out of pocket, the decks tried to sell an elite image; later they forgot everything they knew about snob appeal.)

At the Empire State Building, the marble and nickel surfaces of the public spaces at ground level were nearly matched in spit and polish by the observation deck. The eighty-sixth-floor observatory was a very elegant spot in the Al Smith era. It offered an opulent art deco soda fountain made of black Belgian marble, a spiffy cocktail lounge serving a wide selection of domestic and imported wines and champagnes, and soft wicker chairs on the west side of the building where visitors could relax and view the sunset in surroundings suggestive of the first-class deck of a great ocean liner.

Today all this luxury has vanished. To be sure in many places there is a posh restaurant connected with a skyscraper observation deck (often in recent buildings it is a floor below and maintains a strictly separate existence), but the observation deck itself is a place for the multitudes making few pretensions of grandeur. When refreshments are served they are the inevitable American favorites: hot dogs, hamburgers, potato chips, pizza, and very often soft drinks from machines.

No observation deck worth its salt would be without its souvenir store (or at least counter) where one can obtain every imaginable kind of trinket, knick-knack or gewgaw. There are miniature models of the building in a multitude of sizes, spoons, cups, dishware, postcards of the building and the surrounding city, buttons, pennants, keychains, pens and pencils, beer steins, mugs, calendars, posters (at the Empire State Building recently one may find over a dozen different posters for sale including cartoon versions of King Kong perching humorously atop the tower), hats and beanies, blazers, belts, and buckles — all shameless and unadulterated advertisements for the building and its management.

There are inevitably distractions aplenty attached to the observation level. There are machines which stamp out souvenir coins with the name of the building, miniature photo studios, and sometimes recording studios where one may record one's own voice for posterity, receiving a little phonograph record as tangible evidence of a visit to the great building. Sometimes to distract the young, and to halt them in their mad stampede around the periphery of the building, one finds the ubiquitous video games and pinball machines, drawing in the quarters by the thousands and again making the observation deck a valuable source of revenue for management. The chief attraction, however, continues to be the view from the top. In the glass and steel boxes that prevailed for several decades, the open-air deck became nearly a thing of the past. There are exceptions, as for example the World Trade Center which wisely provides both inside and outside sightseeing, but it seems likely that in time the completely exposed deck will disappear. Already there are no such open-air observatories in Chicago. In New York, the old style persists in buildings such as the Empire State and the RCA Building, but some of the fascinating oldies, such as the Woolworth with its Gothic bric-a-brac, are closed for all time.

The open-air platform offers delights that simply cannot be duplicated by the comfortable and wind-resistant glass panels, however large and commodious. The brisk outside air and the immediate contact with the elevated altitude are stimulating to the imagination. One feels at one with sky and city. Of course on a cold day these open platforms can be mean and inhospitable, but they are perfect on a clear, warm day. (Even so, they can be windy, since the building acts as a kind of wind tunnel.)

On a clear day the city may be seen nowhere to greater advantage than from a high tower. It lies below in a grand panorama, stretching in all directions, and in the highest buildings the view of it is unobstructed. Visitors usually exclaim at the tiny automobiles and other toy-like vehicles below, but most moving of all is the sheer breadth and immensity of everything. It is this epic sweep that makes the heart skip a beat and takes the breath away. Observation decks are often supplied with pay-as-you-go telescopes for viewing the environment, or perhaps distant places, but mostly they diminish the quality of the spectacle rather than add to it. They are expensive and have the bad habit of turning off just at the moment that some interesting object is fixed in view—almost as if some building functionary has command over the unwanted blinder. The telescope, though, is really not what is important. If one really wants a close-up of the Chrysler Building or the *Queen Elizabeth II* in harbor it is best

to go to where they are. What the observation deck offers, and what may be equally enjoyed nowhere else, is the sweeping whole of a great city — a city in its miniature wholeness and completeness.

All of the really tall skyscrapers on which observation decks are located are subject to weather conditions, even when they are completely enclosed. In cities like New York that suffer frequent heavy air pollution, there are but few days of the year when there is virtually no haze. On the other hand, there are also times when there is absolutely no visibility at all. To the credit of the managers of these facilities, it should be said that they almost always apprise their potential customers of daily visibility conditions, often posting signs saying "Visibility five miles in haze," for example. Interestingly, even the warning "no visibility" does not always keep the visitors away. Even looking out at clouds can sometimes be a rewarding and aesthetically appealing experience. If the clouds are lying at just the right height, one may look across the city at a seeming forest of skyscraper pinnacles, for this is all that can be seen above the bank of clouds. Night, too, has its drawbacks and rewards. Lights may be all that one can see, but their charming and bewildering complexity presents a kaleidoscopic panorama of colors and dramatic silences.

Any mention of the skyscraper as a tourist attraction and as a place inviting to tourists and visitors inevitably leads to another and sadder subject. Over the years tall buildings in America have gained a certain amount of notoriety as places where people of desperate or deranged states of mind make a final leap into oblivion. The observation platform, intended for more pleasurable pursuits, has often been the place for these tragic acts. Jumping from high buildings has never been a statistically common form of suicide, but it is dramatic and gruesome and usually gets a lot of publicity.

When one considers the easy availability of high buildings in large cities, it is even surprising that the number of jumping deaths has not been higher. When one considers the near certainty of the result when the leap is actually taken (most people who jump from the third floor are killed, to say nothing of the twentieth, or the fiftieth or the eightieth floor), it is a matter of some curiosity that the method has never been more popular. Undoubtedly many of those who attempt suicide are more anxious to make some cry for help or some kind of symbolic gesture, so that ultimately only the most desperate and deranged can summon up the courage to go over the edge.

Still, while a leap from some high place has always been far behind firearms and poisons as a means of suicide, the method is available, and has been around for a long time — before skyscrapers in fact. For centuries,

poets and romanciers have written of "lovers' leaps," "the bridge of sighs," and similar means of precipitous self-destruction, so the urban skyscraper did not bring the method into existence. As to the chosen spot, certain places seem to become attractive to jumpers according to the amount of publicity they receive. Shortly after it was built, the Brooklyn Bridge became a popular site for suicidal jumpers, and a fair number of deaths were recorded there before 1900. Interestingly enough, an Irish lad from the Bowery named Steve Brodie managed to jump from the Brooklyn Bridge as a stunt and survive, though not unscathed. Most of the others wound up in the morgue.

Later, other places became popular, sometimes for reasons not alto-gether clear. In New York, the 110th St. Elevated Station of the 9th Avenue Elevated Line was popular for a long time, because the Elevated reached a great height at that location. There was also a curve nearby that came to be known as suicide curve, where people leaped out of the vesti-buled cars. In Washington, the Washington Monument was a rather com-mon place for suicides in the 1920s, but not thereafter. But even then the leap was not easy to make since the opening slits were small and certainly awkward to penetrate.

From the early days of skyscrapers, the major buildings which offered open observation decks proved attractive to would-be suicides. Some have also jumped from windows or ledges of lofty hotels or office buildings. No survivors have ever been recorded among those who took the long leaps, although naturally there have been survivors among the few who landed on a setback one or two stories below an observation deck, or who some-how got caught or entangled. A great many of those who stand up on a wall or a ledge are obviously asking to be coaxed back in, and do eventually change their minds. Most who hesitate for any length of time do usually allow themselves to be talked back in, and for a long time it was a belief in the New York City Police Emergency squads that anyone who stays on a ledge for an hour will never jump.

There have been exceptions to this rule, however, and one of them was the famous "man on the ledge" who had New York traffic tied up for hours on July 26, 1938. The man on the ledge was 26-year-old John William Warde, and it was people like Warde who succeeded in dramatiz-ing and publicizing the high leap as a means of suicide. While a number of deaths attributed to falling or jumping out of high buildings have been accomplished in relative privacy, with few or no eyewitnesses, cases like those of Warde — where crowds assemble, news cameras grind away, and radio commentators stand by with philosophical reflections on the state of the world — create an indelible impression in the public mind, and

perhaps are responsible for an epidemic of similar incidents involving people who might not otherwise turn their minds to the high ledges and observation platforms.

Most of the persons who jump from high buildings are mentally ill, and a number are later found to have been treated for mental problems. Occasionally an otherwise healthy jilted lover will go right over the edge in wild and precipitous abandon, but Warde was undoubtedly in the mentally unstable category. He had tried to kill himself the previous summer with a knife and had spent some time in the Central Islip State Hospital on Long Island where he was diagnosed as suffering from a manic depressive psychosis. A week before his appearance on the ledge in New York, Warde had gone out to the middle of a bridge on Long Island and peered strangely into the water, causing the bridgetender to call the police. But nothing was done, since Warde did not actually attempt suicide.

The dramatic event which did end John Warde's life took place in the middle of busy Manhattan at the Hotel Gotham on 55th Street. Climbing out a window on the seventeenth floor, Warde stood on a ledge between two windows, a position which enabled him to stand upright, but still at a good distance from each window. When emergency personnel from the police and fire departments arrived on the scene, he threatened to jump if anyone attempted to seize him.

Even at the time the New York City emergency units had various kinds of rescue techniques and equipment for dealing with potential suicides, but Warde had picked a spot where it was especially difficult to put any of them into effect. Lieutenant William Klotzbach, a rope and lariat expert from the Emergency Division, went to the window just above Warde, but an overhang there made the lassoing an impossibility. The roof of the hotel was only four floors above, but it also hung out too far, so that any kind of device sent down from there would be noticed long before it reached Warde.

A police patrolman, Charles V. Glasco, changed into the costume of a bellboy and leaned out of the window to try to get Warde's confidence — with partial success in fact, for he managed to keep him distracted and somewhat docile for a number of hours. This, too, is a frequent police technique for ledge walkers, and quite often it works. In the meantime, the emergency crews were assembling elaborate netting down below hoping that it was possible to haul Warde in at any time he was momentarily caught off guard. There was also some discussion of the possibility that Glasco, the bogus bellhop with a sob story of his own, could get close enough to Warde to snap something around his ankle.

It was not to be, however. After dark it was possible to let ropes down

from above to fetch a net on the ground that could quietly be lifted up the side of the building underneath the ledge on which Warde was standing. But with the net only a few floors away, Warde jumped and a big roar went up from the crowd. A policeman on the sixteenth floor lunged for him, but missed. Warde fell feet first until he reached the eighth floor, then bounced off another ledge onto the hotel marquee, and from there onto the sidewalk, where he was immediately pronounced dead.

In the decade or so after Warde's leap from the Gotham Hotel, the Empire State Building became the focus of attention as the place to make fatal leaps. Publicity about the Empire State jumpers predictably brought more such jumpers. Since the building was the tallest in the world and had in its early days a completely open observation platform, it was an appealing place from which to jump. The leap was even relatively easy if one selected the right spot.

The first suicide by a visitor to the Empire State Building took place 18 months after the building's opening. (There had been an earlier suicide during the construction of the building when a discharged worker threw himself down an elevator shaft.) The victim in this case was 33-year-old Friedrich Eckert of Queens. There is a small elevator in the tower that takes passengers from the observation deck to the 102nd floor, and while on this ride several passengers noticed that Eckert was behaving very strangely. When the door opened at the 102nd floor, Eckert hurled himself over an iron gate and ran up the stair ladder to the 103rd floor where there was an open platform originally designed to receive airship passengers. Before any building personnel could get to him he had leaped over the side. He landed on a setback at the eighty-seventh floor, and then pitched over onto the roof of the eighty-sixth floor.

It hardly needs to be said that many jumpers from buildings with setbacks never get to the street as they believe they will. A setback at, for example, the thirteenth floor appears pencil thin to somebody on the seventieth floor. But it is quite capable of catching up someone who believes that he is going to jump out into the middle of the street that may be 50 feet away. The setbacks are usually quite sufficient to catch jumpers, and Eckert reached the end of his life on the eighty-sixth floor of the Empire State Building, where most of the later suicides started out.

Eckert was the first in a string of jumpers from the Empire State Building in the years that followed. Most of the jumpers were from the open observation deck on the eighty-sixth floor. Between 1932 and 1947, when a protective fence was put up, 16 people went over the wall from the eighty-sixth floor of the Empire State. A great many more were hauled back or talked down. In a three-week period just before the fence went

up, guards managed to haul in five aspiring jumpers. The Empire State was getting a great deal of adverse publicity that year, and this was the reason for the fence. The passionate *Daily News* and the gaudy *Mirror* saved their front pages for the Empire State, embroidering suicides with headlines like "Pretty Irma: She Leaped for Love from the World's Highest Building."

Interestingly enough, the Empire State's fence, a seven-foot wire mesh affair with incurving steel spikes, did not completely deter would-be suicides. Some people have managed to get over it and have successfully plummeted to their deaths. Others have gotten over and still been frustrated. On the cold and windy night of December 2, 1979, Elvita Adams got over the fence and jumped, but a strong gust of wind blew her right back to the building at the eighty-fifth floor. She landed on a ledge fracturing her hip, but was shortly hauled to safety.

All of the famous New York skyscrapers with open observation platforms had suicides over the years. The Woolworth had its share during the times when it held the record as the world's tallest building. Since losing the record and closing its observation platform, the Woolworth has not attracted would-be jumpers. The RCA Building has had its suicides from a completely open platform, although jumpers have to negotiate a setback that is slightly disguised. If it does not stop them they are on their way.

The biggest deterrent to skyscraper suicide in recent years is the design of the buildings that have been erected in recent decades. Most of them, like the Sears Tower, offer no open platform but rather a completely glass enclosed observation deck. (The World Trade Tower observatory has an enclosed portion and an open roof, but the edges of the latter are defended like a fortress.) The large glass windows serve tourists quite well: They provide protection from the elements, an uncluttered view of the environment, and a restraining element of security. They also dampen any tendency to throw things overboard, and above all, they severely restrict the number of people attempting suicide.

But for those who really want to make the big leap, there are plenty of high windows or other surfaces available in major cities. There are thousands and thousands of sash windows in New York or Chicago in older buildings, but ventilation is their main use. The number of jumpers has always been overestimated by the general public. Even after the stock market crash in 1929, the number of jumpers was very small in comparison with suicides by other means in that time period.

Leaping from a high building as a way of ending it all surely crosses a great many people's minds, and a number even talk about it. But there

the action mostly stops. In the 1980s, an elderly lady, Martha Z, boarded a southbound Clark Street bus in Chicago somewhere on the north end of the city. Wafer thin, emaciated, and half blind, Martha was tired of life. She told this to passengers on the bus, including the driver, for she sat at the very front of the long seat right behind the driver. She proclaimed that her intention was to go up in the Board of Trade Building and jump off. Her fellow passengers thought she was just talking and feeling sorry for herself, although she asked the driver to let her know when she was in the vicinity of the Board of Trade Building. She asked for assistance getting off the bus, but no passengers followed her thereafter.

She went to the Board of Trade Building, and after a bit of aimless wandering around located an elevator guard and asked him if there were floors where she could open a window and look out. He suggested a visit to the trading floor instead, but Martha was not interested. She took an elevator to the thirtieth floor and tried to open a window at the end of one of the corridors. It did not yield — stuck, no doubt. Martha started for the other end of the corridor but was intercepted before reaching it. The security guard had called the police, and Martha Z spent the night in a Chicago police lockup. Her escapades high up were never repeated.

For every suicide or would-be suicide on American skyscrapers there have been many thousands of others who instead rode the elevators to take in the view. A clear day on the observation deck of the Empire State Building or the Sears Tower is a joy to behold, and few who have savored the experience will ever forget it. The great American metropolises are objects of beauty and complexity, and there is no better way to see them. Even the best camera in the world cannot capture the feel and the beat of a great city better than a pair of human eyes. Human eyes can capture the static and the dynamic at the same time. If it is true that our cities have somehow failed, or that they have grown weary or stale, the view from the top still makes them seem credible and spiritually alive. And it is not a world of make-believe, but a world of what may still be.

Chapter 14

SKYSCRAPERS GO MODERN

When the great building boom of the late 1920s came to an end, the city of New York was supplied with sufficient office space to meet demand for 25 years. Even the popular Empire State Building did not outlive its disparaging nickname "The Empty State Building" until the dark clouds of war hung over the nation in 1941, and the owners and managers of many an older and less desirable building were filled with woe for another decade or more. But the time would come when New York builders and developers would take to the skies again. By the time they did, however, the mood and spirit of architecture had changed, and the new buildings would little resemble those art deco classics that shot up so quickly in the late twenties.

What brought about the change? Did it have to do with costs of building and labor? With architectural trends? With social developments in American history? Or was it a combination of a number of things? One thing is clear: a spirit of modernism had captured the architects of the postwar period, and the skyscrapers after 1950 were more utilitarian, impersonal and standardized in style than those of the twenties. To a large measure the influence of the European architects came to the fore in this period, and American ideas began to give way to the kinds of architectural philosophy only hinted at by the Saarinen *Tribune* design of 1922.

Among the architects who most strongly influenced the skyscraper in America were a few who never designed a single skyscraper themselves, Saarinen himself for one. Although he came to America in his later years and quickly gained a reputation as one of the world's great architects, he was not given any commissions for tall buildings, and his reputation rests entirely on other achievements. Then there was the case of the Swiss-born Le Corbusier, who certainly had a great influence on architectural thought in the middle years of the century. It was he who preached the doctrine that the business of modern architecture was to supply human creatures a "machine for living" and who taught that modern buildings

175

should capture the spirit of the modern age and be designed for useful-ness, much as were airplanes, streamlined trains, stainless steel razors, office furniture and kitchen utensils. Le Corbusier came to the United States several times and studied its skyscrapers, making a large number of erratic and cryptic statements about them. He was both fascinated and repulsed by Rockefeller Center on his visit to that complex in 1935. He liked tall buildings and was taken by their technological usefulness but he was less charmed by the layout, the exterior space, provided by New York City itself, although he never offered any feasible suggestion about how to change the longstanding configuration of streets and buildings in Manhattan.

Le Corbusier never got the opportunity to design an American sky-scraper, although when the United Nations Building was designed (and it was one of the earliest tall buildings built in the postwar era) he was a member of the international committee of supervising architects. Cor-busier came to that chore full of ideas and enthusiasm, but in the end his ideas were pushed aside and he went away in a huff. Nonetheless, his ideas had their effect little by little, and certainly Le Corbusier had a strong influence on the architecture that dominated the postwar scene.

Another one of the great European architects who had an influence, and actually moved to America in his later years, was Walter Gropius. Gropius also never designed an American skyscraper, but as a professor of architecture at Harvard University from the late thirties until his retire-ment in 1952, he exerted a great influence on commercial building in the United States.

Like Le Corbusier, Gropius and his German followers were trying to make some kind of accommodation with modern industrial society and destroy the longstanding picture of the architect as some impractical belle artiste or designer of cathedrals. Since his founding of the Bauhaus School in Germany in 1914, Gropius was striving for greater standardization, collectivization and impersonalization in all the arts. As a young man Gropius got his start as a designer of factories, and he worshipped the machine for its uniformity and anonymity. He liked to think of a tall building as a factory turned on its end, an iron box with glass walls. When he moved his Bauhaus School from Weimar to Dessau in 1925 he designed the school's headquarters, a huge glass-walled shed—quite the place for the Gropius philosophy to be disseminated.

From these roots grew the later American skyscrapers, buildings that scorned prettiness, ornament, the personal touch, in favor of products created by engineering skills, "untouched by human hands." These buildings were glass and steel cages, barely differing from one another.

There is always something to be said in favor of such buildings, and some architectural critics have pointed out that they seem to coincide more perfectly with the aims of modern business oraganizations which no longer reflect the dominance of the entrepreneur but rather that of the technostructure. The robber barons and financial buccaneers had been replaced by a new kind of executive, and perhaps a new kind of building was needed.

Among the European architects there was one who had both influence and design experience in the United States, and that was Ludwig Mies van der Rohe. Son of a stone mason at Aachen, Germany, Mies began his career at 19 when he started working for Bruno Paul, a designer of fashionable and expensive furniture in Berlin. Later he worked for the industrial designer Peter Behrens, who had also trained Gropius, and doubtless here Mies van der Rohe became infected with the same kind of ideology espoused by Gropius.

In theory at least, Mies van der Rohe seemed to be every bit as much a believer in the standardization and impersonalization of the machine age as Gropius. As early as 1924, at which time he was 40 years old, he was expressing an ideology that could only be regarded as an extremist version of the prevailing European opinions: "Ours is not an age of pathos; we do not respect flights of the spirit so much as we value reason and realism. . . . We are concerned today with questions of a general nature. The individual is losing significance; his destiny is no longer what interests us. The decisive achievements in all fields are impersonal, and their authors are for the most part obscure. They are part of the trend of our times toward anonymity."

In a rather strange way, the architect's words do not perfectly reflect his practice. Mies van der Rohe was a somewhat more inventive and individualistic architect than he would have cared to admit. Perhaps his early training as a designer of fine furniture had something to do with this trait (and Mies kept up this interest in later years, designing some of the most beautiful and luxurious furniture of the twentieth century), for he knew how to exploit the beauty of material, and it would be a mistake to believe that in his architecture he lacked a sense of form and texture and pure aesthetic appeal.

Mies van der Rohe came to the United States in 1938, and his influence grew steadily thereafter. He became head of the architecture school at the Illinois Institute of Technology in Chicago, and while there he had an extraordinary impact on Chicago architecture. In New York, the skyscraper for which he is most remembered is the Seagram Building at 375 Park Avenue, opened in 1958. But long before the Seagram Building,

Mies was a force in American architecture, his theories and designs being incorporated in a number of buildings before Mies himself got into the act.

The European masters had taken a strong hand in American architecture while it slept during the Depression years, and when building started up again, the undeniable force of men like Le Corbusier, Gropius and Mies van der Rohe was being felt even by those who tried hard to deny it. Things would look different from now on, and there was no turning back to recapture the styles and flavorings of those now distant years of dying prosperity and American joie de vivre.

In view of the infusion of what has been called the International Style into American architecture, it is fitting that the first important skyscraper of the postwar era should have been the United Nations Secretariat Building at the edge of the East River in midtown Manhattan. When the building and the surrounding complex were first proposed, an international team of celebrated architects was called in to consult on the project. The group included Le Corbusier of France, Wallace K. Harrison of the United States, Sven Markelius of Sweden and Oscar Niemeyer of Brazil. It was obviously expected to be an international project, although not all of the participants were ultimately happy with the way things turned out.

The placement of the permanent U.N. home in New York was rather strange to begin with, but the decision was prompted in large part by the fact that the U.N. was already located in the New York area, having taken up temporary residence at Flushing Meadow Park (the site of the 1939 New York World's Fair) and Lake Success after World War II when the prospects for a peaceful home abroad were dim.

At first a more bucolic setting was proposed in Westchester County, New York, where the U.N. delegates and officials could almost certainly have enjoyed more leisurely surroundings. But a gift of $8.5 million from John D. Rockefeller, Jr., enabled the U.N. to obtain the East River site without cost. The parcel of land in question—now known as United Nations Plaza—lies between 42nd and 47th streets, and had previously been acquired by the great boom-and-bust promoter William Zeckendorf for private development. It lay within a typical depressing riverfront environment of coal docks, factories, heating plants, breweries and saloons.

Three major buildings were built on this site after all of the technical and diplomatic problems were solved (for example the little plot of land

Opposite: A 1976 view of midtown Manhattan, showing the box and slab buildings that had begun to dominate the skyline. Leading the way was the U.N. Secretariat Building along the East River at left. (Photo courtesy United Nations/Y. Nagata.)

is now international territory, not part of the city of New York): a 544-foot Secretariat Building, completed in 1950; a low-slung General Assembly Building, completed in 1952; and the Dag Hammarskjold Library, completed in 1962. Of course no effort was spared to make the surrounding land attractive and inviting.

A great deal of preliminary discussion went into the project, with Le Corbusier trying to press his views of urban planning on the assembled architectural dignitaries. Fascinated with New York, but repelled by its straitjacket grids, Corbusier saw a playground for his schemes — buildings placed in the middle of streets, architectural structures fighting back at the city. As things turned out he had his way in his early concept of three buildings — a dominant slab skyscraper to house the bureaucracy, a conference wing, and a heroic and monumental assembly hall. In the end, however, Le Corbusier lost out to Wallace K. Harrison on most of the details of the project, and he left New York unhappy once again that he had failed to make any kind of dent on the great megapolis.

In another way, though, the U.N. project was a triumph for Le Corbusier, and all of the Europeans. The U.N. Secretariat building was the first true expression in New York of the International Style — the first great glass curtain wall. Even though the details of the building itself are unremarkable, it would spawn an endless number of offspring in the next several decades. The Secretariat stands out among the skyscrapers of New York because of its site, which permits it to enjoy a certain lonely eminence over on the East River and prevents it from being crowded in. No building of this height in New York can be better seen from all angles.

When the Secretariat building opened many architectural critics doubted that it would give rise to a number of others in its image. Henry-Russell Hitchcock, for example, believed that "the most significant influence of the Secretariat will be to end the use of glass walls in skyscrapers — certainly in those with Western exposures — unless exterior elements are provided to keep the sun off the glass." This turned out not to be the case, even though it was admittedly foolish to give the great glass slab a north-south orientation and thereby expose the occupants of both the east and west sides to the annoying rays of the slanting sun.

Large glass windows, however, were becoming popular everywhere — in stores, homes, and offices — and it was obvious that more glass boxes were on the way in the skyscraper field in New York. Immediately after the U.N. Building came an obvious masterpiece of the modern style that would do much to publicize the virtues of the glass box to corporate America. This was the Lever House at Park Avenue and 53rd Street, a building that made extraordinary use of its materials and of its lot.

Lever House was the first important intrusion of commercial development in what had since 1910 been an exclusive residential neighborhood, and it stimulated a great deal more such construction — not all of it successful — in the years to come. The building was the work of Skidmore, Owings and Merrill, most specifically its chief designing partner Gordon Bunshaft, who would play an exceedingly important role in American commercial architecture in the coming years. The success of the building was due not only to the art of Bunshaft, but to the very satisfactory exploitation of the lot. Having a whole block to work with, the Lever Company very wisely did not insist that the whole lot be filled. So Bunshaft came up with not one but two slabs of glass and stainless steel — one a horizontal building on columns over an open first floor, the other a vertical slab poised over the north end of the lot. It was a beautiful addition to Park Avenue. There was light and space all around, freedom from the endless caverns of limestone and granite that made the urban environment so cramped and airless.

Here was the first of many tall American buildings on "stilts," a design feature that Bunshaft picked up from the Europeans — from Le Corbusier, and especially Mies van der Rohe. The first floor was a covered open area, free of shops and clutter, that added to the feeling of freedom and openness. In the early fifties there was a widespread belief that Park Avenue would either be strictly residential or strictly corporate, so there was no idea of filling up the ground floor with rental space. Later on such an idea might have met with resistance, so it was by a kind of grace that this kind of design was introducd in the Lever House.

The building on stilts was copied so many times in later years that some would find the idea monotonous. But when the Lever Building first went up, the block and the building were a joy to behold. They still are, in fact, since many of the later contributions to corporate America on Park Avenue's golden mile are depressingly standardized and impersonal.

If Lever House brought the skyscraper on stilts to the attention of New Yorkers, it was another and even more striking building that brought this style its fullest aesthetic flowering, its most triumphant success. This was the Seagram Building of Ludwig Mies van der Rohe at 375 Park Avenue, surely Mies' masterpiece, and one of the great skyscrapers of the twentieth century. The building is beautiful, expensive and lavish, a monument to corporate success in the twentieth century and to a harmonized understanding between architect and owner.

The selection of Mies as the architect for the Seagram Building has a rather curious story behind it, and the whole thing was somewhat fortuitous since Mies had not made a great reputation as yet in America.

Samuel Bronfman, the great whiskey baron who had emigrated to Canada from Russia in the early years of the century and made a fortune there during American Prohibition mostly on the basis of high-toned bootlegging operations, had moved his once small Seagram's distillery company to the United States with the end of Prohibition and brought it into the

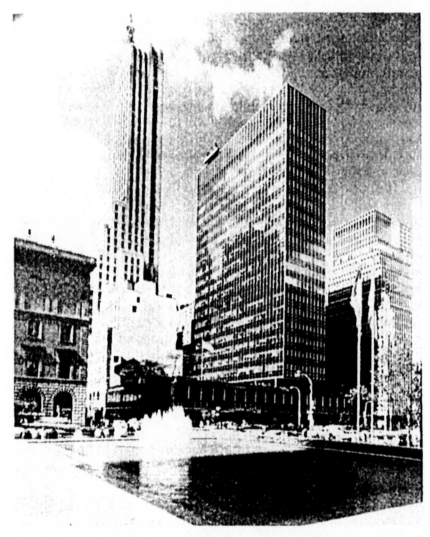

One much-admired postwar skyscraper is Lever House (right-center) at 390 Park Avenue, designed by Gordon Bunshaft of Skidmore, Owings and Merrill. The company wisely chose not to use all of its space for the skyscraper, thus adding light and space to a crowded thoroughfare. (Photo courtesy Lever Brothers Company.)

forefront of the American distillery industry. By the 1950s he possessed one of the great American fortunes, and accordingly looked around for someone to design a suitable building to commemorate his fantastic financial success. He wanted something impressive, of course, but he had not really given the matter a great deal of thought.

He was nearly ready to turn the project over to a safe commercial architectural firm when he received a frantic message from his daughter, Phyllis Lambert, herself a practicing architect, and immediately she flew back from Paris to convince her father that he ought to get the best international architect available so as to acquire a truly striking and memorable modern building. Bronfman acceded to his daughter's demands, as fathers often do, and he appointed her as head of a committee to find the architect. Numerous big names, including Le Corbusier and even Frank Lloyd Wright, were considered and rejected. Finally it was Mies van der Rohe who was chosen, because Phyllis Bronfman Lambert believed he represented the wave of the future, the architect who above all others could bring true beauty to the International Style. Obviously she made the right choice, at least for this building.

The Seagram Building brought to perfection the "curtain wall" type of architecture, because glass and metal are harmonized so smoothly that the organic whole, the totality, cannot be picked apart. There are dark spandrels and I-beams that serve a purely decorative non-structural purpose (although they house window-cleaning equipment), and they give a vertical accent and a real feeling of proportion to the mass. The overall feel of the bronze-glass wall is serene, symmetrical and well-proportioned.

And the building was set like a jewel, back from Park Avenue on a commodious plaza with green Italian marble rails serving as benches along the sides, and with two large fountains in the foreground. The setback was intended not only to frame the building and offer a breathtaking view of it, but to add a gentle pleasantry to the cityscape.

No expense was spared to make the building beautiful and awe-inspiring inside and out. The details of the public spaces, lobbies and hallways are the equal of anything done in the lavish days of the art deco skyscraper, although cooler, less ostentatious. Even the lavatory fixtures and the lettering on the mailboxes in the lobby were designed especially for the building. In spite of his endless praise of machine-like impersonality and orderliness, Mies never forgot his youthful training as a maker of rich furniture, and he outdid himself in attention to detail.

The Seagram Building offers visitors a treat in the Four Seasons Restaurant which is off the main lobby. The restaurant is one of the few

great originals to spring up in New York since the Second World War, and its design was a cooperative venture between Mies and his collaborator on the building, Philip Johnson. There is a central dining room, vast and generous in space, with a central pool—altogether a sumptuous place, not at all a Bauhaus-like factory box in the sky in its inspiration. There is a wood paneled bar of modest and dignified proportion, and throughout a fine selection of art objects—a large Picasso stage backdrop in the corridor and other modern sculpture and graphics. The tableware, linen, and other fixtures were especially designed for the establishment. Altogether the Four Seasons is proof that high style did not die in 1929—if such proof is necessary.

In the years since the 1950s there have been a number of imitators of the Seagram Building, some more successful than others. Alas the great triumph of the Seagram Building was hard to duplicate, and many of the imitations left much to be desired. Sometimes the imitations seem uninspired and repetitive, and sometimes they become monotonous for no technical fault of their own but simply through overproliferation of the style. A few boxes or slabs here and there can be pleasing, especially when nicely set off as were the Lever and Seagram buildings, but one after another box to the sky can be the source of claustrophobic annoyance.

A good example of the overbuilding of modern boxes is the group of buildings that rose to the west of Rockefeller Center in the 1970s—the Exxon, McGraw-Hill and Celanese buildings. Nothing is wrong with them as buildings, one supposes, but they are massive, threatening, and too much alike. They crowd in on Rockefeller Center in an annoying and distracting way, and while they were intended to extend and complement the center, they actually have the effect of suffocating the air space to the west. (One of the ever-present dangers of clusters of skyscrapers is that they will bring too many people into a small geographical area, making it virtually intolerable during rush hours.) All of these buildings are set back from the street but in a perfunctory and meaningless way. They do nothing and say nothing to the world outside—quite a contrast to the setting of the Seagram Building where proportions were so carefully treated.

Even at its best the modern style of skyscraper was not without its severe detractors, although the opposition took several decades to coalesce. Starting in the 1970s there were plenty of critics—architectural, social and general—who vociferously complained that they missed the imaginative skyscrapers of the twenties with their rich use of stone, their playfulness, their jazziness, their plushness. Many began to complain that little good was done for the American skyline by the architectural offspring of the Bauhaus and other European schools. In his 1981 book, *From*

Bauhaus to Our House, Tom Wolfe, who is a frequently scathing and bitter social critic, but also a marvelously funny and observant writer, complained that modern architecture was a perverse joke played by empty-souled Europeans on bourgeois America. American business executives despised these new buildings, said Wolfe, had no understanding of them, yet sheepishly allowed themselves to be cozened and threatened by architects into accepting them. They paid the commission and moved in anyway, hoping perhaps to counteract the sterility of the glass boxes by hauling into their cramped precincts whatever they could find of comfort, nostalgia or prosperity. Every prestigious law firm, according to Wolfe, moves into one of these glass-box office buildings without a whimper, but then hires a decorator with a budget of hundreds of thousands of dollars to turn their uninviting quarters into something resembling a Restoration townhouse:

> I have seen the carpenters and cabinetmakers and search-and-acquire girls hauling in more cornices, covings, pilasters, carved moldings, and recessed domes, more linenfold paneling, more (fireless) fireplaces with festoons of fruit carved in mahogany on the mantels, more chandeliers, sconces, girandoles, chestnut leather sofas, and chiming clocks than Wren, Indigo Jones, the brothers Adam, Lord Burlington, and the Dilettanti, working in concert, could have dreamed of.

It was Wolfe's theory that American architects, beginning in the 1930s, surrendered to the Germanic gurus in the persons of Gropius and Mies van der Rohe. They began promoting buildings that were nothing more than boxes, German workers' cubes. These must be machines designed by machines. The Germans called for flat roofs, so every roof must be flat. Banished forever were cornices, pitched roofs, overhanging eaves, anything suggestive of the "crowns" of discredited and despised kings and dukes. Every nicety, every kind of playfulness, was to be avoided. And the Americans, remarkably, stood for it, took all this humiliation without a murmur of complaint. They were willing, said Wolfe, "to accept the glass of water in the face, that bracing slap across the mouth, that reprimand for the fat on one's bourgeois soul," dished out by the cold, joyless, puritanical and mechanistic European engineers.

The roots of this trend are puzzling and difficult to trace. Before World War II, it is said, architects did the bidding of their clients, sought to please them and design the sorts of buildings they liked. When the modern movement in architecture took hold, on the other hand, architects drew into themselves in a kind of peevish introversion and took dictation only from their own ruling cliques, refusing to design buildings that

would please their clients. They dictatorially told the public what kind of buildings they should build.

There may be some truth to all this, but most histories of architecture (and Wolfe himself) are unclear on exactly how this change in attitude came about. Wolfe is satisfied to say that apostles of the Bauhaus ideology came to America, took prestigious chairs in architecture at eminent universities, and began shoving around sheepish American architects who immediately fell into line and began putting out stark, austere, abstract, functional, unornamented buildings, forcing their clients to accept such buildings against their will.

The reasons for these architectural changes in the broader context of American social history are obscure and perplexing. Clearly some enormous changes took place between the dark years of the Depression and 1950, perhaps the most obvious of which was that there was a long hiatus during which virtually no skyscrapers were built. It might be reasonable to expect radical changes after such a long period of inactivity. Too, there were major changes in building technology, a wholly different set of financial conditions after World War II, and, of course, a radically different labor market. Buildings had to be constructed using much more efficient engineering techniques, which by itself would have opened the door to the engineers and technocrats from Europe. By 1950 architects were having to tell clients that they could not have buildings like the Empire State Building or the Chrysler Building because they cost too much. Plans for buildings that called for intricate stone work, limestone or marble faces, metallic ornament, rich carvings, or elaborate interiors with moldings suddenly became an economic impossibility. Or so people were told. Tom Wolfe responded that yes, such buildings might well be more expensive, but not necessarily "too" expensive. Clearly another Chrysler Building in 1950 would not have been beyond the budget of many corporations.

Undoubtedly, though, there were a great many things which had changed between 1930 and 1950, the relationship between client and architect being one of the more important. In the early years of the twentieth century, architects in general, and certainly most of the successful architects, thought of themselves as being in a close partnership with their clients. Architects like Daniel Burnham, Charles Follen McKim and Cass Gilbert were men of affairs who believed themselves to be in harmony with the business leaders and capitalists whose buildings they designed. Perhaps a cultural abyss between architects and those who employed them was inevitable in the 1930s, with many architects receiving no work at all, a good number leaving the field, youngsters clinging to the universities and worshipping those who wrote books about architecture in lieu

of the thing itself, and in view of the left-leaning sympathies of intellectuals. The architect, it became facile to believe in those dreary years, was an independent artist not driven by baser tastes — especially those of the bourgeois and the disgustingly rich. It was the business of the architect to inform, to generate taste. Accordingly, many architects fell into line with the ideas of people like Le Corbusier, Gropius and Mies van der Rohe because they wanted to thumb their noses at those who lacked rarefied expertise. They wanted to take control of architecture for themselves. The Europeans had shown them how to do it.

In this analysis Tom Wolfe was probably mostly right. But he was heavy-handed in condemning all of the modernistic buildings. The truth was that a number of the glass box skyscrapers built in the 1950s, 1960s and 1970s were objects of great beauty and dignity. There were masterpieces like the Seagram Building and Lever House and a good number of others. Consider, for example, another design of Gordon Bunshaft, 140 Broadway, probably the best work of Skidmore, Owings and Merrill in New York. There is no ornament here in the traditional sense, and the ambience of the building is decidedly technological, but what refinement and taste! The building is somehow warm and inviting in spite of its wide glass surfaces. It is of modest height and hugs the ground in a loving way. It is set off from Broadway by a generous and well-proportioned plaza dominated by a sculpture by Isamu Noguchi, a large orange cube standing on one edge as if it were the toy of some baby giant frozen in motion. Those who say that the modernistic skyscraper lacks a look of richness should feast their eyes on the refinement, good taste, and subtlety of treatment exhibited by 140 Broadway.

The modernistic skyscraper did not lack for enthusiastic supporters even in the 1970s and 1980s when the public and architects alike got tired of one box after another. Architectural critic Ada Louise Huxtable found herself out of sympathy with those who said that the glass box skyscraper was an "icy curse" visited on cities by Mies' "failed" vision. She agreed that many of the skyscrapers built in New York and elsewhere around the country were short on poetic license, and she could understand how many people came to miss the lyricism of the art deco masterpieces of the twenties; on the other hand, she believed that the best buildings of the modern period were marked by understated splendor and structural panache.

Furthermore, said Huxtable in her book *The Tall Building Artistically Reconsidered,* the Miesian skyscraper "is the basis of a superb vernacular, probably the handsomest and most useful set of architectural conventions since the Georgian row houses." These buildings seem singularly appropriate to their time and place:

> The Miesian aesthetic has produced an eminently suitable twentieth cen-
> tury vernacular style for this century's unique and overpowering scale — a
> fact that has yet to be fully realized or appreciated by critics or historians.
> Vernacular art grows out of the high art of the time and is applied to its
> common needs and purposes. As with all vernacular architecture, it is the
> standardization and anonymity of forms reduced to a rational, useful
> simplicity — here the sleek, reflective surfaces and facets of glass, mirror
> and metal — that have universal application and appeal. The result is as
> right for today's skyscraper cities as Georgian detail was for the scale and
> purposes of the eighteenth century. This vernacular accommodates the
> inhuman size, mass, and bulk that are the inescapable facts of life and
> architecture with an appropriate and saving simplicity. Glass towers, what-
> ever their drawback — and most of their faults are independent of aesthet-
> ics — make a magnificent street architecture.

Whatever the judgment of history about the modern skyscraper, it
became obvious by the 1970s that modernism had spent itself, and that
new trends in skyscraper design, indeed in all of architecture, were in the
offing. Within a decade or less modernism gave way to what has often
been called postmodernism, a term that is not very helpful. Over the long
sweep of history, terms like modernism and postmodernism will doubtless
prove to have a short lifespan. One important reason is that the term
postmodernism is used by literary critics, philosophers, linguists, and
others in entirely different ways. For purposes of simplicity, however, it
is probably sufficient to say that in architecture the term postmodernism
was selected precisely because its users wanted to make clear that they
were not rejecting modernism but merely making modifications in it.
Charles Jencks, the author of several books on postmodern architecture,
explains that postmodernism refers to a continuation of modernism, and,
at the same time, a transcendence of it. Postmodernist architects "accept
the irreversible nature of the modern world and modernization, but deny
that this cuts us off from the Pre-Modern past. This past is as much a part
of the present as any aspect of the twentieth century." Jencks attempts
to define the term with precision (but without entirely avoiding profes-
sional argot), when he says that it refers to "hybrid, 'impure' buildings that
are designed around historical memory, local context, metaphor, spatial
ambiguity, and an intense concern with architectural linguistics."

For the layman it probably suffices to say that the postmodern archi-
tects want to keep all of the technological advantages of modernism but
to bring a playful and freewheeling style back to architecture. The
postmodernists want to bring back things which the modernists spurned —
history, ornament, familiar imagery, context, contrast and variety, sym-
bolism. Practically speaking, the movement began as an attempt to make

architecture more popular, more understandable to the public, more simpatico to the layman, whereas modernism was often thought of as austere and aloof. Modernism was a language only for other architects. Charles Jencks pointed out that the modern movement had proved "simply too limited, provincial and impoverished. Like *cuisine minceur*, it was very good every third day but hardly a full diet."

The shift to postmodernism doubtless had something to do with social and economic changes in the 1970s; it was not a matter of aesthetic ideologies alone. During the 1950s and 1960s architects were overproduced by universities and schools of architecture, and at the same time there was a glut of office buildings in most cities; accordingly a great many architects were desperate, much as they had been in the 1930s. Many firms disappeared; large firms shrank down to small ones overnight. Young architects just out of school found that they could make a much better living as Amtrak conductors or plumbing supply salesmen than they could at their drawing boards. The profession everywhere was hurting, and many architects were now willing to please their clients, were willing to drop the snooty pretense that "this is the kind of building that is being built today." They were once again considering the wishes of those who employed them. So when the client said vociferously "give me anything but a flat roof," he got something other than a flat roof. When he asked for something other than a "dumb box," he got something different.

By the mid-1970s it was apparent to people in cities like New York and Chicago that skyscraper design had at last begun to change, even if not immediately or in a revolutionary manner. Up on the upper West side of Manhattan rose a tall, charming and eccentric new skyscraper, the Citicorp Building, located in the block bounded by Lexington and Third avenues and 53rd and 54th streets. There were no really tall buildings in this vicinity, so this new and different structure had a perfect setting and had a dramatic effect on the city's skyline. Instead of a flat top the building is sliced off at a 45-degree angle in its top 130 feet, announcing to all the world that things now were going to be a little different. The building otherwise might be taken for just another modernistic box — slick tech with a whitish-silver aluminum sheathing. That sliced-off roof, however, was a welcome sight to most New Yorkers. The silver aluminum top merges imperceptively with the clouds, much as does the spire of the Chrysler Building some dozen blocks to the south.

The building was designed by Hugh Stubbins & Associates and did not really make a claim to be anything other than a modernistic skyscraper — the sliced-off roof was built with the idea that the building might eventually be energized by solar collectors — perhaps as much a piece of

wishful thinking as the plan to moor airships at the top of the Empire State Building. But there were other interesting features of this block, which, as a whole, is called the Citicorp Center. The entire site was planned for multiple uses—stores, restaurants, and even a church. The 900-foot tower of the Citicorp Building rests on four massive columns,

The Citicorp Center, designed by Hugh Stubbins, was the first of the postwar giants to abandon the flat roof. It features a slanted top, and crouching beneath it between the four long stilts are a retail complex and a church. (Photo courtesy Hugh Stubbins and Associates; copyright Edward Jacoby/APC.)

each 22 feet square and 115 feet high, and these are ingeniously placed not at the corners but at the middle of each side, thus making room to insert the church, shopping areas and an interesting sunken entrance.

The church, St. Peter's, is surely the first to be nestled beneath a massive high-rise building, but the inspiration was a secular one. Citicorp had purchased this block from St. Peter's parish under a complex real estate transaction which involved a promise to build a new church for the one that had to be demolished. The aesthetics of all this is open to debate, but the main point is that here was some stirring of the architectural fancy that had been held in restraint over the previous decades.

But it is not so much the Citicorp Building which brought New Yorkers to the realization that a new architectural age was dawning. The really revolutionary development was the AT&T Building, the drawings for which were released in 1978 and soon made the cover of *Time* magazine. Designed by Philip Johnson, who collaborated on the Seagram Building with Mies van der Rohe and who certainly had all of the modernist credentials, the AT&T Building, located on upper Madison Avenue, sported a top carved in the manner of a Chippendale highboy. It was not a style that anyone would want to copy over and over again, but obviously a breakthrough had been made—architects now had the license to play around with all kinds of new shapes and forms in the skyscraper. Around the country a varied (some would say motley) collection of postmodern skyscrapers began to appear, freely picking up on once discarded architectural conceits. In the wake of the AT&T design there were medieval battlements in lower Manhattan. PPG Industries erected a pinnacled, mirror–Gothic building in Pittsburgh. In short, eclecticism was quickly becoming the byword of the day. Attempts were made to construct new art deco high-rise buildings, or to take to classical flights of fancy—away went the flat roof and the dumb box, and in their places were so many gold domes, cornices, Gothic spires, sliced-off roofs, and curved or pinnacled silhouettes that the mind of the casual viewer must have been left in a confused state of wonderment. Once again everything seemed possible in skyscraper design. There were those who said that such a trend could too easily get out of hand, as for example when the Republic Bank headquarters in Houston was built to resemble a gingerbread guild hall.

Even if there was a looseness and a waywardness in this new eclectic era—which is what some traditional modernists complained of—architects were now at least making a valiant attempt to speak the language of the people. Coming to the forefront of the architectural fraternity were such persons as Robert Venturi, who for a long time had been attempting to forge a link between architecture and pop culture, and Robert Stern,

a practicing architect and professor at Columbia who became a nationally known figure on television and a spokesman for a broader and more civilized architecture that would preserve traditions and maintain historical continuity.

Among those who bewailed these new developments was Ada Huxtable, who complained that postmodernism gave the public nothing to hold

A postmodernist movement in skyscrapers was launched in the 1970s when architect Philip Johnson revealed this design for a new AT&T headquarters building. The "highboy" top was amusing to some and infuriating to others. (Drawing courtesy AT&T.)

onto spiritually, just a jumble of forms going off in all directions. She pointed out, too, that where the skyscraper was concerned postmodernism had not really solved some other extra-aesthetic problems that had arisen in America's large cities. In New York, for example, there were some probably misguided changes in the zoning ordinances in the 1960s, and these resulted in overcrowding in certain areas. Was the rush to crowd the Times Square district with skyscrapers—with the expectation of reclaiming this seedy and forlorn neighborhood—really a good idea, or would it result in just another kind of urban blight? Too, Huxtable found the crowding in of buildings on Madison Avenue between 50th and 60th streets to be utterly intolerable. What good is it, she asked, to have a Chippendale top on the AT&T Building if one has to lie down in the gutter to look at it?

On the other hand the postmodernist movement did much more than bring a profusion of chaotic styles to the cityscape. The new concerns for the environment and for local lore and tradition gave birth to many healthy new impulses. Consider, for example, the superb development in downtown Manhattan at Battery Park City. Stanton Eckstut's design guidelines for the area in 1979 made decided inroads into the megalith skyline which had brought this area into aesthetic disrepute during the previous decades. Garnering ideas from the city itself, Eckstut used street grids to provide continuity; he offered landscaped spaces and called for a rich diversity of architectural styles and visions.

Once again it seemed possible that lower Manhattan might be a place of tolerable human scale; that skyscrapers and other structures in the world's most overbuilt neighborhood could provide a touch of whimsy and individuality. Perhaps the men and women in the gray flannel suits toiling nearby, the bond traders and stock pickers, could once again be treated to an environment that was bold and romantic rather than merely claustrophobic; expressing, as they had always wished, a sense of dramatic power in a form and a language they could understand.

CHICAGO
CATCHES UP AT LAST

For many years Chicago was a distinct second to New York in the race for the sky. During the first three decades of the century the city's foolish and crippling height restrictions stunted the city's skyline; afterward there were the years of inactivity during the Depression and World War II. For a while after the war there didn't seem to be much zip or daring in the Chicago building industry, and between 1947 and 1955 fewer than a million square feet of net rentable office space entered the market. But all this changed very quickly after the building of the 601-foot Prudential Building in 1955, and in the decades of the 1960s and 1970s Chicago exploded into a burst of building activity that would once again allow it to rival New York as the city with the skyline. With the opening of the Sears Building in 1974, Chicago would regain the long-lost title to the world's tallest office building.

The Prudential Building, which broke the ice for Chicago in the midfifties, is hardly an architectural wonder, but as a stimulus to growth it was interesting. The Prudential was built on air rights of the Illinois Central Railroad, which established a unique and scenic lakefront entrance into Chicago before the Civil War. In the crowded downtown Chicago area this exploitation of railroad air rights would be lucrative for those wishing to build office buildings in the next several decades, and it would work out well for the railroads too in their time of financial distress. In the case of the Prudential this business of straddling the railroad was particularly complex since what was involved was accommodation of the Illinois Central's track, suburban terminal and adequate overhead for the catenaries of the electrified suburban trains.

By exploiting this valuable airspace the Prudential was able to get a very choice location in the city. No other buildings could be built south of Randolph Street on the west side of Michigan Avenue, so the Prudential Building offered unexcelled views of Grant Park, Michigan Avenue

and Lake Michigan. A Stouffer's Restaurant called "Top of the Rock" quickly became a great tourist attraction in Chicago and was a popular place to see the sights of the city.

The Prudential Building houses the regional offices of the Prudential Insurance Company, among others. (It is called the "home" office, although the insurance industry makes misleading use of the term since the executive offices of the company are in Newark, New Jersey, as they have been since the company's founding in 1875.) It would be only the first of several giant insurance companies which would invest in tall buildings in the post-World War II era. But from the perspective of Chicago, this is the one that started everything moving.

To be strictly accurate, however, before the rise of the Prudential there were a few interesting developments on the Chicago scene that are worth mentioning because their influence turned out to be important in the years to come. Ludwig Mies van der Rohe was to be responsible for some important Chicago skyscrapers in the years before his death, but even before the construction of the Prudential some typical Mies type buildings had appeared in Chicago—apartment buildings to be exact. There were the 21-story Promontory Apartments of 1949 and the two buildings at 860-880 Lake Shore Drive built in 1952. These buildings helped to pave the way for a clean and economical modern style of architecture in Chicago in the postwar era, and while they were not major skyscrapers, their attractiveness had much to do with Mies' later commissions for skyscrapers in New York and Chicago.

It was especially suitable that Mies van der Rohe should make his mark on Chicago architecture since he had made Chicago his home in 1938 after leaving Germany when Hitler closed the Bauhaus School of Architecture. Mies became head of the Department of Architecture and Urban Planning at the newly formed Illinois Institute of Technology, and became largely responsible for the planning of a campus for that institution. Between 1941 and his retirement in 1958 he designed 22 buildings for that campus, an achievement which alone would suffice to make Chicago a showcase of Mies architecture, much in the way that it had once been a showcase for the work of Burnham, Sullivan and Wright.

With his reputation as one of the masters of twentieth century architecture growing by leaps and bounds after 1950, it was not at all unusual that Mies would have been called upon to do a number of Chicago skyscrapers, and of course he influenced many others. The talent of Mies can be seen at the Federal Center on Dearborn Street between Jackson Boulevard and Adams Street, which is surely one of the most compelling uses of space in the crowded Chicago loop. The great plaza, with its red-

painted Calder stabile "Flamingo," is one of the most refreshing open spaces in any metropolitan area in the world. And Mies went out in a blaze of glory with his last Chicago skyscraper, the IBM Building on the Chicago River between Wabash and State streets. Built in 1971, the IBM Building has a bust of the world-famous architect in the high-ceilinged and travertine glass lobby.

The IBM Building is 52 stories high, has a typically Miesan curtain wall of dark aluminum and bronze-tinted glass, and is modern and sophisticated from an engineering point of view. Temperatures are controlled by computer, and the heat given off by machines (of which there are a great many in this building), lights and human activity is reclaimed by a reverse refrigeration system. Too, heat transfer between inside and outside is retarded by a plastic thermal barrier that separates the wall from the frame. In the IBM Building all the old fears about the exposure of curtain walls, stated by critics of the United Nations Building, were laid to rest.

While Mies did not actually design a large number of Chicago skyscrapers, his influence in the 1960s was widespread and sometimes overpowering. During these years the most prominent architectural firm in Chicago, if not the nation, was Chicago-based Skidmore, Owings and Merrill, which turned out a number of buildings clearly in the Miesan tradition. Among the buildings turned out on the drafting boards of Skidmore, Owings and Merrill which obviously show the influence of Mies are the Civic Center (now the Richard J. Daley Center), the Brunswick Building, the Inland Steel Building and the Equitable Building. On the other hand, none of these buildings was a slavish imitation of a Mies design by a long shot, and they are all aesthetic triumphs in their own right. For example, in the Equitable Building, there is an interesting variation on Mies's use of four-window groupings, with the outer two windows narrower than the inner ones. In the Equitable design the distinction is further exaggerated with dramatic impact. Similarly, in the Richard J. Daley Center, tremendously large structural bays are responsible for relieving some of the monotony that is sometimes complained of in Mies' buildings.

Skidmore, Owings and Merrill is probably the most successful firm of commercial architects in the United States in the latter half of the century, and it is based in Chicago. The firm must surely be able to challenge the record number of contracts and assignments won by Daniel Burnham around the turn of the century. The partnership started when Skidmore and Owings both worked on the Century of Progress of 1933, an exposition which enjoyed a continuity with the great Columbian Exposition of 1893 by having Daniel H. Burnham, Jr., as director of works. Louis

Skidmore was chief of design and Nathaniel Owings was supervisor of development.

The roots of the firm of Skidmore, Owings and Merrill were firmly implanted in traditions of the Chicago school of architecture, and they were able to bring the riches of that school to bear on their borrowings from the modern movement, so even with the commanding voice of Mies van der Rohe in the background, Skidmore, Owings and Merrill have their own powerful resources to draw on, and this surely accounts for their tremendous popularity and commercial success. Their Connecticut Mutual Life Building at 33 North Dearborn Street, for example, utilizes a tripartite window division that clearly harks back to the window arrangements of the Chicago school.

Skidmore, Owings and Merrill are responsible for two of Chicago's tallest buildings: the Sears Tower and the John Hancock Building. Both of these represent strong departures in design and monumental technological advances in nearly all categories of building construction. The Hancock went up first, and although it was later overtopped by the Sears Tower, is probably the firm's most interesting skyscraper in Chicago.

The John Hancock Center was built on a vacant lot at 875 North Michigan Avenue on the city's famous "magnificent mile," an area of the city given over to fashionable hotels, restaurants and apartments as well as office buildings. The original idea was to have two buildings on this site, one devoted to luxury apartments, the other to offices. As it turned out, the concept of a multi-use structure was kept and the two buildings were built — but one on top of the other.

The project was originally conceived by Jerry Wolman, owner of the Philadelphia Eagles football team, but when his resources became exhausted in the process of construction, the John Hancock Life Insurance Company took over financing, and the building bears its name, although the company is not really a substantial tenant. The project came to Skidmore, Owings and Merrill and they responded in top form. Dropping the idea of twin towers, they decided to go with one giant structure, topping in height all of Chicago's existing structures. The building is 100 stories high as built — 1,107 feet to the roof and 1,449 feet to the top of the television towers.

On the concourse level and the lower floors there are shops and businesses, composing a very inviting commercial center. There are then 29 floors of office space, 48 floors of apartments, an observatory and then a two-story restaurant, with extensive radio and television facilities on the roof. The tapering form of the building has given the Hancock a distinctive place on the Chicago skyline, but the design that came from Skidmore,

Owings and Merrill is of both technical and aesthetic interest. All four walls of the building incline inward from the vertical, which not only achieves a dramatic effect but enabled the builders to provide for the more commodious functions of shops and other public functions at the base, less extensive but still large floor areas on the office floors, and then smaller areas on the apartment floors where it was considered desirable to have an outside exposure for all rooms.

More important, perhaps, was that the architects had discovered a formula that provided a good answer to Chicago's tempestuous wind conditions. In addition to the obvious advantages of the tapering walls, the building features diagonal braces, each pair of which extends across 18 floors. These braces add visual interest to the building, but they do their part economically in requiring less steel than is usually necessary in a conventional steel frame. The Hancock looks solid and is solid, but the diagonal bracing also provides refreshing geometrical patterns that are missing in so many modern rectangular boxes.

In the layout of offices and public spaces, for convenience of elevators and other services, the John Hancock Center could certainly win any architectural prize. It is one of the great skyscrapers of the modern era.

Chicago has been somewhat luckier than New York in having distinctive and individualistic tall buildings built in the last few decades. New York does have the Citicorp and a number of others that surely look novel, but Chicago is once again the place to go to look at a number of different and amusing tall buildings.

One of the most attention-getting complexes of the last several decades is Marina City, built in the mid-sixties on the north bank of the Chicago River between State and Dearborn streets. Another expression of the multi-use concept, the two 60-story towers contain apartments, garages, offices, a bank, a television studio, and a marina. The buildings are of concrete, which works out well practically and visually. On the lower 18 floors which house the parking spaces, a single helical slab easily accommodates the flow of traffic. The two buildings are both a sheer delight to the eye.

Another building that attracts considerable attention in Chicago — and one that is right in the heart of the Loop — is the First National Bank Building on Madison Street between Dearborn and Clark. At 850 feet, the First National Bank is not as tall as the Hancock Center but makes its own very dramatic use of a graceful inward sweep of long columns. There are steel framing members, but they are sheathed in gray-speckled granite which harmonizes very nicely with the bronze-tinted glass. It is

clearly one of the most beautiful buildings of Chicago of the postwar era.

Another extremely comely building of recent vintage, although hardly a skyscraper by current standards, is the U.S. Gypsum Building at 101 South Wacker Drive, designed by Perkins and Will (who were also involved

Marina City in Chicago consists of two towers of concrete construction with main loads carried by cylindrical cores. They are multi-use structures with offices as well as apartments; the first 18 floors provide room for parking. (Photo by author.)

in the First National Bank). The building is perhaps the most sleekly clad of all the recent Chicago buildings. There are long unbroken columns sheathed in marble, the spandrels are slabs of black slate, and the windows are dark with a bluish gray tint. Some may find the effect too ostentatious or luxurious, but the geometry and balance of the structure keep the

One of the most prominent tall buildings of recent years in Chicago is the First National Bank Building on Madison Street. The inward-tapering construction, shown off dramatically by the plaza, provides a very attractive visual effect. (Photo by author.)

whole muted and dignified. The setting of the building is enhanced by the fact that the building is turned at a 45-degree angle to the street lines – the kind of nicety that designers ought to think of more often.

The Inland Steel Building at 30 West Monroe Street also shows a Mies influence but it came from the drafting boards of Skidmore, Owings and Merrill. Actually there are two Inland Steel buildings, of unequal height, joined side by side. The taller of the two is a kind of utility structure housing elevators, stairs, mechanical equipment and the like, and its presence contributes to the freedom and commodiousness of the main building itself. Because of the large spans made possible by modern steel construction it was also possible to dispense with interior columns, adding to the feeling of space within the building and maximizing freedom for interior organization.

Not all of Chicago's recent contributions to the skyscraper competition have been so successful, as evidenced by what has become the second tallest building in Chicago – the Standard Oil (now Amoco) Building. Actually the building might have been pleasing had it not been so tall – 1,136 feet in height, right out on the lakefront. The building poses somewhat the same problem for Chicago that the twin World Trade towers pose for New York. It is a problem of scale, of tipping everything overboard, so to speak. And the tallness is accentuated by its thin verticality: The building is square but measures only 194 feet to the side.

Undoubtedly an oil tycoon would find this pleasing, and surely the architects believed that they were building a building that would look streamlined and classy, but the ultimate effect is a pretentious and dehumanized streamlining that seems to say, "Don't come and visit this building." And as if to reinforce their threat, the builders supplied no observation deck, even though at that locale it would enjoy absolutely unobstructed views of the whole city and of Lake Michigan.

Few buildings of recent years have gotten as much attention as Water Tower Place on North Michigan. The interior seems to be loved by Chicagoans and visitors alike, and the public spaces with marble, chrome and glass appointments may recall some of the luxury of the golden age of skyscrapers from the 1920s. Paul Gapp, the *Chicago Tribune*'s delightful and perceptive architectural writer, charged that the building has the overall impact of "cold, sepulchral ugliness." The big retail complex below it he called "an animated mausoleum," and he lamented that the building of such monstrosities makes the so-called magnificent mile less magnificent year by year. But there is some excellent use of interior space in both the "mausoleum" and the tower, and the complex does answer the great need of cities like Chicago for buildings that remain lively and attractive at night.

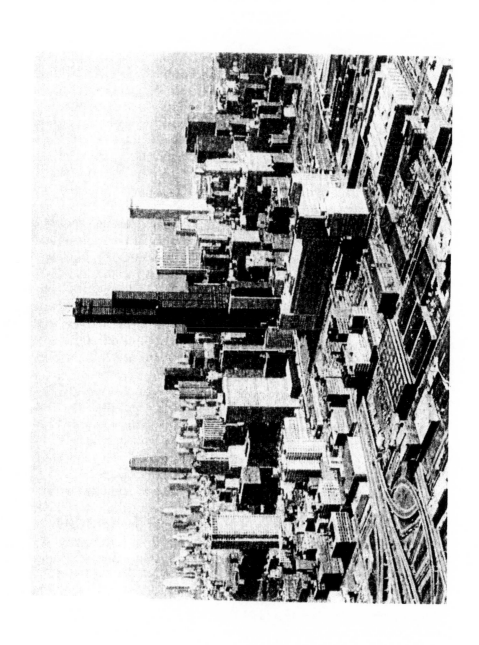

But if Chicago has all too often been deluged with the commercial dead hand, with the garish and pretentious, it has fared better than one might have expected. New and exciting buildings (not all of them skyscrapers) go up every year. Sometimes they appear in the funniest places and in the strangest guises. Down on the southern edge of the Loop, in an offbeat neighborhood mostly associated with dreary lofts, warehouses and drafting firms, one encounters a remarkable high-rise prison. It is the 28-story Federal Prison at Clark and Van Buren streets. With its triangular shape and its slit windows, the building is obviously throwing down the gauntlet to the prevailing Miesan tradition in architecture of the past several decades. The building looks so humane and inviting that one would almost consider running up a short sentence to try it out. As a solution to the various technical problems of separating a number of kinds of facilities (there must, for example, be separate floors for male and female inmates), the very innovative and resourceful Chicago firm of Harry Weese and Associates made especially good use of the strange triangular shape. The bottom 13 floors house administrative, medical and other facilities. The next two floors are for pretrial inmates, and the top double-deck floors house the regular prison cells of various classifications.

Some 4,000 penologists from all over the world have visited this $10 million building, and most have raved about the facilities. Alas, the general public is not invited inside.

Chicago has become a veritable showplace of the so-called post-modernist skyscraper, and anyone who takes a boat excursion along the Chicago River west from Lake Michigan will see a profusion of such structures with sliced off roofs, antique highboy shapes and all manner of other oddities. Some are highly distinctive, others banal.

It was in Chicago where it all began. Chicago was witness to the birth of the modern skyscraper, and although for a long time it neglected the tall building, it has fought back and once again vies with New York for supremacy. New York has naturally not been bested as to numbers of buildings, but Chicago can challenge it in terms of quality, high style, and just plain fun.

Opposite: *The Chicago skyline of the 1980s. The three tallest buildings shown here, left to right, are the John Hancock Building, the Sears Tower, and the Standard Oil (now Amoco) Building. At the far right of the picture are a number of Chicago's early skyscrapers.* (Photo courtesy Sears, Roebuck and Co.)

Chapter 16

PUBLIC EXTRAVAGANZA:
THE WORLD TRADE TOWERS

The twin towers of the World Trade Center (each 1,350 feet) are now the tallest buildings in New York City; they top by 100 feet the Empire State Building, which held the record for 40 years. The World Trade Towers are largely unloved by architectural critics and have had few champions since first they began to pierce the New York skyline in 1967. The massive towers seem entirely out of scale with the tapering tip of lower Manhattan, rising abruptly into the sky like two upended florist's boxes. Down below there is insufficient breathing space around them, and up above they seem to put the isle of Manhattan off balance; they remind one of a pair of giant's legs threatening to tip the whole island on its end, perhaps sinking everything into the sea. The effect on New York's graceful skyline has mostly been annoying and mocking.

This great project—and it was a massive one, since the entire complex is the largest assemblage of commercial office space in the world—was well enough intentioned. The idea for a center of roughly this kind originated back in 1946 when the New York state legislature studied the possibility of a trade center on lower Manhattan. Such a center would be multi-tenanted, but mainly devoted to representatives of the world trade community: exporters, importers, shippers, customs house brokers, international bankers and government trade agencies. But the World Trade Corporation founded to examine this concept recommended that available public money would be better spent in improving the deteriorating waterfront area nearby. The original idea did not die, however, and in the late 1950s a group called the Downtown–Lower Manhattan Association, under the leadership of David Rockefeller, chairman of the Chase Manhattan Bank, again put forward the suggestion as a way of improving and upgrading the general area of lower Manhattan.

The "problems" of lower Manhattan had long been curious and

perhaps unexplainable to the outsider. Here was the financial capital of the United States, perhaps the world: Wall Street, the Stock Exchange, all of the great banks of New York, concentrated into a very small area. The neighborhood was still growing, and still improving. In the 1960s the Chase Manhattan Bank was constructing a new 60-story building in the financial district. But to the west of Broadway, and right down to the wharves of the Hudson River, was what Chairman Rockefeller referred to as a "commercial slum." Not at all the ordinary kind of slum, to be sure, because there were no low-slung flophouses or rowdy pool halls, but rather endless rows of small-business establishments of the dirty-fingered variety—electronics and hardware stores, pet stores, locksmiths, wholesale fishmongers, auto parts suppliers, appliance stores, and specialty and retail stores of all sorts. Hugging the Hudson River for many years were wholesale food markets and produce dealers of every imaginable type. Between there and Broadway was an area that was especially well known for its ham radio stores, outlets for electronic gimmickry, etc. Generally the environment was somewhat old and seedy, but not nasty or dangerous.

David Rockefeller saw in this project a chance to do a great deal of good for lower Manhattan. This low-rent neighborhood right next to the greatest financial center in America could be upgraded by providing more office space, which should be a boon in an area which always seemed to be crying out for it. And the space could be gotten rather cheaply. Said Rockefeller: "this area is now largely occupied by commercial slums, right next to the greatest concentration of real estate values in the city. . . . I don't know of any other area in the city where there's as good an opportunity to expand inexpensively."

But it was not so inexpensive that any New York businessman or group of businessmen would come forward and put up the money for such a project. Gone was the daring of Rockefeller's father, John D., Jr., who put through the Rockefeller Center project in the dark days of the Depression by taking his great dream, with hat in hand, to all of his friends and business acquaintances. No, said David Rockefeller, "the successful activation of the World Trade Center could be undertaken only by a public agency."

The obvious choice of such a public agency was the rich and prosperous Port Authority of New York and New Jersey: the superagency that controlled not only the port of New York, but its major airports, the George Washington Bridge and the Holland and Lincoln tunnels—all fabulous money makers over the years. The Port Authority was mildly interested, but wary. One of its reports suggested that the project was

economically feasible, but warned that "in an undertaking of this magnitude financial loss is to be expected during a limited initial period of development." Time would show this statement to be something of an understatement.

There were initial obstacles to be overcome. The Port Authority was an agency of the states of New York and New Jersey, and the people of New Jersey were less wildly enthusiastic than those in New York. Eventually, however, they were won over by promises that the Port Authority would take over the bankrupt Hudson and Manhattan Railroad (a tube rail line to Jersey City and Newark under the Hudson River) and build for that line a new terminal in the World Trade Center complex. One of the buildings later demolished to make way for the trade center was the old Hudson Terminal Building, which housed terminal facilities below ground for the 60-year-old tube line.

There were strenuous objections from the merchants in the area, as could be expected. A group calling itself the Downtown West Businessmen's Association estimated that in the proposed 13-block site there were 1,400 commercial establishments doing over $300 million worth of business and employing about 30,000 people. All of these people and businesses would be squeezed from the area. To be sure, the neighborhood had few strong supporters from outside the area or from local organs of opinion. For many years the West Side had had a great number of daily pedestrians who rode the Hudson River ferries from New Jersey—ferries belonging to the Jersey Central, Erie and Lackawanna railroads—but these ferries had gradually been eliminated, and the side streets were largely deserted even in daytime hours.

Legal fights with associations and businessmen in the area were protracted, as were the Port Authority's own arrangements with its sponsoring bodies, so the World Trade Center was delayed for nearly a decade after the time originally projected for occupancy by David Rockefeller. For a while it was hoped that some of the center would be opened in time for the New York World's Fair in 1964, but, as things turned out, not a single building was demolished on the site until 1965. Planning was complicated beyond belief, and in a sense the center has been plagued ever since by vagaries in planning and economic projections.

There was nothing in the original planning and projections that required the construction of the two monster skyscrapers that eventually resulted. The architects hired to study the matter and design the buildings were Minoru Yamasaki of Birmingham, Michigan, and Emery Roth of New York. They toyed with a number of different configurations of buildings and a number of different arrangements of the ground space. At

one point consideration was given to a single gigantic 150-story building, but this was generally considered too big.

Another possibility was to build a series of somewhat lower towers — three or four buildings of 50 or 60 stories. But the architects finally rejected this idea, fearing that "it would look too much like a housing project." Eventually, Yamasaki came to the idea of building the two 110-story buildings because he believed they were not too tall (after all, they would only be 100 feet taller than the Empire State Building) and because this plan would allow him to minimize the number of lower buildings and thus provide maximum free space at ground level.

So the two great towers were planned and built in the years between 1967 and 1971. They did indeed provide fairly generous plazas at ground level, but even this open space did not keep the buildings themselves from perturbing and unbalancing the skyline of lower Manhattan. To the student of skyscraper technology the two great towers are rather interesting, nonetheless. In the classical skyscraper the construction provides for a skeleton of structural steel supports, the outer walls serving merely as a skin. This had been the nature of the skyscraper going back to Jenney's Home Life Insurance Building. In the two World Trade Center towers Yamasaki called for the exterior walls to bear the load. This feat was accomplished via closely spaced vertical columns, tied together by massive horizontal beams at every floor. The only interior columns were in the central service core. This plan resulted in plenty of column-free floor space within, but sacrificed generous windows that are usually among the singular joys of living or working in a skyscraper. Yamasaki offered the rationale that the narrow 24-inch windows would calm the fear of height in most people, although there has never been any evidence that denizens of tall skyscrapers are actually timid of them.

Still, construction of the two towers was a marvel of modern building technology. To make room for the center, 1.2 million cubic yards of earth and rock were excavated. This material was used as fill to create 23.5 acres of new land at Battery Park City along the Hudson River.

The towers were erected from within. Four kangaroo cranes, lodged in the elevator shafts, lifted the steel up the sides of the building and were jacked up floor by floor as the construction continued. When the top was reached the cranes were dismantled one at a time and lowered to the ground. The last kangaroo crane was dismantled by a guy derrick which in turn was dismantled on the spot and brought down on the freight elevator.

The 16-acre plot of land did include room for more than the twin tower buildings of 110 stories. In this same phase of the construction were

included a U.S. Customs Building of eight stories including a concourse level and two other buildings called the Northeast Plaza and Southeast Plaza buildings, each of which stood nine stories including the concourse level. Altogether the buildings in the complex provided 9,500,000 square feet of office space, housing 50,000 employees and accommodating 80,000 daily visitors.

The two towers were well planned in terms of elevator service. The elevator system was divided into three zones, each system having its own lobby. There are "skylobbies" on the forty-fourth and seventy-eighth floors, and 23 express elevators and 72 local elevators in each tower. Each tower also has four large freight elevators.

Needless to say, the World Trade Center is a study in superlative size in all dimensions. The scale of the lobbies and exhibition rooms is gigantic. The windswept plaza is as large as five football fields—almost five acres. In the two tower buildings there are 43,600 windows with over 600,000 square feet of glass. Underground parking areas can accommodate 2,000 cars. The feeling (and the reality for that matter) is of the proverbial city within a city—and a rather large city at that.

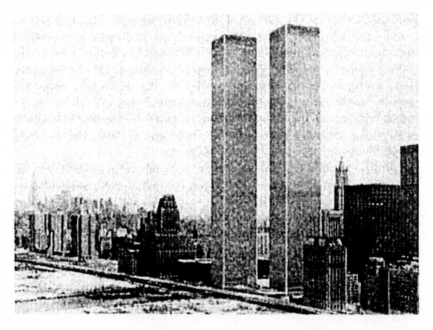

The two World Trade Towers now dominate the skyline of lower Manhattan. These two giant boxes have taken over what was once a fairyland of spires and pinnacles. Unlike most early skyscrapers, they were built with public money. (Photo by author.)

Among the worries of social and architectural critics in the early stages of planning of the center was that the project could turn out to be cold, isolated, stark and dehumanized. Unfortunately these fears were somewhat realized. Too, the lower Manhattan area, already overpopulated by daytime-only office workers, was being further crowded by other buildings of the same sort. The fear was that thousands of 9-to-5 workers would use the center during the day, leaving the area a ghost town at night.

Plans were made to avoid this pattern, but they have only been mildly successful. The towers do have very nice observation decks, two restaurants on the 107th floor (North Building) that are well patronized of course, but the fact remains that the buildings are far from Manhattan hotels, theaters and restaurants. There really is not enough to hold people in the area after business hours. A very important early requisite was a hotel for the complex, but from the beginning this project got caught up in administrative and political red tape. Everyone felt it necessary to have a nearby hotel for international visitors, customers, and tourists, but nothing happened, and all kinds of obstacles developed. At one time the hotel was promised for the American bicentennial in 1976, but it was again put off. In the late 1970s construction on an 825-room hotel was finally begun.

In general the locale is a big lonely place. Yamasaki's great plaza is a windswept no man's land which gives the feeling of eerie loneliness characteristic of a Surrealist painting of de Chirico. In the underground concourse, however, things are a little livelier, with some feeling of the former neighborhood that was destroyed. Here at least is a little urban color and bustle to take the place of the charming commercial "slum" that was eradicated. If there were more of this sort of environment the center might be a still greater magnet to the visitors and tourists.

In one area the World Trade Center has not been an unqualified success. The office space has not been completely gobbled up. It did not quite share the fate of the Empire State Building during its first decade—the vacancy rate which caused the Empire State to be called "the Empty State Building"—but the building was not rapidly occupied. Surely the complex had been overbuilt, something that doubtless would not have happened if private capital alone had been used. The twin towers were not by any means a financial catastrophe, but it is interesting to note that ten years after the building opened the Port of New York Authority was thinking about selling the buildings.

To help the Port Authority out, the state of New York, under Governor Nelson Rockefeller, consolidated many of its local offices in the World Trade Towers. The state signed a long-term lease for the space at a rate

of $9.63 a foot, although by 1980 private tenants moving into the building were signing leases at $18 to $20 a square foot. Even this last figure was a bargain by 1980. Good space in commercial office buildings in lower Manhattan was going at a rate of $30 a foot and up, indicating that the Port Authority was taking the kinds of losses that no private owner could or would endure.

Whether or not the World Trade buildings became a major symbol to Americans generally, or even to most New Yorkers, some 20 years after the opening of the complex the buildings attracted worldwide attention when a group of Islamic terrorists set off a bomb in an underground garage beneath the two towers. It was an act which raised serious issues about other skyscrapers' vulnerability to attack, especially those which might somehow be seen as icons of capitalism or emblems of American success. The minds of many Americans were especially drawn to the ramifications of this act because the United States had been relatively free of the terrorist activities that had become commonplace in other parts of the world.

The bombing of the World Trade Center took place on Friday, February 26, 1993, at 12:18 P.M. The explosion left a crater some 200 feet wide and several stories deep within the garage. The roof fell in on the underground PATH railway station, trapping many people under rubble for varying lengths of time. Four employees of the Port Authority were killed as they ate their lunch in an underground office; a fifth victim died of a heart attack after the explosion. Another body was not found until March 15. But the explosion was terrifying in the extreme to occupants of the towers. Most of the office workers in the buildings had to walk down stairwells (some from the 110th floor) that were filled with smoke, and some 1,000 people suffered injury, mostly from smoke inhalation.

There was considerable difference of opinion among architects and engineers about how close this act of violence came to toppling the towers. Most agreed that the bomb was not sufficiently well placed to bring down the buildings, but some engineers pointed out that individuals with more expertise (and with more favorable access) might have been successful in demolishing at least one of the buildings with a like amount of explosive. Following this explosion, however, building authorities took steps to limit access to the underground areas of the World Trade Center. (And doubt- less officials at other well-known skyscrapers followed suit.)

Several weeks after the bombing, four suspects were arrested and charged with committing the deed; several others were arrested or turned themselves in later. By means of very delicate and minute investigations, the FBI and other authorities discovered that the bomb had been delivered

to the underground garage by means of a Ford van rented from a Ryder agency in Jersey City, New Jersey, immediately across the Hudson River from the World Trade Towers — a place where the buildings have an overwhelming presence. In this neighborhood where the towers loomed over everything, they may well have been a symbol of American wealth and power for anyone with a grudge to bear.

Although police and FBI agents had no direct evidence linking the suspects to the crime, after thousands of hours of highly complex investigation they were able to build up a very substantial case against the defendants. A year after the bombing, in February 1994, the four principal subjects were found guilty of the deed and later sentenced to long prison terms.

The bombing of the World Trade Center proved once again, if indeed the point needed proving, that giant skyscrapers continue to inspire people with awe and wonder. In cities like New York and Chicago they continue to be living symbols of commercial achievement and of the American way of life, even though they are often taken for granted by city dwellers. Nor is this distinction likely to change in the years ahead.

Chapter 17

CLIMBERS AND DAREDEVILS – THE OLD AND THE NEW

George Leigh Mallory, the English mountain climber who began the long series of expeditions that eventually led to the conquest of Mt. Everest, was once asked why anyone would climb a mountain. "Why, because it's there," replied the great mountaineer. Such an answer probably means nothing at all to people who have never aspired to scale the side of a mountain, but to those who crave the taste of glory, the answer means everything. Mountain climbing is a passion and an obsession, however impractical or foolish it may seem to the outsider.

Skyscrapers, too, seem to inspire extravagant passions. Like a mountain, the skyscraper supremely occupies its site and stands up boldly in defiance of the tiny human below. It provides a challenge. Some rise to the challenge of ownership; others see an opportunity for self-aggrandizement, as when the Woolworths or the Chryslers hoped to see their name identified with these soaring monuments. Still others are delighted merely to possess an office or other tenancy in these prestigious urban monoliths. And there are those who savor physical contact with these modern monsters, perhaps including a few who would love just to be able to kick a skyscraper in the rump or to play a joke on this seemingly rigid and humorless structure. There have been bomb threats to skyscrapers and not a few disturbed souls have even contemplated violence against these symbols of commercial success; bomb threats are far from uncommon. The would-be attackers' animus is nearly always against inhabitants or owners of the buildings, not the buildings as such.

Since height and soaring strength are the imposing characteristics of skyscrapers, it is small wonder that buildings which soar into the sky have inspired the desire to climb them—just as mountains inspire the same kind of daring. Such adventurers have been few over the years, but they have been present even since the earliest days of skyscrapers. Those who

212

are motivated to climb have always appealed to the imagination and have been objects of close attention by the public and the news media. And the climbers have their own rewards unknown to the mountain climber: they perform their exploits not in some remote mountain country but right above the city streets, in full view of the multitudes.

In one respect, skyscraper climbing is surely a lesser sport than mountain climbing. Provided there are adequate holds and the climber has studied the situation and has made adequate preparations, most climbs of high buildings are more or less routine, although hardly without danger. There is little danger of avalanche or stone fall; there is little likelihood that one will make a false step on ice, snow or verglas; a brick or a window ledge or an ornament can safely be expected to hold in place. On the other hand, especially in recent years, climbers of buildings have been regarded as public nuisances, and their presence is generally not welcomed by building owners or managers.

Daredevils who attempt to assault the side of tall buildings are not new, though. There were a few practitioners of the art back in the 1890s. Mostly in those days the tricks were done by unemployed or idle steeplejacks with time hanging heavy on their hands. They would perform merely to draw a crowd on a quiet afternoon, or, in a few cases, to earn a few extra dollars. There were a fair number of steeplejacks in those days, itinerant workers who went from town to town following their trade, since few towns could afford to keep a steeplejack busy full of time. But steeplejacks discovered that they were the object of fascination, and that when they were employed in their routine work of painting, cleaning or repairing a steeple, they would draw crowds of onlookers who were riveted by their dangerous acrobatics on high. Actually the work was not as dangerous as it appeared since the men were invariably roped up and attached to the surface as a protection against a fall. Falls were rare, the perverse hopes of the expectant crowd notwithstanding.

When tall buildings came into existence steeplejacks occasionally got work in them, pointing, painting window ledges or doing other such tasks, but in later years their vocation would pass into other hands. Sometimes, with little to do between jobs, a steeplejack might decide to excite a crowd (and perhaps a tight-fisted building owner who was not eager to pay for repairs to a building's exterior) by scaling the surface of some office building as a lark or a scouting expedition, allegedly to report from above on the condition of things. Such escapades were every bit as exciting to the bypassers of city streets as the high steeple work — if not more so, since the skyscraper presented a seemingly sheer vertical surface.

The scaling of an office building unroped was indeed a bit more

dangerous than working on steeples, which invariably were supplied with all kinds of handholds, cornices, cracks and crevices. The office building climb looked much more daring and difficult, so it was more magnetic to the public. In reality, however, the climbing was not as difficult for a confident climber as the average onlooker supposed. Most of the early skyscrapers were of brick and offered good hand- and footholds. Very often the ambitious steeplejack would be able to make his way up the surface by following the window line, almost without interruption. Sometimes there was a little trouble in the beginning since the lower floors of some skyscrapers were faced with smooth decorative surfaces such as terra cotta or even marble. Such buildings could simply be avoided in favor of others that offered enough ornament or other handholds to get past the first few floors and then onto the common brick, after which the work became much easier. On the brick one could merely follow the windows from floor to floor and ledge to ledge. If the corners of the building were ornamented with large stones offering adequate holds, as was often the case, the building could be mounted almost as easily as if it had a ladder built up the side. The climber could put on all kinds of acts to make the exploit seem difficult, but it would be rather easy work for someone not afraid of heights.

As years went by, most of these building climbers disappeared, especially since techniques were invented for maintaining the buildings from fixed platforms dropped down over the roof or from windows. A man on a platform or in a swinging chair was just not as exciting as a bold human fly making his way unaided up a sheer wall. The crowds would still assemble to watch the digging of the foundation or the antics of the steelmen and riveters as the building's skeleton grew, but the window washer or repairman was no longer very interesting.

Although the art of climbing up the outside of tall buildings faded for many years, the interest in it never completely died out, for there were always a few ready to try. After the Empire State Building opened in 1931, its management was regularly beseeched by amateurs who wanted to assail the building, but the idea was firmly but politely rejected, even though it might have led to front-page publicity for the half-vacant building. No building manager worth his salt wanted to risk getting involved in lawsuits or other difficulties that might have resulted from such a venture. Since there were few in those days who would attempt this kind of act — clearly a trespass on private property — without permission, none of the great Manhattan skyscrapers was scaled, and high building daredevilry elsewhere died out also.

Starting in the 1970s, however, the desire to scale tall buildings

reasserted itself. Now the venture was seen as a challenge in a new light — not only was there a greater technical challenge of climbing sheer walls, this time mostly of solid glass sheets looking even more unclimbable than ever (although not necessarily as lacking in grips as they might appear), but there was a new challenge of defying authority. The climbs became a prank, a thumbing of the nose at ownership and private property. Instead of asking for permission, the climber would plan the stunt secretly and carry it out in defiance of the law and wishes of the building owner. Some fun might be had if the authorities tried to haul the climber in or cheat him of his intended triumph.

This new attitude of the climbers was evident in the spring of 1977 when a mountain climber by the name of George Willig set out for an ascent of one of the World Trade Towers. The World Trade Towers had by this time overtaken the Empire State Building as the tallest in the city, and the gaunt and abrupt appearance of the two buildings made them likely targets of those who saw some fun in defying authority. Here was a natural stage on which old-fashioned American ingenuity and resourcefulness could dramatize its contempt for the achievements of government and big business.

Willig got to the top after careful reconnaissance and detailed preparation, but, as expected, he was promptly arrested on charges of trespassing. In a matter of days Willig went from hero to public nuisance (since it was alleged that he did considerable damage to the building and its hardware), and back to hero again. Charges against him were eventually dropped.

Out in Chicago the Sears Tower became the focus of much the same kind of activity in the late 1970s — quite naturally since it was the tallest office building in the world. Several well-planned attempts were made, all without permission, but were finally defeated either because the climber tired out and allowed himself to be hauled in or because the climber was captured by building workers and police who went into pursuit using the building's window washing equipment to pursue an offender who had not counted on such firm opposition.

On Memorial Day 1981 the feat was finally accomplished by 25-year-old Daniel Goodwin in a red, yellow and blue Spiderman costume. Goodwin, too, had planned carefully and had at least one accomplice. He was fully prepared to resist an attack by the platforms used by window and repair crews. Whereas earlier climbers had limited themselves to a single track of the window washing system and could thus be apprehended, Goodwin came equipped with suction cups that would allow him to move across the window surface from one track to another, thus defeating all attempts to capture him before reaching the top.

Mountain climber and stuntman George Willig makes the victory sign for news photographers after his well-planned climb of one of the World Trade Towers in the spring of 1977. (Ted Crowell/Time magazine photo.)

Thus ingeniously equipped, Spiderman Goodwin managed to get to the top of the Sears Tower in seven and a half hours. At the roof he was met by representatives of the Chicago police and summarily hauled off to the lockup, charged with misconduct, criminal trespass and criminal damage to property. Several weeks later he was fined $35 for his prank, obviously a purely nominal amount when one considers the possible and actual damage to the building and the number of hours required of building employees, police and other workers. Magistrates have not been very vindictive in cases of this sort, and with the incident itself a fleeting memory, justice tends to be merciful.

When he was later asked why he had pulled this stunt, Goodwin replied, "Because it is the tallest building in the world." What better answer could there be?

In the fall of 1981 Goodwin was at it again in Chicago, having also spent time scaling office buildings in Dallas and San Francisco. He made two attempts to climb the John Hancock Building on North Michigan Avenue, with passersby and school children cheering him on. His second attempt, on Veterans' Day (Goodwin seemed to enjoy making his climbs on prominent holidays), was successful even though firefighters cruelly attempted to wash him off the building with a cascade of water from high pressure hoses. This time justice was more severe: Goodwin was placed on probation and warned sternly to leave Chicago buildings alone, or else.

Even before George Willig attempted his long climb up one of the World Trade Towers, a French aerialist pulled off an interesting stunt involving both towers. After long preparation during which he scouted the buildings over 200 times, Philippe Petit on August 8, 1974, crossed between the two buildings by means of a rope. Since the roof of the building on which the public is permitted is quite well protected against potential jumpers, Petit's task was anything but easy. Nonetheless he managed to get across, thus surely establishing a record of some kind. He was arrested and charged with trespassing, but later the District Attorney of New York agreed to drop the charges if Petit would put on free performances for children in the city's parks.

Some of these daredevils have had supposedly serious motives in mind when they tackled the great towers, although admittedly most went about their business with a carefree spirit of jollity and mild contempt. On July 23, 1975, the World Trade Towers had a visitor from the sky when Owen J. Quinn skydived onto the top of one building. Quinn's avowed purpose was to dramatize the plight of the poor, although exactly how it was supposed to do that was not altogether clear. This announced motive put Quinn in a somewhat different category from most of the pranksters

who were just out to have a good time. In spite of his good intentions Quinn was arrested on charges of criminal trespass and reckless endangerment.

Whatever the charges brought against them, the various pranksters have generally become public favorites and local heroes, at least for a day or so. A few are writing books about their antics, even detailing their methods and techniques. Tall buildings are rather stately and formidable in appearance, and assaults on them tickle the fancy of many, so it is hard for the authorities to see these people as serious malefactors. Sometimes, too, one wonders if the building owners and managers are really as displeased by these events as they appear to be; after all, the climbs are wonderful sources of publicity, with the front page of the local newspaper being plastered with pictures of a building which just may be in need of attracting new tenants or customers. In spite of all the fuss and annoyance, the building managers are probably as amused as the rest of the spectators when it is all over—secretly at least.

French acrobat Philippe Petit made an unauthorized crossing between the two World Trade Center buildings on August 8, 1974. He was arrested, but the charges of trespassing were dropped when he agreed to put on performances for children in city parks. (UPI photo.)

At times in New York the various feats of daredevilry come in spurts of rapid succession. In September 1981 several attempts were made to parachute onto the top of the World Trade Center. All participants were immediately apprehended by the police, although early on the morning of September 14, in the second attempt in a week, a 41-year-old man from Connecticut named Richard Nordli missed his target entirely and landed on the streets of lower Manhattan. He, too, was seized by police after arriving at the Trade Center in a taxicab.

The motivation for many of these escapades is often obscure, sometimes even to the stuntmen themselves. New York seems to be a magnetic attraction for demonstrative daredevils of every stripe. On September 14, 1981, the very day that Richard Nordli was making his failed pass at the World Trade Towers, a homeless 21-year-old man who claimed to be running for mayor of New York broke a window in the base of the crown of the Statue of Liberty and climbed out onto the top of the statue's crown, from which point he showered leaflets down on the tourists below. The man, Arthur Allen, wearing an "I Love New York" T-shirt, held to his post for two hours before being pulled in by police. He was hauled before a federal magistrate and charged with destruction of federal property. He was released on $1,000 bail.

In recent years some more benign spectacles have actually been encouraged by building managers, with the idea that if things are properly organized and publicized a good show may be refreshing to the spirit — and perhaps the pocketbook as well. The Empire State Building, for example, has revived an annual affair from a long time back: the run-up. The run-up is simply an organized running race in which participants run up the stairs from the first floor to the top of the building.

The idea originated at the Empire State the year after the building opened. A group of Olympic skiers who were in the United States to attend the Winter Olympics at Lake Placid, New York, visited New York City as tourists. Looking for something athletic and novel to do, they got the idea of running up the stairs of the world's tallest building. It all started with the Polish team, which spontaneously made a rush for the top only to encounter there the Czech team, which was also visiting New York. The Czechs issued a challenge to the Poles for a race on another day, but the building authorities began to see a dangerous precedent developing and put a stop to the whole business.

But the Poles had given birth to an idea that would not die, and in the late 1970s the run-up was revived at the Empire State Building, which was now in need of the publicity, having lost to the World Trade Towers its title of the tallest building in the city and the world. Furthermore, the

1970s saw the revival of running or jogging as a popular sport or means of physical conditioning, and the idea seemed a refreshing and timely one. The Empire State management found it easier to agree to the romp since it was sponsored by the New York Road Runners Association, which agreed to limit participation to conditioned runners who had already participated in long-distance running events.

The first of the new run-up events sponsored by the New York Road Runners Club was held in 1978 with 15 participants and probably twice as many newsmen, photographers and others struggling to keep up and make documentary records of the event. The race that first year was won by 37-year-old Gary Muhrcke, who subsequently won a moment of notoriety when it was revealed that he was drawing an $11,822 annual disability pension from the New York Fire Department. As it turned out Muhrcke was not really a malingerer or welfare cheat as some assumed: Doctors testified that while he could run he could not lift heavy objects as required in his job.

The run to the top of the Empire State Building is not a fun race by a long shot, and has never drawn large crowds. There were 24 competitors the second year and 34 the third. Obviously the race requires conditioning in muscles not used in any of the usual running events, and few have been willing to go to the trouble to train for the competition; nonetheless the race has always attracted a lot of interest and publicity.

In February 1981 the fourth annual race was won by Pete Squires of Yonkers who raced the 1,575 steps to the eighty-sixth-floor observation deck in 10 minutes and 59 seconds. Squires was an accomplished runner in a number of categories, having won a string of victories in long races in Central Park. He was also the 1980 winner of the Big Apple Award as the best all-around runner in New York.

All participants agree that the Empire State race is pure hell. Squires himself admitted that he started grabbing the railings around the sixtieth floor and that his lungs were burning. Michael Chacour, a 40-year-old Argentinian who came in next to last in a field of 38 (30 men and 8 women), remarked: "I had to fight getting dizzy. I had a sense of sensory deprivation. It was dark, very dark. Very dry. You see only the steps in front of you. You hear the others, but they seem very distant. It's an eternity. You wonder if you are ever going to see the light." Still, Chacour thought the race worthwhile, one of the few elite races in the world with a small field. All that may change, of course, although one doubts it. Surely only a scant few runners want to take the trouble to take up the training regimen necessary to win this sort of race, so different from the usual marathons they are familiar with.

Of all the possible pranks, antics and other exercises of the human spirit and imagination that may involve buildings of great height, there may be some as yet undreamed. One cannot say what stunts may be concocted in the years ahead, but they are sure to be a nuisance to building owners and managers. Privately, however, they are sure to be delighted by it, just as the rest of the amazed spectators are.

THE TALLEST TODAY: THE SEARS TOWER

After nearly three quarters of a century of dominance by New York, the prize for "the world's tallest office building" returned to Chicago with the opening of the Sears Tower in 1974. The Sears Tower is 1,454 feet (443 meters), and thus 154 feet taller than the World Trade Towers in New York. The technology of very tall buildings is well developed now, so if the economic climate is right one can imagine a taller building being constructed almost anywhere in the world in the years to come. But the Sears Tower restored a bit of pride to Chicago, the city which, after all, gave birth to the skyscraper back in the 1880s.

It is perhaps fitting that this new record holder for Chicago should have borne the name of the nation's largest and most successful retail merchandise firm. The Sears Roebuck Company is a deeply rooted product of the Midwest, and of Chicago specifically. Its tall tower, just outside the southwest corner of the Loop, overlooking the vast and now largely decaying or abandoned railroad yards, is a monument to American ingenuity. For Sears grew up with the railroad, which spread out like the fingers of a hand over the endless undulating prairie. It was Sears and the railroad that brought to every farmhouse and hamlet of the wide open spaces the comforts and luxuries of American manufacture — watches, sewing machines, baby carriages, clothing, furniture, bonnets or corsets for the ladies, indeed anything that the newly prospering ruralist could desire.

The Sears Building stands not at the center of the city's financial district, but off at the edge, not too far from the neighborhood of lofts and warehouses and drafting firms, but day in and day out it casts its shadow over the Union Station, the La Salle Street Station and the various city freight houses that were for so long an essential link in the Sears empire. Richard Warren Sears, the founder of the company, got his start by exploiting the sales potential of the railroad in the vast open spaces. He was

born in Minnesota and got his start in life as a telegraph operator and sta-
tion agent. For a while he was the all-purpose agent at North Redwood,
Minnesota, a community of only three houses. Bored with his duties at
the telegraph key, he discovered he could earn a little money on the side
by ordering things up through the railroads—wood, coal, lumber and
other things—and selling them to the farmers and the Indians.

Later on Sears formed an alliance with a wholesale watch firm and
began peddling watches with the help of various railway agents along his
line. This venture was immediately profitable (in six months Sears had
made $5,000) so he decided to set up his own watch firm in Minneapolis
in 1886. In the following year he moved to Chicago because it had clearly
become the railway capital of the Midwest, and formed a partnership with
a young watchmaker named Alvah Curtis Roebuck. The two entre-
preneurs continued to deal primarily with railway station agents because
they were bonded, were generally men of good character, and had regular
contact with the large number of people who drifted by the depot in small
rural towns.

A few years later Sears and Roebuck were able to sell their watch
business at a profit of $70,000, but almost immediately they were back in
business having discovered a new sales gimmick that had already been
discovered by another Chicago based retail merchant, Aaron Mont-
gomery Ward. Ward had brought to the craft of long-distance selling the
merchandise catalog, whereby customers could leaf through a list of items
available and order therefrom. New Jersey–born Ward had gotten his
Midwestern foothold by selling his merchandise through the all-pervasive
farmer's organization known as the Grange. Sears did not have the ad-
vantage of such a widespread formal organization, but he still had his con-
nection with the railroad agents and he planned to exploit this to the
fullest.

For a while in the early 1890s the catalog was not central to Sears' suc-
cess, and magazine advertisements drummed up the greatest part of his
business. But by 1893 the catalog was the coming thing, and it was the tool
that would raise Sears to the forefront of retail merchandisers. By 1893,
at which time the present name of the company, Sears, Roebuck & Co.,
came into use, the catalog was 196 pages long. At that time the catalog
was sold for 5 cents, although later Sears started giving it away to the ma-
jority of customers. Still, distribution was not exceedingly easy in the early
days. There were the station agents, to be sure, and for a while Sears sent
catalogs to volunteer distributors in batches of 24 with the idea that they
would get a small commission if anyone they had given the catalog to
became a customer. Later, when word of mouth got around, customers

wrote in directly to the company and got the catalog by rural free delivery.

In only a few years the idea exploded. By 1897 a total of 318,000 catalogs were printed. By 1904 the catalog (now two issues a year) was enjoying a press run of a million copies. By 1907 the figure was 3 million. And this in turn was small potatoes compared to what was ahead in the prosperous years of the twentieth century. In 1927, in its own gigantic printing plant, Sears and Roebuck was churning out 10 million circular letters, 5 million general catalogs, 23 million semiannual sales catalogs, together with other sales materials, for a grand total of 75 million annual items.

In the early years Sears wrote every word of the catalog himself, and he was a flamboyant and aggressive salesman. Nearly every item in the catalog was touted as being "The Best in the World," or as "Lasting Forever." On every page of the catalog were shouting banners: "Astonishing Offer," "Satisfaction or Your Money Back." Sears did not discover sales exaggeration, but he played it fortissimo like Beethoven at the piano. By 1907 he could safely brag, and he never failed to do so, that "If anyone can prove that any other five catalogue houses in the United States, selling general merchandise to the consumer, the same as we do, can show combined sales for the twelve months ending July 30, 1907 greater than Sears' $53,188,901.00," the company would forfeit $10,000 in cash to any worthy charity.

Over the years Sears has kept its strong identification with Chicago, not only keeping its executive offices in the city but also opening large retail stores in the city and its suburbs. (In time these stores were to become as important to Sears as the catalogs.) Most importantly, Chicago remained for years the hub of Sears' warehousing and distributing operations. Beginning back in 1904 the company purchased a vast tract of land along Homan Avenue on the city's west side, and there built one of the largest complexes of its kind in the world. Sears became the largest single employer in the North Lawndale and Garfield Park communities by the 1960s.

The Sears Tower of the 1970s is perhaps a suitable monument to the great merchandising monolith. It is a somber mass, utilitarian looking and not pretty, but commanding and impressive nonetheless. Surely it was a welcome change from the typical crackerbox of the period leading up to its construction. The building had to be big if it were to hold all the Sears offices, for the firm initially occupied fully half of the building—quite an exception among named buildings since very often a firm may enjoy the public relations value of a name yet occupy no more than three or four

floors of the building. Sears occupied the lower 50 floors of the Sears Tower, which offer the greatest floor space, since the building is set back at the fiftieth and sixty-sixth floors. (After it fell on hard times Sears greatly cut back its occupancy of the building.)

The building was designed by the fabulously successful commercial firm of Skidmore, Owings and Merrill, and it is certainly a triumph of modern technological construction. The chief designer was Bruce Graham and the chief structural engineer was Fazlur Kahn. The building consists of a series of nine tubes banded together — tubes of various heights that provide the setbacks, although this effect is not obvious to the distant eye. The building is much more inspirational on close inspection than at a distance, where it looks more like a driftwood carving made by some giant. But the design is nonetheless remarkable. Each of the framed tubes is 75 feet square, and they are banded together structurally to provide lateral strength which is much needed in "the windy city." The nine tubes rise together for 49 stories, at which point the northwest and southeast tubes terminate. At the sixty-fifth floor the northeast and southwest tubes stop, and at the ninetieth floor the remaining north, east and south tubes terminate, thus leaving a singular rectangular tower to the top of the building. This is by any standards a design of considerable aesthetic appeal and practical usefulness at the same time. The building is encased in black aluminum and bronze-tinted glass, providing a somber and subdued exterior.

Everything about the building otherwise must be expressed in terms of the grandiose. The building is not only the tallest office building in the world, it is the largest such building devoted to private enterprise, containing 4.5 million gross square feet of space. The building, which took four years to complete, and which engaged a labor force of 1,600 people (small by comparison with the great building projects in New York at the beginning of the depression), made use of 76,000 tons of steel and enough concrete to build an eight-lane highway five miles long. It has more than 16,000 bronze tinted windows, and 28 acres of black aluminum skin. The building weighs 222,500 tons and is supported by 114 rock caissons that are sunk to bedrock. It cost $150,000,000.

The Sears Tower was designed to be as completely automated and labor-free as possible for a labor-costly era. There are 103 elevators divided into three separate zones, and needless to say these are completely automated and traffic controlled. Even the elevators that take visitors to the observation deck have a recorded voice to tell visitors about the building. The all-electric building makes use of the latest techniques of energy conservation. It contains the most advanced and comprehensive

system of safety in any high-rise building, with automatic sprinklers, smoke detectors, emergency diesel generators and elaborate communication systems for all emergency uses. Even the window washing system is completely automatic and requires no human labor. Six window washing machines clean the exterior windows six times a year. And the machines actually work.

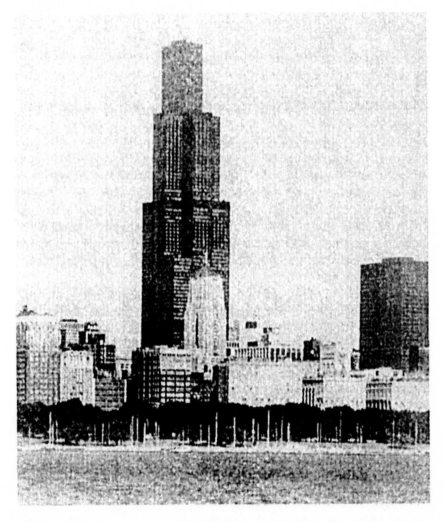

The Sears Tower in Chicago, at 1,454 feet, is the tallest building in the world today. It may not be a thing of great beauty, but it certainly is an engine of urban boosterism for the Midwestern metropolis. At its foot is The Board of Trade Building, for years Chicago's tallest. (Photo by author.)

Sears has taken pains to make the building inviting to visitors, who add considerably to the building's own planned population of 16,000 persons. No one going to the top of the building should fail to look at Alexander Calder's delightful swinging sculpture on the main floor lobby, Wacker Drive side. This great and whimsical work entitled "Universe" gives a certain amount of gaiety to the somber utilitarian structure which houses it. The sculptural work of the man who invented kinetic art is so large that each of its parts—a spine, three flowers, helix, pendulum and sun—has to be driven by its own motor.

The 103rd story observation deck is one of the nicest anywhere—completely glass enclosed and protected from the elements, yet with windows large enough to get an unobstructed view of any part of the city. The deck is open from 9 A.M. to midnight seven days a week, and naturally includes snack and souvenir facilities. All sorts of other human services are provided from the ground up. Lobby and mezzanine floors contain banks, retail stores and all manner of other services. There are five restaurants in the building, including a delicatessen, a coffee shop, an elegant multi-room restaurant, a pub and a 1,500-seat cafeteria for the Sears crowd.

The Sears Building may not be the most elegant or beautiful building in the world—perhaps that would be asking for too much from the great purveyor to the masses. Still, it has charms and distinctions of its own, and it has not been surpassed as yet as a technical marvel of modern construction. Some will say that the building's only distinctiveness is in being the tallest office building in the world. But this is not true—it is a remarkable and inspiring place with its own distinctive charm.

Chapter 19

AMERICAN SKYLINE

The skyscraper is the most striking architectural feature of the modern American city. More than that, it is a symbol of the American way of life, an expression of American personality. The old cities of Europe are introverted and characterized by subtlety and restraint. They do not shout their charms to the casual traveler but only to the determined seeker of cultural and architectural distinctions. The visitor to Florence or Naples or Vienna is not abruptly startled by those cities' silhouettes, but inhales their distinctiveness and glamour by degrees, as in the sniffing of some rare bouquet or vintage wine.

The American skyline, on the other hand, is a symbol of the outgoing American nature, of the desire for overt statement and the forthright claim of achievement. In the vast and open American spaces one is often brought up with a start when out of a flat and lifeless plain a cluster of magnificent buildings arises—buildings that are manifest reminders of the richness of American agriculture, or of the presence of oil or minerals. Those who denigrate the United States as a nation of crass materialists, who believe that the prevailing philosophy of Americans is that expressed so well by Calvin Coolidge, that the business of America is business, will deride the skyscraper as a monument to getters and spenders. These are office buildings after all—manifestations of mundane commerce and mirthless industry.

Nonetheless it can hardly be denied that as outward flowerings of the American city, skyscrapers are not without a style of their own. They minister to the spirit as well as the flesh. They appeal to the eye and to the intellect as the unraveling of vast technological mysteries. They appeal to the emotions because we humans are moved by the overcoming of the forces of nature and the settled laws of the universe. Even those most prone to scoff at American materialism find themselves struck dumb by the great towers of lower Manhattan. They seem to appreciate that these buildings do, in fact, mean something.

Some, especially those who pronounce the doom of the urban metropolis, may think of the golden age of the skyscraper as belonging to a time now spent. But there seems to be no diminution of the desire to build to the skies, and as new urban areas arise, construction of tall office buildings in the city's core is not far behind. Although the 1920s may have been the boom period for skyscrapers in New York, an even larger number of skyscraper cities have gone up since the Second World War. Indeed many cities of the South and Southwest have discovered their metropolitan tone and style only in recent decades. Such cities as Atlanta, Houston, Phoenix, Seattle, Denver, and Honolulu, once undistinguished in terms of skyline, have come into their own as American cities only in the last few decades. Today, they are typical American cities, and in the configuration of their own unique skylines, they also have their personal and clear-cut identities, recognizable to the knowing and venturesome eye.

As to skyscrapers themselves, at the beginning of the 1990s, there were easily four times as many of them in existence as there were in the 1940s. At the same time, the really impressive structures that tower above the city streets remain of necessity fairly small in number. Building them is expensive, and perilous from an economic standpoint if they cannot be filled.

At the beginning of the 1980s there were approximately 250 skyscrapers of 40 stories or more in the United States, with about half being in New York and Chicago. If one were to take a census of buildings 25 stories or higher, the number would increase several times over, although by today's standards few would probably call such buildings skyscrapers. On the other hand, the number of real giants has not increased as dramatically as one might think—they are, after all, expensive and daring undertakings, and the number of reckless Chryslers or Woolworths has diminished with the passing of the original spirit of American capitalism. The Woolworth Building of 1913 is still among the tallest buildings in the United States. The Woolworth's 792-foot height is topped by only 35 other buildings, and all but a few of these are in New York and Chicago.

The dedicated sightseer in the United States who would study the American skyline and savor the great monuments of urban architecture has no difficulty finding something to caress the eye. Each skyscraper is a salient feature of the city which possesses it, and the American city is demonstrative and exhibitionistic. The skyscraper is always easy to see, and it was designed to be seen; those who build them want to show them off. Often in the great American city they are well framed by land and sea

and air, but even when they are surrounded by miles and miles of urban sprawl the city's core is eyecatching and of commanding presence. Moreover, many of the greatest skyscraper cities are set off by bodies of water which surround them -- one thinks of New York, Chicago, San Francisco, Cleveland, Detroit — and the setting of a skyscraper fairyland can be as brilliant and shimmering as anything that may be dreamed of. If they do indeed deceive, and mask the hidden unrest of some urban malaise, their visual appeal is still a remedy and a confection that is hard to deny.

Of course the skyscraper was long the exclusive possession of the great Eastern cities — New York, Boston, Chicago, Philadelphia, and Cleveland. All historical surveys of the development and aesthetic of the skyscraper must begin with these fertile grounds. But the once narrowly restricted skyscraper development has spread itself far and wide. Keeping up with it all can be confusing and elusive.

As new urban centers grew in wealth and population during the twentieth century they sought to mock, insofar as was practically feasible, the most handsome attainments of America's commercial capital. Once the concept was born in Chicago, New York began the skyscraper craze, developed the technical expertise, and harbored the workers, builders and architects with the specialized knowledge to build to the sky, and it was many years before the skyscraper became a familiar part of the typical American cityscape.

Before the First World War, nearly all of the architects and building firms capable of building skyscrapers of any imposing height were located in the East, so it is small wonder that little was being built anywhere else. At the time of its great fire in 1906, San Francisco possessed not a single skyscraper worthy of the name. The same was true of Los Angeles, Dallas and Seattle. On the other hand, smaller satellite cities of New York (such as Newark, New Jersey, less than ten miles from downtown Manhattan) were already erecting some imposing buildings before 1910. However much Newark has declined since, it must be remembered that it was once among the 15 largest American cities, and packed a powerful industrial wallop at a time when Dallas and Atlanta were commercial infants.

A city like Newark, at the turn of the century, was clearly in a position to take advantage of the Eastern building industry that was rapidly taking form in the New York metropolitan area. Indeed, Newark was a bustling city before the turn of the century and built a gigantic (but not particularly tall) building for the Prudential Life Insurance Company in the 1890s. By the time of World War I, Newark had a number of tall buildings strung along Broad Street, its main thoroughfare, and the city looked like a

miniature New York in the making. In the 1920s, when New York skyscraper construction was in its most active phase, Newark would erect two general office buildings of fair height for the day—the Lefcourt Newark Building (later Raymond Commerce Building) and the National Newark and Essex Building. These two buildings remain the top of Newark at this writing, although a certain amount of new construction has been going on since 1970.

Some of the great Eastern cities outside of New York were rather slow to get into the habit of building skyscrapers, partly for reasons of their conservative instincts and partly because of a restrained feeling that one ought not really to be aping upstart New York. This attitude certainly prevailed in Philadelphia and Boston, both older and more traditionally minded cities than New York. Washington, D.C., never joined the race for the sky because of the widespread belief, locally and nationally, that the great public buildings like the U.S. Capitol and the Washington Monument should not be dwarfed or otherwise beclouded by monuments to commercial gain and profit. This decision was perhaps a boon to Washington in sparing it from the construction of lookalike glass boxes when they were in vogue, thereby allowing the city to keep a distinct flavor of its own.

Philadelphia and Boston did get into skyscrapers, but not in a big way until after the Second World War. Both cities were old money, old family—Philadelphia the domain of the Union League Club mentality, and Boston the province of the Cabots and the Lodges who presumably believed that Boston's dignity and wealth had already been achieved and demonstrated long ago.

Of course anybody who knows anything about Philadelphia will remember that the best known tower in this famous early capital city of the United States is the City Hall, finished in 1894. Five or six of the new skyscrapers that have gone up in Philadelphia in the last few decades are now taller than City Hall, but City Hall's 548-foot tower, which includes a 37-foot statue of William Penn at the top, still reigns supreme. (For many years there was an unwritten law that no building rise higher than William Penn.) City Hall is a genuine curio of American architecture with its French Renaissance style, the tower serving mainly aesthetic and ornamental purposes. At one time the tower was considered a kind of Victorian eyesore, but even amid a lot of new skyscrapers City Hall continues to exercise its charms among a forest of boxes. The late 1980s witnessed a veritable splurge of new tall buildings in Philadelphia. One Liberty Plaza (now the city's tallest at 960 feet) opened in 1987. It and Two Liberty Plaza (1989), the Mellon Bank Center (1989), the Bell Atlantic Tower (1991), the Blue Cross Tower (1990), and Commerce Square (1990) are all taller than City Hall.

Boston, too, had its classical skyscraper that was not surpassed for many years, and appropriately for this great trading and seafaring metropolis it was the U.S. Customs House on North State Street. The building is an old one, dating back to 1847, but a 495-foot tower sprang up over the original dome in 1915. The building offered an observation deck and was popular with tourists who enjoyed the spectacular views it offered of Boston Harbor and the great city itself.

At the present time the tallest building in Boston is the 60-story John Hancock Tower, opened in 1976 and designed by I.M. Pei & Associates. Far less striking and original than the building of the same name in Chicago, the Boston John Hancock is still a remarkable and technically advanced modern skyscraper. It was much in the news in the 1970s as the skyscraper whose windows fell out. And in fact the glass exterior surfaces of the building were an unmitigated disaster to the Hancock's owners, architects and contractors ever since the building topped out in 1971. Long before the official opening, the original glass had to be replaced by coated tempered safety glass. The original glass lites (not windows), 10,344 in number, had a way of breaking mysteriously, and it was thought that replacing them with safety glass would solve the problem. But the John Hancock's problems were not over on that score: Not only were the owners involved in years of expensive litigation, but windows continued to break and fall out, causing the company for a time to hire unemployed persons to stand looking up at the building during daytime hours and blow a whistle if there was any sign of a glass slab falling out on a luckless passerby below. To this date, the troubles with the Hancock glass have not been adequately explained.

Except for this very serious problem the building has fared well. The building is rhomboid in shape (a parallelogram in which the angles are oblique and adjacent sides are unequal) so as to harmonize with the nearby Berkeley Building and with Trinity Church. The projected cost of the building was $158 million (a sum far exceeded with the many window problems), and construction required 32,000 tons of structural steel, the largest amount ever used on any building in New England.

About 26 of the 60 floors (the actual height of the building is 790 feet and there are two mechanical floors above the sixtieth floor observation deck) are occupied by home offices for John Hancock; the rest is tenanted space. The public is treated to an enclosed all-weather observation deck on the sixtieth floor which offers not only extensive views of Boston and its environs, but numerous historical displays, including a scale model of Boston in 1775, a "photorama" of 110 mounted color transparencies of New England scenes, and other exhibits. The lobby of the John Hancock

contains a 14 by 17 foot reproduction of the Declaration of Independence in stainless steel with lettering in gold leaf. The 2,300-pound reproduction is suspended from the 35-foot lobby ceiling.

Leaving the eastern shore of the United States and passing into the thickly settled regions of the country between New York and Chicago, there are a great number of skyscrapers, some of which have long been firmly identified with a particular city or region of the country. Cleveland is a good example of such a city, for there the Terminal Tower has been a visible symbol of that metropolis. Opened in 1930, the Terminal Tower was for many years the tallest skyscraper in America outside of New York City. (Remember that for a long time Chicago was laboring under height restrictions, and as the depression began Chicago had not grown above 605 feet, whereas the 52-story Terminal Tower is 708 feet.)

The Terminal Tower is a part of an impressive public square and nearby Lakeside Mall, planned by Daniel H. Burnham in the classical mode, the flavoring of which has continued to contribute to Cleveland's considerable civic dignity, even as much of the city itself has been in decline and the inner city ringed by urban decay. The Terminal Tower and the hotels, department stores and office buildings nearby have allowed Cleveland to continue as a major metropolitan area in the United States. A number of skyscrapers of the 1970s and 1980s have also helped.

The Terminal Tower, long the most prominent visual landmark in Cleveland, was the climactic achievement of the Van Sweringen brothers, Oris and Mantis, two inseparable bachelors who founded a gigantic real estate empire in Cleveland starting with their development of the area known as Shaker Heights. They saw the potential of Shaker Heights, then a purely rural area on a bluff to the east of the city of Cleveland, as youngsters when they had a newspaper route in the vicinity. Later the Van Sweringens got into railroads in a big way, acquiring the Nickel Plate Railroad because it owned trackage they could use to build their Shaker Heights Rapid Transit system. Still later they had large interests in the Chesapeake & Ohio and the Erie railroads, each of which came to move its executive offices to Cleveland, the former in the Terminal Tower (which also housed the Nickel Plate offices), the latter in the nearby Midland Building.

The Van Sweringens built the Terminal Tower as both an office building of imposing proportion and a railway terminal for Cleveland's major long-distance lines. The long-distance lines have since departed, so only the office building distinction remains, although the Shaker Heights Rapid Transit continues to arrive at the terminal. The Terminal Tower

and the adjacent public square (a concept that grew out of Cleveland's early relationship with the town squares of New England—and northern Ohio was, after all, once known as the "Western Reserve" of Connecticut) continue to be the heart of Cleveland, showing that the right kind of public planning can nobly resist all forms of urban decay.

Another famous industrial city that has done even better in surmounting its most serious problems is Pittsburgh, which has managed to conquer its image as America's most polluted industrial center. Pittsburgh remains the great steel city, but in recent years it has taken on the appearance of a clean and attractive manufacturing town, with numerous attractive modern buildings. Pittsburgh of course is a place of considerable natural beauty, nestled as it is among the hills of the Appalachians, but it also is a city of some historical importance, because it is here, at the juncture of the Allegheny and Monongahela rivers, where the Ohio River begins, and where the Western explorers and traders began their journeys to settle the great open spaces of the Midwest. And from tiny Fort Pitt at this spot the present city of Pittsburgh grew as an oak from an acorn.

The famous Golden Triangle of downtown Pittsburgh is the site of one of the boldest and most innovative skyscrapers of the past several decades—the U.S. Steel (now USX) Building at 600 Grant Street. This 64-story building towers over the rest of Pittsburgh, quite properly symbolizing the industry that made the city famous. Needless to say, the building was planned as a showcase for modern uses of steel. It was also intended to consolidate all of the Pittsburgh offices of U.S. Steel, formerly spread out over 12 separate buildings in the city. Begun in 1967 and opened in 1970, the building enjoys a two-acre plaza, creating a parklike setting. Triangular in shape, the exterior columns of the building are of Cor-Ten Steel, a high-strength, corrosion-resistant metal that changes to a lovely dark russet color as it ages.

In addition to the Cor-Ten columns (a U.S. Steel product, of course, introduced in 1933), the building is a veritable museum of steel usages and modern steel technology. The building uses USS "T-1," which is about three times as strong as ordinary steel, in the lower interior columns where loads and stresses are greatest; USS Ex-Ten for floor beams and core columns; and carbon steel, the workhorse of the construction industry, in places where high strength is not essential.

There are a great many other technical advances in the USX Building, which make it one of the most up-to-date skyscrapers in the world. There is, for example, a computerized operations and control center which electrically operates and monitors everything from air conditioning and

fire alarm control to light switching. There is even an automatic mail distribution system that picks up and delivers mail on a conveyor. The building has a heliport, and, on the sixty-second floor, an elegant restaurant called the Top of the Triangle. Alas, there is no observation deck.

No mention of Pittsburgh is possible without saying something about what was for years its best known skyscraper—the University of Pittsburgh tower, perhaps the only skyscraper to house a major university. This building, known as "The Cathedral of Learning," was designed by C.Z. Klauder, constructed of Bedford stone and treated to Gothic detail. The shaft is 42 stories (535 feet), and contains an impressive vaulted Commons Room four stories high.

If Pittsburgh was once the starting point for the many travelers to the West down the Ohio River, it must be remembered that in the nation's early days, it was by barge and flatboat that nearly all of the development of the vast Midwest was carried on, and most of the cities of the region were situated along rivers or the Great Lakes. Even Chicago, which owed its growth to the coming of the railroad, had its earliest settlements because it was at the mouth of the Illinois River on Lake Michigan. Many great American cities are situated on the waters of the great rivers, and their majestic skyscrapers are often set off by the comfortable spaces which the waterways provide.

Most visitors to American cities arrive, of course, by air or by automobile; how much more richly rewarded they would be if they could enjoy the towering edifices of Cincinnati or Louisville or Memphis or St. Louis from some paddlewheel steamboat as they rise beyond the bend of a river. All of these historic cities have their skyscrapers, the most notable of which have been built since World War II. None of them is precisely famous for its skyscrapers, but all have been given a modern look by the building of the past several generations. As one sails down the Ohio River, for example, Louisville, Kentucky, has built its great new office buildings right up to the bluff above the river. But also strung along the river, and in sharp contrast to it, are remnants of many pre–Civil War dwellings and buildings, which give the city its distinctive and idiosyncratic personality.

St. Louis has been in something of a decline since World War II and has not seen the rise of a great number of tall buildings in recent years as might be befitting that great gateway to the West, but the triumphant arch designed by Eero Saarinen and standing right at the edge of the Mississippi serves to give the city a majestic kind of skyline of its own. Of historic significance in St. Louis is Louis Sullivan's masterpiece of an earlier era, the Wainwright Building.

Many of the midwestern cities had notable skyscrapers built in the

twenties or before, although many of them have been forgotten today after having been overshadowed by their bigger brothers. One curiosity that is not so easily overlooked is the Foshay Tower in Minneapolis, a building in the form of an obelisk, mocking the style of the George Washington Monument. The building was another one of those acts of personal puffery so common at one time. It was the dream of utilities magnate Wilbur B. Foshay, who was hardly able to enjoy it since he was a pathetic victim of the 1929 stock market crash, just as was Samuel Insull in Chicago, mere months after the building opened. Designed by Magney and Tusler, the building was 32 stories (447 feet) and was touted as the tallest building in the Northwest, since people in Minneapolis have always regarded the Northwest as beginning on the west bank of the Mississippi River. The Foshay Tower had an observation deck that was long popular with visitors to the Twin Cities, and since has been topped by a 163-foot antenna tower.

When the building opened in 1929, Foshay had a grand and gaudy bash to celebrate the event, and being flush at the time he invited 25,000 visitors from all over the world to attend the celebration. He even offered expense-paid trips to cabinet officers, senators, governors, congressmen, and others, most of whom showed up. There were 19-gun salutes provided by the military, and there were endless speeches. The band of John Philip Sousa played all of the favorite marches under the baton of the composer himself (including one entitled "Foshay Tower – Washington Memorial March," for which a grateful Foshay handed the maestro a check for $20,000). There was an unveiling of a glorious nude statue called "Scherzo," around which danced a large bevy of half-nude young nymphs requisitioned for the event by the flamboyant Foshay. All the visitors went home delighted, and the invited guests left with solid gold watches in their pockets.

The building itself was an expensive item, costing over $3 million. It was built of Italian marble, and no expense was spared to make the interior gaudy and opulent. Inside there were gold plated doorknobs and handmade wrought iron grillwork; the lobby featured a massive gold and silver plated ceiling and a terrazzo floor hand laid by experts brought in from Italy. Foshay himself planned to occupy an elaborate suite on the twenty-seventh and twenty-eighth floors. Here there was a magnificent library with a fireplace, three bedrooms, three baths, a dining room, a kitchen, a breakfast room and a butler's pantry. The master bath was said to be the pièce de résistance, and rumor had it that the bathtub was of pure gold. Some said that the spigots delivered champagne and perfume as well as the water of ordinary mortals, and it has been well attested that

the walls were of Italian Siena marble, with delicate glass panels in the ceiling through which filtered a pale mysterious light, giving the feeling of some vast underwater chamber.

Unfortunately Foshay never got to move into these grand and glorious quarters, for only two months after the dedication ceremony on

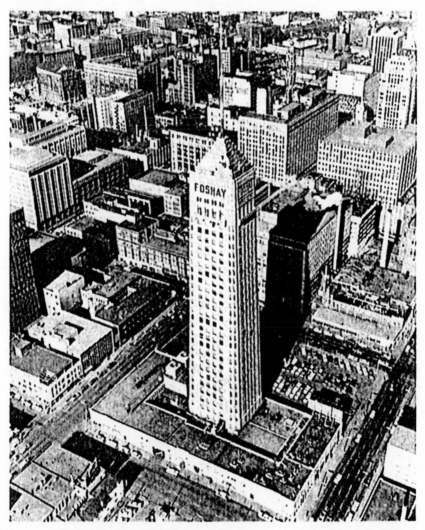

For years the Foshay Tower was the top of Minneapolis. Built in a megalomanic attempt to mimic the Washington Memorial, it had the original owner's name carved in stone at the top. Foshay went broke in the depression, but his name could not be easily removed. (Photo by author.)

August 30, 1929, the stock market crashed and Foshay's utilities empire was among the first victims. Foshay fell much more cruelly and much more rapidly than Samuel Insull, his Chicago counterpart, and in the thirties he spent three years in Leavenworth, after which he tried to build his fortune again. But the building was lost to him (by mid–December 1929 it was already losing $8,000 a month), his only consolation being that his name was etched in giant 10-foot-high lettering on all four sides of the obelisk. Later owners of the building found that it would cost a small fortune to blast these letters away, so no attempt has been made to do so. Foshay claimed that the building was a monument to George Washington, in the Midwest, and there were as many as three commissioned busts of the nation's father in the building. Although Foshay lost his building and his dream, the building and the dream never lost him, and the name FOSHAY is still clearly etched on the Minneapolis skyline.

The Midwest has prospered mightily in recent decades, but surprisingly enough, outside of New York and Chicago, the skyscraper has flourished most triumphantly of late in the South and the Southwest, with such cities as Atlanta, New Orleans, Dallas, Houston and others building some of the most attractive and tallest buildings of the postwar period. Atlanta has become perhaps the skyscraper capital of the South and can claim one of America's most striking and modern-appearing skylines. The city boasts the tallest hotel in the world in the Peachtree Center Plaza Hotel (721 feet), which is also the city's tallest building. It has a very nice observation deck and a splendid skytop restaurant. Among Atlanta's other prominent skyscrapers are the Georgia Pacific Tower and the Southern Bell Telephone Building, all products of recent building booms. Another sign of Southern prosperity in recent years is the 60-story NationsBank Building opened in Charlotte in 1992, a time when skyscraper construction was sluggish in most of the United States.

In Texas, of course, things have to be done in a big way, and Houston and Dallas not only have gone in for some impressive tall buildings in recent years, but have a larger number of them than any other American cities outside of New York and Chicago. Houston has 39 skyscrapers over 400 feet in 1995, including one with a height over 1,000 feet – the 75-story Texas Commerce Tower (1,002 feet). Dallas has 28 buildings taller than 400 feet, the tallest building being the National Bank Plaza at 939 feet. The skylines of the major cities in Texas – and throughout the Southwest for that matter – were mostly a product of the 1960s; accordingly, one finds more than enough examples of the skyscraper box. Using a kind of whimsy fostered by Charles Jencks, one might call them skybox cities. Houston and Dallas kept building up to the early 1980s, even after some

people were wondering if there was a need for all of the available office space. Because of the highly competitive nature of the real estate market both cities also welcomed numerous examples of the more eclectic post-modern buildings, with sliced off tops or extravagant ornamentation. A good example of postmodern eclecticism is Houston's 780-foot National Bank Center with piles of gingerbread in eccentric setbacks, enlivening what otherwise might be a very boring building.

Some architectural critics are not pleased with buildings of this sort. Ada Louise Huxtable, for example, who is suspicious of post-modernist buildings that wildly grab inspirations from here and there, heartily disapproves of the National Bank Center for reasons that probably would have been applauded by Louis Sullivan, namely that it is literary in its inspiration—the idea being more appropriate for a Grimm tale than for a skyscraper. It is, says Huxtable, a flat and lifeless zigzag against the sky. She finds a little more reassuring the 901-foot Transco Tower in Houston, which seems to be a kind of grudging tribute to the art deco skyscrapers of the twenties. The stone entrances and arches at the ground are uninspiring, but this is at least a worthy attempt to bring back the art deco flavor which once worked for the tall building.

Huxtable saves quite a bit of her scorn for Gerald Hines of Houston, who seems to be the Sol Hurok of Southwestern skyscrapers. Hines has developed numerous tall buildings and has been drawn to odd postmodern structures which provide a "recognition factor" on the city's skyline. Some of his buildings seem to have been built on the theory that anything weird and eccentric looking (without regard to whether it was any good) would draw prospective tenants away from older buildings, many of which had been hurting since the early 1980s.

Every once in a while one hears rumors that somewhere in Texas the tallest building in the world will go up. Working drawings for such buildings have indeed been drawn up, but at this writing they seem to be only flights of fancy.

The greatest metropolis in the far West, is, of course, Los Angeles, which is a sprawling city of the horizontal rather than the vertical. The impetus to enter the race to the sky was never particularly strong in Los Angeles, and for many years the 428-foot City Hall Building, with its once important Lindbergh Airplane Beacon, was the tallest structure in the city and the city's most important vertical symbol. In recent decades some two dozen buildings have topped the old City Hall, but even the natives of the city would be hard put to name any of them.

San Francisco has always been more important as a skyscraper city than Los Angeles. Indeed, no city in America, with the exception of New

York and Chicago, has been a more glorious showcase for the skyscraper than San Francisco. The city is rich in tall bank buildings and home offices of insurance and other financial institutions, which is only natural for a city that has long been the financial capital of the West. San Francisco took to the tall building rather early, and was already reaching for the sky at the time of the earthquake and fire of 1906.

San Francisco caught the skyscraper fever from Chicago, and some of the famous Chicago architects contributed early buildings to the city. For example, Burnham and Root contributed the Mills Building at 220 Montgomery Street in 1891. This building, built for Darius Ogden Mills, one of the financial titans of the West, survived the fire and is the only unaltered Chicago-style building in San Francisco, and it is one of Burnham and Root's most pleasing efforts. It is a modified form of Richardson Romanesque, with a fine arched entrance and delicate exterior ornament. The lower floors are of white Inyo marble veneer; the upper stories are of buff brick with graceful terra cotta ornamentation.

After the earthquake and fire of 1906, San Francisco became a leader in the construction of strong and durable office buildings, and the Chicago influence, as well as experience with poor subsoil, continued to be relevant. San Francisco has a good number of post–1906 buildings built in the Chicago style and using the Chicago window arrangement (one large horizontal window flanked by two narrow vertical windows, usually double-hung). A good example of this type was the Rose Building at 226 Sutter Street, but the visitor to San Francisco will find a number of interesting examples between the financial district and Union Square.

Starting in the 1920s, San Francisco began erecting tall and elegant office buildings that could have been the envy of anything that was going on in Chicago at that time. For many years the tallest building on the West Coast was the Russ Building at 235 Montgomery Street, designed by George Kelham and opened in 1927. The Russ Building occupies a site that had belonged to Christian Russ since 1847, holding first his personal residence and later the Russ Hotel, an establishment locally popular with miners and merchants from the 1860s. The 435-foot Russ Building was (and is) both attractive and extremely practical. The building was a marvel in its day, containing 1,370 offices and every imaginable service to the building's tenants who were a miscellaneous collection of lawyers, businessmen and entrepreneurs. The building was financed in a new and unusual way: Shares were sold directly to the general public by a corporation especially created to complete the project.

The building was of steel-frame construction with an elegant terra cotta surface and picturesque top, showing some of the same kind of

imagination that was being expressed in New York at the time. The building is E-shaped, with three wings to the west, permitting natural light and ventilation. There is a gracious two-story high Gothic entrance that belies the utilitarian purposes of the building, which was planned for all of the modern conveniences known at the time. For example, the building was the first skyscraper built to accommodate the automobile, having a 400-car garage beneath the Gothic façade.

Since it was the tallest building in San Francisco until 1964, the Russ Building was always popular with tourists. On the twenty-fourth floor there was a glass-shielded sun deck with benches and other places for tenants to meet. There was an observation deck that offered an excellent view of the city. Financially, and from a practical standpoint, the Russ Building was always a smashing success.

There are several other examples of elegant 1920s-style skyscrapers in San Francisco, including the Pacific Telephone Building and the Medical-Dental Building on Sutter Street.

In the years after 1960 San Francisco, no less than the typical American metropolis, was visited by the glass box skyscraper. Some of its examples were very routine; others were of some interest. One may consider, for example, the Crown Zellerbach Building, a product of the enterprising and far-reaching Skidmore, Owings and Merrill; the Bank of America Headquarters; and the Embarcadero Center complex. Probably the best known recent skyscraper in San Francisco — and it has become something of a visual symbol of the San Francisco skyline — is the Transamerica Pyramid at 600 Montgomery Street. When it was opened in 1972 the building prompted some good natured and not so good natured scoffing from architectural critics, but it is clear that the building is a delightful and quixotic masterpiece, one of the nation's most attractive skyscrapers.

The Transamerica Pyramid is San Francisco's tallest structure at 853 feet, although there are only 48 usable stories. The top 212 feet form a hollow spire lighted from within. The building was designed by William Pereira and Associates of Los Angeles. The Transamerica Corporation is a large conglomerate, based in San Francisco, that started as a bank holding company, founded by A.P. Giannini of Bank of America fame. In the late 1950s the company got out of the banking business and branched out into a number of miscellaneous business ventures, mostly on the West Coast: real estate, insurance, hotels, airlines, auto rentals, computers, movies, entertainment, records, and so on. Transamerica occupies about one-third of the building; the remainder is rented to various tenants.

Critics were not slow to point out that Transmerica's shape was

wasteful and extravagant. The tapered design is surely costly, and the building's offices range in size from 180 square feet on the lower floors to 45 square feet at the top. Still, from an architectural and engineering standpoint the building is a wonder. The curtain wall of the building consists of 3,000 precast quartz aggregate panels, each of which weighs three and a half tons and contains two windows that can be pivoted and washed from the inside. The building has two wings for utility purposes: the one on the east houses 18 elevators, and the western wing contains an emergency stairway and a smoke tower. One suspects that any fire will be meted swift punishment at the tower since the building has one of the most elaborate and modern fire detection and control systems in the nation. All manner of other technical problems had to be solved in this building with the decorative (and useless) top. For example, cooling is provided not from above but from two large cylinders at sidewalk level.

Although not associated with the name of an empire builder, the Transamerica Pyramid is in the tradition of buildings like the Woolworth and Chrysler buildings which serve as clear-cut visual symbols of business enterprise. Transamerica is a nondescript conglomerate, like W.R. Grace or Gulf + Western, that needed visual exposure if its name was to have any meaning to the general public. In this way a largely faceless financial enterprise could enjoy a little visibility and supply a little fun as well.

The hilly terrain of San Francisco makes it the only city in North America where it is possible to look down on tall skyscrapers from other buildings of diminutive size. This up-and-down quality of the city's byways and neighborhoods serves to make the city a charming showcase for buildings of all sorts. No discussion of San Francisco should fail to mention the large number of interesting hotels that provide towertop restaurants and lookout posts of one sort or another. For example, one of the elite gathering places of the world is the Top of the Mark restaurant in the tower of the Mark Hopkins Hotel, and the hotel itself with its central tower is a delightful 1920s period piece with its Gothic terra cotta ornamentation.

The Fairmont Hotel, too, was always an important high place in San Francisco, and this distinction was reinforced by the construction in 1962 of a tower containing a dramatic exterior elevator offering fine views of the city. The scenic outside elevator seems to have caught on in San Francisco, and is also well featured at the St. Francis Hotel, which dates back to the immediate post-fire period but sports a new tower built in 1972 and designed by William Pereira, the architect of the Transamerica Pyramid. The old building has a gray-green sandstone façade with green copper cornice, and Pereira wisely chose a wide bronze-colored cornice for the tower

to echo the original. The tower has an outside elevator that is dramatic but, alas, much too fast. The Fairmont is much more indulgent of the sightseer.

In the years since World War II, a number of other West Coast cities have entered the skyscraper age, most notably Seattle, Washington, whose beautiful skyline enjoys the setting of Puget Sound, with Mount Rainier some 50 miles distant—a magnificent background for any city on a fair day, and one that has appeared in numerous ads and posters. Seattle's tallest building is the Columbia Seafirst Center, but visitors to the city probably think first of the 605-foot Space Needle, a prime tourist attraction in the city since the 1962 World's Fair. San Diego, California, has become one of the great metropolitan regions of the West Coast, and has developed its own comely skyline edging the picturesque and ever-beautiful San Diego Bay.

When one thinks of the many magnificent skyscrapers that have gone up around the country since the early 1970s, it is worth considering

The San Francisco skyline in recent years shows examples of all skyscraper styles. The pyramidal Transamerica Building designed by William Pereira affords the city a new sense of fun, as this 1974 shot shows. (Photo courtesy San Francisco Convention & Visitors Bureau.)

especially the large number of attractive and inviting hotels that have taken to the skies, sometimes with startling effect. For decades the Waldorf Astoria was the tallest hotel in the United States as well as one of the most elegant. Now it is exceeded in height by such buildings as the Peachtree Plaza Hotel, but in addition a number of interesting hotels of unusual design have been built in the last quarter of the twentieth century. There are, for example, the towers of San Francisco just mentioned, and one immediately thinks of the growing chain of Hyatt Regency hotels which offer their visitors most unusual settings — often open atriums with balconies and crosswalks, and elevators with glass enclosed cars.

One of the most stunning hotels of the chain is the Hyatt Regency in Dallas, Texas. As in all of its hotels the Hyatt chain has given much thought to the setting and grand design, and its Dallas hotel is part of an elaborate local development called Reunion on the western edge of the downtown area. Included in the overall scheme is a newly restored (vintage 1914) Union Station, a 10-acre park, a city-owned Reunion Arena, and an 18,500-seat special events center.

But the skyscraper hotel and an adjoining tower are the heart of the Reunion development. Both hotel and tower adjoining were designed by Welton Becket and Associates of Los Angeles. The 30-story luxury convention hotel has 1,000 rooms and is encased in an exterior surface of silver reflective glass. The interior is one of the more striking Hyatt Regency appearances, featuring a 20-foot cascading waterfall and a central lobby atrium rising to 200 feet (the eighteenth floor), the south face of which contains an enormous six-story glass curtain wall. Glass-enclosed elevators carry guests and visitors inside the atrium for 18 floors, then through a skylight to the additional 12 floors.

Adjacent to the hotel is the 50-story Reunion Tower, a new and exciting landmark not only for the Reunion complex but for the city as well. Atop the tower is a giant geodesic dome, 118 feet in diameter, consisting of an open-web network of anodized aluminum struts. Enclosed in this dome, which contains 25,000 square feet, are a revolving cocktail lounge, a revolving restaurant, and an observation deck.

Although the scale and magnificence of things at the Reunion Tower are not often surpassed, the phenomenon of the revolving tower restaurant or cocktail lounge is characteristic of developments in hotels around the country since the 1970s. A great many hotels have added this feature to attract visitors to what is (most characteristically) a posh restaurant which slowly changes the view of the city below while the patron dines. Needless to say these rooftop restaurants turn at a slow pace, and the customers are assured of a shifting view and not an unsettled

digestion. The revolving restaurant has thus become a major addition to American skyscrapers.

In discussing the tremendous proliferation of the skyscraper in the years since World War II, some mention must be made of the cities of Canada. Although technically outside the scope of the present book, Canada is in many ways the country whose urban geography and topography most nearly resemble those of the United States (a comparison that many Canadians resent). Aerial views of a number of the most important Canadian cities have little about them to allow the casual observer to make the discrimination between the cities of these two friendly but competitive neighbors, so a brief discussion of Canada's skyscrapers seems in order. Moreover, many Canadian buildings of importance were designed by American architectural firms, and the technologies and building trades of the two countries are shared, so that it is only natural that the urban areas of the two countries would take on a similar appearance, whatever the cultural differences underneath.

Canada has some beautiful and dramatic skylines, such as that of Vancouver on the West Coast. Vancouver, with its matchless location on the Strait of Georgia, was an obvious place for great buildings to rise, and it was only natural that they should since Vancouver is the western commercial capital of Canada. There are over a dozen buildings over 300 feet in Vancouver, most of which were built since World War II and many of which are both appealing to the eye and impressive in design.

Of course Canadian skyscrapers had their birth in eastern Canada where all of the original commercial interests had their roots. In Montreal, the largest city of the province of Quebec and a vital city in the commercial affairs of Canada, a number of impressive modern buildings have arisen. Visitors with an architectural bent will be especially interested in the modern complex known as Westmount Square, since it is the most significant Canadian achievement of Ludwig Mies van der Rohe.

For a long time the most famous skyscraper in Montreal, if not all of Canada, was the Sun Life Building in downtown Montreal at Dominion Square. Touted for years as the tallest building in the British Empire, the Sun Life Building lost some of its glamour when Sun Life moved its corporate headquarters to Toronto, and, even before that, when Montreal began to erect a number of modern glass box skyscrapers, all of which put the Sun Life Building in the shade. In 1990, Montreal was the home of three modern skyscrapers above 600 feet: Place Victoria, Place Ville Marie and the Canadian Imperial Bank of Commerce. All dwarf the once glorious Sun Life Building, which now seems lost among the statuary of Dominion Square. Two other giants have arisen since 1990.

The other major city of Quebec is Quebec City, one of the great original settlements of North America. Of course the skyscraper has wisely not been allowed to intrude on the great bluff overlooking the St. Lawrence River, and it has not been allowed to rise in old French Quebec along the river and below the bluff — these thankfully continue to carry on with their own personal charm, making Quebec one of the few cities in North America with anything like an Old World flavor. But to the west, and tucked behind the traditional city, are modern and strictly American high-rise buildings — some of governmental agencies (for this is the capital of the socialist-minded province of Quebec), and some of private enterprise. A number are architecturally very interesting.

Of the large Canadian cities, none would seem to have more the flavoring of an American metropolis than Toronto, Ontario, Canada's largest city. Of course locals hardly relish the comparison, and indeed even the occasional sightseers will notice that Toronto has a style and substance all its own, but a view of Toronto from the air or from the shores of Lake Erie seems to reveal a city that might well fit in anywhere in the United States. As the largest Canadian city, Toronto has more skyscrapers than any other city in the land — over 30 buildings at a height of 400 feet or more in the early 1990s, with banks and financial institutions strongly predominating. Toronto's most intense source of pride, however, is the Canadian National Tower of 1,821 feet. While not strictly speaking a skyscraper in the usual sense, the CN Tower is presently the world's tallest self-supporting structure, and thus a golden nugget in the record books.

* * *

Where will it all end? Is the skyscraper a lasting product of American technology and culture, or is it a symbol of the excesses of American life that will eventually slip into the sands of time like some antediluvian monster? It is impossible to know, of course, or even to make confident predictions about such highly speculative matters.

There are those who say that the American city is a failure, and there is nothing to be done with it but shovel it under. Too, there are many architects, sociologists and cultural critics who may have faith in cities but who condemn skyscrapers as instigators of urban decadence. Feelings about the skyscraper seem to fluctuate in much the same way that the stock market fluctuates. Numerous articles in architectural journals have even proclaimed the "death" of the skyscraper, and naturally such apocalyptic prophecies become exaggerated in times of economic recession. Architects, especially, are prone to make gloomy predictions about

skyscrapers when there are few commissions to design them. Since the mid-1980s the news about city office buildings has rarely been good. In 1991 the press reported the gloomy news that the Empire State Building was sold by its owner at the time, the Prudential Insurance Company of America, for a reputed pittance of $40 million. The building, which was encumbered by a complicated leasing arrangement, would surely have fetched $400 million under different circumstances. The Empire State case is merely one dramatic example of the difficulties that managers of office properties have been laboring under in the 1990s.

There are very few cities in the United States at present where the occupancy rate in skyscrapers is a source of optimism. In certain areas of the country vacancy rates for all office buildings are at a near-disaster level. Houston, for example, had a vacancy rate of 25 percent in 1991, and only one important office tower had been built there in five years. Similar dreary vacancy figures were reported for New Orleans (28 percent), and other cities of the South and Southwest. All the cities of Texas were particularly hard hit. The Texas savings and loan associations, desperate to make loans, were responsible for financing the construction of many tall buildings, a number of which should never have been built. On the other hand, even in Chicago the vacancy rate has been in the range of 15 to 20 percent in the 1990s, and nearly all plans for new tall buildings were put on hold.

But the end of the skyscraper has been proclaimed many times before, just as a bad end for cities themselves has often been forecast. Still, in recent years many social critics have taken an upbeat attitude toward cities, and there is a widespread belief that somehow cities can be made to work. In any case, there is no great likelihood that Americans in large numbers will turn their backs on the urban way of life, so the effort to improve the quality of cities will probably be an ongoing one. As long as that is the case, skyscrapers will continue to be built and will contribute to the visual design of our cities. They will also probably remain a major force in the social life of American cities. As long as cities survive as centers of economic activity, as long as they remain capitals of culture, as long as they continue to be enjoyable, skyscrapers will impart a certain aura of authority, of stated civility, of dignity and grace, and will probably provide, as they always have, food for the imagination.

BIBLIOGRAPHY

There is no adequate bibliography on the skyscraper. This lack may be due not so much to the vastness of the literature on the subject as to the multidisciplinary nature of it. Skyscrapers have been of concern not only to architectural historians but to engineers, builders, civic planners, urban and social historians, students of American history, chroniclers of business enterprise and of great fortunes, and perhaps authors in a number of other fields as well.

A good deal of the relevant and easily obtainable literature will be found in the bibliography that follows. Nonetheless this bibliography has some obvious limitations. It does not include, for example, a great many sources from outside the United States, although the number of articles and books on this subject in European journals is quite large, and many of these deal with the American skyscraper.

There have been few formal histories of the skyscraper in the architectural sense; most architectural historians have treated the topic as part of larger architectural issues. Some of the best histories of skyscrapers are now long out of date. One recent comprehensive architectural history, Paul Goldberger's *The Skyscraper* (1981), contains no bibliography at all. Other recent books on the skyscraper contain bibliographies that are woefully inadequate or highly idiosyncratic.

For those interested in the development of the skyscraper and its impact in American life, especially in the half century between 1880 and 1930, one could not do better than to turn to the bibliographies in the works of Carl Condit. Not only the bibliographies but the well annotated notes in Condit's *The Chicago School of Architecture, The Rise of the Skyscraper,* and *American Building Art* will give all but the most highly specialized reader a good view of the relevant architectural history. Those particularly interested in the history of the skyscraper in New York would do well to look at two books by Robert A.M. Stern, *New York 1900* and *New York 1930,* both of which have very extensive footnotes pointing to the

249

vast literature on the design and construction of individual buildings during the golden age of the skyscraper.

Probably the best book on the skyscraper written for the general reader remains that of W.A. Starrett, *Skyscrapers and the Men Who Build Them,* written in 1928. Certainly this is the most readable and entertaining introduction to the subject for the ordinary reader. The skyscraper literature of the last half century tends to be more specialized, sometimes too pedantic or fussy for the general reader. Books like Goldberger's *The Skyscraper* or Ada Louise Huxtable's *The Tall Building Artistically Reconsidered,* while well written and solid, mostly reach out to specialized audiences or those with considerable architectural background and expertise.

Anyone who wants to delve into the present issues involving the skyscraper, including all of the running controversies, should consult the excellent current bibliographies found in the *Avery Index to Architectural Periodicals.* One may also wish to consult standard reference works such as the multivolumed *Encyclopedia of Architecture, Design, Engineering and Construction,* edited by Joseph A. Wilkes, which also contains bibliographies in a number of areas.

On the subject of the place of the skyscraper in urban life, many of the references listed below will be of considerable help. For a pictorial presentation of the development of the skyline in both Chicago and New York, probably the best available books are *Chicago: Growth of a Metropolis,* by Harold Mayer and Richard C. Wade, and *The Columbia Historical Portrait of New York* by John A. Kouwenhoven. Both books also have helpful bibliographies.

The central focus of the present book is the social history of the skyscraper in America. There is no previous single work on this topic, although the subject is touched upon in a great many articles and books cited below. For a broader general treatment of architecture and social history, see *The Architecture of America: A Social and Cultural History* by John Burchard and Albert Bush-Brown. The present book has not attempted an extensive discussion of the life and working conditions of skyscraper office workers since this area is merely a subcategory of the much larger fields of sociology, urban life, and white collar working conditions. The bibliography that follows gives some sources, but an individual interested in the subject should go on to the classics in the broader field such as C. Wright Mills' *White Collar.*

This selected bibliography does not pretend to be a complete survey of the literature on the skyscraper. It contains a fair sampling of works on the subject which may be of interest to the general reader, or which have

been used by the author in preparing the book, or which relate to specific topics referred to in the book.

Adams, Thomas, Harold M. Lewis and Lawrence M. Orton. *Regional Plan of New York and Its Environs*. Vol. 1, *The Graphic Regional Plan*. New York, 1929; Vol. 2, *The Building of the City*. New York, 1931.

Adler, Jerry. *High Rise*. New York, 1993.

Agrest, Diana. "Architectural Anagrams: The Symbolic Performance of Skyscrapers." *Oppositions* 11 (1977), pp. 26–51.

_____ (ed.). *A Romance with the City*. New York, 1982.

Alex, William. "The Skyscraper: U.S.A." *Perspectives U.S.A.* VIII (Summer 1954).

Alpern, Andrew. *New York's Fabulous Luxury Apartments*. New York, 1975.

Andrews, Wayne. *Architecture, Ambition and Americans*. New York, 1955.

_____. *Architecture in Chicago and Mid-America*. New York, 1968.

The Architectural Work of Graham, Anderson, Probst and White (2 vols.). Chicago, 1933.

Aregger, Hans. *Highrise Building and Urban Design* (Transl. of *Hochhaus und Stadtplannung*). New York, 1967.

Arnaud, Leopold. "The Tall Building in New York in the Twentieth Century." *Journal of the Society of Architectural Historians*, May 1952.

Atherton, William Henry. *The Metropolitan Tower*. New York, 1915.

Bach, Ira J. (ed.). *Chicago's Famous Buildings*. Chicago, 1980.

Bailey, Vernon Howe. *Magical City: Intimate Sketches of New York*. New York, 1935.

_____. *Skyscrapers of New York*. New York, 1928.

Balfour, Alan. *Rockefeller Center: Architecture as Theatre*. New York, 1978.

Barthes, Roland. *La Tour Eiffel*. Paris, 1964.

Bartlett, Alice Hunt (ed.). *The Anthology of Cities*. London, 1927.

Beedle, Lynn S. *Philosophy of Tall Buildings*. American Society of Civil Engineers, 1978.

Beer, Thomas. *The Mauve Decade*. New York, 1926.

Behrendt, Walter Curt. *Modern Building: Its Nature, Problems and Forms*. New York, 1937.

Bernhardi, Robert C. *Great Buildings of San Francisco*. New York, 1978.

Birkmire, William H. *The Planning and Construction of High Office Buildings*. New York, 1900.

_____. *Skeleton Construction in Buildings*. New York, 1892.

Black, Mary. *Old New York in Early Photographs*. New York, 1973.

Bonner, William. *New York: The World's Metropolis*. New York, 1929.

Bonta, Juan Pablo. *Architecture and Its Interpretation: A Study of Expressive Systems in Architecture*. New York, 1979.

Boorstin, Daniel. *The Americans: The Democratic Experience*. New York, 1973.

Bossom, Alfred C. *Building to the Skies: The Romance of the Skyscraper*. London, 1934.

Boyd, David Knickerbocker. "The Skyscraper and the Street." *American Architecture and Building News*, November 19, 1908.

Boyer, M. Christine. *Manhattan Manners: Architecture and Style, 1850–1900*. New York, 1985.

Bragdon, Claude. *Architecture and Democracy*. New York, 1918.

_____. "Architecture in the United States: The Skyscraper." *Architectural Record* 26 (1909), pp. 84–96.

Brugmann, Bruce, and Greggar Sletteland. *The Ultimate Highrise: San Francisco's Mad Rush Toward the Sky*. San Francisco, 1971.

Buitenhuis, Peter. "Aesthetics of the Skyscraper: The Views of Sullivan, James and Wright." *American Quarterly* 9 (1957), pp. 316–324.

Burchard, John, and Albert Bush-Brown. *The Architecture of America: A Social and Cultural History*. Boston, 1961.

Burnham, Alan. *New York Landmarks*. Middletown, CT, 1963.

Burnham, Daniel H., and Edward H. Bennett. *The Plan of Chicago*. Chicago, 1909.

Cadman, S. Parker. *The Cathedral of Commerce*. New York, 1917.

Campbell, Robert. "Hitting the Ceiling: Height Without Romance." *Architectural Record* 179 (1991), pp. 51–57.

Caparu, M.A. "The Riddle of the Tall Building: Has the Skyscraper a Place in American Architecture?" *The Craftsman* 10 (1906), pp. 477–488.

Carr, Ross S. "Between Tradition and Revolution: The Art Deco Skyscraper in New York." *Columbia Art Review*, Winter 1976, pp. 11–13.

Chase, W. Parker. *New York: The Wonder City*. New York, 1931.

"Chicago Board of Trade." *Architecture and Building*, June 1930.

"Chicago Reaches for the Sky." *Engineering News-Record*, April 1942.

Christ-Janes, Albert. *Eliel Saarinen*. Chicago, 1979.

"The Chrysler Building." *Architecture and Building* 62 (1930), p. 233.

Churchill, Allen. *Park Row*. New York, 1958.

Ciucci, Giorgio, et al. *The American City from the Civil War to the New Deal*. New York, 1980.

Clark, William Clifford. *The Skyscraper: A Study of the Economic Height of Office Buildings*. New York, 1930.

Clary, Martin. *Mid-Manhattan*. New York (42nd Street Property Owners and Merchants Association), 1930.

Cochran, Thomas C. *Business in American Life*. New York, 1972.

Coley, Clarence T. "Office Buildings Past, Present and Future." *Architectural Forum* 41 (1924), pp. 113–114.

Comer, John P. *New York City Building Control, 1800–1941*. New York, 1942.

Committee Appointed by the Estate of Marshall Field for the Examination of the Structure of the Home Insurance Building. Chicago, 1939.

Condit, Carl W. *American Building Art: The Nineteenth Century*. New York, 1950.

_____. *American Building Art: The Twentieth Century*. New York, 1951.

_____. *Chicago: Building, Planning and Urban Technology, 1910–1929*. Chicago, 1973.

_____. *Chicago: Building, Planning and Urban Technology, 1930–1970*. Chicago, 1974.

_____. *The Chicago School of Architecture*. Chicago, 1964.

_____. *The Rise of the Skyscraper*. Chicago, 1952.

Corbett, Harvey Wiley. "America Builds Skyward." In *America as Americans See It*. Ed. Fred J. Ringel. New York, 1932.

_____. "Raymond Matthewson Hood, 1881–1934." *Architectural Forum*, September 1934.

Dixon, John Morris. "John Hancock Center." *Architectural Forum*, July-August 1970.

Dreiser, Theodore. *The Color of a Great City*. New York, 1925.

Dublin, Louis I. *A Family of Thirty Million: The Story of the Metropolitan Life Insurance Company*. New York, 1943.

Duffas, G.L. *Mastering a Metropolis: Planning the Future of the New York Region*. New York, 1930.

Early Modern Architecture. New York (Museum of Modern Art), 1940.

Ellis, Edward Robb. *The Epic of New York*. New York, 1966.

Empire State: A History. New York (Empire State, Inc.), 1931.

Feininger, Andreas, and Susan E. Lyman. *The Face of New York*. New York, 1954.

Ferree, James Barr. "The High Building and Its Art." *Scribner's*, March 1894, pp. 297–318.

Ferriss, Hugh. *The Metropolis of Tomorrow*. New York, 1929.

_____. *Power in Buildings*. New York, 1953.

Fifty Years on Fifth, 1907–1957. New York, 1957.

Filler, Martin. "High Ruse." *Art in America* 72 (1984), pp. 150–165.

Fine, Lisa M. *The Souls of the Skyscraper: Female Clerical Workers in Chicago, 1870–1930*. Philadelphia, 1993.

Fitch, James Marston. *American Building, I: The Historical Forces That Shaped It*. New York, 1973.

_____. *American Building, II: The Environmental Forces That Shaped It*. New York, 1972.

_____. *Architecture and the Esthetics of Plenty*. New York, 1961.

Fleming, Ethel. *New York*. London, 1929.

Flinn, John J. *The Standard Guide to Chicago*. Chicago, 1892.

Ford, Larry Royden. *The Skyscraper: Urban Symbolism and City Structure*. Dissertation, University of Oregon, 1971.

Frankl, Paul. *New Dimensions: The Decorative Arts of Today in Words and Pictures*. New York, 1928.

Fraser, John Foster. *America at Work*. London, 1904.

Friedel, Frank. "Boosters, Intellectuals and the American City." In *The Historian and the City*. Ed. Oscar Handlin. Cambridge, MA, 1966.

Fuller, Henry B. "The Upward Movement in Chicago." *Atlantic Monthly* 80 (1897), pp. 539–544.

Gapp, Paul. *Paul Gapp's Chicago*. Chicago, 1980.

Gayle, Margot, and Edmund V. Gillon, Jr. *Cast-Iron Architecture in New York*. New York, n.d.

Gibbs, Kenneth Turney. *Business Architectural Imagery in America, 1870–1930*. Ann Arbor, MI, 1984.

Giedion, Siegfried. *Space, Time and Architecture*. Cambridge, MA, 1946.

Gilbert, Cass. *Reminiscences and Addresses.* New York, 1935.

Goff, Lisa. "Chicago Builds a New Skyline." *Progressive Architecture* 67 (1987), pp. 46–53.

Goldberger, Paul. *The City Observed: New York.* New York, 1979.

_____. *The Skyscraper.* New York, 1981.

Goldman, Jonathan. *The Empire State Building Book.* New York, 1980.

Goldstone, Harmon H. *History Preserved: A Guide to New York City Landmarks and Historic Districts.* New York, 1974.

Granger, Alfred. "The Tribune Tower as a Work of Architecture." *Western Architect,* December 1925.

Gropius, Walter. *Apollo in the Democracy.* New York, 1968.

Hayden, Dolores. "Skyscraper Seduction—Skyscraper Rape." *Heresies* 2 (1977), pp. 108–115.

The Heritage of New York (New York Community Trust). New York, 1970.

Hill, George. "Some Practical Limiting Considerations in the Design of the Modern Office Building." *Architectural Record* 2:4 (1895), pp. 443–468.

Hine, Lewis W. *Men at Work.* New York, 1932.

Hines, Thomas S. *Burnham of Chicago: Architect and Planner.* Chicago, 1974.

Hirsch, Susan, and Robert J. Goler. *A City Comes of Age: Chicago in the 1890s.* Chicago, 1990.

History of Architecture and Business Trades of Greater New York. New York, 1899.

A History of Fifty Feet in New York at Wall and William Streets. New York, 1926.

A History of Real Estate, Building and Architecture in New York City During the Last Quarter of a Century. New York, 1899.

Hitchcock, Henry-Russell. *Architecture: Nineteenth and Twentieth Centuries.* Baltimore, 1963.

_____. "Sullivan and the Skyscraper." *RIBA Journal* 60 (1953), pp. 353–360.

Hoffman, Donald. *The Architecture of John Wellborn Root.* Baltimore, 1973.

_____. "The Monadnock Building." *Journal of the Society of Architectural Historians* 26 (1967), pp. 269–276.

Hood, Raymond Matthewson. "The Design of Rockefeller Center." *Architectural Forum,* January 1932.

_____. "Exterior Architecture of Office Buildings." *Architectural Forum,* September 1924.

_____. "The Tribune Tower: The Architect's Problem." *Architectural Forum,* September 1924.

Horowitz, Louis J. *The Towers of New York.* New York, 1937.

Howe, Frederick. *The City: The Hope of Democracy.* New York, 1965.

Hoyt, Homer. *One Hundred Years of Land Values in Chicago.* Chicago, 1933.

Hudnut, Joseph. *Architecture and the Spirit of Man.* Cambridge, MA, 1949.

Huxtable, Ada Louise. *The Tall Building Artistically Reconsidered.* New York, 1984.

Industrial Chicago (2 vols.). Chicago, 1891.

Jacoby, Stephen M. *Architectural Sculpture in New York.* New York, 1975.

James, Marquis. *The Metropolitan Life.* New York, 1947.

James, Theodore, Jr. *The Empire State Building.* New York, 1975.

Jenkes, Charles A. *Late Modern Architecture.* New York, 1980.
————. *Skyscrapers—Skyprickers—Skycities.* New York, 1979.
Jenney, William Le Baron. "The Chicago Construction, or Tall Buildings on a Compressible Soil." *Inland Architect and News Record,* November 1891.
Johnson, Philip. *Mies van der Rohe.* New York, 1978.
Jordy, William H. *American Buildings and Their Architecture, III, Progressive and Academic Ideals at the Turn of the Century.* Garden City, NY, 1976.
————. *American Buildings and Their Architecture, IV, The Impact of Modernism in the Mid-Twentieth Century.* Garden City, NY, 1976.
Kaufmann, Edgar (ed.). *The Rise of American Architecture.* New York, 1970.
Kauschke, Hans Gerhard. "Going Height Crazy." *The Futurist* 20 (1986), pp. 8–11.
Kilham, Walter. *Raymond Hood: Architect: Form Through Function in the American Skyscraper.* New York, 1973.
King, Moses. *King's Views of New York.* New York, 1912.
Kirkland, Edmund Chase. *Dream and Thought in the Business Community, 1860–1900.* Ithaca, NY, 1956.
Klaw, Spencer. "All Safe, Gentlemen, All Safe." *American Heritage,* August-September 1978.
————. "The World's Tallest Building" [Woolworth]. *American Heritage,* February 1977.
Koolhass, Rem. *Delirious New York.* New York, 1978.
Kouwenhoven, John A. *The Columbia Historical Portrait of New York.* New York, 1953.
Krinsky, Carol Hershelle. *Rockefeller Center.* New York, 1978.
Kroos, Herman E., and Charles Gilbert. *American Business History.* Englewood Cliffs, NJ, 1972.
Lamb, William F. "The Empire State Building" (Part IV). *Architectural Forum,* January 1931.
Larkin, Oliver. *Art and Life in America.* New York, 1949.
Le Corbusier. *La Ville Radieuse.* Paris, 1974.
————. *When Cathedrals Were White—A Journey to the Country of the Timid People.* New York, 1947.
Lee, Gerald Stanley. "The Metropolitan Tower." *The Intelligencer,* February 1913.
Lehman, A.L. *The New York Skyscraper.* Dissertation, Yale University, 1970.
Leich, Jean Ferriss. *Architectural Visions: The Drawings of Hugh Ferriss.* New York, 1980.
Leitich, Ann. *New York.* Leipzig, 1932.
Lethaby, William R. *Architecture, Mysticism and Myth.* New York, 1975.
Lockwood, Charles. *Manhattan Moves Uptown.* Boston, 1976.
Loth, David. *The City Within a City: The Romance of Rockefeller Center.* New York, 1966.
Lowe, David. *Lost Chicago.* Boston, 1975.
Lowe, Frances. "A Chase Up into the Sky." *American Heritage,* October 1968.
Lubschez, Ben Judah. *Manhattan: The Magical Island.* New York, 1927.
Lynch, Agnes Starrett. *Through One Hundred and Fifty Years: The University of Pittsburgh.* Pittsburgh, 1937.

McCullough, David. *The Great Bridge*. New York, 1972.

Marx, Leo. *The Machine in the Garden: Technology and the Pastoral Ideal in America*. New York, 1979.

Mayer, Harold, and Richard C. Wade. *Chicago: Growth of a Metropolis*. Chicago, 1969.

Menocal, Narcisco G. *Architecture as Nature: The Transcendentalist Idea of Louis Sullivan*. Madison, WI, 1981.

"The Metropolitan Life Building" (pamphlet). New York, 1909.

Mikkelson, Michael A., et al. *A History of Real Estate Building and Architecture in New York During the Last Quarter of the Century*. New York, 1898.

Monroe, Harriet. *John Wellborn Root*. Boston, 1896.

Morgan, Alfred P. *The Story of Skyscrapers*. New York, 1944.

Morrison, Hugh S. "Buffington and the Invention of the Skyscraper." *Art Bulletin*, March 1944.

———. *Louis Sullivan: Prophet of Modern Architecture*. New York, 1962.

Moss, Frank. *The American Metropolis from Knickerbocker Days to the Present Time*. 3 vols. New York, 1962.

Mujica, Francisco. *History of the Skyscraper*. New York, 1977 (reprint of 1929 edition).

Mumford, Louis. *The Brown Decades: A Study of the Arts in America*. New York, 1955 (reprint).

———. "Is the Skyscraper Tolerable?" *Architecture 55*, February 1927.

———. "Office Buildings of Today and Tomorrow." *Architectural Forum 68* (1928), pp. 5–23.

———. *Roots of Contemporary American Architecture*. New York, 1952.

———. *Sticks and Stones: A Study of American Architecture and Civilization*. New York, 1955 (reprint).

Namier, Sir Lewis Bernstein. *Skyscrapers and Other Essays*. Freeport, NY, 1968.

Naumburg, Elsa Herzfeld. *Skyscraper*. New York, 1933.

Newton, Roger Hale. "New Evidence on the Evolution of the Skyscraper." *Art Quarterly 4* (1941), pp. 56–70.

North, Arthur Tappan. *Raymond Hood*. New York, 1931.

Oechlin, Werner. "Skyscraper und Amerikanismus; Mythos zwischen Europa and Amerika." *Archithese 20* (1976), pp. 4–12.

Office Buildings. New York (*Architectural Record*), 1961.

The Oldest Trust Company and Its Newest Home. New York (City Bank and Farmer's Trust), 1931.

Pastier, John. "Postcards from the First Half Century." *Design Quarterly 140* (1988), pp. 3–11.

———. *The Skyscraper in Literature and Art*. New York, 1988.

Paul, Sherman. *Louis Sullivan: An Architect in American Thought*. Englewood Cliffs, NJ, 1962.

Peisch, Mark L. *The Chicago School of Architecture*. New York, 1964.

Pelli, Cesar. "Skyscrapers." *Perspecta 18* (1982), pp. 134–151.

Perry, W. Hawkins. *The Buildings of Detroit*. Detroit, 1968.

Pevsner, N. *A History of Building Types*. Princeton, NJ, 1976.

Philosophy of Tall Buildings. Bethlehem, PA (American Society of Civil Engineers), n.d.
Pictorial Chicago. Chicago, 1893.
Pierce, Bessie Louise. *A History of Chicago.* 3 vols. New York, 1935–1957.
Pokinski, Deborah. *The Development of the American Modern Style, 1893–1933.* Ann Arbor, MI, 1984.
Pond, Irving. "High Buildings and Beauty." *Architectural Forum* 33 (1923), pp. 42–77.
Poole, Ernest. *Giants Gone: Men Who Made Chicago.* New York, 1943.
Portoghasi, Paolo. *After Modern Architecture.* New York, 1982.
"Post World War II Architectural Interaction Between Chicago and New York." *Inland Architect* 28 (1984), p. 59.
Potter, Henry C. *The Citizen in His Relation to the Industrial Situation.* New Haven, 1902.
Proehl, Stephen. *Over New York.* Boston, 1980.
Prominent Buildings Erected by the George A. Fuller Company, Chicago. Chicago, 1893.
Randall, Frank. *History of the Development of Building Construction in Chicago.* Urbana, IL, 1949.
Rapson, Richard L. *Britons View America: Travel Commentary, 1860–1935.* London, 1971.
Rebori, A.W. "The Work of Burnham and Root." *Architectural Record,* July 1915.
Redstone, L. *The New Downtowns.* New York, 1976.
Reed, Earl H., Jr. "Some Recent Work of Holabird and Root Architects." *Architecture* 61, January 1930.
Reed, Henry Hope. *The Golden City.* New York, 1971.
Reps, John W. *The Making of Urban America.* Princeton, 1965.
Reynolds, D.M. *The Architecture of New York City.* New York, 1984.
Reynolds, John B. *77 Stories: The Chrysler Building.* New York, 1930.
Robinson, Cervin, and Rosemarie Haig Bletter. *Skyscraper Style: Art Deco New York.* New York, 1975.
The Romance of Glass. Pittsburgh (PPG Industries), n.d.
Root, John Wellborn. "Architects of Chicago." *Inland Architect and News Record,* January 1891.
———. *The Meanings of Architecture.* New York, 1967.
Roth, Leland M. *A Concise History of American Architecture.* New York, 1980.
Saarinen, Eliel. *The City, Its Growth, Its Decay, Its Future.* New York, 1945.
———. *The Search for Form in Art and Architecture.* New York, 1985.
Sachner, Paul M. "Reshaping the San Francisco Skyline." *Architectural Record* 173 (1985), pp. 58–59.
Schultze, Franz. "The New Chicago Architecture." *Art in America* 56 (May-June 1968).
Schuyler, Montgomery. "The Skyscraper Up to Date." *Architectural Review* 8 (1899), pp. 231–237.
———. "To Curb the Skyscraper." *Architectural Record,* October 1908.
Scully, Vincent. *American Architecture and Urbanism.* New York, 1969.

INDEX

Numbers in **boldface** refer to pages with illustrations